Stravinsky's Lunch

Stravinsky's Lunch
Drusilla Modjeska

Farrar, Straus and Giroux
New York

Farrar, Straus and Giroux
19 Union Square West, New York 10003

Copyright © 1999 by Drusilla Modjeska
All rights reserved
Distributed in Canada by Douglas & McIntyre Ltd.
Printed in the United States of America
Designed by Ruth Grüner
First published in 1999 by Pan Macmillan Australia Pty Ltd., Australia
First published in the United States by Farrar, Straus and Giroux
First American edition, 2000

Library of Congress Cataloging-in-Publication Data
Modjeska, Drusilla.
 Stravinsky's lunch / Drusilla Modjeska. — 1st ed.
 p. cm.
 Previously published: Sydney, N.S.W. : Picador, 1999.
 ISBN 0-374-27089-9 (alk. paper)
 1. Bowen, Stella. 2. Smith, Grace Cossington. 3. Painters—
Australia—Biography. I. Title.
ND1105.B675 M63 2000
759.994—dc21
 [B] 00-034789

FOR AMY, FOR MAYA,

AND FOR ERICA LOEWE

CONTENTS

List of Illustrations

Black and White

I ❧ STRAVINSKY'S LUNCH

II ❧ CONVERSATION PIECE: STELLA BOWEN

III ❦ NO MAN'S LAND

IV ❧ TO PAINT WHAT SHE SAW: GRACE COSSINGTON SMITH

Colour

32. Grace Cossington Smith, *Govett's Leap*, c. 1933, oil on pulpboard, 41.3 x 49.5 cm. (Private collection; photograph by courtesy of Deutscher-Menzies Fine Art)
33. Grace Cossington Smith, *The Lacquer Room*, c. 1935, oil on paperboard on plywood, 74.0 x 90.8 cm. (Art Gallery of New South Wales, Sydney)
34. Grace Cossington Smith, *Bonfire in the Bush*, c. 1937, oil on paperboard, 61.0 x 45.7 cm. (Art Gallery of New South Wales, Sydney)
35. Grace Cossington Smith, *Firewheel in a Glass Bowl*, 1937, oil on pulpboard, 40.5 x 36.5 cm. (Private collection; photograph by courtesy of Bruce James)
36. Grace Cossington Smith, *The Artist's Sister*, 1936, oil on paperboard, 49.5 x 41.5 cm. (Art Gallery of South Australia, Adelaide; South Australian Government Grant and d'Auvergne Boxall Bequest Fund, 1989)
37. Grace Cossington Smith, *Door into the Garden*, 1947, oil on pulpboard, 62.5 x 47.0 cm. (Private collection; photograph by courtesy of Bruce James)
38. Grace Cossington Smith, *Interior with Verandah Doors*, 1954, oil on composition board, 76.2 x 91.0 cm. (National Gallery of Australia, Canberra; bequest of Lucy Swanton, 1982)
39. Grace Cossington Smith, *Interior with Blue Painting*, 1956, oil on composition board, 89.6 x 121.2 cm. (National Gallery of Victoria, Melbourne)
40. Grace Cossington Smith, *Interior with Wardrobe Mirror*, 1955, oil on canvas on paperboard, 91.4 x 73.7 cm. (Art Gallery of New South Wales, Sydney)
41. Grace Cossington Smith, *Interior in Yellow*, 1964, oil on composition board, 121.7 x 90.2 cm. (National Gallery of Australia, Canberra)
42. Grace Cossington Smith, *Still Life with White Cup and Saucer*, 1971, oil on pulpboard, 59.1 x 86.4 cm. (Private collection)

'We make our destinies by our choice of gods.'

Virgil

'For somewhere there is an ancient enmity
between our daily life and the great work.
Help me, in saying it, to understand it.'

Rilke

I

STRAVINSKY'S LUNCH

Let us begin with two sisters dressed for a ball. It is 1904, the beginning of the century that is closing as I write, and the sisters are somewhere in Australia, in a house that isn't quite the measure of their dresses. Beyond this there is little I can tell you, for these adorned 'Two Girls in White' are not in a novel where all could be revealed, but captured for ever in that uncertain moment on the canvas of their artist brother. There they sit, with their forlorn faces, decked in muslin and silk, satin and lace, cream and white. There's a coat thrown over the back of the chair behind one of the sisters and it seems to rise around her like the wings of an angel. The other sister leans into her arm, weary, as if she needs to prop herself up. They are waiting—but for what? For the ball to begin? For the coach to arrive? For the beau? Or are they resigned to their fate which is simply to wait?

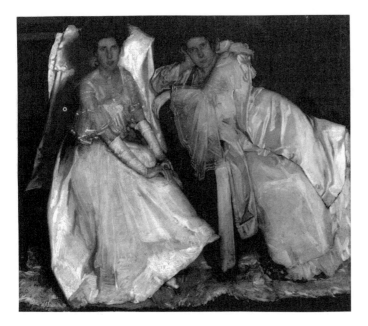

Hugh Ramsay,
The Sisters,
1904 (known
before 1918 as Two
Girls in White*).*

Whenever I look at this painting—which, as it is in the Art Gallery of New South Wales, is quite often—I think they are waiting for the century to begin. Which of course it had; it was 1904 already. And yet, knowing as we do what the century would bring, it is as if they are waiting for something to happen that would release them from the clothes that so utterly mismatch their expressions. You can see from their faces that they are not the girls who went to balls in nineteenth-century novels; and you can see from their clothes that there is nothing of the modern woman about them.

In biographical fact the two sisters were dressed for no better reason than to pose for their brother, Hugh Ramsay, who had recently returned home to them from Paris ill with tuberculosis. He had gone to seek his fortune in the city that promised most for those who wanted to paint the shape of the new century; but it was also a city that extracted its price in poverty and cold studios from those who could not afford its comforts. It might seem a romantic gesture, going to Paris to become an artist, but the stakes were high, and Hugh Ramsay was dead before he was thirty. If the sisters are sad as they watch him paint them, it is because they could see that he was dying. The mismatch of the painting—which one of Melbourne's stuffier critics found 'wanting in beauty or repose'[1]—was that Hugh Ramsay had dressed his mourning sisters for a ball they no longer wanted to go to.

He painted them dressed as good women had been customarily dressed for their portraits in the century that had just gone, and yet, perhaps because of his experience in Paris, that had allowed him a glimpse of the possibilities to come, he could see their discomfort and irritation, and he could see the disjuncture, even if he did not comprehend it. The achievement and power of the painting is that we see the sisters not only as he saw them, but as they saw him seeing them suspended between a past that was over, dying with their brother, and a future to which they could not yet give shape.

If one is to be literal about it, these sisters, these 'Two Girls in White', are waiting for their brother to die. But the success of the painting—with its weird disjunctures that discomfited the *Age* but engage us—is that the sisters are also waiting for possibilities that hadn't yet arrived. Take them out of those dresses and put them into artists' smocks, and those faces belong absolutely to the century in which they were painted. Hugh Ramsay died of T.B., an

individual fate acted out in an individual family in one of those solid, lugubrious houses that still squat on the ridges of our cities, and neither of his sisters became artists. But there were girls from those sorts of families, plenty of them, struggling out of their filmy dresses and into the work-clothes of an artist, looking for a way of being that would match the reach and intelligence of their faces. And their stories, as they would unfold, were to be tied to the fates of their brothers and the young men of their generation, and it was no less sorrowful if they knew them only as statistics posted back from the trenches of a war that would change everything.

The First World War was still a decade away when Hugh Ramsay painted his sisters, and it is a token of his ability that he could capture in their faces something of a century that hadn't yet shown its shape. Which is why this painting is—for me—a beginning; a first glimpse of the ambiguities of expectation and sorrow, promise and apprehension, that are to be found in the lives, and on the canvases, of the women who did exchange those ball-gowns for clothes that could take the smear of paint; the women who greeted the first decades of the twentieth century by lifting those dresses over their heads to see what they looked like underneath, unadorned, no longer in disguise.

<div align="center">✿</div>

In the year of Hugh Ramsay's death, 1906, a young German woman, almost exactly his age—born in 1876 to his 1877—was living alone in Paris. Her name was Paula Modersohn-Becker and, although we know her as one of the first—and best—of Europe's women modernists, at the time she was barely known outside her own circle in a small artists' colony near Bremen in Germany. There is no way that she could have been more widely known, as the only paintings of hers that had been exhibited were student works in a group exhibition in Bremen in 1899. The critical response had been so bad that her parents had begged their daughter—who was then not married—to give up her hopes of art and become a governess. At least when Hugh Ramsay got his bad reviews there was a grudging admission that he could paint, however inadequate the particular painting was considered to be. In Paula Modersohn-Becker's case, the outrage stemmed from the very fact that she—and two other

young women—were on the wall at all, displacing the paintings her furious critic was 'accustomed to seeing there'. 'The vocabulary of pure speech is not adequate to discuss the work of [these] ladies,' he wrote for the good burghers of Bremen—including Paula's parents—to read. 'A wretched lack of talent,' he bellowed as he frightened himself with the prospect of the work of young women spreading itself 'on wall after wall'. A prospect made all the worse by these young women's embracing of modern art. It was one thing to have a woman paint a competent portrait, as girls of the late nineteenth century were taught to do; quite another to have them veering off in pursuit of their own feelings. 'Lawless subjectivity,' he assured his readers, 'has never yet entered the mind of a great artist.'[2] And this was the key to it. The claim made by a woman like Paula Modersohn-Becker did two alarming things. It confronted critics and viewers with a subjectivity that was not only lawless but feminine, and it unsettled their comfortable notions of what art was.

Look at her in this 1906 self-portrait. There she is, bare-breasted against a speckled but otherwise featureless background, wearing an amber necklace and cradling her pregnant belly; her arms are protective, at once bold and diffident as she shows us this vulnerable swelling. You can see at a glance that this young woman has left the safe conventions of late-nineteenth-century portraiture.

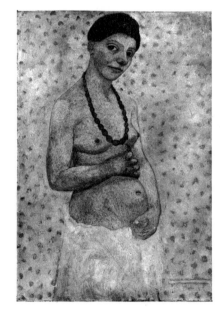

Paula Modersohn-Becker, SELF-PORTRAIT ON HER SIXTH WEDDING DAY, *15 May 1906.*

While *The Sisters* (as the 'Two Girls in White' are now called) owes a debt to Sargent, here there's a whiff of Gauguin, a passing bow to Cézanne. The painting is stripped back to essentials; and so is she, Paula Modersohn-Becker, the artist. Stripped back to flesh and belly. And rather than avert her eyes so that we can watch her without being seen to look, she meets our eye in a manner that is quizzical but challenging as she stakes her powerful claim to the twentieth century. The woman, for

so long the subject of art, the object men paint, turns—pregnant and in command of her own image—and looks back, facing us. Is that the challenge of this self-portrait? Or is she saying that the modern age may have dawned but women still have the realities of their bodies to contend with? *Pregnant* is still not an adjective that goes easily with *artist*.

Just to confuse the issue, let me tell you that in 1906, when she painted this self-portrait, Paula Modersohn-Becker was not pregnant. She had left her husband in Germany at the beginning of that year and had taken herself to live in Paris in search of the life of art she had not managed to find at the artists' colony at Worpswede. When she had married its director, Otto Modersohn, she had, wittingly or not, made the move of aligning herself with a man who was an artist in the hope that the marriage would foster her own artistic ambitions. It is a common move, many women have made it, and it beats being a governess; for the creative woman, drawn to an artistic milieu in pursuit of the freedom she needs both in love and in art, there is often something attractive in the sensibility and knowledge of the men she finds there. So a marriage like Paula Modersohn-Becker's was less a calculated gesture than the merger of desires. She had every reason to believe that her love for this man, and his confidence in her work, would provide the protection and spur she needed. But the reality failed to match her hopes, and after escaping for a few brief interludes in Paris where she felt the stir of possibility that she could not feel at Worpswede, she left Otto. She left the child whom she had inherited from his first marriage in the care of her own mother, and caught the train to Paris. There, where the great shift in sensibility had begun that would usher in new ways of being and new ways of seeing, it was the provincial critic, and not Paula Modersohn-Becker, who was out of step.

I tell the story in the briefest detail and wish to emphasise that Otto Modersohn was not an unloving husband. He adored her, he admired her work, and had the generosity to see that she, not he, was the one with the ability and the quality of vision that could leave a mark past their own time. But they both lived under a social regimen that took for granted the necessary role of a wife and stepmother— and the right of a husband to be supported in his chosen profession. However much he might admire her, and wish success upon her, by this scale his art was a career, hers a supplementary talent.

It wasn't that Paula Modersohn-Becker was unhappy in any straightforward way. Many of her letters from Worpswede show that her daily life with Otto and the child was harmonious for months at a time. Rather, she found that while he was infused with energy by their marriage, she was drained. It was as if she sank under the weight of her role as wife of the director, disappointed that the man who had vowed to her in love could not understand what she needed, what she felt, what she *was*. His view of her, for all its generosity, was obliterated by his need for her; or perhaps it was that his need for her became his view of her. 'Otto seems to need my face to look at several times a day,' she wrote to her sister in her second year of marriage.[3] Seeing her there beside him, Otto was restored to his studio where he painted landscapes with the poetic and rather sentimental sensibility of Worpswede; and Paula Modersohn-Becker was left with the loneliness that assaults women in the company of men who cannot comprehend the burden of their love. By the end of 1905, after four years of marriage, the tug and pull of this conflict had produced an unbearable tension in her. Mother, wife, muse: there was not enough soul left for her as artist. 'I was not able to endure it any longer,' she wrote to her mother from Paris. 'And I shall probably never be able to endure it again.'[4]

In one brief year in Paris, living alone, Paula Modersohn-Becker painted most of the paintings by which we know this extraordinarily talented woman. 'I'm living the most intensely happy period of my life,' she confided to her sister. 'Pray for me.' And she added this tell-tale request: 'Send me sixty francs for models' fees. Thank you.'[5]

She painted women and children, as she always had done, but the images became stronger, bolder, *clarified*, flooded with 'the unconscious feeling that often murmurs so softly and sweetly inside me'. It was as if she painted the essence of that powerful world of play and bond that is created in the safe space between mother and child, a space that is often seen as the prototype, and origin, of creativity itself. She painted still lives, grave with the wonder of objects—fruit, jugs, trays—as if they, like her, were new to a world that was seeing itself anew. And she painted her celebrated self-portraits, peeling away all the roles and expectations that had burdened her; as the letters poured in from her mother and her husband, begging her to return, she painted not so much to decipher the conflict that pursued her, as to *know* the dilemma and to know

what she was, if she could strip back beyond it, or before it, to that raw space of possibility that the mother holds open for the child.

The most famous of the self-portraits from that year of energy and freedom is this one in which she shows herself bare-breasted and pregnant. Which she wasn't. By 1907 she would be; but not in 1906. It seems to me, looking at this self-portrait from the other end of the century, that it is less a premonition than an image of the unknowing with which she—as artist and as woman—was living. Does she hold her belly swollen not so much with a child as with her own imaginings and ambitions? Is her belly swollen with the complexity of her desires? Is the self-portrait a coded acknowledgment that a child was what she did, in fact, want? Or what she feared? Or is it a question rather of what manner of child the woman as artist would bring forth into the world of modernity?

In June of 1906 Otto Modersohn came to Paris to claim his errant wife. She resisted, and he returned to Worpswede. At the end of the year he came again, and this time stayed until she agreed to return to Germany in the spring of 1907. For a year Paula had been in the humiliating position of having to ask for support in the same breath as she begged for her freedom. Her paintings, of immense value at the end of the century, were, in monetary terms, without value in 1906. She only sold one during her life and that was bought as an act of patronage by her friend, the poet Rainer Maria Rilke. Art, as Virginia Woolf has said, is tethered at every corner by crude facts like money and the houses we live in, and there's no escaping this blunt reality.

By the end of 1906 even Paula Modersohn-Becker's strongest supporters were beginning to worry that she wouldn't survive, and that, embattled and imperilled, she would lose the momentum of her work; already they could see the effect of anxiety as she brooded over the impossibility of her situation. After a year alone she was lonely and knew that the cost of independence was not only to be measured by the franc; there are other forms of support that it is hard to live without. She was thirty in 1906; of course pregnancy was on her mind. It was at the heart of the predicament of this young woman pulled inward to the clash between the longings of her belly and her own imaginative force, advised by everyone who cared for her that her best interests as well as her very survival lay in a return to Germany and her husband.

How was she to continue living and working alone, given over

to her painting, when, in March 1907, she realised she was indeed pregnant? She stayed in Paris for one last exhibition of Cézanne—'glorious things from his youth'—before she wrote to her mother to tell her that she would soon be a grandmother. Then she returned to Worpswede. She continued to paint during her pregnancy—still lives, some powerful studies of mothers and babies—but the great self-portraits, with their 'lawless subjectivity', belonged to that year when both freedom and the dilemma were greatest.

The baby, a girl, was born on 2 November 1907, and on 20 November Paula was allowed up from her long confinement. She braided her hair, 'wound the braids into a crown around her head', refused Otto's offer of his arm, walked ahead of him to join her family, asked for the child, and collapsed. When Otto ran to her aid, she had time only to say, 'A Pity,' before she died of an embolism.[6]

The story of Paula Modersohn-Becker, though awful, is not particularly unusual. I tell it less to shock than to illustrate a dilemma: every element of it, except the form of her death, will be replayed in this book. In big ways and in small, being a woman and an artist in the first half of the twentieth century was a dangerous activity that required boldness, and also flexibility.

The Scottish writer Naomi Mitchison knew something of this when, as a very young woman, she found a jug at a jumble sale with the words *Adventure to the Adventurous* inscribed on it. She bought the jug as a talisman and took its words as her motto. There is something satisfying about the shape of a jug, and its capacity to contain, and to pour—which is, perhaps, why jugs turn up in many still lives by the early modernist women. Paula Modersohn-Becker painted a double-handled jug as round as a belly during her pregnancy in 1907. The Australian potter Gladys Reynell drew sheets of jugs to find the perfect design; her friend Margaret Preston painted one of her jugs—round and blue and shiny—in a 1924 still life of her pottery.

Taking up the jug and pouring from it, or drinking from it, both in love and in art, was a task of great complexity for a young woman at the start of a complex, paradoxical century, and it is not much easier for those of us who lift the jug with the century's close. What has changed, though, is that our eyes have caught up with our

modernist grandmothers; we can recognise them, where audiences of their time very often could not. Or perhaps it would be more accurate to say that our modernist grandmothers have taught us how to see the images they made of themselves, because they have also taught us to see ourselves. So that while we can respond with a kick of recognition to the impassioned subjectivity of Paula Modersohn-Becker's self-portrait, at the time that she painted it, in 1906, it was more likely to be regarded as *lawless*, barely decipherable at all.

There is a rider to the story of Paula Modersohn-Becker. Before her marriage, while still a girl in love with the idea of Art, she visited Worpswede several times with her friend, the sculptor Clara Westhoff. It was there that she and Clara met the poet Rilke who, it seems, fell in love with them both. He married Clara soon after, but retained a charged attachment to Paula, becoming crabby when she, in turn, married. He understood, as few men did, the clash between her life and her art, and—from the safe distance of not being her husband—was sympathetic. He tried (without success) to get her work exhibited again, and he took exception to the pregnancy that removed her from Paris. But although he admired her work, during her lifetime he held something in reserve, as if her painting wasn't quite what he thought art should be; in his letters, for all their friendly interest, there is an element of patronage. But he was the one who bought the only painting she sold, and after the critical humiliation of 1899, which was not forgotten, his support was a life-line.

When she died, Rilke was profoundly shocked. Her death, he wrote to a friend, 'stood in front of me so huge and close that I could not shut my eyes'.[7] Still grief-struck a year later, he went to the Cézanne retrospective that was held in Paris to commemorate the great painter, who had died in 1906. As he stood in front of Cézanne's paintings, he understood something about the nature of art as if for the first time, and that something allowed him to see, *really* to see, how good Paula had been. Out of the grief of an understanding that came too late, he wrote a long poem as homage to her and a naked rebuke to himself; fuelled with regret he railed against what he saw as life's savage disregard for art, and especially for a woman's art. 'Ah let us lament.'[8]

What Rilke responded to in Cézanne was an unwavering eye which reached into the essence of the thing itself, a kind of modesty that understood the profound gravity, and mysteriousness, of objects. If it seems obvious to us after a century in which Cézanne has become recognised as the grand master of post-impressionism, revealing the structure of things rather than their surface appearance, then remember the critic at Paula Modersohn-Becker's Bremen show, and Hugh Ramsay's critic in the *Age*. In 1906 the view Rilke came to was neither easy nor usual; for provincial critics and their audiences, indeed for all but the most sophisticated, art, to be worthy of the name, still meant something grander—an ordering of emotion into *beauty and repose*, the elevation of sensibility over lawless subjectivity—or, more modestly, the representation of objects, and people, and places as they appear to empirical observation. Through Cézanne, Rilke was suddenly able to understand Paula's capacity to see in the most simple of things—*fruit in white bowls*—the essential presence of life, a fullness and thereness that needs no explanation, or justification, or myth, to hold it in place. He saw that in its drawing down into the humble—the *sayable* was his word for it—art can achieve the paradox of expressing the inexpressible mystery of ordinary things and modest moments. And he saw, too, that this was the way to the expression of the innermost experience of self. What I love about Rilke is that he had the humility—albeit dressed in awesome language—to translate this realisation into his understanding of the work of a woman who not only painted fruit in white bowls, but the condition of her own heart, which he had not been able to see—or bear?—while she was alive.

> For that is what you understood: ripe fruits.
> You set them before the canvas, in white bowls,
> and weighed out each one's heaviness with your colors.
> Women too, you saw, were fruits; and children, molded
> from inside, into the shapes of their existence.
> And at last, you saw yourself as a fruit, you stepped
> out of your clothes and brought your naked body
> before the mirror, you let yourself inside
> down to your gaze; which stayed in front, immense,
> and didn't say: I am that; no: this is.[9]

This is: it sounds simple, but it isn't. No games or tricks, no demand or diversion. Instead the vision of the witness—knowing utterly, as if she is inside the image, making object subject, and yet sufficiently detached to see it, and herself, without illusion, in the depth and simplicity of being. Because of Paula Modersohn-Becker—because of his love for her—Rilke saw the feminine nature, and value, of that kind of art. Not as a lesser value but as art itself. At last, when Paula was dead, he saw her work—and her life—as a revelation. And he saw that the way forward for him as a poet was to follow where she led, and go deeper into her country.

> I will stand
> for hours, talking with women in their doorways
> and watching, while they call their children home.[10]

In 1928 a young Australian woman called Stella Bowen was working in a studio in Montparnasse, not far from where Paula Modersohn-Becker wrote the letters home that announced her pregnancy. She was painting a self-portrait (plate 7), and in it we can see, as it were, the face of the daughter, the next generation of artist, born of the pregnant dilemma that Paula Modersohn-Becker had shown the world in her self-portrait twenty-two years earlier. There she is, strong and bold, meeting our eye without Paula's diffident tilt to the head, without the heaviness of her necklace. Filling the frame, and brought forward as if onto the very surface of the painting, this is the face of the woman who wears her modernity with the casual elegance of a smock over cream and ochre.

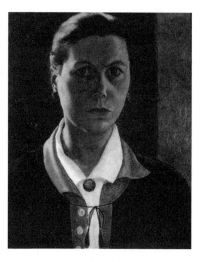

Stella Bowen,
Self-Portrait,
c. 1928.

Although the shirt is made of a rather fine silk, there is no mismatch here between clothes and face; the silk, protected by the smock,

is worn without self-consciousness. There is ambiguity and immense complexity in the expression, but it doesn't come from the phantom of pregnancy, or the premonition of death; and it doesn't come from the imposition of the wrong clothes. What it is, that complexity, is not immediately apparent. Stella Bowen makes no apology and tells no story; the background is without feature—there are none of the trappings of the artist—and the clean lines of the composition draw us to that expressive face. There are no brushes, no easels, no model, no background studio. Just the face, in paint, of the woman who paints. This is not a painting about what she *does* as an artist; it is a painting about what she *feels*. Meet my eye, this self-portrait says, and tell me what you see. Woman? Mother? Lover? Artist?

Stella Bowen painted this self-portrait the year she ended her 'long intimacy', as she called it, with the father of her child, English writer Ford Madox Ford. She separated from him in 1928, the year of her self-portrait, and in 1931, still in Paris where they had been living for some years, she held her first exhibition. These two events were profoundly connected. She was, she said, kick-started into 'the effrontery of taking up painting as a profession' by the demise of a relationship that had been, and in many ways continued to be, the defining experience of her life. Until then, her role had been that of consort to a man who could not write if there was a disturbance of any kind during the mornings. If the household was to survive the writing of his books, the task that fell to her—as muse and lover— was to ensure silence while he worked and to provide relief, companionship and sustenance when his work was done.

She didn't enter the liaison with this intention; she fell in love with Ford, genuinely so, and like Paula Modersohn-Becker she fell also in love with a milieu, and with the possibility, the prospect, of uniting romance with her own creative desires. Love and Art became united as her hopes for one folded into the other. And like Paula Modersohn-Becker she discovered that there is an uneasy rub, a chafing line, between these two desires. Far from solving longings that had seemed impossibly at odds during her Adelaide girlhood, Ford introduced her to the immense difficulties that come with the attempt to live in both heart and imagination, combining passion with the solitary focus of art.

Like Otto Modersohn with Paula, Ford encouraged Stella Bowen to paint. Right from the start he saw that she had the

makings of an artist and he could never understand why she didn't paint more during their time together. He thought that all she lacked was the will. 'That was true,' she wrote many years later, 'but he did not realise that if I *had* had the will to do it at all costs, my life would have been oriented quite differently.' She wouldn't have been available to keep the household quiet for him; on the contrary, she would have needed someone to keep it quiet for her. And she wouldn't have been available when he needed her, and in the way he needed her, at the end of the day. 'Any artist knows,' she wrote, 'that after a good bout of work one is both too tired and too excited to be of any use to anyone. To be obliged to tackle other people's problems, or merely to cook their meals, the moment one lays down pen or brush, is intolerably hard. What one wants, on the contrary, is for other people to occupy themselves with one's own moods and requirements; to lie on a sofa and listen to music, and have things brought to one on a tray! That is why a man writer or painter always manages to get some woman to look after him and make his life easy, and since female devotion . . . is a glut on the market, this is not difficult. A professional woman, however, seldom gets this cushioning unless she can pay for it.'[11]

Stella Bowen wrote this in her memoir more than a decade after she and Ford had separated. If anyone knew the cost exacted by the great male artist, it was Stella Bowen—but she also always insisted on the countervailing benefits that came to her from those years with Ford. When the liaison ended she did not lay it down easily, but she laid it down generously. 'What I got out of it,' she wrote, 'was a remarkable and liberal education, administered in ideal circumstances.' Her role as consort held her back, maybe, and she got to carry a lot of trays, but her point was also that those years with Ford made her the artist she was. Look again at that face: it is the face of the woman who has picked up the challenge that Hugh Ramsay's sisters barely knew was there. There is no doubt about her engagement with life either as an artist, or as a woman of passionate heart. She is certainly not waiting for something to begin.

There is a story that's told about Stravinsky. Since it was told to me several years ago when I was first thinking about this book, it has fallen like a shadow across my page. It isn't much of a story, simply that when Stravinsky was in mid-composition, he insisted that his family ate lunch in silence. The slightest sound, a murmur, even a whisper, could ruin his concentration and destroy an entire work. It's not a particularly unusual story—great male artists have demanded more than that in the name of Art—and yet it has worked on me, and in me, in ways that it has taken me a long time to understand. What began, for me, as an argument, has become taken into my life as a kind of meditation.

When I first heard the story, there were several people present, all of us friends, all of us engaged in one way or another with what are called 'the arts'. We were eating a meal together—dinner as it happens, not lunch. The man who told the story told it as an exemplum of the importance of rigour in artistic practice; such behaviour made Stravinsky the composer he was. When the chips were down, as this man, my friend, put it, art, if it is to be Art, must win out. He was supported by one or two others, who said that if that was the price of great art, so be it; how do you weigh the pleasure that's been afforded to thousands, probably millions; how do you weigh the achievement of, say, *The Rite of Spring*, or the *Symphony of Psalms*, against the discomfort of a few individuals?

I argued, along with other women at the table, that it was perfectly reasonable for Stravinsky not to want to talk at lunch; but it was not reasonable to impose this on others, and certainly not on his children. As far as we were concerned, he should have had his lunch on a tray. We weren't confrontational about this; on the contrary, our impulse was to find a compromise. No one suggested (though it is a thought) that Stravinsky should have gone and got the tray. No, we were quite prepared to have someone—a maid, no doubt—carry the tray to him. Our point was that even in the face of art, *especially* in the face of art, life must go on.

Later, after the argument had spilled over into our lives and had become part of our vocabulary, I looked for the source of this story and found it in a book of recollections by Robert Craft. 'All artists are selfish,' Craft wrote in his *Chronicle of a Friendship*; 'they must be, to

get their work done. And they sacrifice the people around them. [Stravinsky] sacrificed his children to his art . . . I can imagine, from my own early years with him, exactly what life must have been for them.'[12] He then tells of the lunches taken in silence. By the time Robert Craft was eating meals with Stravinsky, the children were long grown up. But there is a story from 1916 when Stravinsky's four children were still young. The dancer Nijinsky asked if he could leave his infant daughter with the Stravinsky family while he went to New York to join Diaghilev. Though Stravinsky's wife would happily have taken the child, the composer said no with such authority that she complied. 'He does love the children,' Nijinsky wrote in his diary, 'but he loves them strangely . . . He is like an emperor, and his children and wife are the servants and soldiers.'[13] Even at eighty-six, 'ill and in bed', Craft says, Stravinsky could still 'terrorise' his youngest daughter.

As we argued about this story—which at the time I knew only in outline—the terms became distorted, friendships showed signs of strain. It was as if a deep fissure was opened, touching us all where we were most vulnerable, for 'life' and 'art'—those two huge categories— rarely sit comfortably together; men and women almost invariably take different positions and get angry. Even now, at the end of the twentieth century, when such battles have been had and had and had again, they still exercise us. At stake are questions about how we live our lives, what we are prepared to ask of ourselves and of those who love us, what value we put on love and what value we put on art; what compromises we will make; which gods we will appease.

While Stella Bowen was in Paris painting her self-portrait, across the Channel in England Virginia Woolf was making her famous inter-vention into this debate. With the publication of *A Room of One's Own*, she put it bluntly that women hadn't a hope of producing art of any sort if they remained dependent on men. What a woman needed, quite unequivocally, was a room of her own and £500 a year—which was a lot of money in 1929. In *To the Lighthouse*, which had been published two years earlier, she had taken up the question of women, men and art, and by giving it the force of character and image, had delved into its emotional and psychological implications.

In the novel, Lily Briscoe, unmarried and a painter, is one of

Mrs Ramsay's guests on holiday in Scotland. She is on the lawn, looking out to sea, with her paints and her easel. What Lily wants is simply to paint what she sees (as if such a thing were simple) but her endeavour is daily complicated and undermined by a shadow that falls across her canvas. The shadow is shaped like a man. His name is Mr Tansley, he's another guest, and he sidles up to Lily Briscoe and whispers: *Women can't write, women can't paint*. That shadow is a powerful image, and a great deal will have to happen before Lily Briscoe's painting can match its power. For it's not only a room of her own and an income that a woman needs—though that is often hard enough to come by—but the place in herself, the space in her soul from which she can withstand the onslaught of a world that cannot, or will not, take her seriously. Lily Briscoe knew that it wasn't true, what Mr Tansley whispered, and that he had his own reasons for wishing to undermine her, but still she bowed and sagged. Mr Tansley's whisper is a refrain through the novel— a refrain that is answered in almost everything Virginia Woolf wrote.

And as every woman who paints—or who writes—knows, it is a refrain that can still need answering. These days it rarely comes as bluntly as it did from Mr Tansley and that, I suppose, can be counted an advance; but something of the attitude remains. It was there that evening, even among friends, in the story of Stravinsky's lunch. The implication was that people who carry trays don't write symphonies and never will. The shadow that fell across my page was shaped like a tray.

Gertrude Stein, who solved a lot of problems by claiming masculine privilege as her own, put around the idea that the confidence of men was waning with the twentieth century, and especially after the carnage and horror of the First World War. That, according to her, was why they were so noisily self-aggrandising; it is a sure sign of insecurity in men, she said, when, like women, they start writing about themselves. And Virginia Woolf recognised, as women do, that a lot of the striding and posing and insisting came from weakness and anxiety. Stella Bowen, who, incidentally, knew Gertrude Stein, thought that 'women are often unimaginative about the vulnerability of Man the Protagonist'. After all, what happens to the man who needs silence at lunch if his family refuses to comply? Could his art be so easily ruined? 'Masculine vanity is one of the

biggest motive forces in the world,' she wrote, 'and if it suffers deflation, the result is often a moral collapse.'[14]

Ford Madox Ford was a man who made a virtue of bad behaviour—his womanising, his debts, his broken friendships, his court appearances—as if they were necessary to the task of art: *the Divine Right of Artists*, he called it. And yet he was also a man tormented by self-doubt, always measuring himself against others. Maybe Gertrude Stein was right. He had been shell-shocked on the Somme not long before Stella Bowen met him in the last year of the war. She knew his wounds. Compassion and complicity came from that knowledge, and this too was part of the dilemma from which she painted her self-portrait.

Ford Madox Ford made demands that strike a modern sensibility as outrageous, but he never demanded silence at lunch. He had meals held up until he was ready, but once the food was on the table he was a great and splendid talker. For Stella Bowen that made all the difference; meals mattered to her precisely because they were an occasion for conversation. Having grown up in Adelaide in a world of formal, starchy meals, she came to love the challenge of a table surrounded by friends talking—'fast and friendly'—of painters and painting, of short cuts to dress-making and the best markets, the conundrums of daily existence. All that was needed on the table was a bottle of wine, a loaf of bread and a salad.

'I am more and more attracted to looseness,' Virginia Woolf is said to have said, 'freedom and eating one's dinner off a table anywhere.'[15]

Lunch, you see, is a refrain. We all need to eat and to drink. If I start with a simple story, a simple need, a straightforward conflict, it is because nothing that comes from it is simple or straightforward. It is in the nature of love, and in the nature of art, to be complex, disturbing, taxing.

But the argument about Stravinsky's lunch that night wasn't only about food and how we eat it. It was also about keeping children quiet. For the story rests on the assumption that the sound of a man's children can be detrimental to his art, and it is up to the mother—or at any rate to someone else—to keep them quiet.

'If you are a woman,' Stella Bowen wrote, 'and you want to have a life of your own, it would probably be better for you to fall in love at seventeen, be seduced, and abandoned, and your baby die. If you survived this, you might go far!'[16] Paula Modersohn-Becker had painted herself pregnant when she was not, during that one year in which she managed to leave the demands of the family behind in Germany. Although both women knew that to have a child would hold them back as artists, neither wanted a life without. In their different ways, the question they were asking was whether both forms of creativity could be open to them. Or is there something antipathetical about babies and art? Paula Modersohn-Becker painted herself as full and round as a jug; and in her images of mothers and children that moved Rilke so, she painted—as few others have—the fundamental nature of that bond. As to Stella Bowen, she was on her own admission enlarged by her intimacy with Ford, and for all her ambivalence about what her life with him came to mean, she was never ambivalent about their daughter. You have only to look at the way she painted her to see that.

But when it comes to children and art, there have probably been more women who have painted without children than there have been mothers who were artists. And it is easy enough to wonder if it is only with the absence of children that a woman's art can flourish; how often does one hear it said of a woman that her books, or her paintings, are her children, as if it were a simple matter of compensation, of one standing in for the other.

When Stella Bowen was living in London during the First World War, in Australia, the country of her birth, Grace Cossington Smith was painting the dilemma from the other side. She, almost an exact contemporary, never had children and for her it was, I think, appropriate that she did not. To say that babies are important too is not to say that they are necessary in the life of every woman. But even without the desire for a child strong within her, Grace Cossington Smith knew what was at stake, and that knowing is in her first great painting, *The Sock Knitter* (plate 17), which was exhibited in Sydney in 1915, while she was still a student. It is not a self-portrait. The woman knitting socks is her sister Madge. For anyone looking at *The Sock Knitter* in 1915, it would have been immediately obvious that she was knitting, as all good young women were, for the soldiers who were away at that most savage of wars we

call the First World War. With casualty lists posted daily, it would also have been obvious that the young men for whom a girl like Madge was knitting were dying before they could return home to marry. There was nothing of the artist about Madge, and in painting her, her sister knew there was nothing full, or filling, about the task of knitting in coarse wool. For Madge there was to be no compensation. Like Grace, she never married. But while the war might be said to have opened up possibilities for a young woman like Grace Cossington Smith whose clear ambition was to paint, it cast a long and painful shadow over the lives of women like Madge.

As for Grace, was it easier without a child? She had her own studio from the time she was twenty-two, and she had a small but adequate income. She wasn't pulled off course by husbands and lovers. And yet her story, as you will see, was not one of easy surmounting. The essential drama of her life was less the meal with its attendant conversations, its demands, its struggles for control, than the dilemma that lies beneath; in a woman's deepest and most private interiority, in the drama of her own psyche, the demands of art—its pleasures, its silences, its refusals—can be as intense as any love affair. Over a very long life, of which nearly sixty years were devoted to painting, Grace Cossington Smith gave herself, largely undistracted and alone, to the task of painting what she saw, what she felt, and what she knew to be true. It was, she said, 'a continual try', by which she meant both in life and in art. If Stella Bowen painted the heart of the modern woman, Grace Cossington Smith could be said to have painted the soul of the woman as artist.

Stella Bowen and Grace Cossington Smith were born a year apart, in the antipodean autumns of 1893 and 1892 respectively. Which brought them to maturity during the twenty years that fell between the ending of one world war and the beginning of the next. Beyond these bald facts their lives were very different. One was a good cook; the other was not. One left Australia on the eve of the First World War and lived the rest of her life in Europe; the other lived for decades in the same house on the outskirts of Sydney. For one Paris and famous names; for the other the quiet life of a provincial suburb. One went off to find a life of art; the art of the other grew out of the

life she lived. The bohemian and the spinster. They are like mirror images of each other, two sides of a coin. One left a memoir and hundreds of letters. The other left barely a written word—instead the glory of oil and crayon and watercolour, and the elliptical evidence of her sketchbooks. And yet there is something in their stories that is the same; not the content but the struggle and achievement, dilemma and preoccupation, courage and hard-won wisdom, differently expressed.

I tell their stories, similar and different both, as a koan in my own practice as a woman and writer. I tell them to understand.

II

CONVERSATION PIECE:
STELLA BOWEN

1. 'I WAS BORN,' Stella Bowen wrote, 'in the sort of house that must inevitably end its days as a boarding house. It was sizeable, rather gloomy, at a sufficiently good but not fashionable address.'[1] The year was 1893, the month was May, and the place was Adelaide. Beyond these few details there is little certainty. Her mother was the daughter of an Anglican clergyman; her father came from a family 'whose outlook was not predominantly Church of England and whose forebears had been in the building trade'. But Thomas Hopkins Bowen died when Stella was three, leaving on her mother's bureau photos of a serious man with a huge moustache—and a legacy of quite well executed Victorian watercolours framed and hung in the lugubrious house, which did not become a boarding house, and is now a smart residence in the smart suburb of North Adelaide.

It was a thoroughly old-fashioned milieu that received the infant Stella Bowen: handlebar moustaches, saintly mothers, English proprieties translated into antipodean niceties to welcome the birth of a child who would grow up to be a thoroughly modern woman. But then history rarely shows its seams. The last decade of the nineteenth century saw the arrival of many girl babies into the arms of Victorian mothers who, thirty years later, would be astonished and alarmed by the lives their daughters were leading. Not that the babies or mothers would have had much sense of this as they gurgled to each other in the nurseries of the western world.

Looking back, Stella Bowen called herself a 'stodgy and law-abiding little girl'. I don't believe it. And I don't believe it on the evidence of one photograph, which is all I've seen of her at that age—seven, or possibly six. She is sitting in a high-necked white Victorian dress at the end of a row of grouped children and adults watching a cricket match at Bishop's Court in 1903. This little girl, even without a magnifying glass, is identifiably Stella: that heavy swath of straight black hair, those wide-open eyes, that tucked-in chin. Her brother, cross-legged in front of her, one of a row of little boys in sailor suits, is pulling a naughty face. Stella, who had been

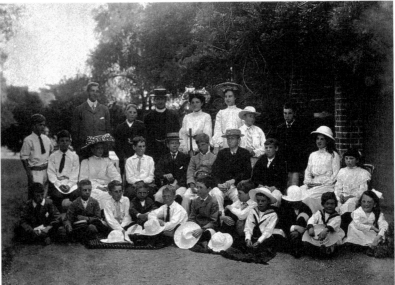

Stella watching a cricket match at Bishop's Court, North Adelaide, 1903. She is on a chair at the right-hand end of the second row, with her brother Tom in a sailor suit at her feet.

christened Esther Gwendolyn, and was called Estelle, is hunched in thought. Her attention is not on the camera, and, it seems, not on the game the group was assembled to watch.

Stella Bowen left Adelaide at the age of twenty never to return. Although she didn't know it at the time, she was to arrive in England on the eve of the First World War. Her memoir, which she called *Drawn from Life*, was written in 1940 during the first full year of the Second World War. As everything she considered her 'real life' was bracketed by those two wars, her sense of her Australian childhood—as far removed in time as Adelaide was from Europe— is rather like a series of photographs: vivid, but curiously remote. That place of memory—with its 'small fry of trivial happenings'— was doomed to vanish into the sepia tones of a pictorial record. Tennis parties, girls in long dresses—'it was a crime to reveal that you were bi-ped above the hem-line'—polite tea parties, dancing lessons watched over by mammas sitting on 'pale blue tufted satin chairs', cricket matches and endless talk of 'home'.

'I wish I knew the truth about that strangely dim and distant life in Adelaide before the war,' she wrote in 1940. 'I have constructed it in my memory as a queer little backwater of intellectual timidity— a kind of hangover of Victorian provincialism, isolated by three

immense oceans and a great desert, and stricken by recurrent waves of paralysing heat. It lies shimmering on a plain encircled by soft blue hills, prettyish, banal, and filled to the brim with an anguish of boredom.'

Paradoxically, it was perhaps precisely because she grew up in a place as secure as it was dull, that she had the underlying strength not only to push beyond convention, but to be one of those who change the terms for those who come after. I make it sound easy, as if all she had to do was to stretch and reach, as if to follow such an impulse were straightforward. But once she left that distant land of her childhood, Stella Bowen learned very fast that other things—safety, security, the regularity she had taken for granted all her young life— were also disappearing into that same sepia-toned history. With the gains she never denied came an irrevocable loss. That is why, it seems to me, a note of yearning and nostalgia undercuts her story of Adelaide's colonial drabness. Running beneath her account of 'those decorous games in the garden', that 'suburb of England', is the exile's call of memory to blue seas, hot nights on a cool verandah, a cornucopia of fruits, the door that is always open.

Her account of her childhood is rather like the lyrical one-page introduction to Christina Stead's *For Love Alone*. When Christina Stead left Australia in 1928, she was slightly older than Stella had been, but she was also reaching for a future that would bring her Love and Art and Destiny. Writing *For Love Alone* in England at about the same time as Stella was there writing *Drawn from Life*, she too looked back to a hazy childhood, and an Australia of magical, almost mythic proportions: the great island continent floating free in the deep blue of the southern ocean, a land of seafarers and tall ships. Travel inland, she wrote, and there are 'plains heavy with wheat, then the endless dust, and after outcrops of silver, opal, and gold, Sahara, the salt-crusted bed of a prehistoric sea, and leafless mountain ranges'.² A romantic, teasing memory to match Stella's of Adelaide, where 'ship-masts reared themselves against . . . spectacular sunsets' and trains 'ran for three days as far as the desert, and then came back again'.

Deepening the common inheritance of gain and grief that every exile knows, both Stella Bowen and Christina Stead suffered the loss of a mother before they left Australia. Christina Stead's mother had died when she was a child. Mrs Bowen died of cancer in 1913 when

she was fifty and Stella just twenty. It was in reaction to this, I think, rather than to Adelaide itself that a deep fissure in Stella Bowen is best understood. All her life, grief would be bound into achievement; shadowing her courage, her capacity for adventure and risk, was a painful sense of loss. She learned young that vulnerability lay close to her strengths.

Stella's mother, Esther Eliza, had married a much older man, who died while she was pregnant with their second child. Thomas Hopkins Bowen had been a surveyor by profession, and a man of artistic sensibility who read poetry, exchanged novels with his wife, and painted in watercolour. Their short marriage—his second, her first—had been happy, although Esther Eliza, whose 'friends were the Bishop's wife, the Governor's wife, and the wives . . . of the higher clergy', did not always see eye to eye with her husband's family. Stella, who was a child when her father died, must have inherited something of his artistic disposition, but for her there was no memory of a father. For Esther Eliza, however, the loss was extreme. At any time it is painful, almost unendurable, to bury a husband with a child kicking inside you, but in that age and that place, when a woman like Esther Eliza was given no other role than wife and mother, it was akin to a life sentence. The widowed Mrs Bowen dealt with it by elevating widowhood to a kind of sacrament. 'My mother,' Stella Bowen wrote, 'was a gentle and loving saint, whose life was lived in willing obedience to all those pious maxims which governed Victorian womanhood.'

In that sorrowful but well-appointed house, Stella grew up secure in the love of a devoted parent, and with uncles and trustees who ensured her material wellbeing. But saintliness in a mother can be as much a burden as a blessing, with its shadow of depression and complaint. The mother, the source of love, was also a source of restriction. How could the daughter of such a woman find the shape of her own unsaintly longings without hurting the mother?

Esther Eliza had recognised her daughter's talent for drawing, and duly made sure that art classes were included in her education. But while the development of 'talent' in a girl was a fine thing, ambition and professionalism were not. When Stella left school and enrolled in the studio of 'a red-headed little fire-brand of a woman' called Rose MacPherson (who would soon be known to Australia as Margaret Preston), Esther Eliza's anxiety turned into alarm.

In 1907, when Stella Bowen was fourteen, Rose MacPherson had returned to Adelaide from Paris. Having run out of money, she came back to replenish, setting up a studio and taking students. Stella joined her classes when she left school in 1910. Although Rose MacPherson had studied Japanese art at the Musée Guimet and discovered 'that a picture could have more than eye realism',[3] she was not yet the modern she was to become. It wasn't until her next visit to Paris in 1912 that she discovered Gauguin and the use of bold colour and stylised form that mark her later work. Nevertheless her introduction of a nude model into her studio classes was enough to alarm Mrs Bowen.

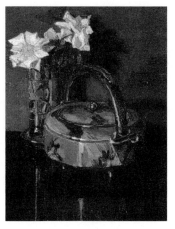

Stella Bowen, The Kettle, *c. 1912.*

Looking back, Stella Bowen could see the inadequacy of the teaching she received from Rose MacPherson. 'I was taught to paint by tone-values, to study degrees of light and shade,' she wrote in *Drawn from Life*, 'and to make a direct attack upon the canvas . . . It is not the method which I now follow, and I could wish that I had an architectural rather than a photo-graphic sense developed in those early lessons. It would have saved a lot of time.' An Adelaide student work of a kettle on a table, rather like an early Margaret Preston, shows a competence in the young Stella Bowen, but little sense of personal style. Nevertheless Rose MacPherson was 'an inspiring teacher' and Stella said that 'going up the stairs to that studio were the happiest moments' of her Adelaide life. 'All sorts of new aesthetic sensibilities began sprouting in my spirit like mushrooms.' It was Rose MacPherson who gave her her first glimpse of Paris and brought her news of a dawning century in which a woman, even a girl like her, might 'regard the human will as a precious life force instead of merely something to be subdued and trimmed to fit a pious pattern'. Rose MacPherson's technique may have been conventional and ultimately not much help, but her 'knowledge, integrity, and dynamic enthusiasm did wonders in setting all my machinery in motion', Stella Bowen wrote in a characteristic moment of understatement.

Miss MacPherson, with her nude model and modern ideas, also set in motion a deep, and deeply disturbing, conflict between a daughter leaning into the twentieth century and a mother tethered to an age that kept its women weak. When Rose MacPherson returned to Paris in 1912, travelling with the potter Gladys Reynell, Stella, coming up for twenty, knew that there was no one else who could teach her in Adelaide. As a first move she wanted to continue her studies at the National Gallery School in Melbourne where Miss MacPherson had trained, but her mother said no.

Stella Bowen's account of this first great struggle, written nearly thirty years later, is filtered through a complex set of lenses. There's the memory of what it's like to be a girl filled with ambition. There's also a woman's understanding of the perils daughters face, for she was writing her memoir as Julie, her own daughter, was leaving home at the start of the Second World War. So her account of her youth, 'chasing sententiously after alien gods . . . called Beauty and Freedom', tempers a girl's ambition with a mother's irony. As she wrote, she knew what she couldn't have known in 1912, that it was not just piety that had held her mother back from embracing her enthusiasm for art. Esther Eliza's shocked response to the nude model—who, Stella said, was 'a little girl of fourteen'—had come from her allegiance to a standard of behaviour that was already outmoded even in Adelaide; but her fears for the fate of a headstrong daughter were those that every mother has, knowing, as a girl does not, the ease with which risk can slide into danger.

After her mother's death, Stella found an entry in her diary which recorded a visit from Miss MacPherson. 'You know, Mrs Bowen,' the future Margaret Preston is reported to have said, 'you won't be able to keep her.' Reading this, and later recounting it in her memoir, Stella was face to face with her mother's grief, insistence and fear, and the price that her own ambitions would exact. In Stella Bowen's niece's album there are several photos of Esther Eliza, and I imagine Stella with the diary in one hand, the photos in the other, looking as one does after a death, looking and looking, as if the image will reveal all that was missed in life.

The photographs are conventionally posed, taken by a professional photographer, some in half profile, or taken from behind, the head turned to glance over the shoulder. The one that caught my attention has Esther Eliza looking into the camera with

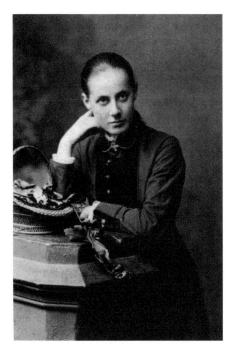

Esther Eliza Bowen,
Stella's mother.

eyes as intent as her daughter's. The face is eerily modern, though her stance—like her attitude to her daughter—is not. She leans in familiar Victorian pose against a small ornate pillar; her face is tilted forward, her hair pulled back. How could the daughter bear the knowledge of all her mother had not had? How could she not see that to have lost her daughter as well would have been insupportable in a life already gravely curtailed by loss? Tom, Stella's younger brother, fought none of these battles. He was still at school, 'and anyway he had the prerogatives of his sex', Stella wrote. 'Boys did leave home. Girls didn't.'

During the 'period of unhappiness' in which Stella's pleas to go to Melbourne were matched by her mother's refusal, she relied for comfort on her Kyffin Thomas cousins—clever, artistic girls from her father's side of the family. Kathleen lent her books by H.G. Wells and Bernard Shaw, which 'blew through my poor little home-made mind like a thrilling but alarming tornado'. Nora, Kathleen's older sister, who had studied the violin in Leipzig, introduced her to Ethel Cooper, who 'played the trombone for visiting orchestras and might often be seen, camouflaged by a black coat and man's tie, amongst the wind instruments at the Theatre Royal'. Miss Cooper was a

traveller, musician and enthusiast for wind instruments; 'women must come to wind', she said. She suggested that Stella take up the cornet and join her women's orchestra. Even this Mrs Bowen resisted. And if the answer to the cornet was no, what chance was there for art school in Melbourne?

Thirty years later, and knowing all that was to come, the adult Stella Bowen could write: 'I am glad to remember that just before her last illness I had promised that I would never again ask to leave home.' As things turned out, she could be glad. But if this conflict had not been resolved by Mrs Bowen's premature death, what would have happened? Such promises surely cannot—and should not— stick. In *Drawn from Life* Stella gave two conflicting possibilities. In one paragraph she was sure that her mother, had she lived, would have come round and let her make her life as she wished. In another she saw herself condemned to those hot, drab suburbs, married to one of the young men from Adelaide's many tennis parties. It was not so different from the fate Christina Stead feared and ridiculed: those girls dressed in cheap gowns marrying clerks as a prelude to a life lived along the railway tracks.

I mention these alternatives not as unlived possibilities— though it is worth casting a moment's thought in the direction of other ambitious girls who ended up in precisely those marriages— but because they indicate the force of a conflict, faced at an early age, that would be replayed many times in her life. In this first test of allegiances, this first clash of art and love, her fear that her talents and hopes would die unused inside her was pitted against her fear of hurting the ones she loved.

The option she doesn't canvas in *Drawn from Life* is that, had her mother lived, she'd have left and gone to Melbourne anyway. It was a crunch that never came, for her mother's death, 'in a gentle radiance of religious faith', released her in the cruellest of ways. 'Her last illness,' Stella wrote, 'was my first experience of tragedy. When they told me she could not recover, I was terror-struck. The freedom that I had longed for was coming towards me, but I did not want it. Not just then.' Freedom, she learned young—and would learn again and again through her life—does not come free. Nor does art.

From our perspective the better part of a century later, this death of a woman who had lived so entirely within the constraints of a Victorian regime stands as one of those odd moments in history

when we can almost see the line between past and future. Mrs Bowen died in July 1913, a year before the war that kicked the stragglers from the nineteenth century clean into the twentieth. From the perspective of the daughter who was embarking on a journey that would take her into modernist Paris, it came to be seen as a moment in which the passing of the Victorian mother gave birth to the quintessential twentieth-century woman. The knowledge of this exchange—death for life—was the burden that would lie like a shadow not only in the life of Stella Bowen but of every woman of her generation who would claim the freedoms—and dangers—of modernity from the death of a maternal order that had traded risk for security. Their daughters grew to become the generation that would reverse the bargain.

Not, of course, that Stella could have realised any of this as she and Tom stood by their mother's grave, or put their arms around each other in the empty house, still decorated with the watercolours and photos of a father they'd never known. Then, in that present, they promised each other that 'everything must always be as she would have wished'. But it was an impossible promise. 'Even in the most poignant moment of loss,' Stella's memoir confesses, 'I knew what to do with [freedom] when it came.'

The trustees, taking charge, sent Tom, then seventeen, back to finish his schooling at St Peter's College. Estelle (as she was until she left) sought an interview with her uncle and put it to him as a trustee that since Tom was at boarding school and she wasn't needed to keep house for him, she should be free to go to Europe. Only for a year, came the reply. The trustees duly bought her a return ticket to London, put her in the charge of a family sailing as far as Marseilles, gave her an allowance of £240 a year, and arranged for her to lodge in Pimlico with the secretary of the Mothers' Union. Safe choices all the way.

'I had £20 a month, I was free,' Stella wrote, 'and I was beholden to nobody.'

2. 'THE GREAT THING about a sea voyage,' Stella Bowen wrote in *Drawn from Life*, 'is that you miss the changing landscape between one country and another. There is no clue in sea and sky to foretell what the next picture will be like.' Linked to this strange sense of anticipation, there is another advantage to a long voyage—at least for the young—for as distance marks itself in the slow unfolding of the ship's wake, there is always the possibility of reinventing, if not one's self, then one's persona. 'The ship became a kind of buffer state between two worlds—a state where the stiff and timorous fledgling was able to try her conversational wings amongst strangers who had never been told that Stella Bowen was quite a dull girl!' The Edwardian daughter was packed away with a name that was never used again, and in place of Estelle, Stella Bowen stepped off the boat-train in London. 'That was in April 1914,' she wrote, 'and I have never gone back.'

The shock on arrival was that at first glance London seemed no more ready to receive her ambitions than the stodgy society of Adelaide had been. The glittering streets of London, the common coin of 'home', names with the status of fairytale, proved cramped and dirty. 'Bond Street was a bitter disappointment, and Park Lane not splendid at all.' The household in Pimlico could have been next door in Adelaide. The secretary of the Mothers' Union and her two daughters, sunk in church work, were 'marvellously good' and marvellously dreary. The son went out a lot. Stella stayed at home with the girls and their goodness. It was not at all what she had had in mind.

Tom's godfather, who had been the Bishop of Adelaide, and his wife, a friend of Esther Eliza, were the only other people Stella knew in England. Travelling through the countryside south of London to visit them, at least showed her the 'amazing grandeur of the English spring', but inside the rather damp grandeur of Bishop's Court she found a world that was crushingly familiar. The bishop's wife, hearing that Stella was taking art classes in London, said how nice it

was for her to have an 'interest' but echoed her mother's disapproval when it came to drawing from the nude. She couldn't see why it was necessary, even if it was, as she put it, 'nicely done'. 'I had come to England in the hope of becoming an adult, and Bishop's Court put me right back under the old cotton-wool lid of fixed ideas, and sweetness and light, under which the chilly blast of independent thought can never penetrate.' For all her £20 she was no freer than she had been in Adelaide.

Yet, ironically, it was through the disheartening connection of Bishop's Court that Stella found the way out. The bishop's wife had a widowed sister who was 'just a tiny bit flightier than herself, and the sister had a daughter who was quite a good deal flightier than her mother'. The daughter had a friend who knew about art and lived in Chelsea, so when the Pimlico arrangement came to an end, which it did mercifully soon, the bishop's wife's sister, who thought Stella needed younger company, arranged for her to board in Chelsea with her daughter's artistic friend. There Stella encountered her first 'bar-parlour' and her first 'studio party'. 'Models in trousers, page-boy hair bobs, mascara'd eyes, unmanly youths and unfeminine girls, and *nobody* in evening dress! To me, it was the acme of low life.' To her astonishment, she also discovered that there were girls in Chelsea with educations as good as hers who thought nothing of going unchaperoned into a man's rooms. Their families might not like it, but they did not emerge shamed and their lives were not ruined.

This was the point Stella Bowen had reached—the first move in the task of extricating herself from 'a background of prejudice and humbug and muddled thinking'—when war broke out in August 1914. 'I was completely unaware of the European situation, or even of its precise geography. I had been brought up on Imperialist-Jingo history but had very little feeling of patriotism.' She was not by nature a political being; the Edwardian world in which she had grown up had given her no reason to be, and all her dreams had been directed towards Art. Had she read the papers and paid the slightest attention, she might have seen what was coming, but as for so many others, the twentieth century announced its paradoxical nature with the dreadful digging in of that war. 'If I had to sum up the twentieth century,' Yehudi Menuhin said at its end, 'I would say that it raised the greatest hopes ever conceived by humanity, and destroyed all illusions and ideals.'[4]

As news reached London from the front, Stella Bowen learned in painfully immediate ways that danger stalked promise as she inched her way into modern Chelsea. She enrolled in war work in the East End, where she was brought up against the social questions she had literally not seen in her extended Edwardian girlhood. 'My introduction to the slums kept me in a haze of unhappiness,' she wrote. But, with another spin of the coin, war work also brought her into contact with young women who would at last join her in the challenge she was waiting for. Mary Butts, writing novels and blazing her way out of her parents' control, was her first introduction to a temperament—'new to me then, familiar now'—that can take a fact and 'fabricate from it a dramatic grotesquerie'.

Then there was Margaret Postgate, the Fabian Socialist who was to marry the economist and writer G.D.H. Cole. Margaret and her brother Ray dented Stella's romantic fascination with art as a way of living, by introducing her to the idea that there are social forces which shape any and every life. They were the first to offer her a way of making sense of the brutalities that were now unavoidably before her eyes, not only in the casualty lists that were posted daily, but in the poverty she'd known nothing about, a mere few miles away on the other side of London. She took their point that there were classes of people, whole sections of society, who benefited from the poverty that was so shocking to her. But with the Fabians she found herself confronted by a question that would trouble her again in her dealings with the British Left before the next war: do the ends justify the means?

She wanted to believe that a world without the gross inequalities and deprivations she saw in the East End was attainable, but she wasn't prepared to give up her claim to art and the exuberance that comes with individual expression of any sort; she feared that under a Fabian order anything to do with the recalcitrantly unequal imagination would be banished as a penance for the existence of the slums. Echoing Virginia Woolf's sceptical reaction to Beatrice Webb, with her compartments for everything including emotional life, Stella was now 'bothered', as she would be again later, 'by the comrades' contempt', as she put it, 'for "grooming" and "glamour" as capitalist vices, and also by the very unsatisfactory position they seemed prepared to assign to the artist in their brave new world'.

When she objected to the Postgates' uninspiring vision of an

egalitarian future as a 'tidy market garden with rows of equal cabbages', they countered that the orchids she wanted were determined by the £20 a month she received. It was a sobering realisation. Yet £20 a month was not so much for a young woman of her class in wartime England with no family and no other backing. By those standards it was a flimsy hold on security, especially when the reports from the front grew worse, prices began to go up, and it was clear that the war would not be over by Christmas. In January 1915 the Zeppelin raids on London began, and for the first time in history, civilian populations had to fear incendiary bombs falling on them from the air. To make matters worse, the winter of 1914–15 was cold and wet. Stella had arrived in England in time for the glories of spring and nine months later was confronted with a dark deluge. 'There was a great downpour this morning,' Virginia Woolf wrote in February 1915. 'I am sure however many years I keep this diary, I shall never find a winter to beat this. It seems to have lost all self control.'[5]

That extreme winter, when nothing seemed in control, Stella Bowen was still a visitor with a return passage to sun and safety; she was not yet committed. On the contrary, she was expected back in Australia by Easter. Later she would describe herself as a beneficiary of the war, but it must have been a tough decision when Tom cabled that he was leaving school to enlist and that her return to Adelaide was therefore 'optional'. Would she step back into safety? Or step forward into the turbulence that was inside her, and all around her? Would she relinquish the guarantee of escape?

She stepped forward. With Tom on his way to France, one could say that of course she'd want to be in Europe. But I don't think it was duty that kept her there. A new life was at last beginning to open to her in London and although it had had a hole blasted in it by the war and by the slums, there was no doubt that she was embarking on something she wanted to see through. What exactly that something was, she could not yet say, but far from frightening her off, the war gave grit to her determination.

Tom enlisted as a private in the 10th Battalion of the AIF. He was in France by the beginning of 1916 when the AIF joined the British Expeditionary Force on the Western Front. His battalion fought in the front line of major battles: the Somme, Messines, Passchendaele, Pozières, Ypres. Australian casualties were high. In

1917 alone they reached 55,000, of whom 38,000 were wounded or killed at Ypres. During the German offensive at the beginning of 1918, there were 15,000 casualties in six weeks, and by the end of the war a fifth of the men who served with the AIF in Europe were dead.

Tom Bowen gained his commission in the field, which was an honour, but it did not make him any safer; in 1917 the life expectancy of junior officers on the Western Front was measured in months. After it was over, he rarely spoke of the war. His daughter Suzanne

Tom Bowen, Stella's brother, in London during the war. 'It must have been very soon after gaining his commission,' his daughter says, 'as there are no "pips" on his shoulders.'

says it wasn't until she was grown up that she heard the story of how he saved the life of a man she knew only as a colleague of his, by carrying him from no man's land on his back. Tom never told the story, and nor did the man he rescued, but their children mention it whenever they meet, even now, eighty years later. Suzanne also remembers that her father once said he had felt the presence of an angel nearby; and she has a brass bell with the word *Ypres* scratched on its side that he made from the tip of a shell case and a bullet. Small mementos of a war in which young men fought in conditions their women would never fully comprehend.

How did Tom speak to Stella of his life at the front when he was on leave in London, or temporarily invalided out with trench foot, his only injury? Even if he wanted to protect her from the horror he had come out of—as so many men did—would she not have seen it on his face? And if not on his, then on the faces of others around her? As conscription into the British Army took more and more men, Vanessa Bell wrote to her sister Virginia Woolf in March 1916 that she supposed 'everyone we know will soon be either in prison or in the army'.[6] There were tribunals in every town for conscientious objectors, and white feathers were handed out to men who were not in uniform. And even if women didn't know the full extent of the misery and fear their brothers and sons and lovers were

suffering at the front, the bitterness of war and its cruelties were inescapable. The bald facts of casualty figures were reported in the papers, sometimes running into thousands of deaths in a single day; newsreels showed shells blowing up young soldiers, horses buckling as their legs broke beneath them. After the showing of documentary footage from the Somme that was expected to boost morale and instead made women cry out in the cinemas, censorship was tightened. Euphemisms proliferated in the press. The Fabians gave talks against the war and asked in whose interest it was being fought.

Although she had a brother at the front whose decision to enlist she seems never to have questioned, Stella Bowen became a pacifist. She continued to work in the East End with the Fabians—and she worked hard—but she gave up rolling bandages with the blood-thirsty ladies of Kensington. It was a complex move, standing against the conservative traditions of her childhood and with the progressive political movements of the twentieth century. It was also a move that gives the first glimpse of her emerging sense of herself as someone who could act in the world, and—in a small way—upon the world. If there was a line to be drawn between the culture her mother had inhabited and the life Stella was stepping into, it came less with Esther Eliza's death, despite the emotional resonance of that moment, than with the profound shift generated by the trauma of the war.

Virginia Woolf, who was thirty-two when the war began—ten years older than Stella—wrote of it as a knife dropping over Europe. In her great novels of the 1920s the knife falls not only across the lives of individuals, but across a society, changing for ever the terms on which everyone lived. *To the Lighthouse* is itself broken into two by a passage which demonstrates in the most brilliant and lyrical way that the knife fell even across the novel. Writing, it tells us, will not be the same again; nor will art; the conditions under which men and women paint and write have been changed for ever.

Before the war, before this 'gulf of misery', feminine creativity could express itself in an occasion like Mrs Ramsay's dinner. It runs for some thirty pages at the heart of the novel, and it is one of literature's great meals. Mrs Ramsay is the kind of woman Esther Eliza might have been, had her husband lived long enough to give her another six children. She presides at dinner—'listening, sheltering, fostering'—seated opposite her dour and disappointed

husband at the other end of the table. There they are, Mr and Mrs Ramsay, masculine and feminine, two poles of a familiar world which, at the moment of that dinner, seems to their children and guests as 'immune from change' as the house itself. It is Mrs Ramsay who makes the occasion the triumph it is. 'They sat separate. And the whole of the effort of merging and flowing and creating rested on her.'

The two discordant figures at the meal are Lily Briscoe, who has been struggling with her painting all afternoon and can't get it right, and the graceless Mr Tansley. It is at Mrs Ramsay's dinner—that hymn to a gentler age—that Mr Tansley, sensing Lily Briscoe's vulnerability, whispers his taunt: *Women can't write. Women can't paint.* The undersurface of this meal is not so gentle; Lily Briscoe bows her head and feels herself sag 'like corn under a wind'.[7]

During the dinner with its perfect *boeuf en daube*, it is Mrs Ramsay who is the artist, and the meal is her painting; for it is she, not Lily Briscoe, who can hold more than one perspective at once, who can command the authority to give structure to the disparate characters around her table, and still know her own feelings. Is Virginia Woolf saying that without Mrs Ramsay there would be no art to life? Or is she saying it is the only art women had?

Mrs Ramsay and her meal belong to a century that had gone; they belong before the war which falls down the middle of the book, bringing with it a 'profusion of darkness which, creeping in at keyholes and crevices, stole round window blinds, came into bedrooms'. On the other side of that darkness, Mrs Ramsay's dinner would no longer be possible; there would be other meals—the informal meals of the 1920s that Virginia Woolf and Stella Bowen liked to eat—but no woman would again have the innocence of Mrs Ramsay painting with life. 'Not only was the furniture confounded; there was scarcely anything left of body or mind by which one could say "This is he" or "This is she."'[8]

The paradox that Virginia Woolf understood even as it was happening—*To the Lighthouse* was published in 1927—was that after the war it would be the lonely figure of Lily Briscoe, once marginal and prey to the sadistic whispers of men, who would be the one to find a way to put the mark on the canvas that would say: *This is she*. Something profound was changing. Mrs Ramsay, like Mrs Bowen, was dead. Such a woman could not live after the war. When

Mr Ramsay and the younger of his children return to the house after it is all over and make the journey to the lighthouse, the children understand not only that nothing will be the same again—not even a meal in a familiar house—but that nothing is any longer only one thing. This time it is Lily Briscoe, alone at her easel, who gives shape to the chaos of emotions that they have all been living with. She finishes her painting, and sees that it is good. 'The problem might be solved after all.'

Stella Bowen had made the first serious moves of her apprenticeship well before the war ended. As soon as she had decided to stay in London after Tom cabled his decision to enlist, she gave up the part-time art classes she had been taking, where the instruction was no better, and probably worse, than Rose MacPherson's in Adelaide. She went first to the Slade but didn't like what she saw. So she took a bus to the Westminster School of Art and enrolled there, where she could be taught by Walter Sickert. There had been a large and controversial exhibition of twentieth-century British art at the Whitechapel Gallery in the summer of 1914, soon after she arrived in London; if she went—which is likely—she would have seen some of Sickert's work and known that by making this choice she was making an aesthetic break as sharp as her break with the value systems she had grown up with.

What would have been less immediately obvious to her was Sickert's place in the complex politics of English art. Stella had arrived in London and made this move within two years of the second of Roger Fry's controversial Post-Impressionist exhibitions. When Virginia Woolf wrote of the changes brought by the war, she knew very well that the nature of art and its relationship with the world had already begun to change. December 1910 was the famous date she gave to the initial impact of this change: the date of Fry's first Post-Impressionist exhibition which had shown over twenty works each by Cézanne and Van Gogh, and more than forty by Gauguin. But it was the second exhibition at the end of 1912 that brought Sickert up against the limits of his liberalism. This time Matisse and Picasso took primary place, and for Sickert there were powerful reservations. He could go a considerable way with a practice and philosophy of art that broke with the old modes of representation, creating an illusion of the world and not its equivalence, but he could not join Roger Fry's enthusiasm for the

idea that art was at last cutting its mooring from the world it described. It was this separation of art from life, claimed in the name of modern art, that Sickert stood opposed to, and as a result by the time Stella Bowen enrolled at the Westminster School he was no longer the cutting-edge teacher he had been before 1910.

So while for Stella that bus trip to the Westminster School was a moment of decisive seriousness, it was not quite as radical a move as it would have seemed from the perspective of Bishop's Court. She enrolled in Sickert's classes with very little understanding of a debate about art and life that she would come to know well enough over the next twenty-five years to give her memoir the ironic title of *Drawn from Life*.

Nevertheless it was an important move, which at the time suited her well. At the Westminster School she was encouraged to be bold with colour and build up form in broad strokes of paint, fresh against each other. She was also encouraged to give expression to the felt experience of painting with its sensual pleasures, and to leave the mark of the brush on the surface of the paint. In an environment in which the relationship between art and life was in question as it had never been before, Stella Bowen took her first lessons towards a way of working that used the texture of paint to express not surface appearance but the force that lies beneath. In these first lessons in modern technique, she was receptive to Sickert's insistence that the rhythm of line and form and gesture, the use of colour and design, always needed a reference back to the world of 'gross material facts', to the thing itself as it was once the surface had been stripped away. He taught her to respond to the particular in the general, to value the idiosyncratic and quirky, and to trust her 'faithful eyes'. And, most important of all, he taught her to look at what she saw exactly, minutely, and without fuss: to watch, as patient as a dog. 'Sickert opened my eyes wide to the beauties of the accidental and the spontaneous,' she wrote, 'and got me right out of the dismal academic rut into which I had been sinking. He taught me the difference between something dead [on canvas] and something living . . . I suppose that this gift of creating life at a touch is the most enviable gift that a painter can have.'

For Lily Briscoe to paint, two things needed to happen. She needed to know her feelings and she needed a structure. Stella Bowen found the first traces of a structure at the Westminster School. She

learned a new way to use paint, and although ultimately it would not be the method she would make her own, it opened her to new possibilities of colour and form. And at the Westminster School she was encouraged to hold her gaze steady as she struggled with the turmoil of her own feelings. In this way, in the environment of war, she took her first steps into a modern idiom.

3. WHILE STELLA WAS studying at the Westminster School and working in the East End with the Fabians, she moved into a studio in Chelsea with a young woman called Phyllis Reid. She had met Phyllis in the hostel where she had moved after the bishop's wife's sister's arrangement came to an end; she and Phyllis had taken the studio when its painter occupant went to the front. It was there, she said, in that studio, that her adult life began.

Phyllis Reid had grown up in a provincial Birmingham family and had come to London to study drama. 'She had immense light green eyes,' Stella wrote, 'with black rims set wide apart. Her slender figure was most excellently modelled through the middle, and her massive light-brown hair had curly yellow edges . . . But although I appreciated all these assets (none better, for I've always been profoundly influenced by good looks) what really drew me first to Phyllis was the similarity between her origins and my own.' They had 'a vast amount to talk about' as they inched their way into an emotional and political emancipation. Even more than Margaret Postgate or Mary Butts, Phyllis was the woman Stella counted as her first 'real friend'.

Unlike Stella, Phyllis had the great advantage of not being shy. She quickly got herself 'into circulation', and drew her more reticent friend along in her wake. Together they started collecting friends: 'socialist-pacifists', conscientious objectors, artists, writers, a mixed bag of 'intellectual people ready to support the opinion that no good could come of war'. Those 'who were interested in the arts of peace', Stella wrote, 'tended to get into a huddle together, for company. Anyway we made friends.'

'It began,' she said, this 'real life' of theirs, some time towards the end of 1915 or early in 1916 (the recording of dates was not Stella Bowen's strong point) when the bishop's wife's sister's daughter's friend, Stella's former Chelsea hostess, asked if she could borrow the studio for a party. 'We were naturally delighted with the prospect of seeing our big room at last filled with people. The party was to say good-bye to some artist going to the front, and to it came Ezra Pound.'

Ezra and Dorothy Pound were then living in Chelsea. Ezra, it seems, noticed the attractive young colonial and took it upon himself to introduce her to a metropolitan and modern aesthetic. 'At that time,' Margaret Postgate wrote in her memoir, 'he was not only a considerable scholar and a poet who looked as though he might do big things, but also a vital and vigorous creature with a face like a bearded faun, a hopping dancer and torrential talker.' Margaret, shy like Stella, 'drank in all that was offered'.[9]

Pound, who was then in his early thirties, extended the education Stella was getting at the Westminster School by insisting that she admire—even if she did not like—a more radical art than she was being shown by Sickert. Pound took her to see the drawings of Wyndham Lewis and the sculptures of Gaudier-Brzeska. Uncompromising in his allegiances, he put her onto *Blast* and the *Little Review;* under his tutelage she read *Prufrock, Portrait of an Artist* and, without knowing the significance it would hold, Ford Madox Ford's *The Good Soldier*. He introduced her to readings at Harold Monro's Poetry Bookshop and took her to literary parties. 'The little Australian,' Dorothy Pound pronounced, 'is quite charming.'

By this route Stella found her way into literary London, and an environment which demanded an independence of thought that would finally loosen the grasp of her Adelaide origins. 'It was a pretty good introduction to all the arts,' she acknowledged. But it was a double-edged existence as she teetered between the excitement of a new way of living and the worsening deprivations of the war. Civilian life became dominated by queues and 'manifold restrictions'. Prices went up. Sugar, hard to come by, was ninepence a pound by 1917, which was a lot for someone living on £20 a month. Meat and butter were rationed. Virginia and Leonard Woolf couldn't afford a turkey for Christmas in 1917 and counted themselves lucky to have found a chicken for six shillings. By January 1918 a single egg cost fivepence and a chicken was more than ten shillings.[10] Worse was the disruption that came with the start of bombing raids by aircraft in 1917. Full moons were dreaded; London slept with the sound of anti-aircraft guns and many nights were spent in the dark of cellars and underground stations. All this, and 'the perpetual weight on our imaginations of the constant killing'. And yet the parties continued as people came home on leave or returned to the front. They must have been strange events, as powerful emotions collided to gunfire and music.

In July 1917 Ezra Pound took Stella and Phyllis to a party given by the novelist Violet Hunt. Violet was then in her early fifties, noted as a supporter of women's suffrage and a writer of novels with titles like *The Maiden's Progress* and *White Rose of Weary Leaf*. She was also known for her long association with Ford Madox Ford. It was a liaison that had begun in a blaze of publicity when the courts had refused Ford a divorce from his first and only legal wife, Elsie Martindale. The case had been on the front pages of the papers while Stella was still at school in Adelaide. Violet had stood proud by Ford's side and taken his name anyway. By 1917 this second 'marriage' was failing under the strain of infidelities on Ford's part and, when Violet felt she could no longer control his affairs, an angry insecurity on hers. In this acrimonious situation, the war worked to Ford's advantage, giving him an escape from 'the intrigues and sophistications of literary London'. He was 'an innovation in our circle', the pacifist Stella wrote, 'because not only was he in khaki, but he actually liked it.'

This wasn't to say that he liked the war; on the contrary, after it was over he'd give the better part of a decade to writing against it. In *The Marsden Case*, his first novel after the war, he wrote that 'every human brain that is thrust into modern warfare is thrust towards something that, full face, is too unnatural, too incoherently, aimlessly, and stupidly cruel, to endure. The individual is carried into it, upon a stream of usages, loyalties, sentimentalities, conceptions of honour and courage, confidences in governments and in leadership, only to encounter a shattering incompatibility in that vast destructive futility. Everyone who got to that completeness of encounter did not cry out or run or fall flat; only a proportion of the war neurotics came to hospital; but all without exception were damaged, distorted, and crippled.'[11] Stella, more than anyone, would have known the extent of the damage before she wrote of him enjoying his uniform. What she meant, I think, was that despite the actualities of war he had a respect, even an admiration, for the 'vocation' of the soldier. By the time she met him, he had been invalided out of France to a Staff posting in the north of England. 'He was the only intellectual I had met,' Stella wrote, 'to whom army discipline provided a conscious release from the torments and indecisions of a super-sensitive brain.'

Before his posting to Yorkshire, Ford had had a bad war. He had served at the Somme in that dreadful July of 1916 when 21,000

British soldiers were killed on the first day of the battle; by the time it ended in November, Allied casualties had reached 600,000. Afterwards Ford wrote of a world in which the living were in close proximity to the dead, of hands pressing inadvertently into rotting flesh, of the stench and the fear. He also wrote of the constant noise of bombardment and the interminable days of waiting, broken by the confusion and savagery of battle. 'The stuff to fill grave-yards,' was his grim phrase for the soldiers in the trenches. The worst aspect of the front for a novelist, he told Stella after it was over, was that 'one had no time to notice one's sensations'.

Ford, who was forty-three during the battle of the Somme, was not on the front line. But dealing with transport and supplies didn't keep him out of danger; at the end of July he was 'blown into the air by something' and landed on his face, damaging his mouth and teeth. When he came round he had no memory; for thirty-six hours he couldn't even remember his name. He was taken to the casualty clearing station 'with the enemy bombs all over it and the dead Red Cross nurses being carried past [his] bed'. He thought he had been taken prisoner by 'the enemy forces and was lying on the ground, manacled hand and foot', surrounded by 'immense shapes in grey-white *cagoules* and shrouds, miching and mowing and whispering horrible plans to one another'.[12]

When Ezra Pound took Stella and Phyllis to Violet Hunt's party, Ford was in Yorkshire and so Stella did not on that occasion meet the man who was to become her great love. But Violet Hunt befriended her, and when Ford was in London on a brief leave in October, she organised another party and once again invited Stella and Phyllis. Ford had apparently asked for 'something young'. Violet, who was no fool in these matters, complied. She knew he was tiring of her, and she knew his war-shattered state. Perhaps she felt she could not refuse; perhaps she still thought it better to keep Ford under her nose and maintain some control over the women he met.

Stella Bowen was twenty-four that year. She was clever, independent, intensely curious, hungry for talk, and—judging by the photos—she was gorgeous. Ford fell for her on the spot. 'All was lost,' Violet Hunt wrote in her diary that night, 'when Stella B going out of the room he threw his arms round me & kissed me. I *could* not respond. He turned sour. At night, after she had gone, he said coldly "Well, I'm going to bed."'[13]

Ford Madox Ford
after the war.

There was something appealingly certain about Stella Bowen that reaches to us all these years later. She may have been shy, but she was earthed, somehow, in herself, in her body and in the small dailiness of life. She had that most attractive capacity of being fully in the present, while remaining intellectually open and imaginatively wide-ranging. If ever there was a man who needed grounding, it was Ford Madox Ford, who by his own account had been 'damaged, distorted, and crippled' by the war. Of course he fell for her youth which, though vulnerable, was neither damaged nor distorted. Indeed, it was that vein of vulnerability that drew him to her. I can say this because he himself recognised it when he paid his own complicated tribute to her through the character of Valentine Wannop in *Parade's End*, the sequence of four novels about the war that he wrote during their years together.

To Stella, Ford seemed 'quite simply the most enthralling person' she'd ever met. 'Worth all of Phyllis's young men put together, and he never even looked at her.' He had the gravity of Ezra Pound, but his interest in her was not as a creature to be taught. He might want her as muse and lover, he might enjoy his role as protector and tutor, but he also responded to deep notes in Stella— her vulnerability, her curiosity, her ambition to understand both the world she found herself in and the place in herself that had always

*Stella Bowen in
the mid-1920s.*

propelled her forward. Ford was a celebrated conversationalist. (Herbert Read, stationed near him in Yorkshire, met him in August 1918. 'What a day I had!' he wrote. 'He talked to me for a solid eight hours.')[14] Stella Bowen fell in love with that capacity for talk, but what really mattered was that he drew her out, and that he *listened*.

The week after Violet's party, Ford wrote to Stella from Yorkshire. 'Dear Miss Bowen,' he addressed her and then, after a brief paragraph that allowed him the excuse, he wrote: 'It seems very remote & cold here & the pale gleams from a luminary that might be a dim sun or a bright moon do little to make up for the sunshine of yr. smile!'[15]

Stella had, she wrote, 'reacted violently against him at first on the grounds that he was a militarist'. This was their first impediment. Later she could describe the impact of Ford as 'a walking temptation to any woman, had I but known it', but imagine how it would have been on that first meeting. Ford, though celebrated—'one of the writers whom Ezra allowed us to admire'—was twenty years her senior, effectively married to her hostess, overweight, short of breath, 'with a pink face, yellow hair, and drooping, bright blue eyes'. On the face of it not an attractive prospect to a pacifist who admitted herself 'profoundly influenced by good looks'. But as soon as they began to talk, she 'found that if he was a militarist, he was at the same time the

exact opposite'. 'You see, my dear Pacifica,' he told her less than a year after Violet's party, 'I am not so eaten up by militarism *dans mon for intérieur* . . . No, I really want the little cottage, in a valley, five miles from a market town—& you! more than anything in the world.'[16]

Violet, who knew nothing of this declaration, but sensed it, was a greater impediment. Not because Ford was in love with her—he patently was not—but because he had been dependent on her and, a great equivocator, was reluctant to face what was happening. It was during the summer of 1918, while Ford was still in the army, that he and Stella became lovers and he made his proposal, inviting her to share his dream of a cottage in the country, where they would find 'summer again' while he recuperated from the shock of the war. 'I'm <u>determined</u> not to be ashamed of my shamelessness,' Stella told him

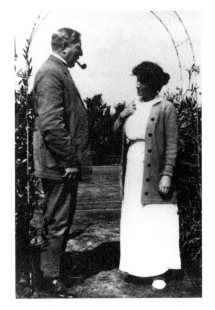

Violet Hunt and Ford before the war.

the following April. 'Because you know if I <u>really</u> felt ashamed I'd be absolutely miserable, instead of being absolutely happy, as I am.'[17]

But Ford still made no admission to Violet. Every year she gave a garden party at her London house, and that summer Ford was to be seen playing his part at her side, a move that salved her pride but did nothing to calm her anxieties. He returned to Yorkshire the next day and took to his bed with neuritis. Stella, secure in the assurance of his love, made herself scarce and awaited the next letter. 'I only know that nothing but you can interest me for ten minutes together,' he wrote soon after the party. 'I belong to you altogether—& to you only, & for good, and all. That is the truth.'[18]

When the war ended in November, Ford was still in Yorkshire and Stella was in London. On Armistice Day Phyllis had gone out early to have her hair done, leaving Stella alone in the studio. 'When the maroons sounded,' she wrote, it proved 'intolerable' to remain alone. 'I ran into all the hairdressers shops in Kensington High

Street looking for Phyllis, and when I could not find her, I went to Ezra's flat in Church Street and dragged him out. The streets were filling fast and we got on top of a bus going towards the city. In those days the tops of buses were not enclosed and we stood up in the front of ours, Ezra with his hair on end, smacking the bus-front with his stick and shouting to the other people packed on the tops of other buses jammed alongside ours, which were nosing a cautious route through surging streets.'

In January 1919 Ford was demobilised. The month before, after another London leave in which Violet had screamed and wept at him, he had told Stella about a row he'd had with the quarter-master. 'It is funny how you can get into the most violent rages over duty yet be the best of friends in the mess two seconds later, without a syllable about what went on over the road. I wonder if it wouldn't be possible to conduct married life on that sort of line: it wd be a tremendous solution.'[19]

With his return to civilian life, Ford was in need of a tremendous solution. The army had been a useful alibi as he dodged Violet's fury (and also Elsie's) but, unlike the quartermaster, Violet had no intention of letting up in the mess afterwards. Ford's time-honoured answer to the problem of an aggrieved woman had been first to escape, then to fall in love elsewhere and, with the emotional protection of a new love, to lie low, put in as few appearances as possible and hope the fuss would stop. But of course it didn't. Violet wanted a clear statement of intent. She knew all too well his capacity for evasion and emotional manipulation; it might have been accentuated by the war, but it hadn't begun with the war.

If Stella had read *The Good Soldier*, Ford's celebrated pre-war novel, with an eye to the character of her lover, she too might have realised that he was a master of the emotional masquerade. Subtitled *A Tale of Passion*, the novel is an account of the sexual and emotional intrigues hidden in the lives of two respectable Edwardian couples. With its ironies and ambiguities, it is still regarded as one of the finest short novels in English and is certainly Ford's best work. Its meanings are multi-layered as the narrator attempts to deceive himself as well as his readers in relating events in which he is more deeply implicated than he cares to admit. A young woman contemplating an affair with the creator of such a character might have been forgiven had she noticed how well he knew the realm of emotional

manipulation. But that was not a reading Ezra Pound would have allowed, insisting instead on an appreciation of its very considerable formal innovations.

When Ford returned to London, he took a separate 'studio', but as it was in the street next to Violet's the move was ambivalent. The pretence of their relationship continued, and Ford's excuse to Stella was that he didn't want to humiliate Violet by making his desertion public. But as his liaison with Stella quickly became an open secret, there was no way he could spare Violet that particular form of humiliation, and he added to it the private humiliation of refusing to engage with her—even to the extent of acknowledging the separation. Living a street away from her was predictably a disaster, and by April he had decamped to Sussex in search of an Arcadian dream that had haunted him since the Somme; it was a common dream of soldiers in the trenches, imagining the 'holes' they 'cringed' in as England's 'grassier ditches'.[20] He took a cottage near Pulborough with the propitious name of 'Red Ford'; it was 'built of old red bricks and old red tiles, all greened over with mossy stains'. Yet even after Stella arrived to live with him in June and he had promised her that 'short of kicking Violet in the face or saying that she was a superannuated Hecate, I have told her definitely that things are at an end between us',[21] he could still be manoeuvred into taking the train up to London to stand by Violet's side.

The afternoon before the 1919 garden party, Violet confronted Ford at his club. There was a scene, a bundle of clothes was dumped, and Ford became rigid with silence. '"Am I not still your wife?"' Violet asked. 'He sat down, opened his hands & sneered & said "I came here on the condition there was no discussion."'[22] The next afternoon he was late for the party. 'It was one of the biggest parties I have ever been to,' Alec Waugh recalled, 'champagne, white ties, etc. I got there a little early and Violet kept saying "I wonder what's keeping Ford. I wish he'd hurry." When eventually he did arrive it was to moon around looking very lost. He did not seem to know if he was a guest or host. He appeared surprised when I went up to say "good-bye" and "thank you". I suppose it was their last public bow. It certainly was a party.'[23]

Ford limped back to the cottage and Stella. But within months Violet had tracked them down and arrived at the gate. It was a messy start.

The final impediment to this irregular union was Stella's brother Tom. After the Armistice he had stayed on as an aide-de-camp to an Australian general at the peace talks. By the time Stella was ready to move in with Ford, he was in London putting off his return to Adelaide and civilian responsibility. Stella, who knew it was little short of a miracle that he had survived, was caught between the pleasure of being reunited with him and a reluctance to tell him the true nature of her relationship with Ford. She didn't want the trustees or the family in Adelaide to know, for while she might refuse to be shamed by her shamelessness, she knew they would not. Nor did she want to put Tom in a false position when he got home.

She also wanted to maintain some leverage over him while he was in London. He was falling in and out of love—including briefly with Phyllis—which was to be expected, but in an uncharacteristically snobbish moment Stella became alarmed when he took up with a young woman she found hard to accept. Her letters to Ford chart the complex relations that were going on at the studio while Ford was in Sussex. Despite trying to conceal their affair, she was critical not only of Tom but of Phyllis, who was juggling a number of lovers (with maximum drama) before deciding to marry a young architect called Harry Birnstingl. But it was Tom that she worried about. 'You know,' she wrote to Ford in April of 1919, 'I believe I could tell Tom all about Us with complete success.'[24] She finally told him shortly before he returned to Australia in the summer of 1919. His daughters say that he didn't like Ford, but never criticised Stella for the choice she had made.

Despite the problems, it is impossible not to be affected by the letters Stella and Ford wrote, almost daily, while he was preparing the cottage they were to live in and she was keeping up appearances in London. When she told him that she was becoming discouraged by the work she was doing at the Westminster School, he replied, 'the only work that one does that is any good is always the work one does against the grain'.[25] It was advice she would not come to understand until much later; then, at the beginning, when he complimented her on her few paintings, she was young enough to believe that her love for this man would bring her into being as an artist. 'Of course you shall be a painter & see the great world,' he wrote to her in January 1919.[26] It was exactly the invitation she had been waiting for since she left Adelaide. So when Ford made his unconventional

proposal—the cottage, a child, a life together without the safeguard of marriage—there was no doubt. They had begun a conversation that could only be continued by living together. 'I was ready,' Stella wrote of her younger self, 'I felt stalwart and prepared for anything.'

To ease her passage, Ford changed his last name by deed poll in June 1919. He gave up Hueffer, his family name, to take her as the next woman he could not call his wife. With Violet insisting that she continue to be known as Mrs Hueffer, and the legitimate Mrs Hueffer suing her, he could hardly introduce a third into the fray. With a change of name he could at least offer Stella the flimsy protection of Mrs Ford. Although she had moved into a milieu that was renegotiating sexual values and behaviour, the vulnerability for a woman of living with a man without the protection of marriage should not be underestimated, as Violet's fate testified.

So when romance is stripped away, Ford's offer was not good. Besides everything else, he had no money. 'I can always addle enough brass to keep us two going . . . Don't worry about that,'[27] he wrote to her in January 1919. But even that proved optimistic. Before she had moved in with him, he was asking her to wire him 'a pound or twa as I have only three shillings left'.[28] For months at a time they had to make do on her cheque from Australia. The £20 a month the trustees had settled on her didn't go up, and although it continued till her death, it was never intended to support two. Over the next decade it often would. So when Stella Bowen said yes and accepted Ford 'as the wise man [she] had come across the world to find', it was an act that was both brave and foolhardy.

'I bear your image on my palm as if it were a precious & crystalline egg,'[29] Ford had told her when they became lovers. 'I long for you almost more than I can bear,' she wrote to him at the cottage. 'I don't believe, that <u>whatever</u> happens, we will ever torment each other . . . do you?'[30] 'I have never remembered or imagined such happiness,' he said after one of her fleeting visits.[31] 'Do write me a long letter about the beans & the peas & all,' she wrote from London.[32] 'I like things if they seem to remind me of you,' he told her. 'Thus I picked two white pansies this afternoon.'[33] 'Shall I get a meat safe for £1?' she asked. 'Rather smallish [but] would hold all we'd want, I should think . . . well made, by disabled soldiers.'[34]

'To have you really belong to me,' Stella had written two months before she moved in, '& to belong really to you is like coming

home after a long exile. You don't know what it's like to be as detached a thing as I've been, not belonging anywhere.'[35] 'I too have been pretty detached,' Ford replied, though Violet Hunt would not have agreed, '& have not belonged anywhere for a long, long time—& now I have got a place of my own—in the sun & against the rain too.'[36]

❧ 4. 'THE FIRST SPRING after the Armistice,' Stella wrote, 'was like no other spring in our time. Nature's existence no longer seemed a mockery, and hundreds and thousands of war-stiffened men and women began tremblingly to embark upon that new and longed-for life whose very naturalness made it seem unreal after the recent horrors.'

When she joined Ford at the cottage, she was embarking on an odd blend of dream, quite beyond the expected, and also a return, or so she thought, to the natural order of things. As a young woman of colonial good sense who had heard reports of the trenches but not seen them, she could easily accommodate an order that took marriage and babies as its bedrock, along with houses and a countryside abloom with flowers; everything in her upbringing had prepared her for it. As a dream, it was rendered all the more potent by drawing into it the more aberrant desires that had been growing in her since girlhood. It seems, telling this story, that at that moment, as war ended and peace began, Love and Art had claimed her in equal measure. Or rather, Love had claimed her, and in the name of Love the cottage also became a shrine for Art.

Ford, having seen the Somme, was more grimly realistic. 'You may say,' he wrote in his memoir, 'that every one who had taken physical part in the war was then mad. No one could have come through that shattering experience and still view life and mankind with any normal vision. In those days you saw objects that the earlier mind labelled as *houses*. They had used to seem cubic and solid permanences. But we had seen Ploegsteert where it had been revealed that men's dwellings were thin shells that could be crushed as walnuts are crushed . . . It had been revealed to you that beneath Ordered Life itself was stretched, the merest film with, beneath it, the abysses of Chaos.'[37] If he was to make his return to Art and regain any sense of solidity, it would be through the powerful antidote of Love; the cottage was an essential ingredient in his regeneration. So when Stella joined him, their desires, although shaped by such

different experiences, were oddly congruent; it was just that he knew, as Stella did not, the insubstantial nature of dwellings. And relationships. 'May you never know, my wench,' he wrote in a long poem entitled *A House*, of the danger 'That's asleep up the stair'.

Even so, anyone passing by, or visiting Red Ford, would have remarked—and they did—on how happy the inhabitants of the cottage were: the famous writer and his young Australian wife. The smell of the stock pot wafted from the kitchen lean-to at the back, and in the mornings the portly man and the young woman could be seen, deep in conversation, walking through the beech woods. There is every reason to suppose that they were happy.

Ezra Pound, who loathed the country, came to visit. He arrived 'aloft on the seat of my immense high dog-cart', Ford wrote, 'like a bewildered Stuart pretender visiting a repellent portion of his realms'.[38] It is not an entirely flattering portrait of the great poet, but then by the time he wrote it, Ford would have read Pound's long poem *Hugh Selwyn Mauberley* so it might have been a slight pay-back for the less than flattering portrait of Ford that had been offered to the world in 1919:

> Beneath the sagging roof
> The stylist has taken shelter,
> Unpaid, uncelebrated,
> At last from the world's welter.
>
> Nature receives him;
> With a placid and uneducated mistress
> He exercises his talents
> And the soil meets his distress.
>
> The haven from sophistications and contentions
> Leaks through its thatch;
> He offers succulent cooking;
> The door has a creaking latch.[39]

'Your heart is golden,' Ford wrote to Pound six months later. 'So are yr words. But . . . remember that you deal with hempen homespun wits.'[40] When it came to each other, Pound and Ford could bury the barb in the joke. But how was it for Stella, reading this poem? I read

it and my eye falls at once on the line about the mistress. Does it let Pound off the hook if I say that it has nothing to do with Stella, it is a necessary block in a great poem, and if the price of a great poem is the misrepresentation of a woman, and a mistress at that, does it warrant the complaint? I could point out the casual sexism, which at the end of the century we recognise in ways that they, at the beginning, did not. We notice that Ford is at least given the honour of being the subject of the poem, of the sentence, and even of the cooking (which on occasion he did with splendour). Stella—or rather *a placid and uneducated mistress*—is part of the environment with no more to draw us into her life than there is to invite us to engage with the leaking thatch or creaking door. When my ruffled feathers settle back down, I can begin to see that from the point of view of Ford's life, there was a very slight element of truth to this. That, I suppose, is why it hurts; and if it hurts me, what did it do to her when the poem arrived from London and Ford unwrapped it at the table? Later she recognised the impersonality of her role as mistress—'consort' was the word she used —not that she ever mentioned these verses, or would have considered herself *uneducated*. 'I happened to be the "new object" at a moment when Ford needed to be given a new lease of after-the-war life,' she wrote as she looked back on this defining relationship. 'And who shall say that this type of lubrication is too expensive for so fine a machine?' Her image of the machine, more 'modern' than anything in Pound's rustic portrait, understood that she was necessary for Ford if he was to function again. She accepted her role as lubricant, and acknowledged it as a necessary part of her own 'remarkable and liberal education'.

Which makes Pound's use of the word *uneducated* nicely ironic. I doubt that he would have used it of her in life—she had, after all, had the education common to middle-class girls of the English-speaking world—and in taking her up for extended education he paid his own compliment to her intelligence. In 1919, despite his teaching, she was still *unsophisticated*, but that is not the same as *uneducated*, and would not have served Pound's purposes; on the contrary, it would have wrecked the line. As to *placid*, again there's a grain of truth, but a grain is all that is necessary to create a false impression. Stella's practical commonsense, her groundedness and goodwill, remarked on throughout her life—qualities that allowed her to enter into the ménage of the cottage and serve Ford's regeneration—are reduced to a single word. *Placid* conjures up the

simple, earthy farm girl Stella was not. It does not suggest the incipient artist, or the stretch of her imagination; it renders the complexity of her desires invisible and doesn't begin to comprehend the tension developing in her life between Ford and her own nascent ambitions.

In fairness to Pound it should be said that it wasn't often that Stella took out her paints at the cottage, and when she did there was still a great deal of the student about her work. Her barn, for example, is not a great debut; it's rather too dark and lacks the clear lines that mark her mature work; you can see the shadow of Sickert in it, and while it has a certain charm, it's essentially an apprentice piece. A portrait of Ford that comes from the same period is more interesting, and not only because of its subject. She paints him face-on, playing solitaire; a solid, rather lugubrious man, mouth agape, caught in a moment of thought. There is a boldness to the figure, a sureness of outline that shows her moving away from Sickert and an evenness to the light—all of which anticipate her later paintings. It is less the work of a lover–amateur than of an artist in the making.

Stella Bowen, THE BARN, *c. 1920.*

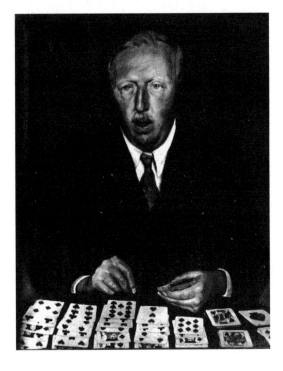

Stella Bowen,
FORD PLAYING
SOLITAIRE,
early 1920s.

Ford was not a handsome man. In her memoir Stella used words like 'large', and 'drooping'. Ernest Hemingway's picture of him was less flattering: a doltish, opinionated man 'breathing heavily through a heavy, stained mustachio'.[41] In every photo his mouth hangs slightly open—the result of a gas attack on the Somme that affected his breathing. I peer at the portrait and the photos, as if by looking at these images I'll see what it was that drew women to him. Creative women. Able women. The hint we get from the portrait is that Stella was drawn to exactly the solidness my eye finds disagreeable: his capacity to fill the frame. Ford himself admired the 'austerity' and 'strength' of the portrait. Confident of her ability, he never understood why she found it so hard to paint while they were together. He didn't understand the work required to maintain a cottage as an idyll. He didn't understand—or if he understood, he took for granted—the price of his regeneration. He certainly didn't understand the conflict a woman might experience juggling the call of the lover and the call of the easel. To say nothing of the call of the baby.

By the spring of 1920, less than a year after she had gone to live with Ford, Stella was pregnant. Ford, who already had two

daughters he rarely saw since leaving his marriage, was overjoyed. It was as if the creation of this next child was necessary to the re-creation of himself as a writer and a man; indeed, the child and the cottage had been bound together in the invitation he had offered Stella in place of the proposal he could not make. And for once in their time together, it seemed as if he was going to shoulder the financial burden and support the desire that came from him as much as her. That same year, 1920, Ford made a small amount of money from film rights; Stella realised some of the untied capital available to her from Australia, and the joint sum was enough for them to buy a larger and less dilapidated cottage a few miles away in 'an extravagantly beautiful and quite inaccessible spot'.

When they moved to 'Coopers Cottage' late in the summer of 1920, Stella's belly was huge as she rode along the country lanes on the top of a cart filled with furniture. For both of them it was a profound moment of arrival. 'There was an immense view, and lovely paths winding through beech woods all over the hillside,' Stella wrote. 'Our cottage, white plaster and oak beams with a steep tiled roof, was about three hundred years old and had settled well down into its hillside. There was an orchard full of wild daffodils running up to the hard road at the top of the hill, a small wood full of bluebells lower down behind the cottage and below that, a big rough field. Ten acres in all, sloping towards the view.'

Coopers Cottage.
'I stripped thirteen layers of paper off the living room walls.'

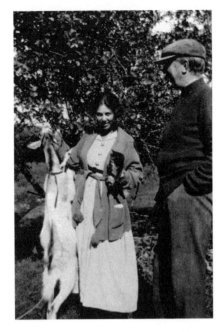

Stella, Ford and Penny the goat. 'Penny would insist on sitting down on the pail whenever I tried to milk her.'

There, in an attempt to become self-sufficient, they planted vegetables and tended 'two litters of pigs, thirty hens, three goats and the old mare, not to mention a cat and a dog'. Looking after the pigs was Ford's contribution and, when one had to be slaughtered, Stella 'took the pram further afield, out of earshot'. Afterwards she smoked the hams and made brawn from the head which she had 'to cut up still hot in front of the fire'. The goats—a 'turbulent billy' and 'a nanny called Penny, because of her resemblance to Ezra Pound'—were hers to look after. While Ford, who smiles happily in the photos, moved between his desk and the pigs, indoors Stella set about reassuring Ford of the solidity of houses—and of this house in particular—as she played her double part, at once the farmer's wife, and muse.

In November, two months after they'd moved in, their daughter Esther Julia, who would grow up to be known as Julie, was born. They went briefly to London for the birth, which took place in a hospital near where Stella's friend Margaret Postgate, by then married to George Cole, was living.

Julie's arrival in a cottage with no modern amenities meant that Stella's time and attention were even more fully engaged. There was no electricity, no running water, no telephone and no refrigerator. 'I know that any self-respecting working woman would have refused to live in such a hovel,' Stella wrote. 'But I never saw it like that, and I'll swear Ford never saw it like that. His geese were always swans.' And so, it seems, were hers. 'I even loved the pigs,' she continued. 'I loved everything I did.'

If Stella's creativity was given over to Julie and to Ford, it was for the joy of it. In 1921, so soon after the war, she knew how many women would not have the blessing of a baby. Helen Thomas, whose

poet husband, Edward Thomas, had been killed at Arras in 1917, looked back to a similar cottage and the deep contentment of seeing her child and husband in easy accord. 'It comes out in such little things,' she said. 'And my heart has suddenly been flooded with joy and wonderful content as if life had given all.'[42] At Coopers Cottage, I think Stella felt something of this, and with Ford writing about the war, its memory a daily presence in their lives, she knew the value of contentment. And Ford, according to Stella, 'adored' their daughter. 'He simply doted.' 'E.J. is quite gorgeous,' Ford wrote to Stella early in 1922 when she had a rare weekend away, 'asleep at the moment outside, before lunch.'[43]

For Ford this kind of responsibility for Julie was unusual, and if he enjoyed it, as it seems he did, it was because it was an interlude in a domestic routine that protected him from the less adorable demands of her moment to moment needs. These fell to Stella and their maid Lucy. Ford, after all, was trying to farm pigs and write. While Stella performed 'prodigies of domestic organisation to keep things quiet', Ford wrote *Thus to Revisit*, a volume of memoirs, and *The Marsden Case*, a not very memorable novel. Two books in nearly four years. Not bad, but not good either; and absolutely not a source of income. Nothing to compare with *The Good Soldier*, which was what Stella, as much as he, was hoping for; an achievement that would make their joint effort worthwhile, a shared pride, a tangible sign of recovery.

Probably the most significant thing that Ford wrote at the cottage took the modest form of a review of *Ulysses* which, by an odd coincidence, came out in February 1922, the month he

Stella with Julie, 1921. For the joy of it.

had those two days on his own with Julie. A question impossible to answer is whether Stella also read it. She doesn't mention it, but she was after all acquiring 'a remarkable education', and in their isolation Ford needed her conversation as much as she needed his. Ford was one of the first to write about a book that is now an icon of modernism but was then quite baffling; he understood the significance of its idiom and was propelled into thinking about his own 'monsterpiece'. He knew that since the war he hadn't produced anything 'on an immense scale' but the *idea* of something on an immense scale arrived like another baby into the cottage.

For Stella, there was rarely any question of taking out her paints. The union of Love and Art meant, in the living of it, *their* love, and *his* art. When she wrote of it later, in *Drawn from Life*, she knew well what the cost had been. 'You can almost live upon a view,' she wrote. 'Almost.'

What she discovered at Coopers Cottage was that love and art, those two great desires, did not sit together as easily as she had hoped when she accepted Ford's invitation. Of course she couldn't attend to her own work when her heart and time were focused on Ford and Julie. Her care for what she called Ford's 'working conditions' meant running the house and tending their child, and protecting him from every interruption and anxiety. Above all he hated 'money problems', and 'if forced to contemplate them at a bad moment, he would collapse into such a misery of despair that our entire lives became paralysed'. So she paid the bills, and concealed the extent of their debts; she kept uninvited visitors—including Violet—from the door, for a sudden unwelcome arrival could ruin a paragraph, even a chapter. The word she used to describe her role was 'shock-absorber', and on the whole shock-absorbers don't get to paint.

In summer a steady stream of welcome visitors came down from London, but although Ford had invited them, they had to be managed in such a way that they did not disturb his routine. 'Herbert Read and his wife came, and Francis Meynell, and Ray and Daisy Postgate, and Phyllis, of course, and Mary Butts, now married to the young poet John Rodker.' It suited Ford well to join them from his desk when he was ready for conversation and the company of friends. But only when he was ready; until then he wanted quiet as he continued to write. It fell to Stella to look after the neglected guests and keep the noise down. Time and again she'd call up to him

that dinner was ready and he'd call back 'just another twenty minutes', and the twenty would stretch into forty or sixty or even more, and she'd be carrying dishes in and out, soothing the visitors, hushing Julie and the babies that visited with Margaret Cole and Phyllis, who had both had girls within months of Julie's arrival.

Then, when Ford was at last ready, he'd come down, and 'there'd be supper, late as usual, under the apple trees, Chinese lanthorns in the branches, a moon, a sweet-smelling tobacco plant, and nightingales. And all of us very late to bed.' Under those trees anxiety fell away, and resentment with it, the dream came back into focus and every chore seemed worthwhile, redeemed by the pleasures—and education—of those late evening conversations. It was a long way from the sort of meal Mrs Ramsay had presided over. But it was through the talk of these evenings that Stella felt herself grow into a shape that could take her back to her easel.

'I loved being with someone ... who lived through his eyes in the same way I did,' she wrote. 'We took such perpetual and unanimous pleasure in the look of everything.' It was as if a new self was emerging in the summer cottage, though as yet the outlines of that self were indistinct. She might paint a portrait of the frame-filling Ford, but there was no question of a self-portrait. And perhaps, at a time of contentment with Ford and a new baby, there was no necessity.

In winter, when no one visited, Stella and Ford talked into the night. After their separation she wrote of having 'the run of a mind of that calibre', and I think that's principally what she meant by 'a remarkable and liberal education, administered in ideal circumstances'. An education that made up for all the negotiations with tradesmen, the meals held up, the hours cleaning, and those days when her paints lay unopened in their tubes. And it made up for chasing the pigs through mud, or, with Julie in her pram, rounding a sow off the road where they risked a £50 fine because there was foot and mouth disease in the district.

'Pursuing an art,' she wrote in her memoir years later, 'is not just a matter of finding the time—it is a matter of having a free spirit to bring to it. Later on, when I had more actual free time, I was still very much enslaved by the terms of my relationship with Ford, for he was a great user-up of other people's nervous energy. He had built his relationship with me on the lines he wanted and nothing is more nearly impossible than to change one kind of relationship into

another, by conscious effort. I was in love, happy, and absorbed. But there was no room for me to nurse an independent ego.'

In the contest of egos—if contest it was—Stella didn't even rank. How could she? She was young, in love and a new mother. Ford was twenty years her senior, an experienced lover of women, a man with two older children whom he'd never had to look after, and an expert at arranging domestic life with himself at the centre as the Great Writer. The dice were loaded. Think of the ego required to enforce silence, to hold dinner up for hours while wives, children and friends grow hungry. Could you do that?

But in the way of giant egos, as Stella well knew, Ford was prey to anxiety and collapse of morale. On the one occasion he had to play second fiddle to her, when she was in labour with Julie, he was in the Coles' house round the corner from the hospital. There, according to Margaret Cole, he 'wallowed' in their spare bed 'like an obese cockatoo', demanding broth and oysters. She sent Ezra Pound out for the oysters and produced the broth from her kitchen. She had little of Stella's forgiving indulgence when it came to Ford. She saw him as a man given to 'extravagant poses and gestures', who responded to the arrival of his child with a 'preposterous demand for solace'.[44]

From that perspective it's probably more to be wondered at that Stella painted at all in a cottage with a baby and no electricity. Yet the portrait of Ford playing solitaire, with candles on the shelf behind him, is focused and deft; it is not the work of a student or hobbyist. There's a concentration in it to match the concentration with which Ford plays solitaire as he plots a novel. When you look at the cards, you can see that his mind is not on them.

It wasn't the only portrait Stella did at Coopers Cottage. When Ford wrote to invite Edgar Jepson down for a visit in July 1921, he included a warning: 'There is only one danger here. If Stella thinks you—or anyone—sufficiently unattractive she gently but firmly makes them sit. This spring she painted a portrait of the Mayoress of Edgbaston so successfully that the Mayor fainted.'[45] It was Ford's way of paying a compliment to Stella's refusal to flatter and deceive. He may not have wished to admit to its implications for their domestic arrangements, but he knew he had an artist-in-waiting with him.

For four years Ford and Stella had lived out the dream of the

rose-covered cottage, and discovered in the process the elemental problems that accompany every fantasy of romance. 'Petworth was five miles away,' Stella wrote, 'and the only means of transport was the high, open dog-cart. These things did not matter particularly, but the rain did. Day after day without any let-up at all. And the darkness mattered, too. And the mud.' By the end of 1922 they were ready to admit defeat. As so often in England, the weather had a metaphorical as well as a literal truth to it. The cottage in the sun was rained out.

When Harold Monro offered Ford and Stella the use of his villa at Cap Ferrat in the south of France for the rest of the winter, there was no hesitation; within weeks the cottage was packed and the pigs sold. As they waited for the dog-cart to take them to the station, the post arrived with news that Duckworth had accepted *The Marsden Case*. It was a small triumph, but enough to let them get on the ferry for France with confidence of another kind of success.

With this move across the Channel, everything about their lives changed.

5. FOR A START, the house at Cap Ferrat 'opened wide on to a great luminous sky with a Saracen fortress on the skyline opposite, and the translucent blue-green waters of Villefranche harbour below'. It was at the top of a long flight of stone steps, and everything—including Julie—had to be carried up them. But at least the steps were dry. 'Dry,' Stella wrote in her memoir. 'That is a great point.' Surrounded by grand villas—'we have the Duke of Connaught on one side of us, & the Rothschilds next door'—this tiny house had a dreadful kitchen but was, all in all, a step up from Coopers Cottage. 'The only provision for cooking was the usual peasants' charcoal contraption,' Stella wrote, 'but since there was electric light and water laid on, my cup of bliss was quite sufficiently full.'

In that house, perched high above the harbour, even the food changed. Stella 'acquired a passion for garlic sausage and black olives and cheap red wine' and for the markets where she bought them. There were no more vegetables to dig, no more hams to smoke, or pig-heads to chop up for brawn. Instead she became known for her *ragoût*. She had discovered the compromise of the tray.

But the most significant change that came with the move to France was that Stella was drawn back to art and reminded of her own ambitions. Along the south coast of France there were artists as well as writers; conversation was no longer reliant on weekend visitors or focused entirely on Ford and writing; there was also talk of paint and painting and painters. There had been precious little of that in Sussex.

Not that her first encounter with French cultural life had been an unqualified success. Dorothy and Ezra Pound, who had moved to Paris, gave a party to welcome Stella and Ford on their way through at the end of 1922, and there she made her first gaffe. Asked for her opinion of literary London, she replied that being a rustic she wouldn't know. Ford was furious. 'He said it was no use imagining

that in Paris I should be able to get away with that kind of ignorance. It wouldn't be tolerated, and besides, it let him down. I must remember that we were no longer in England where the arts were always in disgrace, but in France where it was not considered funny to be an ignoramus about such matters. Quite the contrary.'

It was time to get serious. And they did.

Ford began *Some Do Not*, the first part of his four-volume 'monsterpiece' *Parade's End*.[46] 'I've got over the nerve-tangle of the war,' he told H.G. Wells, 'and feel able at last really to write again.'[47] This sequence of novels was his way of working the war into literature. 'Rendering' was the word he used, and by that he meant the transformation of the events and turmoils of life into the aesthetic pattern of art. Not comment, not interpretation, not copying; but rendering. The question he faced with *Parade's End* was whether war and the enormity of its horror could be rendered.

Inspired by *Ulysses*, the four novels follow Christopher Tietjens through the war; or rather we accompany him in an uneasy, fractured stream of consciousness. The first volume, *Some Do Not*, published in 1924, begins with Tietjens, the younger son of a Tory squire, at odds with Sylvia, his beautiful and faithless wife. In a typical Fordian move, he agrees to take her back, to forgive—and conceal—her adulteries, at exactly the moment he himself falls in love with Valentine Wannop. The next two volumes—*No More Parades* and *A Man Could Stand Up*—remove Tietjens from the two women by blasting him onto the Western Front; it is not until Armistice Day that he resolves to leave Sylvia for Valentine. In the final volume, *The Last Post*, Valentine is pregnant and Tietjens, turning his back on the past, is earning a living by restoring antiques.

This is a bald outline of the work Ford began in the villa at Cap Ferrat. While he embarked on it, he might still expect his lunch to be provided when he was ready, but at least he didn't mind what it was: bread and cheese suited him well. And as they had brought Lucy with them to help look after Julie, Stella's time was considerably freed up. In joyful response to this change of circumstance, she painted the harbour which glistened beneath their house. *Villefranche* (plate 1) is a small painting on wood panel; it looks across the harbour from a slight elevation. The colour has the brilliance of the Mediterranean, and the composition—with the hill on the other side of the harbour cutting across the usual lines of perspective—has absorbed the

'modern' lessons she'd taken in England. In the foreground are two telegraph poles; between them, the old steps of the *quai*. It was a painting which Ford said he liked, but detracted from the praise by adding that it looked rather like a travel poster.

However the real impetus back to art came with a visit to Italy. Quite unexpectedly, in March 1923, Dorothy Pound invited Stella to join her in Florence—a town Ezra hated—and travel with her from there while he went to do some research in Rimini. Ezra, Dorothy said, thought it time Stella saw 'some real pictures'. Ford agreed. 'You so thoroughly deserve it & have so absolutely earned it,' he wrote to her while she was away.[48] 'This tour was a very big event in my artistic life,' she wrote in *Drawn from Life*. 'It was the first time that I had left Julie and Ford.'

'Kiss my darling babe,' she wrote to him from Assisi. 'I pray you both keep well and happy!'[49] Given Ford's self-proclaimed domestic ineptitude (and despite the reassuring presence of Lucy), she had some reason to worry. But from their letters it seems that Ford managed well without her. He still wrote every day and by the time she got back had completed a draft of a play. He even managed to keep writing through a money crisis—which would normally have floored him—when Stella's cheque from Australia was late and there was a confusion that took him not to one but two banks. And he appears to have managed without resentment. 'I'm ever so glad you've pushed off into the great world on an adventure,' he wrote, 'though I wish I were with you just the same.'[50] Six weeks is only six weeks, yet the fact that he managed so well raises the suspicion that his foibles and hypersensitivities were made possible by the availability of female devotion and were not the inevitable outcome, as Stella claimed, of the masculine artistic temperament.

'Although I missed them horribly,' Stella wrote twenty years later, 'this taste of freedom would alone have been sufficient to reawaken all my old excitement about painting.' It was on her return—as we can see in retrospect—that her painting became recognisably hers, with a character as identifiable as a signature in the corner.

Above all else in Italy she responded to the soft clarity of the light and to the way the early Renaissance frescoes, with their 'narrow tone scale', were so evenly suffused with it that there were no harsh shadows: 'a no man's land of diffused light', she called it. 'I

had expected to be worried by the crudities of the early painters and to find difficulty in understanding them . . . Actually, it was precisely the formal patterns of the earlier painting which enchanted me as I had never before been enchanted.' She fell in love with Giotto at Assisi and Piero della Francesca at Arezzo and Fra Angelico at Cortina; she fell in love, as she put it in her memoir, with 'the formal and pellucid serenity of those candid early masters'. Already in *Villefranche* you can see that she was trying for an effect of diffused light, and if there is any merit in Ford's travel-poster comment, it is because she had flattened the composition in that shadowless light. Inspired by the quattrocento masters, she also came to understand the power of 'architectural patterns' in building up the planes of a composition. After Italy, she said, she 'deliberately flattened out shadows and concentrated everything on linear design'.

Only four of Stella's letters from Italy survive, to twenty-one of Ford's—although it's clear that she was writing just as frequently. It is a particularly frustrating loss. There are two letters from Assisi, one from Florence and one from Perugia. We can read of her love for the formal patterns of Giotto's choired angels, but not of her visit to Arezzo and her reaction to Piero's frescoes. We also get a taste of her irritation with the showy excesses of the Catholic church, its effigies and 'wicked bogey-bogey'. As Ford was a Catholic convert, this was a significant and pointed objection. They had agreed to bring up Julie in the Faith despite Stella's misgivings—especially about the Catholic attitude to marriage and women. While they were together they dealt with their differences with some degree of humour, and in any case Julie was still very young, but Stella's letter from Assisi is a reminder of an incipient tension; the time would come when it would harden into one of the few lasting disputes between them.

In Italy in 1923 there were tensions of a more immediate sort, which we know of only from Ford's response to letters of hers that are missing. 'I wonder very much how you & the non-representational Dorothy agree over Giotto!' Ford wrote early in the trip. 'I suppose there's a neutral ground where you can maintain a truce of God.'[51]

He was right to expect trouble; the truce didn't last. It seems that Stella did clash with the 'non-representational Dorothy', and, worse, with Ezra when they joined up with him for the journey back to Paris. Pound was a tough opponent, all the more so given the

double dealing of his 'education' of the *placid and uneducated mistress*, and in clashing with him, Stella was clashing with the man who, after Ford, had most power to wound her. When I think of her trying to hold to her own instincts about art against Pound's arching certainties, I am reminded of Mrs Ramsay at dinner as she contemplated the 'admirable fabric of the masculine intelligence, which ran up and down, crossed this way and that, like iron girders spanning the swaying fabric, upholding the world'.[52]

'Your poor distressed letter has so distressed me that I am cutting my walk to write to you about things,' Ford wrote two weeks before she was due home. 'I know you think I'm an old duffer & that, what applies to me & my art don't to you & yours: but they do.

'Let us begin with Ezra. His <u>criticisms</u> of yourself you simply should not have listened to: they arise simply solely from a frantic loyalty to W[yndham] Lewis—& no doubt to Dorothy. He is in fact singularly unintelligent on the <u>aesthetic</u> side of any art—at any rate in conversation. It is only <u>historically</u> that he is sound about anything . . .

'And, as I have said to you over & over again: the prevalence of one type or other of Art—<u>any</u> Art—is merely a matter of cycles: or even of strata of society. And again: there are certain axioms, one of which is that good drawing will always cause emotions to arise; so will good colour & good pattern. And goodness means observation rendered . . .

'As for not going to the Old Fellows—you <u>must</u> go to them!— to the serene ones, like Holbein & Cranach & Simone Martini. Even Lewis went to them all right ten years ago—but he won't say so . . .

'Darling: I assure you that you have all the makings of an artist; the only thing you need being a certain self-confidence. If you attained to that you would see that, even in your work as it is, there is the quality of serenity—of imperturbability. It isn't the smallest of achievements to have been able to do what you wanted to do . . . unperturbed by the thought of the clamour of Ezra, the acidulities of Dorothy or the tumult of the Prevailing School. That points to a sort of doggedness which is in the end what does it!'[53]

There is generosity and breadth in this letter; one can see what Stella meant by the privilege of having 'the run of that mind'. Ford was well-read and knowledgeable in many areas of art as well as literature, as a glance at any bibliography of his work shows: it

includes biographies and critical writing on Holbein and Rossetti, as well as the Pre-Raphaelite Brotherhood he'd known as a child with his grandfather, the artist Ford Madox Brown.

When I read Ford in the letters, I find I rather like him. It's when I read his books, especially the memoirs but even the Tietjens novels, that I don't. There are writers who have greatly admired *Parade's End*—Graham Greene and Julian Barnes among them—but to my mind there is an emotional posturing that limits their success. As if this most emotional of men is so afraid of a direct admission of feeling that he dresses the powerful things he has to say about the experience of men at war in pompous and self-conscious language. A letter like this shrinks to human proportions the more ludicrous grandiosities of his books. I like what he says about 'the tumult of the Prevailing School', and his ability to step outside it and understand the first glimmers of Stella's own non-prevailing aesthetic.

Ford encouraged her to stay in Paris for a few extra weeks to take some lessons with Sonia Lewitska, a printmaker and designer whom Ezra Pound violently opposed. Ford assumed, where Pound did not, that Stella wanted to go to her and her husband, the painter Jean Marchand, to learn more about brushwork, pigments and 'the mechanics of things', rather than to 'assimilate their fashionable side'. 'Why,' he wrote, 'by the time you are ready to launch out, really, they will be *vieux jeu*.' But the important point is that Ford supported Stella's impulse towards the figurative, even the decorative, against the censorious Pound and the prevailing school of formal austerity.

It is a generous response, open and in no way doctrinaire. Ford even describes the Villefranche painting as an achievement of serenity. Yet it has to be remembered that in other contexts he identified fiercely with his own circle and the standards of taste he was about to establish in the *transatlantic review,* which was to be his project for the following year. Although it's clear from his correspondence that the groupings with which he worked tended to fluctuate, split or dissipate, he put a lot of work and emotional energy into establishing not only his own circle—a word he was very fond of—but its direct line of inheritance from 'the rising of the moon [which] came, exactly a hundred years ago, when there appeared in this planet Gustave Flaubert and his circle'.[54]

While Ford was generous to Stella as mentor, lover and intimate conversationalist, he could also be unthinkingly sharp. I read this letter, but I don't forget his remark about her first French landscapes. The messages he gave her were mixed. 'It was natural that I should be regarded chiefly as a wife and mother, who did a little painting as a hobby,' she wrote, looking back at her younger self. At the time, she wrote from Perugia to tell Ford that she'd done a sketch 'sitting in a gutter in a windy street', but hadn't shown anything to Dorothy. 'Darling,' she continued, 'I find myself wishing I were on the way home, altho' I'm having such a heavenly time, because I do miss you so badly & want you so dreadfully . . . How we shall be able to talk when I <u>do</u> return!'[55]

Above my desk is a postcard of Piero della Francesca's *St Michael*. As it's in the National Gallery in London, I know Stella couldn't have seen it in Italy in 1923. Nevertheless it has been a kind of talisman as I've tracked her story. I love its gentle light, its soft shadows, its 'pellucid serenity' and the way it allows the light to move around the figure of St Michael without false drama, even in battle with a serpent. I love the calm look of surprise on his face, his tender knees, his delicately fashioned red boots and the tension in his arms as he holds the sword and the open-mouthed head of that thoroughly slain serpent. More than any other version of St Michael, this one captures the combination of ordinariness and effort that goes into the slaying of a serpent. This isn't a single heroic act; it's something that is required of us in life, an effortful and ordinary necessity. It's not a portrait of a sensibility that conquers a monstrous dragon

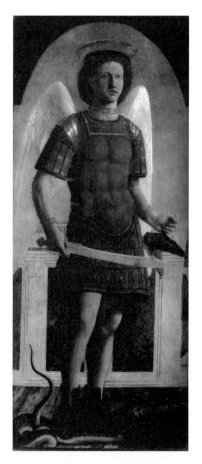

Piero della Francesca, ST MICHAEL.

but one that recognises the serpent as a part of our lives that has to be struggled with, even killed, again and again.

Virginia Woolf talked of killing the Angel in the House. It was a different metaphor but a connected idea. The Angel in the House was her term for that part of the feminine self that keeps a woman tame; the angel who flatters and deceives, who whispers and seduces, who serves and charms, and who asks—and needs—to be loved. For her it was never a matter of killing the Angel once and for all, but a life-long engagement with the problem, the tendency, the desire. This was the problem that beset Lily Briscoe when the shadow of Mr Tansley fell across her canvas.

When Stella arrives at Cap Ferrat, changes the domestic economy and paints the harbour below the house, I feel it as a moment of victory, a small serpent slain, though the moment she slays it, Ford belittles the deed by likening the picture to a travel poster. A few months later, when she stands before Giotto and Piero, it is another serpent slain, another small moment of triumph. And then Ezra Pound ridicules her interest in Sonia Lewitska, her interest in figurative painting, her enthusiasm that does not accord with his. The mentor becomes censor. And Stella cared what Pound thought. Lily Briscoe didn't even like Mr Tansley. 'He was really, Lily Briscoe thought, in spite of his eyes, the most uncharming human being she had ever met. Then why did she mind what he said?'[56]

Stella caught the train back to Ford, back to Julie, back to the household. She put up her easel and started again. *Avignon* (plate 2) is a bolder design, and this time it's possible to see the 'architectural' build-up of planes, the diffused light and serenity; but, unlike *Villefranche,* there's nothing pretty about it. 'Austere' would be a better word. It is not seductive or coaxing as travel posters are; we are not invited to visit this bridge, but to consider its shape, its essence, its 'bridge-ness'. The capacity to capture this quality is what Ford meant by *rendering.* In Ford's terms, the Villefranche painting was *commenting* on itself, a word he used for the opposite of rendering in art. Rendering, in his terminology, does not need to comment, for it is 'so much more universal as a communication'.[57]

Nevertheless Stella sent *Villefranche* to the Salon des Tuileries for exhibition. It was shown under the name Esther G. Bowen and priced at 200 francs; the details are still on the back. Unsold, it was returned to her and is now with the family in Australia. Matching it,

almost the same size and also painted in oil on wood panel, is an untitled scene of a French seaside village (plate 3). As it's undated, it's hard to be sure whether she painted it before or after the visit to Italy. I suspect it was done before, in those first months in France. Ford spoke of travel-poster paintings in the plural and in this picture too Stella used a dramatic composition, with the town perched on a cliff that falls into a brilliant sea. Tiny figures walk the streets, and the houses are drawn with the precision of a map. It is a happy painting.

When Stella returned to France in May 1923, she painted four small portraits 'in great detail' on wood panels. They were shown at the Salon d'Automne in Paris that year where they were described as *aimables petits portraits, fidèles et serrés.* Beyond that I can't comment because I haven't seen them. I don't know where they are.

In tracing Stella Bowen's life there are many absences. There are missing letters; there are her own silences like a form of punctuation one barely notices in her otherwise conversational memoir. And there are many missing paintings, of which these four portraits are a small sample. Some of the 'lost' paintings survive in the form of black-and-white photos that she sent back to Tom in Adelaide. These have been kept by his daughter, Suzanne Brookman, and it is due to her curating of the material which came to the family that we know as much as we do about her aunt. She and I and many others have searched for the lost paintings, and every now and again one turns up, but so far these have been portraits that were commissioned later.

That those four early portraits have been lost is a comment on the regard in which her work was held. Now we can see them as symptomatic of a moment when something important was set in motion. But was that how it seemed at the time? In 1923 no one thought to photograph or document them despite the fact that they were accepted by the Salon d'Automne. No one including, I suspect, Stella herself. At this juncture even her memoir, whose major theme is the story of her coming to maturity as an artist, shows more interest in Ford's adored Provence than in those portraits. She doesn't even tell us who the subjects were.

Nevertheless she could see, and Ford could see, that already during those few short months in France and Italy, something had changed in her as well as in him. When Harold Monro wrote to say he would be needing the villa again, they both knew that there was

no going back to a life of retreat for him and domestic devotion for her. Their mood was expansive, they were working well, and Julie was 'growing like a giraffe'. So when they left Cap Ferrat, they sent instructions back to England for the cottage to be sold. They joined Phyllis and her husband, who were visiting from England, for a holiday in Le Puy, and then moved to Tarascon. From there they toured the unfashionable—and therefore inexpensive—hinterland for the rest of the summer. By September they had received the money from the sale of the cottage and were ready to return to city life. 'The gay and glamorous Paris of the nineteen-twenties was waiting to engulf us,' Stella wrote.

And engulf them it did.

6. IN RETROSPECT IT seemed to Stella that all would have been well if she had been more like a French wife; if she had kept Ford in the country, controlled the purse strings and limited his access to Paris. 'But I . . . never in my life wanted to dragoon anybody. Besides I wanted to paint.' For that to happen a certain level of independence was essential—and also Paris. 'You won't find heather in a bean field,' Ford had told her early in their courtship, scrambling the message as he took her off to live in Sussex. 'Live in the milieu and be as deep as possible in the atmosphere.'[58]

Stella's point was not that she had reneged on the household—not at all—but that because she did not devote herself to it totally, giving up any idea of a life or a career for herself, her hold on Ford inevitably slipped. In Sussex she had been the perfect wife. There had been very little to divert her attention from him—or his from her; she had poured herself into their 'deep intimacy' almost as if it were an artwork of another kind. In Paris her ambition was different: to set the family up domestically, and therefore emotionally, as a secure base from which Julie could begin school and she and Ford could *both* work. It wasn't that she wanted distance from Ford; on the contrary, she had taken his name and, although their friends knew the fiction, she regarded her liaison with him to be as firm as marriage. Her hope was for a shared life of love and work: Art and Love brought into harmony.

In practical terms, the possibility of a secure base slid from view as Ford diverted all their capital—hers as well as his—into the *transatlantic review*, which he founded almost as soon as they arrived in Paris. It was a sinkhole for money. Every penny that came from the sale of Coopers Cottage went into it, and much more. Ford's biographer, Max Saunders, calculates that it cost them about 120,000 francs, or £1,500, for the one glorious year it ran. That was a lot of money in 1924. Virginia Woolf's 1929 ideal of £500 a year (the price of a room of one's own) was a high income for a woman, especially if she had to earn it; few women civil servants (not that there were

many) earned more than £250. It wasn't until 1927, the year of *To the Lighthouse,* that Virginia Woolf's own income from her books reached £500. In 1925 it had been £164, and her total earnings, including journalism, had been £223.[59] Her income was of course supplemented by Leonard's, but these figures give some indication of the scale of the expenditure on the *transatlantic review*. It meant there was nothing left for the house in Provence that Ford had imagined, or the apartment in Paris that Stella wanted and they needed. For £1,500 or even less, they should have been able to get both. Five years earlier Leonard and Virginia Woolf had bought 'Monk's House', quite a large house in Sussex, for £700.

But money was not the only consideration for either Ford or Stella as they stepped into their new Parisian lives. The *review* propelled them into the heart of the expatriate community and gave Ford the standing and kudos he wanted. Regarded in purely literary terms, it was one of his most influential achievements: a stylish journal of the avant-garde which, despite the 'tumult', would give 'equal space to all the schools'. Tristan Tzara, Dorothy Richardson, Erik Satie, e.e. cummings, Havelock Ellis and Pablo Picasso were among the names in the famous pages of the *review*. Ernest Hemingway, James Joyce, Djuna Barnes and Gertrude Stein were all published by Ford—and were at the tables of the cafés where he and Stella ate. 'Ford enjoyed himself superbly,' Stella wrote.

On Thursdays the *review* was 'at home' and Stella 'made tea for all and sundry at the office, which opened straight on to the Quai d'Orléans'. She took the view that a party was as good as a hot bath for relieving the day's accumulated tensions. 'I have always had a passion for parties,' she wrote, 'if they are given with no ulterior motive but that of enjoyment.' Her idea of a good party meant music and dancing, an occasion when people could be 'a little exaggerated, less cautious, and readier to reveal their true spirit than in daily life'. For Ford a party could be a 'cure' for the 'mental prostration' that comes at the end of a day's work at the desk.

Ford and Stella's parties became famous. They held them in their studios as they moved from one part of Montparnasse to another, and when these became too cramped, they took over a restaurant called the Nègre de Toulouse for 'everyday eating', and a *bal musette* for Friday night dances. Mary Butts, Stella's London friend, 'a gorgeous apparition at a party',[60] who had left her husband

and was living in Paris with Cecil Maitland, a rather unstable painter, was at most of them. 'It was a good idea,' she wrote. 'It was cheap. It was innocent as only Paris can be innocent. And when [the parties] ended something in an epoch came to an end and was written off . . . I can see it now. A small place, panelled in varnished wood, with its bar at the entrance, and harsh drinks in coarse glasses, and, inside, the little raised dancing floor with a minute balcony high on one wall, no more than a cage, where the drummer sat.'[61]

At one of their studio parties Stella feared that the floor would give way; at another someone kicked Mary Butts and a brawl broke out under the concierge's window. At the *bal musette* Natalie Barney, '*l'Amazone* . . . short, plump, all in dripping white fringes', famously danced with Ford; Margaret Cole, over on a visit, met 'Gertrude Stein, a stoutish lady whose clothes seemed held up with safety-pins, surrounded by Picassos'.[62] Neither Stein nor her companion Alice B. Toklas danced, and when not surrounded by Picassos they gave domestic advice. The Russian painter Pavlick Tchelitcheff brought Edith Sitwell to meet Stella. Herbert Gorman, Joyce's biographer, watched Ezra Pound 'entertain himself' on the dance-floor and Ford, 'a behemoth in grey tweeds . . . plod happily and with a child-like complacency through the dance, his partner swaying like a watch-fob before him'. At another table he saw Stella deep in conversation with Olga Rudge, the violinist who was just then becoming Pound's mistress.[63]

One could almost get the impression that life in Paris was one long party. But under every party beat the pulse of the day's anxieties. Ford's accumulated at his desk, where he was not only working on the *review* but also writing the war volumes of *Parade's End*. Stella's took a more practical turn. With their funds being soaked up by the *review*, her days were dominated by the 'long, unequal struggle to get together another permanent home. It overshadowed everything.' Paris in the 1920s might have been glamorous, but it was no place to rent. To LET signs were virtually unknown, queues had to be joined, concierges bribed, and the 'most astute rogues in the world' contended with. When a studio did become available, the lease would only be for a few months; each respite was temporary before the queues had to be rejoined, the concierges bribed, and the boxes repacked.

In an attempt to gain some stability, Stella rented a house in the

village of Guermantes. Gertrude Stein had suggested that she look outside Paris where leases were longer and the houses 'charming'. But the village was an hour and a half away, and that didn't suit Ford or the *review*. Stella was caught between his needs and those of their daughter. Julie was only four when they had arrived in 'gay and glamorous' Paris, and while Ford adored her, that didn't mean he would bend to her requirements any more than he would to Stella's. It wasn't that he intentionally went against them; he simply didn't see life in terms of the mutuality of their needs. Which left Stella juggling the trays.

When I consider the story of Stravinsky's lunch and everything that extends from it, the tray seems, on the face of it, an honourable as well as sensible solution. It allows life to go on, the symphony (or novel) to get written and even, possibly, the woman to get to her easel. But does it? Or is this solution at best a holding mechanism as the woman tries to carve out a space for herself without too much disruption? It might be sensible by one reckoning, but by another it's a placating, makeshift manoeuvre. The man strides in and demands silence at lunch. He sets impossible conditions for his art. The woman responds with a tray.

By the time Stella found the house at Guermantes, Lucy, homesick, had gone back to England and been replaced by Madame Annie—a woman who proved fiercely possessive of Julie, hated interference, and was given to tantrums and sudden outbursts. There were days when Stella was caught in the gusts of this new drama, but for all her shortcomings Mme Annie was essential if Stella was to paint or accompany Ford into the expatriate Paris he intended to enjoy. So Stella settled on the compromise of leaving Mme Annie and Julie at Guermantes during the week, which meant another rent to pay but gave them a certain stability. At weekends she would either join them—with or without Ford—or bring them to Paris.

'I suppose,' Julie wrote in her introduction to the 1984 edition of *Drawn from Life*, 'considering our circumstances, that I did not see as much of her as I feel I did. Of course the reason is clear to me now—I always felt enveloped in her love and care, and always had her total attention when we were together . . . I was always treated as a person and not simply as a child.'[64] 'She ate in our restaurants,' Stella wrote, 'and was perfectly accustomed to mixing with our grown-up friends.' Picasso drew a sketch of her on a napkin at one

of the dinners; Julie's grand-daughter tells the story with a smile—
for the napkin wasn't saved.

During that first year in Paris, Stella also spent a lot of time
raising funds for the *review*, appeasing its debtors, soothing artistic
egos and generally managing its affairs while Ford stayed at his
desk. 'He would say,' she wrote of those years in Paris, '"I can finish
my book this month if you can manage that I am not worried by
anything."' In that respect nothing had changed. He still needed his
silence—'he could not bear whispering'—and he still needed Stella's
attention when he had finished. In some ways it was worse because
in Paris there were more 'admirers' to be talked to and stage-
managed. 'And when there was bad news—as for instance an
expected contract falling through, or a publisher going bankrupt, or
any of his multifarious negotiations with the world of letters going
wrong—the air would be so filled with pain that we could neither of
us do any work at all. I would far rather bear a worry alone than
shared with Ford. It was easier.'

Some Do Not, the first volume of *Parade's End*, was published in
1924; *No More Parades* followed in 1925 and *A Man Could Stand Up*
in 1926. Ezra Pound declared the emerging sequence a masterpiece,
and Ford—who had for so long doubted whether he was a genius or
a hack—was thereby confirmed in the legitimacy of demands which,
to him, were not demands at all, simply the way he needed to live.
Writing at that rate was impossible without someone to buffer
interruptions. And what he was writing about was tough. If he had
to queue . . . If he had to appease Mme Annie . . . If he had to answer
the debtors' calls . . .

In the autumn of 1925 Stella found a studio at 84 rue Notre-
Dame-des-Champs, with the help of her friend, the painter Nina
Hamnett. There was no kitchen or bathroom and no separate
bedrooms—'just a water-tap, and electric light, and some heavy
moveable screens'. But it was large, with enough space for her to
paint as well as for Ford to write, and they had a year's lease. Ford
wrote at a desk Stella had built for him on an upper platform;
underneath there was plenty of room for her to paint. When Mme
Annie and Julie were there, she could make space for them with the
screens and still have room for her easel.

At this moment of relative stability Stella should at last have had
the freedom she needed to paint. 'I actually imagined that, between

the attic and the studio, I had got a permanent home together at last, which would frame and shelter our family life and the deep-rooted and absorbing relationship that I had with Ford. That relationship still governed every particle of my life . . . and I was so conditioned to its furtherance that I had never questioned the solidity of its structure. Nevertheless, there was a crack.'

'The accident,' Proust writes, 'comes from the direction one least expects, from inside, from the heart.'

In the autumn of 1924 a young woman called Ella Lenglet had turned up at the *review* with an interesting manuscript. Since leaving Dominica at sixteen, she had worked in various desultory jobs, including as a chorus-girl. Unhappily married, she'd lost two children; her son had died in infancy and her daughter had been taken into care. She was thirty-four when she arrived in Paris (three years older than Stella) and, judging from photographs, rather alluring in a vulnerable, needy kind of way. Ford, who was fifty-one that year, took her work seriously, advising her to write about what she knew. This she went on to do, though hardly in the way he had in mind. With his belief in the 'Divine Right of the Artist', he assumed not only that the artist to whom this right attached was male, but that whatever the artist did would be protected by the silence, if not approval, of those close to him. So it didn't occur to him that he might be leaving himself vulnerable when he seduced Ella Lenglet, giving her in return a pen name, her first literary break and the material for her novel of adultery that shot her into prominence. The woman's new name was Jean Rhys, and the novel, a thinly disguised *roman-à-clef*, was published in Britain in 1928 as *Postures*, and then in America as *Quartet*, the title by which it's now generally known.

It is not entirely clear when the affair began. Jean Rhys has left a melodramatic and unreliable account of it in *Quartet*; Stella gave few details, and her dates in *Drawn from Life* don't always match other parts of the record. However, the one event with a date we can be sure of was the arrest of Jean Lenglet, Rhys's husband, in December 1924. When Lenglet was tried and gaoled for embezzlement in February 1925, Ford assumed the role of protector, and it seems to have been then that he took Jean in to live with him and Stella.

'She lived with us for many weeks whilst we tried to get her on her feet,' Stella wrote in her only direct comment on the course of the

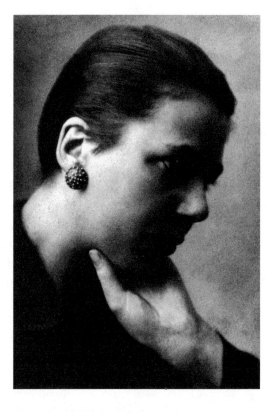

Stella in Paris,
c. 1926.

affair (though she placed those weeks in the following autumn). 'Ford gave her invaluable help with her writing, and I tried to help her with her clothes. I was singlularly slow in discovering that she and Ford were in love.' By her account she agreed to take in the destitute Jean Rhys with no idea that an affair—or 'three-cornered fight' as Jean Rhys called it—was looming. By Jean Rhys's account, which, as fiction, isn't necessarily reliable, Ford had his hand on her thigh at their first meeting. It was a thoroughly unpleasant affair. If Jean Rhys is to be believed, Ford would go to bed with Stella, wait until she was asleep, or he thought she was asleep, and creep through the apartment to stand at the foot of her bed.

Those are the details you will find in *Quartet*. Stella gives none in *Drawn from Life*. She might have been slow to realise what was happening, but the public nature of expatriate life in Paris meant that the affair soon became highly visible. Ford saw no reason to be discreet as he flirted at their table at the Nègre de Toulouse. 'If only we may be spared any Lenglet scandals in the future,'[65] Stella wrote

to him after it was all over. As early as December 1924, the artist Paul Nash had seen Ford bundling Jean Rhys onto a train out of Paris, as he told a friend in England: 'I bumped into that old rascal Ford. He was extricating or further involving himself—God knows which—by, with, or from some woman, some more or less new one, and looked a little distracted. I think she'd been making him a scene.'[66]

The affair was like a small bomb going off in Stella Bowen's life. When it began she was still very much in love with Ford. Yet in *Drawn from Life* she passes over the affair with Fordian deftness and doesn't even mention Jean Rhys by name. By evoking an atmosphere but not giving any of the details, she sidesteps a question that hovers over this episode: why did she allow Ford's mistress to continue living in the studio? Because she was caught in the habit of complying with him? Because he seduced her with assurances? Or because, like Violet Hunt, she thought she could tame the affair—and him? A combination of all these pressures perhaps. She wrote a memoir of such skill that it takes several readings to realise that on crucial points—and this is one of them—she was saying very little.

Quartet, on the other hand, is a novel of revenge. If Stella was reticent about the details, Jean Rhys had no such scruples. She shafts Stella in an unflattering portrait of the self-satisfied bourgeois wife, 'just sitting tight and smiling'.[67] Ford is presented as an ageing seducer who isn't even a good lover. But these unpleasant portrayals are overshadowed by the casting of herself as victim, 'huddled . . . as if there were a spring broken somewhere'.[68] As Marya, she says she hates men for the way they reduce women to 'sob stuff, sex stuff' with their 'hard greedy eyes'[69]; and yet she claims to be in love with a man before whom—in her own imagery—she abases herself as a dog before its master.

Stella, of course, had read *Quartet* long before she wrote her memoir. Even before it was published she knew what to expect. In 1927, the year Jean Rhys's first collection of stories was published (with a chivalrous introduction by Ford), she gave a hint of how much it had hurt her. It came in a letter to Ford written at the beginning of that year, just after she had read Hemingway's *The Sun Also Rises*, which took her as a model for a crass, loud-mouthed, insensitive Canadian called Mrs Braddocks. 'It seems pretty good,' was her comment on the novel. 'I like that hard clean sort of effect—but I think it gives also the effect of brittleness—or is that nonsense?

It is also rather dazzling & tiring.' Stella was by nature generous and didn't have to struggle to find this kind of response in herself. It was much harder for her to admit to being wounded. All she said was: 'He has touched me off rather nastily—rather on Jean's lines. So I feel very discouraged! Even you don't quite escape. Still it's all of no consequence.'[70]

But of course it was of considerable consequence.

On Ford's side, how did he react to seeing Stella caricatured by a man he admired? Did it diminish her in his eyes? Did he not see that Hemingway's casual behaviour, compounding his own, might move her into a gradual process of withdrawal?

The first signs of the change that was taking place in Stella are to be seen in two portraits of Ford. They were the most ambitious pieces of work that she undertook during those two disrupted years in Paris. It wasn't that she had stopped painting under the accumulating strain of living with Ford, rather that she had marked time, losing the momentum generated by her visit to Italy. She continued to do the covers for Ford's books, as she had since they were in Sussex. She had illustrated *A House* with a silhouette of Ford working by the light of two candles, and *The Marsden Case* with a picture of two couples facing towards a theatre, with their backs to a table set with fruit and wine. In France she designed the covers for several travel books as well as for *Some Do Not*, and she may well have been responsible for the logo of the *transatlantic review*.[71]

The portraits of Ford which she did late in 1924 or early in 1925 are not flattering. Despite her penchant for the unattractive subject, in Sussex she had allowed him a certain dignity. In these two portraits she shows him dishevelled and salacious—even dissolute. In the first (plate 4) he sits side-on, wearing a bow-tie, looking as crumpled as his clothes. The expression in his pale eyes is curiously vacant, as if he has worn himself out in pursuit of his own desires. When his mother saw this portrait, she said it was 'very clever but hideous' and that he looked 'like a Frenchman with a past'.[72] Ford still fills the frame, or rather spills into it, giving an effect quite different from the bounded strength and clear lines of the earlier study of him playing solitaire. In the second portrait (plate 5), a last look back to Sickert, there's resentment in the very paintwork, an ominous collision of colour—brown, ivory and grey—with the brush strokes lying over each other. Did she realise how harsh this

image was of the man who had precipitated her into emotional free fall? 'Even when working at my easel,' she wrote, 'my head was conscious of Ford's needs and wishes and states of mind.'

In the summer of 1925 Ford found Jean Rhys a job on the Riviera, ghosting a book, and when she returned to Paris she moved into a hotel, where she began drinking. The affair continued unhappily, with Ford paying her an allowance as well as her bills. As an escape, Ford and Stella took Julie and Mme Annie south to Toulon for the winter. In *Drawn from Life* Stella places this trip a year earlier, in 1924, but that winter (while Jean Lenglet was under arrest) they were in Paris.[73] Perhaps she misremembered because, despite the unhappiness of the preceding months, it was an expansive time for her when she returned once again to her art and began to 'slip out from under the weightiness of Ford's personality and regain [her] own shape'.

On the recommendation of their friends the painter Juan Gris and his wife Josette, Ford and Stella took rooms for the family at the Hôtel Victoria. There Ford began the next volume of *Parade's End* while Stella rented a studio with 'an uneven brickfloor, a roof supported by twelve great beams and the harbour view'. Othon Friesz, the Fauve painter, had found it for her in the same quayside building as his own.

'I fell in love with Toulon at first sight,' she wrote, with its 'tall, shabby and colourful old houses unmarred by any intrusion of modernity' and backdrop of 'rocky, fortress-capped mountains'. But what she fell in love with there, like a counter-echo to Ford, was not only the physical beauty of the town; in the company of artists she again glimpsed the possibility of a life in which her deep interest in art could be given a more central place.

'In Paris I had sat at hundreds of café tables with Ford,' she wrote, 'listening to talk about literature and *le mot juste*. In Toulon, I was able to listen, at last to talk about painting. Juan Gris was no great theoretician. *J'aime composer*, was all he would say . . . Friesz, older and more successful, was more aware of his own methods, and more talkative. Francis Carco was staying with him . . . and they both had plenty to tell of the early struggles of *les fauves*.' It was a great day for her, she said, when Friesz, 'who can paint water so liquid that it would run away out of any picture less well composed than his', told her that it had been a great day for him when he had

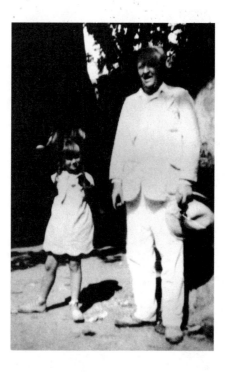

*Ford and Julie in
1925, probably
in Toulon.*

*One of Stella's
many sketches
of Julie.*

contemplated a composition of the sea and, at the prospect of filling it all in with blue, decided not to. 'Before these giants,' she wrote, 'I was miserably conscious that my notions about painting were extremely embryonic . . . It is platitudinous to say so, but being a woman does set you back a good deal.'

Before they returned to Paris at the end of the winter, Ford and Stella detoured to Rapallo, in Italy, where the Pounds were now living. For Stella it was an equivocal visit. She admired their 'sixth floor flat with a big *terrasse* overlooking the harbour' and found that stretch of coast even more appealing than the south of France, but she didn't like the political atmosphere and couldn't share Pound's enthusiasm for Mussolini. 'I did not like coming upon [his] heavy features stencilled all over the walls and glowering at me from every corner.' From Rapallo they went to Provence on their own, leaving Julie and Mme Annie in a hotel at Tarascon; Stella's account of their days together in the villages around Carcassonne is told with love.

Ford and Pound in Rapallo in 1932.

It was after Easter by the time they returned to Paris. Back in their studio at 84 rue Notre-Dame-des-Champs, Stella's prospects for her own work faded as she was thrown back into the turmoil of their lives and Ford took up with Jean Rhys again. Stella says nothing of this, but it must have seemed a futher betrayal after those apparently happy months in the south. The affair finally came to an end in the summer. Jean Rhys, by her own account—and also her biographer's—became angry and recriminating. Ford, reverting to form, stayed at his desk and refused to be disturbed. 'A man seldom shows up to advantage,' Stella wrote, 'when trying to get rid of a woman who has become an incubus.'

'When it comes to managing my own affairs,' Ford wrote in one of his memoirs, 'I am worse than hopeless.'[74] 'Poor Ford,' Stella wrote in hers. 'If ever a man needed a fairy godmother, he did.' He

had a 'genius for creating confusion' and a 'nervous horror' of having to deal with the results. Which left Stella, stripped down and raw, having to minister to Ford, placate Jean Rhys and take charge yet again of their domestic and financial arrangements. 'And I simply hated my role,' she wrote.

More than six months later, in January 1927, when Ford and Stella were living separately but not yet separated, she was still meeting the payments that Ford had promised to Jean. 'I do wish you would not keep so silent on that subject,' she wrote to him in New York. 'It worries me so much as you know. Meanwhile I go on with the weekly payments. That & your mother's allowance about equals the Australian money.'[75]

She gives no hint of these painful details in *Drawn from Life*. Fifteen years later she could employ an ironic tone and give an account of the affair in two brief pages embedded in an extended meditation on a woman's gaining of independence. She casts Ford's unnamed 'girl' as a talented, pretty and tragic figure with 'bad health . . . shattered nerves, an undesirable husband . . . and a complete absence of any desire for independence . . .' But even in the veiled account of the memoir there is a hint of the turmoil and shock that the affair threw her into. Jean Rhys 'took the lid off the world that she knew and showed us an underworld of darkness and disorder', Stella wrote. Although by this she meant the world of criminality and desperation that Jean Rhys knew, her words echo the poem Ford wrote as he recovered from the war in the first years of their love affair: his sense of the fragility of houses that could be so easily blasted into chaos, and her countering certainty that she could make a home that would, in every sense, be a haven from darkness and disorder. The Jean Rhys affair did indeed take the lid off her world; it showed her the shadow-side of a woman's great hopes for love. Far from providing a resolution to the conflicts she had experienced as a young woman in bringing Love and Art together, her 'deep intimacy' with Ford took her to the heart of the profound clash between the demands of her life as a woman and those of the harsh taskmistress of art.

※ 7. WHEN THE AFFAIR ended, Ford considered it but a *pic de tempête* and said that nothing would upset them again. 'But of course he was wrong,' Stella Bowen wrote with the crisp authority that comes with hindsight. 'The desire for freedom was already beginning to work in me, and what he really needed was another mate.' But the mere fact that Ford could be so cavalier in his return to her indicates that it was not like that at the time. Perhaps it is because she made her way inch by inch until something had crossed over in her and she was indeed independent, that *Drawn from Life* is so compelling. As I say, it takes re-reading to realise how carefully constructed it really is. Nevertheless, what Ford failed to understand when he broke her trust was that the qualities that had drawn him to her in the first place—her courage, her intelligence, her engagement with life—were precisely those that would take her away from him. When Ford had told her that she rested like 'a precious and crystalline egg' in the palm of his hand, she had been too young, and too much in love, to heed the warning implicit in the image—that while the egg may well feel itself to be safely held, a hand can close on it, or simply lay it down.

'Why did not my godfathers and godmothers in my baptism, and my copybooks at school, and my mother when she tried to explain the facts of life, all tell me, "You must stand alone?"' she wrote in her memoir, some fifteen years after Ella Lenglet had turned up at the *transatlantic review*. 'How dare parents encourage their girls to remain in a state of receptive idleness so that they may be ready at a moment's notice, to follow the dictates of a love affair? How can the nations afford to waste the immense volume of women's energy that is left over after the emotional life has taken its toll?'

It is with the separation from Ford that the complexities of *Drawn from Life* come into focus. Indeed, falling as it does at the centre—in every sense—of her story, the separation is a kind of driving force for its existence. It is in the nature of a memoir to present a version of events directed less at one's contemporaries—

who often know too much—than at the future. The messy figures who people our lives become characters, and haphazard living is tidied into narrative. In writing hers, Stella Bowen had learned a great deal from Ford. With consummate skill she put forward a version that would take the sting out of the humiliation she had suffered with Ford's very public affair, and at the pens of Pound and Hemingway. She didn't make a direct attack on any of the men— indeed, it could be argued that it was essential to her task that Ford came out of it well[76]—instead transforming the grand narrative of romance with which she began into the struggle of a woman for her own independence. If there is a single thread in *Drawn from Life*, it is the coming of age of the woman as artist. It is a complex story she has to tell, for the independence she achieves gains its impact from the strength of the love story from which she extricates herself. Which is why the separation, presented with bracing clarity, is at the heart of the memoir.

'After being quite excruciatingly unhappy for some weeks,' she wrote towards the end of her account of the Jean Rhys affair, 'I found on a certain day, at a certain hour, that for the first time, I was very tired—not to say bored—with personal emotions, my own no less than Ford's. This feeling recurred with greater and greater frequency until it became perpetual.

'I think that the exhilaration of falling out of love is not sufficiently extolled. The escape from the atmosphere of a stuffy room into the fresh night air, with the sky as the limit. The feeling of freedom, of integrity, of being a blissfully unimportant item, in an impersonal world, whose vicissitudes are not worth a tear. The feeling of being a queen in your own right! It is a true re-birth.'

This marvellous passage is like a clarion call reaching across the years to every woman who has ever struggled with her own disappointments in love, her own gaining of independence. Reading the letters between Ford and Stella is a very different experience. These began in October 1917 and continued over hundreds of thousands of words until Ford's death in 1939, ten years after their separation. A selection—450 pages long—from this correspondence has recently been published. There was no control for either of them in this presentation to the future. Reading the letters is a strange, rather queasy experience. The queasiness doesn't come from the inevitable discrepancies between memoir and letter so much as from

the one-sided intimacy, like eavesdropping, or bursting in on someone asleep, or in the bath.

Parting rarely happens in one go and despite the testimony of *Drawn from Life* theirs was painful and hesitant. For eighteen months Ford side-stepped the issue by making two extended visits to New York. He went first in October 1926, soon after the end of the Jean Rhys affair, for the publication of the third volume of *Parade's End*. He went back again the following year, and on each occasion was away for several months. 'He had a great personal success,' Stella wrote in her memoir of his time in New York, 'and was feted and flattered as indeed he deserved to be. For me, these periods alone in Paris served as dress-rehearsals for the time when I should be permanently alone.' But far from showing an easy passage out of love, her letters exude misery and acute anxiety. At first, she told him, she was relieved to have got him 'shipped off', but 'then I was so tired I just wanted to rest in peace. So I am really more lonely now.'⁷⁷ For the rest of 1926 and well into 1927, for months rather than weeks, her letters chart her desire to have Ford back and to continue a liaison that was still central to her definition of herself.

For two years she lived in the uncomfortable state of being a remnant of a couple, sapped by anxiety, trying to find a compromise—with herself as much as with the uncompromising Ford. For two years she juggled desires and possibilities, as if she could gain independence without entirely giving up the marriage. But the first hard truth she came up against was that with Ford away and the time she had so much wanted suddenly available, she still found it hard to paint. As she was to say in *Drawn from Life*, the ability to work creatively isn't just a matter of time, or a studio to do it in; it also depends on the right inner space. Some kind of balance is necessary between the tension, or edge, of risk, and a sufficient holding, or safety, in which to allow the imagination the roaming it needs. The way she put it was in terms of that independent ego she wanted to nurse; a relationship with herself that allowed her to slip beneath the anxieties and preoccupations and hopes that came with the weightiness of Ford.

From the letters Stella wrote during Ford's two long absences, it seems that the more she hoped for a reconciliation—that subversive longing—the less she worked. 'Our happiness seems so near & tangible now that I am nervous,' she wrote to him in

December 1926. 'If only we may really enjoy it.'[78] Wish and anxiety were fused into one. 'I'm horribly depressed & dissatisfied about my work,' she had written three weeks earlier when suffering from flu. 'I've done so little & so unsatisfactorily ... I went to the studio as usual yesterday morning ... but I could not work & it was all I could manage to keep my promise to Julie to take her shopping after lunch. So I went to bed at 4 yesterday & am still there.'[79]

That first autumn, as the reality of life without Ford confronted her, Ernest Hemingway left his first wife for the woman who would subsequently become his second. The fate of the jettisoned woman was potently before her as she watched her friend Hadley Hemingway make 'superhuman efforts to go down with a smile'. 'What is shocking,' she wrote to Ford in November, 'is to think of someone as miserable & as finished as that, with all the rage & bitterness there must be underneath.'[80] Later that month she wrote that her life had become 'impoverished' without him. 'Sort of thin.' And when she had dinner with Hadley, she told Ford that her friend had 'become quite tough & unsentimental'. Ezra Pound was moving at the time between Dorothy and Olga Rudge, who had had his child the year before, dividing his time openly to the extent that he didn't conceal it, but also rather furtively in that he didn't acknowledge, or speak of it. 'It is uncomfortable to be reminded of the Transitoryness of Human Happiness!' Stella continued in the same letter. 'Also I don't like getting into this sort of Hadley Olga Female World where everybody is a bit sore.'[81]

Ford, revelling in his American fame, kept delaying his return to Paris—there was one good reason after another, though never the real reason—and didn't join Stella and Julie for the Christmas of 1926 as planned. So they crossed the Channel alone to stay with Margaret Cole in Oxford, where George had taken up a post at the university. As Ford continued to catalogue his professional successes, Stella became uncharacteristically crotchety. 'I am bored & cold,' she wrote from Phyllis's house outside London, where she and Julie had gone on to stay. 'Cold water to drink at meals & inadequate fires ... I have just read a very bad book by Edith Wharton & am cross with it ... You are really the only person in the world that I care to talk to!'[82] 'I did not write yesterday,' Ford explained the following day, in a letter that must have crossed with hers, 'because I was recovering from the effects of that confounded party.'[83]

When Ford finally returned to France towards the end of February, he and Stella took Julie and Mme Annie south to Toulon again. In Stella's memoir the shadow of depression lifts as, reunited with Ford, she returned to work in her quayside studio which she had kept on at £10 a year as a kind of talisman. There it seemed—to her at least—that the marriage might take on real meaning again; the possibility of a union between Love and Art flickered once more, but only with the strength of an after-image. While she was working in her studio, Ford was writing longing letters back to New York.

The tinge of sadness that accompanied them in Toulon was due, she said in her memoir, to the recent death of Juan Gris. Gris did not in fact die until May, by which time Ford and Stella were back in Paris. But an impending death can be as sad, or even sadder than the death itself, as if one mourns in advance, so I don't put too much on this slip of memory. But as the state of mourning in advance can also mark the end of a marriage, perhaps the memory of Gris's impending death became entwined with the other sorrow she could feel but not yet name.

Reading Ford's letters to Stella with the advantage of hind-sight, it would seem that despite his protestations to the contrary, he'd begun to leave the 'marriage' on that first trip to New York. Perhaps he sensed an aspect of the relationship had already passed. After a bad night with his chest, he wrote a moving tribute to her, and yet the letter makes no link to the present or future: 'I thought I might die & never have put on record all you have been for me & done for me,' he wrote. 'So, as this is a quiet moment I'll seize it and say that if I've done anything during these last years & if I <u>am</u> anything it has been entirely due to you & never for a moment have I wished that we were not united & never at any time have I had anything against you. I do want to say this—& I'd want to have it published when I die—so I write it & keep it & publish it when I am dead. You have been the most splendid of human beings in the dreadful times we have been through together & all that I am I owe to you & to you alone.'[84]

It is a declaration that she never made public. But the following year he included some of it in a preface to a new edition of *The Good Soldier*, which Stella had read on Pound's recommendation long before—before Violet's house party, before their deep entanglement. 'What I am now I owe to you,' he wrote there. 'Without your

spurring me again to write I should never have written again.'[85] It is a tribute to Stella as muse, which is a very different thing from a tribute to her as wife. Ford was the sort of man who liked to be entranced, and he wrote well under that provocation. But he also needed the services of a reliable wife or he could not write at all. The problem was that the two roles could not be held for long by one woman; inevitably they split. When Stella realised this had happened, she was determined not to repeat the pattern of Violet Hunt and Jean Rhys. 'Don't let me become a "bogie" for you . . . I should hate that!' she wrote as they separated, 'so do try to think nicely of me, I have been so proud of my connection with you, and I have got my darling Julie out of it, not to mention a wonderful education in life!'[86]

Although Stella never made Ford's letter public, privately she told him that it would be her 'absolutely most treasured possession' and it was safely with the correspondence she would leave for Julie when she died. Her own public declaration came in *Drawn from Life*: 'In spite of the discrepancies, or perhaps because of them, I think our union was an excellent bargain on both sides,' she wrote as if in conclusion. 'Ford got his cottage, and he got the domestic peace he needed, and eventually he got his baby daughter. He was very happy, and so was I. What I got out of it, was a remarkable and liberal education, administered in ideal circumstances. I got an emotional education too, of course, but that was easier. One might get that from almost anyone! But to have the run of a mind of that calibre, with all its inconsistencies, its generosities, its blind spots, its spaciousness, and vision, and its great sense of form and style, was a privilege for which I am still trying to say "thank you".'

It is an astonishing summation, and if it comes to us in the crisp, resolved voice of the memoir, its generosity is not undercut—rather the reverse—by knowing something of the private story.

It is in the letters that we glimpse the misery—if not the rage and bitterness—that was *going on underneath* as she absorbed the unwelcome fact that Ford was transferring his affections and hopes from Paris to New York. 'But don't have an affair with her,' she wrote of one of his many lady sponsors on that first trip, 'because I can't bear any more Fair Hair.'[87] 'And please,' she wrote during the next, 'get finished with any too-exacting intimacies you may have formed & don't come back with any entanglements!'[88] Ford, in

response, dodged these anxieties with a continuing barrage of cheerful letters detailing his professional progress through New York. Stella had every reason to know his capacity for evasion; their relationship had, after all, begun with his long escape from Violet Hunt. 'I am not ashamed of any of it,' she told him when the relationship finally ended, 'except the initial step of taking you away from an older woman. I wish with all my heart I had not done that.'[89]

Although hesitant as she moved towards a life without Ford, Stella did not stand still during this period of 'rehearsal'. By Christmas 1926, she had given up the house at Guermantes and found an apartment and a separate studio in the rue Vaugirard, opposite the Palais du Luxembourg. She'd reluctantly turned down Whistler's old studio—'absolutely the most perfect setting for gorgeous parties'[90]—but the new apartment had room for her and Ford as well as for Mme Annie and Julie. When they returned from Toulon in the spring of 1927, Ford moved his desk there so that he could work uninterrupted; but for the rest it was hers.

'Still full of enthusiasm for the early Italian paintings,' she wrote in *Drawn from Life*, 'I had embarked on a triptych of the proprietor and personnel of the restaurant Nègre de Toulouse where I had eaten so many happy meals. This was a perfectly formal pattern done on a gold background with M. and Mme Lavigne in the middle surrounded by appropriate decorations and the waitresses grouped at the sides like a chorus of angels.'

She began this painting in 1926 and wrote to Ford about it as it progressed. Even when Ford was keeping most distance between himself and Stella, he never forgot her work. He was genuinely pleased every time she wrote to say she was painting and he must have had photos of her portfolio, for he tried to arrange an exhibition in New York. In February 1927 he told her that her portraits were attracting 'astonishing' admiration, and suggested that the exhibition be called '"The Ford Family" by E.G.

Stella Bowen,
'Julia Madox
Ford', *1927.*

JULIA MADOX FORD 1927.

Bowen'.[91] In December *Au Nègre de Toulouse* was reproduced in the *New York Saturday Review*, but the exhibition never happened. In 'Julia Madox Ford 1927', which was probably prepared for it, Julie, turned in half-profile, looks out past us with clear, serious eyes. She is neat, with splendid bows on her plaits, a solemn child, drawn with the fierce regard of a mother who knew she could not protect her as completely as she would like from the wreckage of a disintegrating marriage.

Au Nègre de Toulouse is quite different. It foreshadows the 'conversation pieces' she would go on to paint in the 1930s, and her work as a war artist in 1943. She never liked realist group portraits which she thought flattened out character by attending to individual differences of stance and attire. She preferred to do the opposite, taking a group and illuminating the contrast between their formal similarities and the individuality of their expressions. In *Au Nègre de Toulouse* the two outer panels of waitresses make a bow to Giotto as a latter-day angelic chorus; by formalising them in their uniforms she left herself free to evoke individuality in their expressions. They are arranged symmetrically, with M. and Mme Lavigne in the central panel between them. Without meeting each other's eyes—or ours—the patrons of the café are as solidly present as donors in a stained glass window. Behind them on a high shelf is a bowl of fruit, which on its own might have served as a model for a Victorian still life. Also on the shelf above their heads are what I take to be tablecloths folded in such a way that they seem almost to float there like angel wings. 'I think perhaps it will be rather good!' she confessed to Ford.[92] It is a striking painting, indeed 'rather good', but in this first attempt her command of the form is not complete. Almost, but not quite. The faces look arranged for difference and the painting has a quality of being displayed for Ford's approval. It reminds me of Ezra Pound's maxim: 'I believe in technique as the test of a man's sincerity.'

Years later, when she could rest on a certain reputation, Stella said that sometimes she still found herself 'nonplussed before the canvases of certain modern painters through not being able to understand what they are getting at. I can recognise the hand of the master—the certainty and the quality of the paint. But I just don't see why, and this is to my very great loss.' But in one sense it was not simply a loss. After that battle with Ezra Pound in Italy, she knew that she had to avoid the prevailing taste for abstraction, and keep faith not only with her love of figurative art but with the formality

Stella Bowen,
Au Nègre de
Toulouse, *1927.*

she admired in the ancients. 'A narrow view, for a painter, has its advantages,' she also wrote. 'It concentrates his effort and his enthusiasm.' She used the analogy of the artist as traveller. By following well-worn tracks, by working with, rather than against, convention, 'it is as though the starter gets given a lift by train over the first part of his journey and is thus able to penetrate further than if he had had to walk all the way'.

When she wrote to Ford about her work, grappling with technique at this transitional moment, she said again that she wanted to achieve 'a kind of no man's land of diffused light'. In using this phrase she was referring to the impact of 'Giotto's simplicities' and the 'pure spontaneous pleasure' she'd taken in the early Italian masters. But 'no man's land' was a phrase which, after the trenches, could not be used innocently. By using the term in startling combination with quattrocento art, she was indicating, perhaps, that by leaping back so far she could find a way of escaping the bullying assertions of Ezra Pound, and yet be modern. It is also a phrase with feminist connotations, certainly by the time Stella used it in her memoir, and even if it was a retrospective realisation, she was indeed facing *a kind of no man's land* as she struggled towards a way of living—and painting— that was beyond the fall of the shadow cast by Ford. 'If I feel so far removed from painters,' the artist Marie Laurencin said, 'it is because they are men, and in my view men are difficult problems to solve.'[93]

In solving the problem of Ford, Stella Bowen also had to solve the problem posed by high modernism. The world that he had taken her into might have been a wonderful education, but it was also tough company in which to find an idiom that was appropriate both to her and the twentieth century; a way of painting that would register emotional subtlety, at once subjective and yet on a grand enough scale to be seen in the Paris of the 1920s.

Stella had recognised early that Ford was a man for whom facts had an elastic quality. He liked to create 'the effect of authenticity', she wrote, but he could make a fact, 'any fact . . . disappear like a conjurer with a card'. In contrast, Ford thought her 'hopelessly puritanical—not to say provincial—in [her] liking for factual truth'. Her impulse was straightforward: to say what she meant and to paint what she saw. But she knew that if she was to be understood as she wanted to be understood, she had to find a way of negotiating with the terms set by the men who surrounded her. There was no assumed identity for her as artist. Indeed, she was aware that her visibility, and credibility, depended in good part on her proximity to the great men, even as she carved out a space that was independent from and resistant to them. Their work might undercut the old certainties of the immutable self with their play of irony and formal self-consciousness, but the paradox for Stella, if not for them, was that for her there was an emerging sense of a self that had firm things to say. But as with Lily Briscoe, what she meant and what she saw and how she understood herself as a woman and an artist were not so easily expressed.

She knew, or was coming to know, the harsh reality of living with a man like Ford, and she knew what lay beneath the strategies of language he employed. What she did not know—not yet, not fully— was what she might be when she no longer saw herself through the eyes of Ford. He had the capacity to imagine on a grander scale than he could see, but she had the capacity to hold a steady gaze on what was. She had the patience to wait, and to look. During those two years when she was holding on to Ford even as she was letting him go, her achievement was not so much that she accepted what was happening, as that she began to see with the double vision of the woman who is artist. Just as she was engaged with the fading drama of her union with Ford and yet finding herself in the distance she gained from it, so she was in a position of working with the liberated language of the

self that Ford and Pound had introduced her to, at the same time
knowing herself to be at a critical distance from it. 'Clicking in and
clicking out' was how Virginia Woolf put it.

'I have done 5 portraits since you left,' she wrote to Ford in
October 1927, when he was back in New York. 'I guess I must pull
up a bit & try to get some fun.' She had also 'got off 8 drawings to the
frame makers'.[94] In November she finished a painting of a bouquet
of flowers and told Ford she had a model coming 'because I want
to try my hand at a nude, just as an exercise'.[95] *The Bouquet* is another
painting we have only in black and white. It is a curious compo-
sition, in which a dramatic bouquet of large flowers (whose colours
we can only guess at) rests like a large heart on the lap of a woman.
The woman, whose upper body we do not see, is wearing a tasselled
stole, and gloves with elegant, turned-down cuffs. It is an intensely
feminine painting in a slightly self-conscious way, yet here, as in *Au
Nègre de Toulouse*, the future hovers. It foreshadows other paintings
from this period of separation in which she shows only
a part of the female body,
and hands, ungloved, were to
become a determining motif
in her paintings of uncaged
femininity. But it was not until
the nudes and self-portraits
that came in the aftermath of
the separation that she would
make the shift from seeing
herself in the reflection of
Ford's eyes to looking through
to the mysterious otherness not
of modernism, not of men, but
of her own nature.

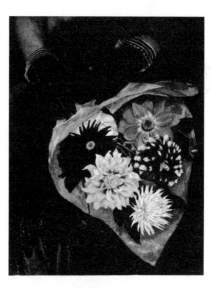

Stella Bowen,
The Bouquet,
1927.

By the autumn of 1927,
during Ford's second absence,
Stella's letters became more
concerned with her own work than with his and at last show signs
of the boredom that the memoir represents as coming so fast. As she
began to paint herself out of the corner she was in, finding herself
in the silence of her studio, a note of exhilaration and pleasure in
work enters the letters, and also a note of irritation. She stopped

addressing Ford as 'Darling' and asking anxious questions about his emotional life. 'My dear', which she substituted, has a distinctly different connotation, especially in reply to letters that still addressed her as 'Darling'. It does not strike me as accidental that it was during these last months of 1927 that Ford began to firm up a love affair in New York.

The extent of the change in Stella could not have been lost on him when, in October 1927, she dropped this request into the letter about the five portraits she had just done: 'I would like to ask you not to envisage using your bureau here in the studio in any way for the *review*. Since I've been working here hard, regularly, I realise how much I count upon being quiet and alone in the studio.'[96] It is an extraordinary moment, coming late in a correspondence that runs for hundreds of thousands of words, between a man who never doubted his right to whatever working conditions he required, and a woman who by her own admission was for years more preoccupied with his needs than her own. To my mind, this letter is as triumphant and as bracing as the passage in the memoir that celebrates the feeling of being a 'queen in your own right'. Perhaps even more so, for it comes in a sequence of letters redolent of the grievous loss that is involved in surrendering a long love and casting oneself on the world not only as an artist, but as a woman alone with a child.

Stella at Argenteuil, Monet's village outside Paris, just after she and Ford separated.

8. WHEN THE END came, it came fast. Ford arrived back in Paris in the spring of 1928 and put it to Stella that he divide his year between her in Europe and his new love, Rene Wright, in New York. Stella declined the offer. 'The complete camouflage would be impossible to me,' she wrote in an exemplary letter of separation. 'There must be an absolute and public break between us. I shall therefore tell people . . . we [have] mutually agreed to separate for good. I cannot make up any tale of having "chucked you out", nor will I use the word "divorce". . . My reason is not because I want to make difficulties for you and R., but because it seems to me undignified and ridiculous, when everyone knows the truth, and when Violet has so exhausted the topic of her marriage or non-marriage to you.'[97]

This was not a reference to the beginning of their liaison, but to Violet's recent and rather scurrilous memoir which had been published by the same American publishing house as the *Parade's End* novels while Ford was in New York. Where Stella had once had to face Violet over a gate, now, as the man they had shared was leaving her, she was confronted by the public spectre of the aggrieved and angered woman she had displaced. It was a position she was uncomfortable with—and felt herself uncomfortably close to. 'It was the revolt against a false position that made me feel savage,' she wrote in her letter of separation, admitting that she, too, was capable of anger.

Violet Hunt gave the American edition of her memoir the splendidly menacing title *I Have This to Say*,[98] and it was indeed a weapon. Casting Ford as a philanderer and moral coward, she relied on an always reliable interest in gossip to cash in on his publicity and say what she had to say. 'The dirty cat,' Stella wrote in response to Ford's dismay, which was made 'excruciatingly more disagreeable' by Rebecca West sailing into New York. 'She has told several people,' he wrote to Stella, 'that V. H. is an admirable & martyred saint & that every word of the book is true.'[99]

Violet was cleverer than Jean Rhys, whose vengeful and savagely self-lacerating *Quartet*—also published while Ford was in New York—sabotaged its attack by representing love as without meaning, thereby magnifying her own abjection. Violet, in contrast, enlisted a narrative strategy Ford himself was a master of. What makes a man? she asked. What makes an artist? Inverting his scale of values, she set about undermining him not as an artist but as a man. She was quite happy to acknowledge his 'genius', placing him among the pantheon of writers and artists, a move that strengthened her own position by association. But she then neatly undercut him by detailing his failures as a man in the face of love. Love, in her view—which she invited her readers to share—was an ideal greater than Art. The implication was that writers who understood love were not only better men but also greater artists. With maximum publicity she established herself as a martyr to Love, and her memoir as the trial and judgment of Ford Madox Ford. 'Of course,' Stella wrote to Ford when the book came out, 'recalling so publicly her relationship to you is a pretty good way of getting back on me.'[100]

It was indeed a 'battle of the books'.[101] Ford had already shafted home his hatred of Violet as well as his love for Stella in the first volume of *Parade's End*. 'If you wanted something killed you'd go to Sylvia Tietjens in the sure faith that she would kill it; emotion, hope, ideal; kill it quick and sure. If you wanted something kept alive you'd go to Valentine Wannop: she'd find something to do for it . . .'[102] And in one of his least successful novels, *When the Wicked Man*, published in 1932, he portrayed Jean Rhys—who had made another assault on him the previous year in *After Leaving Mr Mackenzie*—as the drunken and abusive Lola Porter. More cunningly, he used the next volume of his memoir to regain the terms of the debate set up by Violet Hunt.

In *Thus to Revisit*, his memoir of 1921, he had already put his position that the value of a man was not to be accounted in his dealing with women, with love, or even with life, but in his constancy to Vocation. Vocation was an ideal greater than Love, and the greatest vocation was that of the artist—followed closely by the soldier. According to this logic, it was by his constancy to Vocation—and therefore to Art—that a man like Ford must be judged. The public accounting of a life, in other words, was to remain in the realm of the public. 'To report the details of private history, affections or intimacies,' he wrote, 'is usually infamous—unless, like

Boswell, you should be paying public tribute to a figure whom you have much loved.'[103] By this, of course, he did not mean the women he had loved. On the contrary, he wrote, 'art must be an exact, not an intoxicated, occupation, and Artists must be selfless'.[104] To be selfless, in this view, meant the effacement of the self by the rigorous application of the intellect. Personal life—the way in which one might eat one's lunch, for instance, or discard one's lovers—was neatly ejected from the legitimate concerns of Art.

In *It Was the Nightingale*, the next volume of the memoir which was published in 1933, Ford made a move worthy of Mr Tansley. He reminded us of his 'contempt for novels written with a purpose' and confined himself to writing about Vocation. Because his dedication to Art meant the rendering of only certain sorts of experience, he could confine the display of feeling first to the war, and then to literary life. So scrupulous was he in his avoidance of personal detail that we are led to believe that he was quite alone in Harold Monro's villa above the Villefranche harbour, and even at Red Ford as he adjusted 'the flavour of garlic'.[105] In Paris he placed himself alone at every address we recognise as also Stella's. But at least he gave her the tribute of that preface to *The Good Soldier*. His public revenge on Jean Rhys and Violet Hunt was not only to refuse personal knowledge of them, but to ignore their work—an omission that wounded them both. The memoir is full of Ezra and Hemingway and Joyce, even Proust (who had died in 1922). Gertrude Stein and Katherine Anne Porter get a mention, but not Jean Rhys and certainly not Violet Hunt. The implication, which did not need to be spelt out, was that writers who, like them, give way to the display of emotion—who 'hate', or write 'to a purpose'—have little capacity for Vocation, and therefore for Art, as they lack discipline, become bogged in the personal and marooned in the shallows of Love.

During the course of his love affairs with both women, Ford had in fact taken up and promoted their writing, just as he had encouraged Stella to paint. In expansive mode, when his own powers were not compromised, he was generous indeed; challenged, he was not. In *Thus to Revisit*, he had said rather proudly that artists would by their nature—by which he meant their self-appointed privilege of masculine irresponsibility—'commit acts of immorality and end in the Divorce and the Police Courts'.[106] It was reasonable to land up in court, but not to be landed in a memoir, and a woman's memoir at

that. The final twist in his memoir was to claim for himself and deny to them the lofty terrain of high modernism, where men could give their lives, as he had done, not only to the Vocation of Art but to the Transformation of Art. That was the fidelity, the sacrifice, that made a man a Man—and art Art. And made him Ford Madox Ford.

'Our modern masculinists,' Virginia Woolf wrote at about the same time, 'Tho' they flatter us, they despise us.'[107]

There's a certain enjoyment to be had, I suppose, in reading the savage furies of Violet Hunt and Jean Rhys. But beyond the momentary frisson at the sight of a man unmanned, it achieves little, for the woman is left as victim, the passive object of another's desire—or lack of it. Despite that frisson—or because of it—I read their books with a curious sense of shame, and also an edge of fear. Perhaps Stella did too. Shame at the laying bare of feminine masochism; fear of the vengeful feminine. Stella Bowen knew the underside of femininity, but she never indulged its display. And vengeance went deep against her grain. While there are discrepancies, a sort of tidying up, between the letters and the memoir, there is little distortion. What strikes me, reading her—letters and memoir alike—and looking at her paintings, is that there is rarely a false note. In that letter asking for a clean and public break she made no rebuke: 'I can't face the world unless I may tell people something like the truth or be silent! If pushed, I might say that your interests seem to have shifted so much to New York, that in any case you do not propose being much in Paris, and that I have asked for my freedom, rather than to continue on the terms you offer. On your side you might represent me as having become impossibly independent.'[108]

Of all of the combatants in this literary war, Stella Bowen alone saw the demands of life and the demands of art as complex and conflicting, each with their own validity, embroiling men and women in very different ways. While *Drawn from Life* is in part a narrative of her shift of allegiance from Love to Art, it is also an act of resistance to the opposition that sets one against the other. It is her answer both to Violet Hunt's paean to Love, and to Ford's apologia for Vocation.

If nothing else, Stella was thoroughly practical. The possibility of combining creative independence and intimacy with the great male artist, or a greatly loved man, which she had tried to achieve in Paris, hadn't worked. Given the imbalances, it couldn't. She wasn't going to drain away the rest of her life as the discarded woman when

there was work to be done and another life to be made. 'I am told,' she wrote in *Drawn from Life*, 'there is enough water-power running away in England to give us all free electricity, if the influence of vested interests did not prevent it being harnessed. I believe that woman's powers—her two eyes, her two hands, her ears and her brain—are running to waste because vested interests have got a mortgage on love.' It was not simply face-saving bravado when she suggested that Ford might represent her 'as having become impossibly independent'. In the hyperbole of Violet Hunt and Jean Rhys, the lubrication of the fine machine of Ford cost them their lives. In Stella Bowen's writing, the cost can be counted in the haphazard record of the correspondence; the profit was written in the memoir: *the run of that mind*.

If that was all, it would be a simple equation. But 'bravery', as Edith Sitwell told her, 'is a great trap as well as an asset'. And in this equation of profit and loss there is something missing, and that something is expressed—or is to be found—in her paintings. The memoir was written with the wisdom and strategy of hindsight; the letters with the pain and strategy of relationship. That there was a tension between the two—between the refusal of the memoir and the experience of the letters—expresses itself, it seems to me, in two extraordinary images, *Figure Study* and *Still Life with Part of Me*, which she painted while Ford was in New York and she was embarking on her impossible independence. Two paintings of the female body, one clothed, one naked, cropped at the mouth and thigh; bodies without faces. In both, the female torso confronts us without any of the niceties or avoidances of facial expression, without eye lines, and without the comforting context of background or surrounds. The nude is sliced through the lips. The down-turned mouth of the clothed body is visible, but without eyes that mouth too is eloquently silenced.

I have only seen these images in black and white photos; the originals are among the lost. The photos were sent to Tom from Paris and have been kept by his daughter, Suzanne. You can imagine my astonishment and delight when I came across them in her files. Stella sent them to Tom as she prepared for her first solo exhibition, held in Paris in 1931, when Suzanne was a child. It's not clear when she started sending photos to him, although most that are still in Adelaide date from the years of the separation. Perhaps it was

because of this rupture that she felt herself drawn back to her connections in Adelaide and wanted her work to be known there, at least among family and friends. Where the originals of these two paintings are, we don't know—and it's not as if there hasn't been a raft of people on the look-out. Ironically, the fact that we know about them raises the impossible question of what else is lost that we know nothing about. Without them the story I could tell would be quite different.

As well as being a pair in themselves, the two cropped images also pair a *Reclining Nude* (plate 6) and the *Self-Portrait* (plate 7) with which I began this book. These two paintings, which are safely in Adelaide—one with the family, the other recently given to the Art Gallery of South Australia—also date from the separation and were exhibited at her 1931 exhibition. The clothes in *Still Life with Part of Me*—an elegant rendering of bohemian Paris—are sufficiently close to those in the *Self-Portrait* to assume shared tones, the same darks and ochres, the same brilliance of creamy white at the collar. In this case the known colours of the one, it seems to me, are a guide to the unknown colours of the other. With the nudes there is also a link. Although it's impossible to be sure, the model—judging by her hair and her nipples—may have been the same; the curtain or drape behind the *Reclining Nude* has a similar pattern of stripes as the rather richer fabric, or curtain, that is nipped in to follow the contour of the cropped nude's body. Perhaps she was the model Stella told Ford about in November 1927, just months before the separation was finally acknowledged.

The *Reclining Nude*, which has much the same palette as the self-portrait, is conventionally composed; the body is angled and the gaze diverted in an allowing reverie, so that we, her audience, can look undisturbed—which is how it usually is with a nude. With the black-and-white *Figure Study* it is less a nude we are faced with than the body of a naked woman—which is quite a different proposition. How many other nudes present us with the body, bumpy and uneven, of an actual woman? For this is how it strikes us, as if it really is a photo we are looking at. She is lit from one side with uncompromising contrasts; there is nothing diffused about this light. Without a face, this is the female body in its rawest form. Here, it seems to me, is the note of anger that is missing from the memoir and the letters.

Stella Bowen,
STILL LIFE WITH
PART OF ME,
c. 1927.

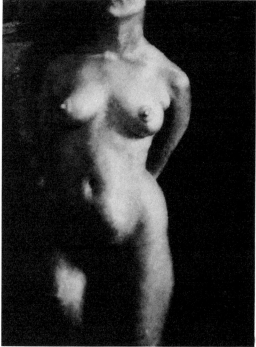

Stella Bowen,
FIGURE STUDY,
c. 1927.

Are these cropped bodies of femininity, if not Stella's rebuke to Ford, then the shadow of impossibility in the independence she fought for? Can the nude be read as the sacrificial body of the woman? With no face, no identity, cropped literally through the lips, does it pose itself as the body that is used regardless of the mind or spirit? Take this, Ford Madox Ford, for this is what you take. Possibly. And yet it is not an image of abjection in the mould of Jean Rhys. I am not convinced by the idea of this nude as Stella Bowen's version of the Violet Hunt and Jean Rhys rebuke.

Still Life with Part of Me also invites us to absorb the full impact of the woman as artist: the artist with a woman's body. When the photo arrived in Adelaide this was the title, but in the catalogue to her 1931 exhibition, it is listed as *La Palette*. The title for the exhibition is not exceptional, and draws attention away from the faceless woman to the palette. The other title is both more interesting and more confronting. The palette provides the element of still life, which is not usually a confrontational genre. Yet the brushes fan out like arrows, sharp and spiky. With the smock open to the vulnerability of the chest, and the palette held beneath the breast, this painting seems to ask if the task of the woman as artist is as much an endeavour of the heart as of the implements she holds. Without eyes for guidance or balance, the heart might seem to overwhelm the woman; but as the ambivalence of the palette suggests, no artist is born only of the heart. Is this the question that severs the self-portrait at the mouth, as if, in possession of a palette, the woman who is reduced only to a part of herself isn't sure how to face the world?

'I see grief on a large scale,' Edith Sitwell wrote to her at the end of 1928. 'Remember, dear, you have not lost the battle. Because you really *have* got something out of life; and you have created yourself. You have your child, you have your beautiful nature, and your understanding—the last two are largely, though not entirely, brought to their perfection by what you have suffered. It has not been in vain.'[109]

When Stella Bowen did show her face to the world and called the result a *Self-Portrait,* her eyes are steady. Though the earrings remain the same, this isn't the chic young woman caught by the camera; it is the portrait of a woman whose heart is exposed without the shield of the palette, and whose eyes are no longer hidden from herself. Painted as she separated from Ford, or just after, it is an

image that acknowledges the pain of parting but refuses to be reduced to it. There is a great deal of hurt and a certain angry pride. Light falls on a face that does not smile; the sombre smock is tied across the brilliance of cream and ochre; a brooch holds the collar of the blouse closed at the neck. Her eyes, tinged red, meet ours in a challenge which invites not the admiration of the world but its attention. This, they say, is the condition of the woman as artist. Woman? Lover? Mother? Artist? The distinctions are false. A woman is all of these, and reduced to none. To be an artist is not a matter of surmounting, or refusing, or even of juggling, but of bringing the values and knowledge of heart and belly into the work, into the image, into the paint. Double vision. Double task.

The great achievement of Stella Bowen in these four paintings reminds me again of the moment in Rilke's *Requiem* for Paula Modersohn-Becker when he came to see the magnitude of the moment in which a woman lets herself inside her own immensity *and didn't say: I am that; no: this is.* Stella Bowen, like Paula Modersohn-Becker, does not say *I am that.* Instead: *This is.* The distinction is slight—and vast in its connotations. It is not the statement of the woman who says 'I have been reduced to that', but of the woman who can enter the experience of her own life and dwell there without defence or denial, the woman who can hold a steady gaze and say 'this is the condition of my life'. *This is:* a statement, seemingly simple, that Rilke came to recognise as the essence of art. Not the transcendent gesture, but the naming of things 'more intensely than the Things themselves ever dreamed of existing'.[110]

It is easy enough to see what Stella Bowen meant when she said that her deep entanglement with Ford had been 'a wonderful education'. When one looks at her early work, like the barn with its uncertain composition, and then at the work that came in a burst of activity during those years of apparent disaster when the relationship collapsed, one can see at once the distance she had travelled. She was not yet forty when she painted her *Self-Portrait,* which could be said to be young to have produced an image which surely stands as one of the strongest statements of a woman grappling with precisely the conflict she was daily experiencing as she struggled to give both art and love their due. But when I consider that *wonderful education,* that *excellent bargain* and then look at these intensely feminine images, the next question that arises is what else went into the

making of them. What feminine inheritance? There is something at play here that is not Ford, not Pound, not Juan Gris, and certainly not Wyndham Lewis.

Would she have seen the work of Paula Modersohn-Becker? Or Gwen John? Or Marie Laurencin?

Paula Modersohn-Becker died in 1907 and during her lifetime sold only one of her 259 paintings. I have no evidence that she was exhibited in Paris while Stella was there. At a tangent I can say that there is a curiously strong connection between a later German hyper-realism and two paintings that Stella did during those years of separation. The stark image of a young man slumped over a table, another of soap bubbles on a similar table, and a third of chairs on a moonlit balcony have, it seems to me, echoes of Max Beckmann or

Stella Bowen,
UNTITLED,
c. 1928 (left).

Stella Bowen,
UNTITLED,
c. 1927 (right).

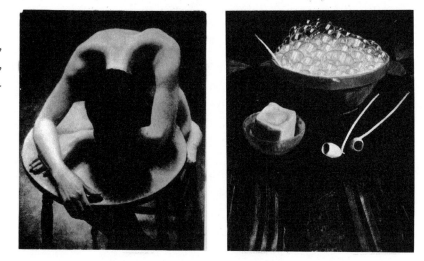

H.M. Davringhausen, and are unlike anything she did before, or later. She sold two of them and sent the photos to Tom. They don't suggest a connection to Paula Modersohn Becker, but they do indicate that her education was not confined to France, or to Ford.

Links between Stella Bowen and Gwen John or Marie Laurencin are easier to make. Both artists were exhibiting in Paris while Stella was living there, and as Marie Laurencin knew Gertrude Stein, Stella would at least have been aware of her. She may have been afraid of entering a female world where everyone was *a bit sore*, but

there were formidable women at work in the Paris she'd entered with Ford; a feminine underbelly to the modernism from which she'd taken her first lessons. Natalie Barney came to their parties. Djuna Barnes was published by Ford. Nina Hamnett found the studio in the rue Notre-Dame-des-Champs for them. Edith Sitwell, whom Stella painted for her 1931 exhibition, became a close friend. This portrait, also only available to us in black and white, shows a woman whose bearing is assured yet slightly slumped. Confidence and uncertainty, grandeur and modesty are held in measured tension; the mirrored image of the back of her head shows the vulnerability—the thin hair and unprotected neck—that is not so evident in the bearing of the face. But it is the magnificent hands, clasped on her knee, that make the portrait; that is where Edith Sitwell's queenly powers reside.

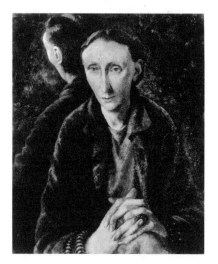

Stella Bowen,
EDITH SITWELL,
c. 1926.
'The sweet voice, the almost exaggerated courtesy and the extreme sensitiveness to other people's feelings, were so immediately winning that we all took her to our hearts at once.'

When Stella painted her friend, would she have known that Wyndham Lewis had also painted her, slightly earlier, in 1923, when he was cast back into figurative and portrait work because his abstract canvases weren't selling? Would Edith Sitwell have reported that his portrait (now in the Tate Gallery) reduced her in every way, showing her small against the frame, diminished in turban and elegant robes as she looks calmly down at her book? Would she have told Stella that her hands were not there at all, obscured in an abstract pattern of sleeve and book?

'I get from cubism the same feeling that a book on philosophy or mathematics gives me,' Marie Laurencin said in 1923. 'Aesthetic problems always make me shiver. As long as I was influenced by the great men surrounding me I could do nothing.'[111] This is a far cry from Gertrude Stein's famous claim on masculine privilege when she said that 'Pablo & Matisse have a maleness that belongs to genius. *Moi aussi*, perhaps' (although even she kept this opinion to her notebook).[112] Marie Laurencin, who had been the mistress of Apollinaire and had divorced her husband, made a living and a reputation through the extreme femininity of her work. Her enigmatic figures, all pastels and pale tones, offer an alternative modern sensibility, a femininity that invites the interest of the world even as it holds itself apart.

Stella shared with Marie Laurencin an interest in character and figure, but her aesthetic was starker, without the rather soft-focused beauty of Laurencin's highly self-conscious feminine canvases. She didn't share the ironic sensibility of the Marie Laurencin who said 'love interests me more than painting'.[113] But she would have seen in her a woman who lived—and lived well—by her art. In the Paris of Picasso, Matisse and Braque, no woman could hold her own in avant-garde critical opinion, but Marie Laurencin's insistence on the femininity of her painting had the confusing effect of demoting her critical status and at the same time boosting her sales. 'It is easy to be charmed by the work of Marie Laurencin,' Stella Bowen wrote in 1934 when she was working as an art critic in London. 'Almost too easy . . . These are pictures to be glanced at, not dwelt upon!'[114]

Across the Channel there was Vanessa Bell, a woman Stella admired for the fluidity and freedom of her work. Her friend Nina Hamnett knew her and Stella would almost certainly have seen some of her work when it was exhibited with London Group shows during the war. By the time Stella was preparing for her own exhibition, she had given up the broad brush strokes and roughness of paint she had learned in London. 'For years,' she wrote in her memoir, 'I could not feel any virtue in a picture done in thick opaque paint, or with undefined edges.' But like Vanessa Bell, she maintained a tension between a consciousness of paint as paint and close attention to the emotional reality of the subject of the portrait. Their female figures—alone, lost in thought, transported into themselves—share an idiom of ambiguity and inner struggle. But

Stella's mature awareness of Vanessa Bell was not to come until she returned to London in the 1930s.

Of all the feminine models Stella would have known in France, perhaps Gwen John—who shared a patron with Marie Laurencin—is closest to the mark. Once a mistress of Rodin, Gwen John was living in seclusion outside Paris while Stella was in Montparnasse with Ford, but as she held herself aloof from the expatriate world they inhabited, it's doubtful that Stella would have met her. However, as she exhibited at the Salon d'Automne and the Salon des Tuileries during the early 1920s, Stella would have had the chance to see her work. Stella's palette is more robust, her use of colour is bolder and her tones are less misty, but the interiority of Gwen John's portraits resonates with hers: that sense of a woman's engagement with her own painful story. Stella never removed her female figures —or herself—from the world as Gwen John did; but she too allowed the figure to fill the frame and the face to express the tension of feminine existence while countering it with the sureness of her composition. 'As to me,' Gwen John wrote in an undated letter to a friend, 'I cannot imagine why my vision will have some value in the world—and yet I know it will . . . I think it will count because I am patient and *recueilli*, in some degree.' 'Don't you think that French word is beautiful,' she wrote in another letter. 'It means I think to gather in, to be collected.'[115]

Were these the influences that Stella Bowen gathered in as she lifted her eyes to the world and painted the self she had brought into being in her studio? Was this the education she found for herself despite Ford, a necessary counterweight to the masculine moderns who had been her mentors? For the sting in their *wonderful education* was that exactly as she—and the women artists of her generation— had shed the clothes of the last century, so to speak, and were able at last to investigate their own unclad subjectivity, they were in danger of being eclipsed by a masculine avant-garde which had claimed the century in the image of their own troubled consciousness. There was no easy answer to the way a woman might present herself to this world as an artist who could be taken with sufficient critical seriousness, and yet remain true to her own experience.

'I love and adore Paris,' Stella wrote in her memoir. 'I love the way its quick and brilliant life runs openly on the surface for all to see. Every face in the street, every voice, every shape, is hard at it,

telling its story, living its life, producing itself.' But in the seclusion of her studio, as she prepared for the exhibition that would at last show her to Paris, it was rather different. As she struggled with the ambivalences of her own heart, she could take courage from the women around her, she could find a holding structure in the early Italian masters whom she could render modern as she resisted the tumult of modernist Paris; but alone in the quiet of the studio with Julie at school and Ford in America, the immediate reality was none of these things. It was the smell of paint, colour as it was squeezed from the tube, texture and the shine of light on canvas; it was the ability in herself to join with her materials. It took ego to get into the studio, a sense of worth that allowed her to leave the demands of Ford and the worry about their relationship outside the door; but once in the studio, it took surrender, a paradoxical lack of ego, to allow the painting and the act of painting—the materiality of the task—to be brought into unity in the midst of fragmentation.

A provincial in Paris, a woman in a man's world, at a moment in her life when love and art seemed most at odds, Stella Bowen produced a self-portrait calm at the centre of immense contradictions, flooded with feeling, given over to thought, the imperturbable statement of the woman who knows what it is to be perturbed and yet can say: *This is*. It is a portrait that puts her in the company not of Violet Hunt or Jean Rhys, or even of Ford Madox Ford, but of Paula Modersohn-Becker, or Virginia Woolf at a moment such as this when she wrote that 'there rises somewhere in my head that queer, & very pleasant sense, of something which I want to write: my own point of view'.[116] It was not that Stella Bowen achieved some kind of fancy balancing act between a self-effacing femininity and a striding masculinity, or even that she resolved the conflict that had been part of the baggage she had brought across the world as anxious for Art as she was for Love. Rather, through living deeply both in her love for Ford and the independence of her art when she reached it—and claiming life in both—she transformed the question that had begun as not belonging anywhere into learning *not to be a stranger*.

'On the day of my *vernissage*,' Stella wrote of the exhibition which opened on 15 May 1931, and in which she tested herself without the support, or even presence of Ford, 'I was told to bring my pictures to the gallery at 8.30 am where the unshaven dealer, a

cigarette hanging from his lower lip, stood them around the stained and empty walls and cocked a cold eye upon them. In the grey light of that rainy Monday morning they looked absolutely awful. I could not imagine how I had ever had the effrontery to try to take up painting as a profession and I helped the dealer hang that show in a mood of the blackest despair I had ever known.' At the Galerie Barreiro in the rue de Seine that morning, they hung twenty-five paintings. Both the self-portraits and nudes were there, as well as the portrait of Edith Sitwell, and one of Ford. There were six other, un-named portraits, a mask held by Edith Sitwell, *The Bouquet*, a glacier she'd painted on a quick visit to Switzerland in 1930, and five paintings, each listed simply as *Une Fenêtre*.

'At midday I got home to find that Phyllis [and her new husband Aylmer Vallance] had arrived from London and they comforted me with drinks and with love. At three we were back at the gallery and there was a big bouquet of flowers from someone and all of my friends turned up and were lovely to me. By the end of the day my morale was sufficiently restored to enable me to listen with profit, humility and pleasure to the serious criticisms of my painter friends . . . Pavlick saying *vous avez quand même une certaine honnêteté* was more flattering to me than any jam, and what is more, I sold one-third of all my pictures despite the slump . . .

'That night we had a grand party . . . For the moment every-thing was fine and dandy.'

9. WHEN FORD AND Stella separated there was, inevitably, the question of who would live where. For a while it was averted as Ford, pining for New York, went back there when Stella refused his offer of a three-way part-time relationship. But by the end of 1928 he was in Paris again, this time with Rene Wright, and they moved into the smaller of the two studios that Stella had rented in his absence in the rue Vaugirard. It was an arrangement that suited Ford, but the proximity was too much for Stella, who tramped the streets again, joining the queues until she found somewhere else for her and Julie to live. 'He made a great scene the night before I came away,' she wrote to Jenny Bradley (who was married to Ford's literary agent and had become a close friend), 'on the grounds that my moving out of 32 was not giving him a fair deal & he would not be able to see Julie so much & that therefore I must let him take her to America... So you see it's all a hateful mess.'[117]

Stella had found a large and beautiful space in the rue Boissonnade. It was perfect—or she could see that it would be—but empty. Knowing it to be a risk, she took a deep breath and hired an architect to convert it into living quarters for her and Julie—Mme Annie had married and departed—as well as a studio where she could take her commissions, and a separate flat that could be sub-let. In the process, she said, 'I must have been one of the last of the thousands of foreigners to be despoiled in a big way by a French landlord.' She signed for six years while rents were still absurdly high, and got no relief when the depression brought them crashing down. Worse, she used the last of the untied capital that was due to her from Australia to convert the apartment, and then the architect charged her more than twice the quoted price. Edith Sitwell, who had admitted herself 'worried' by this financial move, had nonetheless agreed that it would prove a good investment—and so it should have, had Stella not been confronted with an impossible bill at an impossible moment. The fact that the architect had assured her that his estimate would not deviate by more than ten per cent

had no legal bearing; her lawyer seemed to be more on his side than hers.

In economic terms it was a disaster. Emotionally it was necessary. 'It was to symbolise,' she wrote, 'the new independent life I was building out of the ashes of my life with Ford and provide the necessary background for an ordered existence.' As with so much else in her life, risk was bound once again into adventure, and danger was entwined in every hope for rest and security. Nevertheless it was there, in the rue Boissonnade, while she tended her bruised heart, that she did much of the brilliant burst of work that went into her 1931 exhibition. 'A fresh corner in your life,' Edith Sitwell called this move.[118] A young American woman working for *Vogue* took the second flat and proved a good friend as well as a good neighbour. She, Stella and Julie ate meals together on quiet nights; only very occasionally—as on the night of the exhibition—did they throw open the doors for a party and dance. For the rest, Stella lived quietly, relying on her women friends for ballast as she brought herself into focus as an artist. 'All impossible love,' James Hillman says, 'forces upon us a discipline of interiorising.'[119] Some of her finest paintings came with this ambivalent taste of freedom, this first surge that was sublimation and release, both. She captured something of the mood of her life at the rue Boissonnade in a view from

Stella Bowen, THE VIEW THROUGH JULIE'S ROOM FROM THE STUDIO, RUE BOISSONNADE, *c. 1931.*

her studio through Julie's room to the verandah. Slatted blinds hide the street from the ordered, rather enclosed life inside, but light pours beneath the slats as if to remind her of the world from which she was temporarily in retreat.

After the painfully cropped images she had painted while Ford was in America and the profound statement of the self-portrait, she began to paint friends and the domestic spaces she, and they, inhabited. 'I painted various interiors,' she wrote of this time, 'which

Stella Bowen,
FROM THE RUE
NOTRE-DAME-
DES-CHAMPS,
1925.
'We did not know
that we were
building castles
upon sand.'

always turned out to be pictures of windows. I loved painting windows and I loved painting hands.' In a view from the rue Notre-Dame-des-Champs, which she had painted, I think, just before Ford made his first trip to America, we look through a window onto a grey, wintery street, bordered on one side by apartment buildings and on the other by a garden square. The window opens out, and the angles of frame and glass cut the line of the street in such a way as to emphasise the separation and distance between inside and out. The soft folds of the curtain add to the effect of holding us back as we look down onto the street and square below. The street is curiously empty, even desolate; but the room where we stand, which we can feel but not see, is no more inviting. There's a note of hankering in the perfectly placed parked car which points away, as if it is waiting to take someone somewhere.

Perhaps the pleasure of painting windows lay, for Stella, in giving pictorial form to the ambiguities of the complex passage between different, and differently problematic, realms: inner and outer, public and private, safety and danger. For as well as literally acting as a passage between the world inside and the world beyond, her windows capture the uneasy balance between the secrets of

Stella Bowen,
Untitled,
c. 1930.

private existence—inside the bedroom, inside the studio—and the expectations and obligations—as well as the possibilities—that await us outside. It is as if she needed to frame her images with the additional mediation—or protection—of a window for something new to emerge, both in herself and on her canvas. In both these paintings there is stillness, an acceptance of things as they are, and a view of the world opening, fold after fold. Is the quiet of these paintings a kind of complement to conversation, the silence into which we can step from the hurly-burly and the dance? 'I loved painting windows and I loved painting hands,' Stella wrote. 'I daresay Mr Freud would have seen some peculiar significance in this, though I have no idea what it might be.'

As to hands—in both *Figure Study* and *Still Life with Part of Me*, painted two years earlier, the hands of the figures had been hidden. The nude held hers behind her back; the palette hid Stella's own hands in the self-portrait. In the *Reclining Nude* one hand is visible in the foreground, inert on the bed. Compared to the hands in the portrait of Edith Sitwell, that limp hand is poorly executed. Hands and windows are technically difficult—a challenge that, at the moment of separation, Stella had not been quite ready for.

In the portrait of Edith Sitwell, probably painted in 1930 or early in 1931, the hands are magnified in proportion to the body. The long, bony fingers with their rings and polished nails are held in tension and control; again that edge of meaning. Because the painting is constructed of triangular shapes—the body itself, the reflected images, even the knee on which the hands rest—the triangle of the clasped hands, echoing the shape of her curiously boneless face, brings our focus down from the eyes that do not meet ours. This is a portrait about hands. Stella went on to fill another frame entirely with Edith Sitwell's 'extravagant hands'—this time bedecked in 'huge Victorian ornaments' and holding an African mask. Tiny slits of light are all that is visible through the crack of the mask's eyes, but the power of the hands makes this absence of a face teasing rather than angry. The question of what manner of woman lies behind the mask makes its challenge in a very different register.

Ford had once told Stella that the best work was done against the grain, and looking at the paintings from the rue Boissonnade, it would seem that it was so. The rub of tension, the spur of conflict, the scratch of discomfort. However, I doubt that it was the emotional grain that Ford had in mind; his impulse was towards a more competitive, intellectual arena, where fashion had to be resisted and art remade. Virginia Woolf was closer to the mark, drawing together the emotional and the intellectual when she said: 'I do my best work, and I feel most braced with my back to the wall. It's an odd feeling though, writing against the current: difficult entirely to disregard the current.'

The metaphors are becoming mixed. The current that Stella Bowen could not ignore was not so much metaphor as fact. The large fact of money. Independence—as Stella quickly learned—costs. In the best of times it costs, and this was not the best of times. Eighteen months after she and Ford parted, the economy crashed into the century's worst depression and she found herself dominated by the question of money, which she had once treated in the most cavalier and romantic fashion. 'Money worries would be so simple,' she wrote to Tom, 'if one just had oneself to consider.'[120] But even that was not entirely true. One of the lessons she'd learned from the Jean Rhys affair had been the effect of penury on a woman's life. 'You can't have self-respect without money,' she wrote in *Drawn from Life*. 'You can't even have the luxury of a personality.' She had no intention of losing self-respect, or personality. Or of entering an

underworld of darkness and disorder. In the late 1920s, when she first left Ford, commissions had been easy enough to get: 'An Australian girl who wanted to send her picture to her fiancé—a girl writer who wanted one for her old home in Virginia, the wife of a rich tourist, and various children whom Julie learned to keep distracted by working her little model theatre just in the spot where I wished them to look.' With this sort of work coming in, she could afford to paint hands and windows. She could take on a portrait of Edith Sitwell as a challenge of eye, heart and friendship. But by the summer of 1931 commissions were rare and she was in debt. 'It's the easiest thing in the world,' she wrote to her cousin in Adelaide, for people 'to economise on portraits.'[121]

Stella and Julie, aged 9, in the Luxembourg Gardens, 1930. 'I wonder if really understanding books have been written about the very special comradeship of mother and daughter facing the world together,' Julie wrote in 1984.

In August, while Ford took Julie to Toulon, Stella joined an artist friend in the Haute Savoie, painting every day and barely looking at a newspaper. It was a sort of last lull before the full impact of a crisis from which she could not escape. 'Before returning to Paris,' she wrote, 'the cold winds of fear began to penetrate even to our mountain retreat. There were rumours of war and rumours of financial collapse all around and the political atmosphere was appalling. On the morning after my return to the rue Boissonnade, I opened my *Herald Tribune* to see in the right hand corner, £1 sterling = frs. 103. That sentence had read £1 sterling = frs 125 for months and years, and when it quickly sank to 86, I knew that I was ruined.'

Money runs as a base beneath every aspect of Stella Bowen's story, from that first romantic gesture with which she accepted Ford, to the very end when she could not raise enough to return to Australia to die. She had grown up in an era when middle-class daughters could expect to be supported by their families. Her adventures and her claims of independence as a young woman had been backed by the small income that had been supplied by the trustees of her mother's estate. In 1914, £20 a month, or £240 a year, was comfortable enough. During the early 1920s it was still sufficient to boost Ford's meagre finances to a level that made life tolerable; even if he earned nothing they could still manage. But by the jittery summer of 1931 it wasn't enough to keep her and Julie in Paris. Not nearly enough. The situation was made worse by the fact that her money came in Australian pounds, and even before that summer the Australian pound had slipped to sixteen shillings against sterling. Expatriates were leaving Paris, the supply of commissions was dwindling fast, there was the now exorbitant rent on the studio in the rue Boissonnade as well as the debt to the architect. By the end of 1931 there was every reason to be afraid. 'Playtime,' she wrote, 'was clearly over.'

Ford's return to France hadn't helped. He had returned shortly after her exhibition with a new lover, the young Jewish-American painter Janice Biala. It's not clear what happened to Rene Wright—there is a suggestion in a letter from Stella to her friend Jenny Bradley that she had objected to the support, such as it was, that Ford was giving to Stella and Julie—but whatever it was, the change suited Stella. She liked Janice, increasingly as the years went by, but Ford's return that summer proved another current to brace herself against. 'I find his presence in Paris fairly trying,' she wrote to Tom. 'He expects to keep very friendly, which is all right in theory, but he manages to bother me.'[122]

'Everyone here is broke,' Ford wrote to his friend Douglas Goldring early in 1932. 'And there is talk of nothing but the *crise*.'[123] Later that year when he was in London, he told Goldring that he and Janice had been standing on a suspension bridge over 'the majestic Rhône' at the time of the Wall Street crash, and that when Janice opened her bag a sudden gust of wind had caught it and sent the *billets de mille* that they had just got out of the bank in time swirling into the air and down to the river. Goldring, who doubted Ford's grasp of 'factual truth', considered this one of his

'impressions'. But the story has been told to me by Stella's family. In their version—which came to them from Julie—it was Stella's money that blew out of her bag and landed in the river. She was not on a suspension bridge over the Rhône, but in Paris crossing the river after withdrawing all the cash she had for her and Julie to live on.

Ford made stories of his impoverishment, or else grumbled that he was unappreciated, badly published and out of print. Stella was practical and set about earning what she could. When they had separated, Ford had assigned his English royalties to her, and with this gesture felt himself absolved from further responsibility. The problem was that he'd never sold well in England, and with the depression small sales dwindled to no sales. Not only that, but Stella was left with the task of selling his subsequent books to publishers in Britain, with all the work one would expect of an agent. She even had to arrange for his manuscripts to be retyped, so 'towsled' were they when he'd finished with them. In 1930 Edith Sitwell was trying to sell one of his manuscripts for her in England. Sotheby's, she told Stella, 'swear that there is not the *faintest* chance of getting £350 for the M.S. They say it will not fetch more than £40 or £50 . . . They were very gloomy, and depressed me so much, I could have cried.'[124]

With sales falling during a depression, the publishers Stella approached were just as gloomy. 'You realise,' she wrote to Ford in 1933, 'that there were no English royalties at all during last year.'[125] Far from supporting Stella and Julie, one could say that, if anything, Ford—who was borrowing from the also impoverished Ezra Pound—was an additional liability.

'I have just done a portrait of Jean Gorman which she and Harold Loeb like very much but I don't think I do,' she wrote to her cousin Kathleen Kyffin Thomas in January 1931, a few months before Ford's arrival in Paris with Janice. 'It was not a commission & was never intended to be sold but only to embellish my exhibition. But 10 minutes ago Ford's concierge rang up to say that she didn't know what to do, because unless frs. 2000 (£17) was paid for Ford's income tax in three days, the bailiffs will demand his keys & will sell him up 3 days later. I know they are very fierce against foreigners who don't pay their taxes & I know Ford had not paid his. But I simply have not got 2000 frs. So I think I shall appeal to the Gormans, as the only friends of Ford's I am in touch with here, to settle this tax by buying the picture. Do you think I can do such a thing?'[126]

Kathleen Kyffin Thomas was the cousin who had spurred Stella on with novels of H.G. Wells and Bernard Shaw during their Adelaide girlhood. Kathleen had visited her in Paris just after she left Ford and was struggling with her sudden change of circumstance and identity. 'I can't tell you what a real joy it was to have you with me,' Stella wrote after Kathleen left. 'Apart from the joy of finding our relationship just as warm & fresh as ever, after so long, there was a very special pleasure, to me, in having a Real Relation coming into my life! A bit of background can be a wonderful comfort to a person who has been playing a very lone game for a long time.'

More than anyone else, it was to Kathleen that she wrote of her money worries. From these letters we can see how extremely hard it was for her to support herself and Julie, and that when the chips were down and she was in difficulties, it was not Ford who came to the rescue but her women friends. 'My dear,' she wrote to Kathleen in 1930, 'something lovely has happened which has relieved me so immeasurably that I feel quite silly & light-headed! You know that I was due to go to my lawyer to get him to arrange the longest possible credit for me with my architect, whose total bills have been got down to £40 <u>less</u> than I at one time feared (there will remain about £160 to pay) he said that if I could guarantee to make one payment in June, and another in January, he could probably get the architect to agree to wait, but that he must have a guarantee. And yesterday Edith simply insisted on guaranteeing the October and January payments, & Hadley [Hemingway] on making up the proceeds of my exhibition to the necessary figure in June, if needed. Of course, I <u>may</u> be able to pay it all myself, if I have luck with Ford, & if not I shall certainly manage to repay them both in time. But can you imagine the marvellous relief of knowing I'm not going to be sued, or bothered? I simply can't believe it, and aren't those two women utter & absolute angels?'

She did not, of course, have any success with Ford. When she paid back these *utter angels*, it was from her own earnings. She painted her way into independence, and in doing so proved that when it came to her own capabilities, it was not impossible. Which makes it all the crueller that every success was met with new impossibilities imposed by the external world.

Within months of her exhibition, when everything had seemed so 'fine and dandy', Stella Bowen's story stalls. The narrative is

derailed. By Ford. And by the crises of the 1930s. In an attempt to ease both situations, Stella decided to winter in Toulon where she still had her beloved quayside studio. Living there would get her out of Ford's Paris; there was a suitable school for Julie and congenial company for them both. It was a chance to work, store up some paintings to sell on her return, and at the same time recoup some money by renting the Paris flat. But Ford objected. He and Janice were along the coast at Cap Brun. They had spent the summer in a villa

Ford and Janice Biala in the early 1930s.
'She was a young Polish-American painter who made him very happy until the day of his death, and she developed a strong affection for Julie.'

with a charming garden of fig trees and oranges, and didn't want to lose it when they returned to Paris for the winter. So he persuaded Stella to take it over. A villa, he told her, was a better environment for a child than 'some quai side slum'. Still susceptible to him—and to the slightest suggestion that Julie might suffer from the 'impoverishment' of their life alone—Stella agreed. Reluctantly, but she agreed. 'We arrived at noon and Ford and Janice left for Paris that evening,' she wrote. 'I had never felt so sharp a pang of desolation as when, alone with Julie, I looked around and took stock of the domestic difficulties which confronted us.' The villa was not a winter house. Ford and Janice had lived in the garden, which was indeed charming, but the summer was over. While it might have suited Ford to have reliable winter tenants, it was hardly the environment for a child—let alone for a painter. He was sensibly retreating to Paris from a house that was too dark, too cold and too damp for a writer to work in. A painter, of course, needs more light than a writer; more light, more space and more equipment. 'We were there for nearly 5 months,' Stella wrote to Kathleen, 'cheeseparing in a dismal sort of exile.'

It is at this point in Stella's story that I find myself feeling the anger and bitterness she saw *going on underneath* in Hadley, and of which she left so little trace in her own writing. Edith Sitwell alluded to it, but there is barely a sign of it even in Stella's letters.

Grief, yes, but bitterness, no. Was it really not there? If it was to be found anywhere, it would be in her letters to Kathleen; but there she is generous; fed-up occasionally, but always pragmatic. That's how Ford was; she accepted his 'fine machinery' and didn't rail against him in separation any more than she had when they were together. It is my anger, not hers, that shows when I write of him leaving her in that dreadful house, even if there were sumptuous views all around them. Compared to this, silence at lunch seems the least of it.

A room of one's own and £500 a year, Virginia Woolf had said in 1929. By 1932, £500 a year was wildly optimistic. Stella at least had an apartment of her own that she loved, but she had gone badly into debt getting it, and her income had been reduced by the drop in the exchange rate to as little as £100 a year. The imperative in these dismal circumstances was to make some money, and in the middle of a depression Stella wasn't going to be precious about how she did it. So when her American friend, the critic Ramon Guthrie, cabled her to ask how many commissions at $300 each she would need to make a visit to New York worthwhile, she jumped. Three, she said. Come, he said. And she did.

'Oh! If only I can pull things off,' she wrote to Kathleen. 'I think it's extraordinary how one gets a stroke of luck just when one is at the last ditch.' There was still money to be earned on the east coast of the United States in 1932, so Stella borrowed the funds to get there. 'I was scared of the whole proposition,' she continued to Kathleen, 'but it was obvious that I must accept it & forge ahead! And everything has gone off beautifully! People have liked my pictures a lot, & if it were not for the depression I can see how certainly I'd have got many more orders . . . The astonishing thing is that I should have had any orders at all! Most painters are just starving, & I've only had work because I've been painting children, & doing them for half price.' In six months on the east coast of America she made enough to pay off the architect, and even had a little left over. It seemed at the time a salvation, and momentarily it was, but as she said to Kathleen, 'the whole matter' had 'little enough to do with the Art of Painting'.

An English critic had told her that 'it was impossible for a professional portrait painter to remain honest as an artist'. As she moved from one country house to the next in New England, this was indeed an issue. But only once did she baulk. An old woman gave

her a photo and asked her to paint her long-dead husband from it, and then delete thirty years from her face and arrange her beside him. An 'artistic blur' was what she wanted. 'The job was very well paid,' Stella wrote in *Drawn from Life*, 'and I would have undertaken anything, from murals in the Hudson Tunnel to tinting postcards, if it would have helped to buy security for Julie at home. But I could neither paint the lady from the blurred photo, nor match her age, from the life, with the picture of her dead husband.' Instead, she painted the widow alone; she was not pleased with the result and 'had a bad conscience about taking the cheque'.

For the rest, she was put up in extravagantly comfortable houses where she had to flatter children and produce likenesses on demand for people whose money was being spent not on art but on the vanity of the family. 'When a rich old man who was ordering pictures of his second batch of grandchildren, said, "And we want you particularly to be sure and give the children *a happy expression*. We think you have made my other daughter's eldest boy a little sad," I answered coldly, but with terror at my heart, that I was afraid I couldn't guarantee any particular expression. I couldn't tell how the pictures would turn out, and I thought to myself, "If only you knew, my good man, how lucky you are to get a likeness at all. *I* don't know how it happens!"'

She tried to comfort herself that 'it was something, after all, to be the kind of person who is met with a huge limousine and installed in the best guest chamber with a pink porcelain bathroom and paid quite a few dollars for painting a bit of flesh, when painting a bit of flesh was just what I liked best'. But such self-admonitions rang as false in her ears as they do in ours. 'Once in the limousine, I always got the same old pang of cold fear. Here I was putting myself once again at the mercy of the unknown. I was to be a hostage until I had given satisfaction; I could not escape, even for an hour, to be comforted by my cronies. I was alone in the enemies' camp.'

Her time in America was not without compensations. There were also friends and connections from Paris and London, who put her up in less style and restored her to more familiar ways of living—and talking. As to the rest, although she didn't much like it and resented being at its mercy, she was deeply interested in American wealth. She paid careful attention to the 'gadgets' that filled the kitchens, laundries and bathrooms of the houses she

painted for. 'Their plumbing is too astonishing,' she told Kathleen. 'When the thermometer falls below 70° the oil furnace in the basement bursts spontaneously into flame, the radiators start working & when the temperature rises above 70°, it stops, & then does it all over again!' She examined the 'cooking installations', and was not impressed by the 'over attention to means at the expense of the end' as 'rissoles, stewed prunes and cereal' emerged from the splendour of lavishly enshrined machines. But she saw at once that 'in the right hands' these mechanised kitchens meant 'freedom and leisure' for people like her. She and Ford had rarely had the luxury of running hot water. In Toulon there was 'a battered saucepan on a charcoal burner'. Domestic craftsmanship it might have been, but every bouillon took a great deal of time. However, her interest in these matters did not unduly affect her equilibrium; with the very rich, she had the stance of an anthropologist.

The test came when she went to stay with Sinclair Lewis and Dorothy Thompson, whose portrait she painted with her son beside her. Here was the intellectual couple who had succeeded where Stella and Ford had failed. Red, as Sinclair Lewis was called, had made money. The marriage had endured. Their establishment was as open and generous as Ford and Stella's Paris studios had ever been. 'We have ever so many friends in common,' she told Kathleen. But for Red and Dorothy there was space and elegance at Twin Farms, their property in Vermont. Each had a separate domain to work in privacy on either side of a central hub, where visitors were generously accommodated. 'How delectable are the fruits of success,' Stella wrote; but far from envying it, she understood exactly the effort involved in earning every cent of it 'by the sweat of their own brains'. Knowing what she knew, she didn't underestimate the cost of that sweat. 'The admiring visitor sees nothing of the grinding hard work that has gone into the making of it all; the headaches and the self-discipline and the perpetual, relentless effort through all kinds of personal storms that a literary and journalistic career entails.'

Nor was it lost on her that the success of the entire enterprise depended on Dorothy 'flying between the two farms. To be Dorothy is to be three women in one with the vitality and organising power of six. To be Dorothy, in fact, is to deserve success.' Dorothy Thompson was a journalist, with a regular column she wrote from the farm; an easier mix with a high-profile literary marriage than

painting, perhaps, but Stella was giving her full credit. 'She is a great authority on European politics,' she told Kathleen, '& I had expected to find a hard boiled American newspaper woman, but discover, instead, a real cosmopolitan with one of the most generous minds I've ever struck. And a dear.'

Here, like a shadow of the story that didn't happen, was the life Stella and Ford were perfectly suited for, the life they would have lived had they had the means; as it was, they had lived a shoe-string version of it in Paris with their parties and dinners that swept everyone up. How much of their failure, would it have seemed to Stella, facing the success of Twin Farms, could be put down to the strain of poverty? She doesn't say. In *Drawn from Life* the failure is put down to the clash between the demands of Love and the demands of Art, as well as to the particularities of their own desires and personalities. But without money Stella's quest for the blending of these two great ideals—or for any art at all—was made very much harder. By the time she visited Twin Farms she knew this with the thorough knowing of experience. She says nothing of it in the memoir; it's only in her letters to her brother and to Kathleen that we glimpse the depth of her anxiety. 'Forgive all these money details,' she wrote to Kathleen in her long account of this venture, 'but to me they are just thrilling! . . . And as a result of this trip, I'll be able to get along almost to the end of the year, before which I hope some more work may have turned up, & that I'll have found, if not a tenant, at least someone to share 18 rue Boissonnade. In Paris I've found a Tailor who took my picture of the glacier in exchange for a spring coat, & who says he'll take a portrait of his wife in exchange for a fine new winter overcoat! Also I'm to pay my "homme d'affaires" who fixes my income tax etc, with a picture! I'm becoming convinced that I can't <u>afford</u> not to go on painting! Which is a very exhilarating thought!

'God bless you all! And please pray that my luck holds!'

It didn't. The trip to New York cleared the studio of debt and extended her reputation as a portrait painter, but it was not enough to hold her secure against the economic realities of Paris in 1932 as the depression bit further. When she had watched the exodus of expatriates as she struggled to pay off the architect, sailing to New York and returning, she had believed that her investment was too great to leave. But she was wrong. 'After the studio was cleared of

debt,' she wrote, 'it took just six months to convince me that life in Paris was no longer possible. I became convinced for the simplest of reasons; I had no more money.'

It was a great sorrow to leave the city of her wonderful education, the city that had grown her from romantic girl to artist, and had turned provincial hope into cosmopolitan achievement. But the last image she gives us isn't of Ford, or her education, or even of art, but of the sorrow of leaving a city where she'd learned the pleasures and importance of lunches 'with *hors d'oeuvre* and a fine salad', a bottle of red wine and 'fast and friendly talk', the conversation of intimates. These, in her view, were the meals that give meaning to the twists and turns of our lives, these the conversations that help us become the people we are. 'There was nothing about these lunches to make one homesick for the roast beef and Yorkshire pudding and the subsequent somnolence of the English Sabbath. On the contrary.' But it was to England that she had to retreat, and it was there that she spent the remaining years of her life. 'For if Paris offers a good antidote to emotional troubles, she is adamant where money is concerned. She allows no blurred edges or wishful thinking on this stark subject.'

By May 1933 there was nothing for it but to put Julie in a *pension de famille* to finish her school year at the Ecole Alsacienne and 'creep back' to England to see what kind of life would be possible for them there. 'I sailed in the third class women's cabin from Dunkerque to Folkestone. At midnight, listening to the creaking timbers of the vessel, I remembered that it was my fortieth birthday.'

10. LONDON HAD NONE of the dash of Paris and the food was as bad as she remembered. 'The slow and heavy tempo' of English conversation seemed to infect even the streets. 'The prams were pushed,' Stella wrote, 'as they had always been pushed by dawdling women, peering into unattractive, well-filled shops.' It seemed that across the small ribbon of water that divided them from Europe, the English were oblivious to danger; but insularity, she discovered, had its compensations: 'as one lay awake in the early morning hours, the clatter of the milk-bottles produced a comforting and sedative effect'. 'Lovely, free, magnanimous England,' Freud called it, but then he arrived in 1938 as a refugee from the Anschluss. Stella, who had come from a situation of considerably less danger, saw it less kindly. Nevertheless, in 1933 relief leavened the sorrow of leaving France, and her anxieties eased as she rediscovered the many 'marvellous friends' she had in London. 'I found comfort, kindness, uncritical friendship and loyalty—all those English virtues that I had forgotten about in my enthusiasm for France.'

A large studio in Kensington was found for her through a London–Paris connection. Margaret Cole, who had become 'a considerable personality', introduced her to well-connected Labour sympathisers—Lady Cripps, for instance, and D.N. Pritt—who could afford to have their portraits painted. This started a small ball rolling, and after the dead halt of Paris every commission was to be celebrated. Another source of income came through Phyllis. Her second husband, Aylmer Vallance, who was editor of the *News Chronicle*, offered her a weekly column to cover London's art exhibitions. 'Round the Galleries', which she wrote for eighteen months, brought in an annual fee of £240. 'It is a little easier than at first,' she told Tom in a long Christmas letter, 'but it bothers me a lot. It takes two days out of every week . . . and it's hard to write about pictures for people who know nothing about art & care less.'[127]

The most immediately noticeable thing about 'Round the Galleries' is that instead of using her own name, she chose the by-line

of 'Palette'. It is a neat irony that she chose this name for her critical debut, for of course it was the title she had used in 1931 for her cropped self-portrait. Then she had shown herself without a face; now, as 'Palette', she stepped into the position of newspaper critic. With this pseudonym—which concealed her even as she was exposed—her public voice became confident and certain.

Of the English painters, she liked Nevinson and Nash, Sickert and Augustus John; but she didn't like Stanley Spencer and was critical of most of the London school, whom she regarded as bound to an idiom that had once been innovative but was now tired. 'They appear,' she wrote, 'merely to have exchanged a study of nature for a study of other painters.'[128] Reading 'Round the Galleries', it is clear that what she admired was not formal innovation for its own sake, or even 'originality of outlook', but painters who were 'at home in themselves' and had found a way to capture the immensity of ordinary, modest experience. Her greatest praise was for 'the accidental subjects' of Bonnard and Vuillard, and the 'candid, tranquil and precise' street scenes of Utrillo.[129] Her heart was still in France.

As she told Tom, it took a lot of work to cover the galleries (sometimes as many as fifteen) and produce a readable column each week, but having 'regular money' changed 'the whole face of existence . . . It does not mean that I can have a new hat . . . but it does mean that I have no anxiety about the weekly food & fuel . . .'

Through another connection she got Julie into a progressive day school in Hampstead. Even with reduced fees, the school's bills were 'the greatest difficulty'. But when she was writing this letter for Christmas 1935, at least she was able to say that she had sold a story of Ford's, 'which will pay this term, anyhow'. Trailing behind this decision about Julie's schooling came the long shadow of Ford's Catholicism. He took Stella's choice as a deliberate move against a religion she had never liked. 'It does not seem to me to be very sporting, to say the least,' he complained. To make matters worse, Julie was putting on weight and had become keen on hockey. Ford disapproved on both counts. 'I write of this with less feeling than I could exhibit,' he wrote.[130]

Stella, separate at last, replied smartly that she resented the 'tone' of his letter and considered it an 'unfair addition to our difficulties'. Nevertheless she gave detailed attention to his points

one by one. 'Julie herself says that the anti-Catholic talk at King Alfred School is much less violent than the anti-Protestant talk at the Ecole Alsacienne, & she draws the conclusion that mutual tolerance is desirable. Short of sending her to a convent—which I won't do— it is impossible to insure her against hearing some contrary opinions . . . Some day of course she must find a confessor. I admit however, that I dread for her a future enslaved by the catholic view of marriage.' As to her 'vanity' and 'inferiority complex', Stella wrote, 'she was certainly made to feel her ungainly size much more acutely while she was staying with you'. And when it came to her school clothes, she added, 'is there any useful purpose served by making her thus ashamed? She feels no shame here.' Either about the hockey or her size. 'Such weight,' Ford had complained, 'cannot be natural,' as if it were Stella's doing, a kind of personal insult. This from a man who weighed seventeen stone and had a weak heart that would kill him within five years. 'Once again,' Stella's letter concluded, 'I have explained myself & my reasons for what I do with Julie. But I think that this is the last time.'[131]

Stella Bowen, 'Sketch of Julie', c. 1933. 'She looked beautiful at the school Fancy Dress party and got second prize,' Stella told Ford in 1934.

It was not, of course, the last time Ford complained, nor was it the last time Stella explained—but judging by the letters, a little more had crossed over in her as she crossed the Channel, and I think he felt it. As she ceased to buckle, he backed off. Only slightly, but with a man like Ford even a small move back was a recognition, if not a concession. As he weakened in those last years of his life, the heat went out of their exchanges. Her letters took on a slightly impatient briskness, and it wasn't long before Julie was old enough to conduct her own negotiations with her father. From the podgy hockey-playing schoolgirl there is suddenly a voice. 'I hope you will be thrilled to hear,' she wrote in 1937, 'that I am <u>still</u> getting thinner—very slowly, it's true, but still! Personally I think it's due to

the coronation.'[132] The towering figure of Ford dwindles to a father who needs humouring, and a business partner to be kept informed. 'As I explained to you some time ago,' Stella wrote, 'the Stamp Duty varies in ratio to the price paid by me for the copyright.'[133]

With the move to England, Stella Bowen's story takes on a stumbling quality. Or perhaps it would be more accurate to say that there is a sense of water rising, of boulders tossed in her path, for the stumbling was not of her making. If her story were a film, it would begin at her mother's grave and end with the triumph of her *vernissage*: from Adelaide to Paris—the birth of the woman as artist. The credits could roll with her paintings listed, and the date of her death discreetly noted. 1947. No one would notice how soon it was to come. And we would be spared the task of trying to make sense of these English years when her life was caught in another roll of history, with war bearing down, economic hardship all around, and the terrible values of the extreme and vigilant Right rising like a tide across Europe.

The shock of arrival this time was that she found herself in conflict with the British Left, to which most of her friends held some degree of allegiance. When she had come across the Fabians in the last war, working in the slums of Homerton through 'a haze of unhappiness', she had wanted 'to run away from it all, and start painting'. When she returned to London in 1933 she said it was as if she had made an enormous detour through the individualistic 1920s—'love, aesthetics, and the personal life'—only to find the British Left oddly untouched by all that had absorbed her in Paris. It wasn't that she was unsympathetic; on the contrary, having had a whiff of fascism in Europe, she was deeply sympathetic to the politics of social justice. 'Unless,' she said, 'one is a gangster at heart one must believe in something.' She didn't need convincing of the failures of capitalism; 'the "starving in the midst of plenty" is sufficient proof of that'. But she hated the rhetoric of the British Left.

'When I first came to England,' she wrote, meaning her return in 1933, 'an earnest and learned revolutionary of my acquaintance said to me that he thought happiness was the last thing to take into consideration in estimating the value of life. I was quite shocked.' She was no more able to accept that the end—even an egalitarian end—justified savage means than she had been in 1915. 'When a Communist writer declared to me with a flaming conviction that I

could only envy, that to *sacrifice a whole generation* would not be too great a price to pay to stop man's labour being exploited for profit, I was ready to cry mercy.' And not only because she had a daughter who, with war once again approaching, was of an age ripe for sacrifice.

For Stella Bowen the journey *was* the story: remove the process of life and you destroy life. She had left Adelaide all those years before in pursuit of great destinies, and in the doing of it had discovered the dangers of living by an ideal. What interested Stella was not social legislation—'I was born without the slightest desire to instruct or to reform society'—but the transforming power of experience which, for her, would always be more potent than any theory. Faced with the intellectualising sadism of the British revolutionary who would jettison the impulses of the heart for heartless equality, and a way of thinking that valued order over passion, she stood her ground for engagement with life. That, for her, meant engagement with the creative force of art, and imagination, and love. She wasn't going to say that Art was a solution, or Love the answer to anything. She wasn't going to pit imagination or feeling against social reform; but equally she wasn't going to let them be tidied out of sight. She might have learned the price of orchids, but she didn't value them any less.

One way of looking at these years in England, as war inched closer, would be to say it was a period of making do. Earning money drove her in tiring and diverting directions: the column in the *News Chronicle*, stints of teaching, commissions as they came. If we'd had a plan for her, it wouldn't have been this scrappy existence. But as she knew, life isn't to be understood in the plan, the grand design, but in the fluidity of living, in the dark resonances that make themselves felt as much in the plans that fail us as in the achievements of our own design. So another way of looking at those embattled years of the late 1930s, eking out a living and honing her political views against the blunt instrument of the British Left, would be to say that she was forced against the grain again, propelled into a flux that would produce the next big leap: grit in the wheel, sand in the oyster.

At a time when her closest intimacies were with women—with Julie, of course, and with her friends—Stella was particularly interested in art by women. In her column she wrote about women

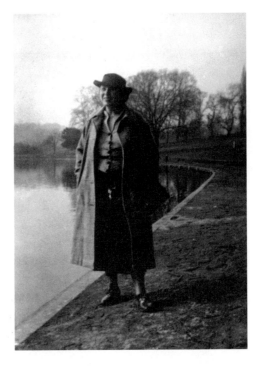

*Stella Bowen in
England, c. 1935.*

painters, many with names we no longer recognise—Elsa Masters, Madge Oliver, Maud Sumner, Edith Lawrence, Sine Mackinnon. She took them seriously, gave them space and wrote of them with the same attention and respect she gave to the men. 'In turning to the catalogue of almost any mixed exhibition I have grown accustomed to discover, more often than not, that the picture that has caught my attention is by a woman,' she wrote in a review of an exhibition by the Women's International Sketch Club. 'It is therefore disappointing to find . . . many of those weaknesses which we associate with the dismal words "lady artist". To be derivative, heavy-handed, weak and over-violent are her too frequent faults; while her best work is often indistinguishable from a man's.'[134] Perhaps because these were failings she herself had struggled to avoid, her criticisms when they came were acute. Marie Laurencin she considered overly feminine; she had respect for Dame Laura Knight, though she was not someone to emulate. The woman she most admired, and with whom she had the greatest affinity, was Vanessa Bell. Her work, she wrote on reviewing an exhibition at Agnews in Bond Street, was 'free, fluid and glowing'.[135]

Vanessa Bell did not have the public profile of Duncan Grant, with whom she lived and was usually compared. During those years between the wars, her work was almost always ranked second to his. It wasn't as showy or as demanding of attention. But the quality it had, that Stella particularly responded to, was one of hard-won emotional knowledge. Her biographer calls this 'the commitment to the thing seen. Even her dullest still life can display more feeling and integrity than that discernible beneath the flourish and animation of Duncan's bravura.'[136]

Vanessa Bell herself approved of the notice that came to Duncan Grant, partly because she thought he was a better painter—an opinion Stella didn't share—and partly because the attention kept him satisfied and therefore left her in peace. It was a way of maintaining a relationship with an extremely difficult man while carving out an autonomous space for herself. Although Stella says nothing of this, perhaps Vanessa Bell was for her a model of a woman who had had sufficient success to buy the conditions she needed to maintain the domestic situation she wanted and still work, without becoming corrupted either by aping the men or, like Marie Laurencin, by an excessive, almost parodic femininity.

At the other end of the spectrum, the kind of art Stella Bowen liked least was the 'Academy portrait', which, in her view, was 'usually as dead as mutton'.[137] She hated the dogged realism that valued precision of meaningless detail—the spotted handkerchief in the pocket, the accidental vase on the shelf—as a way of denoting individuality, while avoiding the much harder terrain of personality. For her the opposite held value. Since her encounter with Giotto and the Italian masters, she had responded to a degree of formality in the disposition and arrangement of figures, which, to her mind, gave maximum scope for the rendering, as she put it, borrowing Ford's term, of personality and moment. Which is why she admired the 'exquisite head of a child at the piano' by Vanessa Bell, and, in a very different idiom, the 'noble shapes' of Henry Moore.

Had she been born in a different age, she would, she said, have painted bejewelled maharajas and robed emperors bedecked in 'ceremonial robes' and 'fantastic gee-gaws'. Or, had her idea of an ideal world existed, she would have settled for a politically unexceptional life, painting small portraits for anyone who could afford a small price. Instead, in a country not given to conversational

flair, she began—against that grain—to paint 'conversation pieces': 'little figures of Hogarthian dimensions sitting about in their own houses'. It was a move of flair and confidence born of those years of hard grind, giving public expression to her views about art, and enacting a private resistance to political certitudes that profoundly discomfited her.

What had caught her eye this time were the eighteenth-century conversation pieces of British painters like Hogarth, Romney and Gainsborough, in which groups of people—usually families—were painted making music, reading, talking, picnicking or fishing: ordinary, informal activities. The conversation piece had gained its name not so much because the group was arranged as if for conversation, but because the way the figures were placed in the composition invited speculation—and therefore conversation—in the viewer. Here was precisely the kind of formality she liked, with individuals held in tight formation and thereby paradoxically freed for the play of emotion. The double, indeed multiple, perspective of the conversation piece suited Stella well. Faced with an ethos that 'the effective person is the one who says that "only one thing matters"', it allowed her to give form to her countervailing belief that 'everything matters all the time'. In a gesture of formal irony that looked in two directions at once, she brought an eighteenth-century genre into her acutely twentieth-century and feminine present.

Already in her portrait of Edith Sitwell she had supplemented the central figure with a reflected image, as if one view was not enough and another glimpse from an unexpected angle would make us reconsider our first impressions. It was a device she used at the end of the war in a sumptuous portrait of—and tribute to—Margaret Cole, suggesting that the complexities of a woman who was mother, activist and writer required more than one lens, more than one profile. In this portrait (plate 8), both tough and loving, we are shown the self-effacing, almost petulant femininity of a woman who might carry a tray, and the intellectuality of a woman who need make no compromise. 'A little square face under an immense mop of dark hair,' Stella wrote of her friend whose nickname was 'Mop'. 'She would edge away from strangers, and despise the small change of mannerly greetings, [but] no bushel capable of hiding her light has ever been discovered.' Both these portraits express Stella's

commitment to friendship, and her fascination with the power and complexity of a loved face. 'What a wizard he is,' she wrote of Augustus John in her column, 'for dragging the heart out of his sitter and giving it pictorial form.'[138] She was far too modest to say the same of herself.

The notion of conversation, as Stella Bowen was using it, and as I do, can be seen as both a feminine and a modern phenomenon: a way of talking that comes with the breaking of formalities within families and between men and women; that comes with the intense inquiry into the drama of self and consciousness; that resists the voices that employ an heroic stance, be it for silence at lunch or the sacrifice of a whole generation. The informal shapes of Vanessa Bell's groups of women leaning into their conversation catch the stance and intimacy that Stella celebrated.

Vanessa Bell,
A CONVERSATION,
1913–16.

Conversation had always mattered to Stella Bowen. She had fallen in love with the *talk* of Ford; she'd disentangled herself through the talk of art, and women friends. Conversation was for her the basis for intimacy: the real exchange that occurs between people who are open to each other in feeling and ideas. That kind of exchange, that kind of talk, mattered in the way she lived her life day by day, and in the way she came to understand herself. During the cheeseparing winter in the south of France, it was the absence of

like-minded people, and therefore the absence of conversation, rather than the miserable amenities that made it an exile. In America the divide between her and her rich clients, which was marked most obviously by money, was experienced more acutely in the impossibility of conversation. In England, where she was forced to articulate views that had been half-formed in the 'playtime' of Paris, conversation became something of a philosophical, even political position.

The 1920s, Margaret Cole wrote, 'in memory make a *pointilliste* picture; the thirties a distortion—something like the experience of sitting in the very front row of a large cinema, where half the screen is out of focus and one blinks at monstrous objects'.[139] As Stella was jolted out of the self-absorption of those last years in Paris where the shadow of Ford still fell across her canvas, she moved away from the conundrum of the proud and wounded feminine heart. Where once she had said 'I' with all the difficulties attendant on that, she now seemed to say 'We'. Not the coupled 'we', but the 'we' that baulks at sacrificing any part of itself, let alone a whole generation.

'The early part of this year was uneventful,' she wrote to Tom at the end of 1935, 'except that I was persuaded to paint a conversation piece of a family in their drawing room, which was a new departure for me and which now turns out to be my best chance of making money. I immediately got another order, but it is not to be executed until after Xmas when the family will be in residence in their lovely Elizabethan house in the country. I also painted another family group (of seven) in the summer holidays for my own amusement, & subsequently sold it to them. And I have just this minute finished another conversation piece of the Underwoods.' Eric Underwood, a barrister, who had written well and sympathetically on modern art and, more unusually, on the work of women artists, offered Stella a private exhibition at his house in Ovington Square. The conversation piece was to be 'the piece de resistance of the exhibition', she told Tom. 'They know masses of people in a different world to mine. Underwood has published several books on modern painting, and has done this sort of thing before so it won't be a bad thing for me.'

In the same Christmas letter she said she was 'working like a lunatic' for the exhibition, but she only described one painting in any detail, and that incidentally; if there was a catalogue, or program, it

doesn't seem to have survived. The commissions themselves vanished into the families who paid for them, and there is no record even of their names. Again and again the trail is broken—as often as not by Stella herself. That we know as much as we do of this hard-working period in London is due to her correspondence with Tom, which became more detailed and more regular after her separation from Ford. But there is a consistent contradiction in the way she wrote of her painting, both in her letters and her memoir. She liked writing about the process of painting, the *thinking towards* that went into it, and the conditions under which it could be done, but she rarely wrote of the paintings themselves. It was the journey that engaged her, and she had an astonishing lack of vanity when it came to the finished product.

In that letter to Tom, the painting she described was one she had done the previous summer when she was holidaying in Madeira with Naomi Mitchison—'a remarkable young woman with her babies & her books'—and her politician husband. Julie, almost at the end of her schooling, was in Toulon with Ford and Janice, but Stella also had the company of Margaret Cole, who was there with her children. I like to think of these three extraordinary women, all of them attuned

Stella Bowen,
THE MITCHISON
FAMILY IN
MADEIRA, *1935.*

to politics, knowing utterly what was upon them, surrounded by children and yet, despite the anxieties, still able to enjoy themselves. 'It was nice to be a guest and have no responsibility,' she told Tom, 'and how novel Madeira is! Tropical but not enervating. Glorious bathing, glamorous gardens, wild mountain scenery—a real musical comedy background! That is where I painted the Mitchisons, piled into one of the ridiculous yellow basket work bullock wagons they have there, which glide on the blue runners, and are canopied like a four poster bed! With some festive tropical foliage, etc. It's a <u>very</u> fancy picture, & the largest & most complicated & I <u>think</u> the most successful I have ever painted.'

The success of this painting, it seems to me, lies in a composition that crams a family into a small space, almost as if it were a single entity, and yet from that crush the individual faces shine with their own recognisable stance. But when it came to giving herself the credit, that comment to Tom was as far as she went.

She hadn't then painted *Provençal Conversation* (plate 9), which more than any other of the late 1930s paintings that we know of captures the flavour of intimacy and conversation, that mood of more than one thing mattering. It is a painting that rises out of the hard work, the necessary repetition, that was bringing in the bread for her and Julie. Much of an artist's work has this quality of repetition —digging the row of potatoes, Van Gogh called it—a kind of ground out of which can come, suddenly, spontaneously, an expression of heart. So it was with this painting, her great painting of the 1930s. In subject matter it is back in France; in the rigour of its conception it could only have come out of those years in England. It places Stella in her forties, it is a landmark, a staging post as full and eloquent as the self-portrait ten years earlier.

Stella Bowen, THE WHITE STEPS, c. 1938. A corner of the 'little square-walled garden' where she painted PROVENÇAL CONVERSATION. 'I set up my easel for six weeks of blissful uninterrupted work.'

In a garden in the south of France four people sit around a table on which there are glasses, wine and a bowl of fruit. Four trees

frame and protect the group, shading them into the intimacy of conversation. In the pond beside them goldfish swim through the lacework of sky and branches reflected in water. It is a large canvas; it is also conceptually large, a leap in imaginative confidence and technical ability. Yet it remains characteristically modest. It is a painting about the modesty that is essential—in both senses—to personal life; an image of ordinary things mattering. It is a painting that says *This is*; the antithesis to the sacrifice of a generation.

Two men and two women are talking at the table. Are they two couples? Probably, but we don't know. There is tension between them as well as the ties of affection, but the conversation that this painting invites us to have is not about marriage; the couples, if couples they are, are not engaged in the romance of each other. Rather, it is a patterning of male and female, of position and possibility. Like a dance. Or a conversation. Right now these are the chairs they inhabit, but the pattern will rearrange. One or other will stand and move, the table will be left empty, or rejoined. The configuration will change. In this painting, in this conversation, masculine and feminine are both required; indeed, both painting and conversation depend on their interaction. Both are *gathered in*.

The self-portrait had been all woman, as Stella faced the world in the absence of Ford. It was self-consciously feminine as she stepped from dependence into a life that was not yet grounded in herself. Can *Provençal Conversation*, painted ten years later, be seen as a regaining of equilibrium as she came to accept the loss of Ford? Or was it a kinder look back to a time when the tension of opposites was held in momentary balance? A kind of farewell to Ford, to the coupled stage of life, as well as an acknowledgment of the fragile conversation of the late 1930s? The moment of pause between the breath that is let out, and the breath that is drawn in.

She painted it, I think, in the summer of 1938, the year before Ford died, though it is usually dated to the summer of his death or even later. Stella was in Provence for the summers of 1937 and 1938, visiting friends—a respite from the rigours, intellectual and personal, of England. There she could relax into the informality that had entranced her at Cap Ferrat, and again in Toulon in the 1920s. Despite her friends, such ease was not generally her experience in England.

And yet in 1938, as commissions dried up and the financial

future again looked bleak, she saw something of this relaxed spontaneity in London through Julie, who had enrolled in design at the London Theatre Studio in Islington. 'It worked out very well,' Stella wrote. 'She was stimulated and inspired, tormented and over-worked and thrown into contact with students of every nationality, under the influence of a mind that she admired.'

Julie had loved the theatre since she was a child; Stella had made cardboard theatres for her to play with on the floor, and she sent a similar one back to Adelaide for Tom's girl Suzanne. It arrived flat in a dress box, ready to be assembled by her niece. There were three changes of back-drop—a brick cottage, a garden path with flowers and an interior. And there were two figures in old-fashioned clothes for Suzanne to add to. It is still in Adelaide, a little wobbly and no longer robust enough for a child to play with, but it captures something of Stella: her attention to detail, her love of theatre and her sense of fun.

Everything about Julie's time at the Theatre Studio appealed to Stella, and her account of it at the end of *Drawn from Life* is like an inverted echo, balancing her own mother's great alarm at the prospect of her daughter seated in front of a nude model. 'Islington High Street was infested with exotic young women in paint smeared slacks, straggling locks, lurid make-up and dye-stained hands,' Stella wrote, 'and with acting students whose heavy circular rehearsal skirts swept the dusty pavements with the authoritative air of Edwardian matrons and accorded strangely with the jersey-clad bodies and tousled young heads that emerged above.' In particular she loved the drama of the fitting room where Julie worked. 'Boys and girls in various stages of undress, taking no notice of anything except the job in hand, stood patiently whilst the designers stuck pins into them.'

Thirty years had passed since Esther Eliza had refused to let Stella go to art school in Melbourne, and from the perspective of the London Theatre Studio that battle seemed as distant and as out of date as the ballgowns that women were once painted in. And yet we know, as Stella knew, that the promise of modernity came at a price. Step into that freedom and you step into its risk. In the summer of 1939, Julie's final performances—for which she was responsible for five scene-changes and twenty costumes—were acted out against the public danger of approaching war. And private sorrow.

In June, Janice Biala called for Julie as Ford struggled for life in a French hospital. He was a difficult patient, resistant and cantankerous, and the doctor who attended him remarked to Janice, 'It is obvious that Monsieur has always done whatever he wanted in his life.'[140] But the Divine Right of the Artist was no use to him at the end, and he died hard.

Stella took Julie over to Deauville and waited while she saw Ford. For Julie it was a moving farewell, and Janice reported that Ford was comforted by her presence. But for Stella it could only have been painful, for when Janice asked Ford if he wanted to see her, she reported that 'he was too sick to care about such matters and said no'.[141] Later, when Stella herself was dying, she called for Janice Biala as the only person she could talk to about her 'real life'.[142] Yet Ford dismissed her, not allowing her a final goodbye, nor wishing one for himself. Stella and Julie returned to England after a few days. Without asking for a priest or taking the last rites, Ford died on 26 June 1939. 'There were three people at his funeral,' Janice Biala wrote, 'a few flowers, and a little bunch of thyme and bay leaves on his coffin.'[143]

Ford's final battle with Stella had been over Julie, but this time it was not the allegiance of her soul that was at issue, as it had been when they first arrived in London in 1933. This time what he wanted was Julie for himself. With the approach of war, he had put it to Stella earlier in the year that for safety Julie should come and live with him and Janice in the States. Stella had replied in some distress that 'you will realise that except for my work, my life is now centered entirely on Julie'.[144] As it turned out he died three months before the war from which he wished to protect his daughter began; but the question had already been settled by Julie. 'I don't think I'd ever leave England in case of war,' she had told him.[145]

When Ford died, the irony was not lost on Stella that Julie, born out of the ruins of one war, had been delivered as an adult into the next. At the end of that summer term, the fabulous world of the Theatre Studio that had enchanted Stella as well as Julie was boarded up, and the creative hopes and theatricality of the young packed away with it. 'Everything was finished,' Stella wrote, 'rounded up, put away.'

11. WHEN HITLER MARCHED on Poland at the beginning of September 1939, Stella and Julie were already priced out of London. There was no paid painting work for Stella and no work in the theatre for Julie. Already, in 1938, Julie had told her father that Stella had had 'a very bad year for painting & is now trying to do some black & white hack work, & we've reduced the charwoman and taken to marketing in Kentish Town'.[146] A year later even the Kentish Town market wasn't saving them, and Stella came to the reluctant conclusion that the only way to survive was to retreat into the country. So almost exactly twenty years after she had moved so innocently into the cottage with Ford, she set off, this time to look for one for her and Julie.

The cottage she found was in Essex, near Purleigh. It was in good repair and, more importantly, it had a large overgrown garden: 'a patch of raspberries . . . currants, gooseberries, a row of scarlet runners and some peas'. It was cheap, and they could dig for themselves as well as for victory. But it proved not to be the most secure of retreats, as they realised when two young officers knocked on the door to tell them that in the event of emergency—'it seems you never say "if the Germans come"'—the cottage would be requisitioned as a first-aid post. The village, Green End, was five miles from an estuary, 'on rising ground overlooking the flat lands towards the sea'. And the sea exposed them to invasion.

On the night they left London, Phyllis drove Stella and Julie down to Green End, and as her 'great fast car sped over the dark and gleaming roads', Stella's mood was forlorn. Everything she valued was endangered. 'All those gifted youngsters [from the theatre] are being used to man guns and milk cows and make shells,' she wrote in *Drawn from Life*. 'They are learning how to deal with incendiary bombs, how to stop haemorrhage and how to carry an unconscious person from a burning building.' As she sat beside Phyllis in the car, the move to Essex seemed more like an ending than a beginning; above her she could see searchlights, 'fifteen, twenty at a time, whose

long batons of light wrote inscriptions on the clouds that were not difficult to read. They spelt war—no future—no safety. *The sacrifice of a whole generation . . .*

'Phyllis's first-born, Cordy, was with us on that night,' Stella continued. 'She was Julie's "best friend" and Phyllis was the nearest thing to a sister that I had ever had. They warmed our home and they warmed our hearts and we made a meal at midnight and went to bed convinced that life was just beginning, after all.'

It was there, in the cottage at Green End during the first year of the war, with searchlights above her and vegetables in the garden, that Stella wrote *Drawn from Life*. She was offered an advance of £100 and took it. Part of the price came because of her association with Ford: the memoir of the consort. As the way in which women saw themselves and each other changed in those years between the wars, the memoirs of notable—and especially artistic—women became a small profitable trade, particularly if there was a whiff of scandal that involved a prominent man. Not that Stella was promising that; if those had been the terms, I doubt that ten times the advance would have tempted her. But the tough reality (as she well knew) was that it was because of Ford that she could command not only the advance, but the authority to write a memoir. She used the remarkable education she had gained at his side in a way that at once bowed to his powers, and slid out from under them.

Just as she had with her painting, Stella Bowen once again made a double-edged move that was both utterly herself and profoundly of the century. She took the love story, a genre traditionally used to good effect by women, and set it against the quintessential modern story of the coming of age of the woman as artist. Christina Stead made the same move in *For Love Alone*, which was published five years after *Drawn from Life*. And Doris Lessing made it more than a decade later with the *Martha Quest* novels and then with *The Golden Notebook*. For all that it was a memoir and not a novel, *Drawn from Life* is a great love story; the young girl travels the seas and is transformed by her meeting with the kingly lover. But it is a modern love story. It is the girl who travels to find the lover, and it is a love that must fail. By 1940 Stella Bowen was writing from the knowledge that there was no living happily ever after; but that didn't invalidate the story or the experience. She didn't tell it to mock, or to berate, or to refuse. On the contrary, the move she made was to allow romance every bit of its

transforming power; she simply changed the nature and terms of the transformation. The girl is lifted up by the union with the prince and becomes through the failure of that love 'a queen in her own right'.

Reading *Drawn from Life* fifty years later, hearing the voice of Stella Bowen reaching across all that has happened since, what I hear is a conversation. She speaks close to our ear, drawing us, her readers, into her story, and drawing our stories into her musings, addressing us directly. As much as any of her paintings, *Drawn from Life* is a conversation piece. It is a conversation with all the people she ate lunches with. It is a conversation with her long dead mother; with Ford Madox Ford, with whom she'd had other late night talks; with Julie and her young friends who were being diverted into the army. Most of all it is a conversation with her readers. As much as an account of her life, it is an account, even a chronology, of an escape from fixed positions, those false gods that trap us.

And yet it is as carefully framed as any of her paintings. The view she gives us is the view she wants us to have. It leaves out Violet Hunt, sidesteps Jean Rhys, and allows us to think that she and Ford were married. Shortly before her death, she told one of the daughters

Stella's cover for the 1941 edition of Drawn from Life.

from his first marriage that this was the book's only dishonesty.[147] And perhaps even that was not dishonest; the process of writing one's life is more complex than that judgment implies. We know from the letters that the story was more haphazard, more painful and far less amenable to control than she would have us believe from the ironically titled *Drawn from Life*. As she well knew, art is not in any simple sense drawn from life; equally, she was determined that if life was to be considered an art, and lived with the courage and attention that is brought to art, then it must deliver its own form of truth onto the canvas or the page.

Stella drew herself for the cover; a quick sketch, nothing fancy. There she is, once again with her hair drawn back, but carelessly this time, as if she has not given it her full attention. Her clothes are rough; the clothes a woman might wear to work in the garden. There is no silk blouse, no brooch, no earrings. She looks past us into a very uncertain future, but there is no anxiety in the face, and remarkably little tension. It is a modest drawing for a queen, but there is dignity, and strength, and freedom. *Reminiscences*, she called the book.

She finished the manuscript in July 1940. With invasion expected, it ends with a pause rather than a conclusion. She and Julie were at Green End, not knowing if they should stay or leave. As they were in a prohibited area, no one could visit them from outside, and they were feeling the absence of comforting friends. 'Sometimes we go and fry eggs for the soldiers,' Stella wrote on the very last page, 'and sometimes we attend first-aid classes at the vicarage.' Incendiary bombs were a nightly reality, and they had their gas masks overhauled. But even in this perilous landscape, in that first summer of the war, the first anniversary of Ford's death, 'the sun shines and the sweet-peas are out and the poppies surpass all expectation'.

'Mostly I feel that one can face dangers at home that one could not face elsewhere,' she wrote, also on the last page. 'Mostly I feel that this is my last ditch. Why, I've had a bench made to sit on in the sun beside the front door in case some day I may become a grandmother.'

A year later, by the middle of 1941, *Drawn from Life* was in the shops. 'I've had lots of fan mail,' Stella told Kathleen in a long letter from London at the end of the year. 'I've had grand letters from [the writers] Storm Jameson & Rebecca West & G.B. Stern who all liked

it a lot. I've just spent a week-end with G.B. Stern in the country as a result (I hadn't seen her since 1919) & am to meet Rebecca, & have already met Storm Jameson, who is a dear. I've also had pages of love from Edith Sitwell who had quite ignored me of later years. And the most curious people write to say they are in violent agreement with everything I say! An old lady sends a stamped envelope & says she can't bear not knowing what had happened to Julie and me since the book ended! A miller in Sussex says he has actually made a pilgrimage to Bedham [where Coopers Cottage was].'[148]

What Stella would have had to tell the old lady was that almost as soon as she put down her pen and sent the manuscript to Collins, she and Julie moved to Grafton, a tiny hamlet in the centre of the country, near Tewkesbury. As invasion was thought to be imminent, it was a kind of evacuation. While they were there, they picked fruit for the war effort, Julie took a secretarial course and Stella revised the manuscript and corrected proofs. They were back at Green End by Easter, and Stella spent the rest of the war moving between the cottage and London, where she lived first in a house lent by friends who had evacuated, and eventually in a tiny mews house she rented in Danvers Street, Chelsea.

Drawn from Life quickly paid out its advance and sold its edition of 2000 copies. But despite glowing reviews—'sincere, revealing and expertly written', 'lively, agreeable and intelligent', 'rich and satisfying'—Collins couldn't reprint because of paper shortages and other restrictions. 'My agent says it's heartbreaking how many books are being "killed" right and left,' she told Kathleen, 'just when the public demand is greater than it has ever been.' Of the little Stella made over the advance, half went in wartime income tax. 'If it hadn't been for the war,' she continued, 'I think the book's success might well have made a turning point in our fortunes. As it is, of course one's own personal little card-house is due to get shaken down at any moment.'

For the second time in her short adult life, Stella found herself living within range of the bombs. Even in Grafton, which was so small there wasn't a post office or a shop, 'we were awakened by a screaming bomb'. 'You know that I have rather a special feeling about houses,' she wrote to Kathleen during the blitz, 'particularly the sort that look as though they have been lived in a lot. I like to paint them. They seem to stand for all the warmth, privacy and

security that was inherent in my home childhood. There is something fearfully indecent about a clean, bright wall paper exposed to the wind and rain.' What she couldn't bear was the way 'the horrible and the normal get jumbled up together. One house is disembowelled, & next door the kettle is singing on the gas.'

Her friends Phyllis and Margaret were remarkably sanguine. They kept on sleeping in their own beds and were enrolled as fire-fighters. 'They have to be ready to put on their hats & go out & cope with incendiaries when the whistles blow.' Stella, who admitted to 'shaking knees and a wobbly voice' at the sound of any 'loud bangs', preferred a bunk in the basement and didn't join them in their tin hats. 'I waste a lot of energy imagining what it would be like to be buried, or gassed, or machine gunned,' she told Kathleen, '& I turn over the relative dangers of going to this or that place by this or that route.' The way she faced the bombs and her own fear was, as it had always been, to embody it in her art and transform it into paint and image. 'I am crazy to make some pictures of the bomb damage,' she wrote, '& have taken all the necessary steps to get a sketch permit . . . The damage in London affects me dreadfully, but if I can somehow come to terms with it by painting it, I shall feel better.'

In *The House Opposite* (plate 10), she painted that horrible jumble of disaster and the ordinary. We look through lace curtains into the ruins of the house opposite, its wallpaper exposed to the elements, a bed still crumpled from its occupant slipping towards the hole blasted in the wall. On the sill of the window through which we look, with the curtains blowing against it, a geranium grows undisturbed in its pot. This time the danger through the window was horribly apparent. It was as if she was looking out onto all that she had refused to recognise in the last war, or was unable to see, so sure was she that she could build a house, a home, that would be impervious to darkness and despair.

The House Opposite was shown at the Royal Academy, and the *Times* 'gave it five lines'. But there was no money in a canvas like this. A few commissions came out of *Drawn from Life*, and another of her paintings was reproduced in *The Studio*, but by the beginning of 1942 Stella wrote to Kathleen to say that the next reluctant conclusion she was coming to was that she couldn't keep painting. It wasn't bringing anything in, and with her Australian money still halved by the exchange rate, she had to find a job. 'Well,' she said,

'it's easier to give it all up on top of a mild little success than it would be in a trough of failure. It's as tho' I'd staked out a little claim to come back to—if ever I am able to come back to it. I can't say I'm very happy about it!'

She was a good deal less happy after eighteen months of slogging backwards and forwards across London to lecture in art appreciation in suburbs as distant as Enfield and Bethnal Green, 'all at night & all woefully inaccessible from Chelsea . . . It makes me cross that I should be paid money to jolly along a lot of suburban dabblers, or to explain to the Workers' Educational Association the difference between copying nature & creating a work of art, rather than to paint my own pictures.' Again and again in Stella Bowen's story there's this disheartening *slipping back*, as if she is reclaimed over and over by a life antipathetic to her art.

> We can so easily
> slip back from what we have struggled to attain,
> abruptly, into a life we never wanted.[149]

That's Rilke again, still thinking of Paula Modersohn-Becker.

At this low point, Stella's life with Julie also changed, and in 1940 or 1941, probably at Grafton, she painted her as if to mark, or prefigure, their impending separation. When she had painted her as a child of about ten, she showed her sitting in a chair, with the springy energy of a girl who is old enough to be curious about the world she's not yet old enough to join. When she painted *Julie* (plate 11) early in the war, her eyes, still intent, are slightly lowered, and there is a musing, rather sorrowful quality to them. The same delicacy, the same intelligence, but clouded, this time, by the hard knowledge of what awaited her. 'She will be 21 on Saturday,' Stella wrote to Kathleen in November 1941, '& it certainly is the first time in history that a young woman attaining her majority faces what is virtually conscription.'

You can almost see the quality of Stella's love for this young woman in the paintwork: in the aliveness of her skin and the texture of her hair. For Julie, there were no silk blouses, no earrings, no brooch. Only rough cotton and wool. The clothes worn by a young woman whose work was needed. When I think back to Stella Bowen's self-portrait, and back beyond that to Paula Modersohn-Becker on her

sixth wedding anniversary, and Hugh Ramsay's sisters, the thought that arises in me as a painful question is whether this is what those ballgowns were to be exchanged for? And yet there is something noble in this face, another generation, the face of the grand-daughter born, as it were, from that distant pregnant self-portrait.

Soon after Stella had painted her, Julie left for six months to work with the Cambridge Arts Theatre—'a mixed bag of backstage duties', Stella said. Living apart they 'missed each other dreadfully'. The Army, which Julie joined at the end of 1941, brought her back to London; as she could type and speak perfect French, she was placed in liaison with the Free French Forces. It was a post that kept her in London for the rest of the war. For more than a year she lived with Stella again until, in 1943, she married Roland Loewe, an American journalist and documentary film maker who was working on propaganda films for the Allies. 'A sweet boy,' Stella said, 'and very good looking . . . That he is moody & emotional goes without saying—that's the sort that always gets attracted by Julie, & she was bound to marry someone highly strung.' As he had been in a motorcycle accident which kept him out of the forces, he and Julie were not separated as most war couples were. They moved into a flat in Lower Sloane Street, not far from Stella, who was left with her tiny mews house to herself and this time discovered, rather to her surprise, that she liked it. 'All my life I've been making homes for another person & have never felt that my life belonged to myself,' she wrote to Kathleen. 'Now I do—I confess that this new feeling is very much to my liking! I couldn't be more devoted to Julie than I am, & I've had nothing but happiness from her. But I must say I enjoy having my 2 (tiny) rooms to myself, & not having anyone to cook for.' The frustration, intense and almost unbearable, was that she could make so little use of it. An occasional commission, an occasional portrait for her own pleasure—when the lectures were written and she'd recovered from her wearying journeys across London. 'I'm 50,' she told Kathleen, '& I haven't the strength.'

At the best of times it takes strength to maintain oneself as an artist; strength, and also resilience. Not so much for the business of finding commissions, though that can be exhausting, but in order to stay open to the world, alive to the possibilities that come, almost unbidden, when one is receptive. It takes a certain holding to maintain oneself in that kind of readiness, which is why—as Stella

pointed out—so many men who are artists consider a wife an imperative. The woman who is an artist has, in effect, to be wife to herself. And that takes immense energy, and when she doesn't have enough, something gives.

The garden at Green End was her one place of respite, but even there, with 'strawberries warm in the sun', as Phyllis wrote in a poem dedicated to Stella and her garden, the war pushed in with its 'bitter reek', and invaded more than imagination.

> What can you smell as you die, all of you young ones,
> In shattered street, dark ocean, or blue air?[150]

With nowhere safe to go, Australia hovers in Stella's wartime letters, rather as it does in *Drawn from Life*, as a haven, a safe place where houses can stand unthreatened and life is still given to the ordinary—a quality she had once found restrictive. When Julie and Roland's flat was bombed, and her cousin Kathleen was apologetic about the safety of Adelaide, Stella was quick to protest. 'It's easier to support the grim things that are happening over here,' she wrote, 'if we feel that the recipe for a gay & easy way of living is not being lost, & it is especially heartening to feel that it is still going on in the country where I was born and which I still regard as my own.'

Perhaps prompted by memories of 'cornucopia' that were evoked by writing the childhood section of *Drawn from Life*, or perhaps only by the tiredness that came upon her with the war, Stella began to think of returning. So it was oddly appropriate that at this moment when life in England seemed impoverished as well as endangered, she should receive an offer from the Australian High Commission on behalf of the War Memorial in Canberra to take up a commission as a war artist. Her name had been put forward by Louis McCubbin, the director of the Art Gallery of South Australia and a member of the War Memorial's art committee. As none of her work had been publicly exhibited, and only two paintings reproduced in a small celebration of South Australian women, I assume that McCubbin knew of her range through the family. That she was inadequately known is clear in the confusion about her name; a War Memorial memo debating whether she was Esther or Estelle, assumed that the name 'Stella' had been 'mutilated in transit by cable'. The family was asked to adjudicate.

Stella Bowen was the second woman to be appointed; Nora Heysen, the first, began painting on the north coast of New Guinea in 1943. Stella's appointment was also made in 1943, and she took it up at the beginning of 1944. Her brief, in the dry language of government, was 'to provide a pictorial record of the activities of Australian forces in the U.K.'. Colin Colahan had already been appointed as a war artist in England and she was to co-ordinate with him. She was to be paid 2 guineas a day, seven days a week, plus fares and a travelling allowance of 2/5d for each day she spent outside London where appropriate service quarters were not available.

Her file is still in the War Memorial's archives, and it makes surprisingly interesting reading; pages of anxiety passed between the War Memorial in Canberra and Colonel J.L. Treloar, who was in command of the war artists, in Melbourne. The core of the problem, still tugging at the thin carbon-copied pages, revolved around the question of which uniform these two painters would be given. Neither of the women understood the significance of the problem, and Stella made the sensible suggestion that surely a pair of slacks and a shirt would do. 'She thinks that she does not need a uniform,' Colonel Treloar wrote. 'If this is correct, there appears to be no point in giving her a commission.' 'But,' the War Memorial replied, 'it will surely be necessary for her to wear one when she visits battle stations.'

The next problem to vex Colonel Treloar and the War Memorial was how to house Stella when she was painting outside London. A man could bunk in with the troops; a woman was dependent on there being nurses or one of the women's services stationed where she was painting. But what about the 2/5d daily allowance? The problem with that—which held up the appointment for several months—was that as a woman would have to avail herself of it more often than a man, the result could mean unequal pay in her favour, which was clearly unthinkable. And so the letters continue, in the middle of a war, until the assistant director of the War Memorial came up with this: 'Perhaps the only solution is to let her wear an ordinary khaki uniform on the lines of that worn by the women's services in England, but without any rank badges, although this will probably mean that she will have to be escorted while sketching in prohibited areas.'[151] Careful posting would have to resolve the question of where she would sleep.

More significant from Stella's point of view were the conditions

that made everything she painted during the term of her appointment the property of the Australian government and forbade her to paint privately. Stella accepted without hesitation. 'I'm absolutely loving my present job,' she told Kathleen later in the year. 'I wouldn't have missed it for anything,' she told Tom. 'It has taken me into a world that civilians usually don't get a glimpse of.'[152] It had also taken her into a productive relationship with the war that had been unnerving her; with her commission and her uniform, she painted her way back to the energy that seemed to have deserted her only a year before.

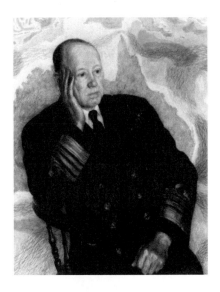

Stella Bowen,
ADMIRAL SIR
RAGNAR COLVIN,
1944.

At the War Memorial in Canberra there are forty-six works that come from this appointment, most of them oil on canvas. She began with portraits: Admiral Sir Ragnar Colvin and Air Chief Marshal Charles Burnett. 'The Admiral was the more difficult subject but somehow I did a better job on him,' she told Tom. Sitting in front of a map of the country he represents, she painted him large in his dark uniform, at a slight angle, not quite slumped but leaning exhausted into one hand, the other clenched in his lap. His expression is almost blank with worry; his hands are as expressive as a pianist's.

But the real pleasure began when Canberra agreed to her suggestion of painting group portraits of the men. 'Do you remember,' she wrote to Kathleen, 'how in my book I said how I longed to paint portrait groups in robes or uniforms as formal decoration, & not naturalistically posed? That is precisely what I now have a chance to do. I'm doing a Halifax Crew with the bunch of heads in the middle, all ensconced in the up-turned fur collars of their Irving jackets, & around them is a sort of border in which you see their seven pairs of hands in action.'

This is one of a pair of particularly fine group portraits. It's known as *Halifax Crew, Driffield*; the other is simply called *Bomber*

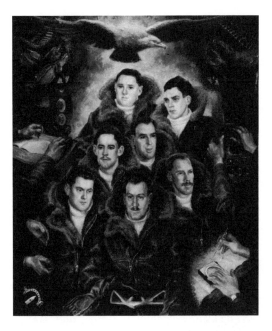

Stella Bowen,
HALIFAX CREW,
DRIFFIELD, *1945.*

Crew. In the unlikely role of war artist Stella found the subject that best lent itself to the idea she had begun in France with *Au Nègre de Toulouse*, and which she pursued through her English conversation pieces. In painting these young airmen in their operational dress, she expressed something essential not only about the dangers they faced, but of the sensibility of a woman coming to terms with her own fear.

'"The lads" from the Halifax crew,' she told Kathleen, 'are all tickled to death because they think that I got such good likenesses.' All of them had completed a full tour of thirty operations, and more than half were well into their second tour. Surrounding the heads of these tough, experienced men is a border made up of their hands at work, and it is in these skilled hands—rather than in their faces— that their vulnerability lies. Over their heads is the RAF eagle like a faint echo of the dove in the religious paintings of the early Italians.

In *Bomber Crew* (plate 12), the eagle is replaced by the sinister wings of the Lancaster in which the imperilled young men of this group portrait make their bombing raids. In the War Memorial in Canberra, there is a simulation of the inside of one of these bombers; with the press of a button one can experience the shudder and noise of the plane. What struck me standing there as it shook was how

small the cave of its body was. In another painting Stella showed men loading bombs up under the plane, a dark beast with its eggs.

Bomber Crew presented Stella with the horrible situation of having to finish the picture from photographs and sketches. In a 1946 Christmas annual for servicemen, the War Memorial published the story of the painting, of which 'not much more than a framework' was completed by 27 April 1944. 'Shortly after nine o'clock that night, the bomb-laden planes of 460 Squadron waddled down the dimly lit runway and roared away into the darkness. The target was Friedrichshafen—a vital industrial centre on the shores of Lake Constance. There was nothing to make the operation any more exciting or spectacular for the crews: it was just another night raid.

'But, by morning, the subjects of the unfinished painting had been reported missing. Nothing more was known. Hope of the aircraft limping home gradually waned—then died.'[153]

It was like 'painting ghosts', Stella told Tom. A chorus of angels, she'd said seventeen years before when she painted *Au Nègre de Toulouse. Bomber Crew* is a remarkable painting. Within the formal structure she captures not only the individuality of the young men so cruelly killed, but the complexity of their task and the jumble of war, at once ordinary and far from ordinary. There they are, uniformly dressed, seven individuals who are acutely alive to their separateness and yet dependent for their survival on their capacity to lay that aside and act as a unit. Bunched together, almost as if they were one entity, they are like a strange ancient creature. The detail that draws my eye is the oxygen mask attached to each helmet, hanging down, almost touching their cheeks, with the mouthpiece that would be over their faces, turned towards us. The inside of this rubber mask is soft, rather like the inside of a sea creature, vulnerable and tender. And yet the soft life-giving apparatus could not save them. It is this underside of uniformed bravery offered in a public portrait of service and honour that moves me. Such unprotected heroism.

In fact one of the young men did survive. Flying Officer T.J. Lynch—you can see his name on his helmet second from the left in the back row—reappeared out of a POW camp at the end of the war like a returning ghost, long after Stella had finished the portrait. He was repatriated, the War Memorial reported, 'in the fifth exchange

of prisoners arranged between the Allies and Germany, and arrived back in England at Liverpool on 5 February 1945'.[154]

Despite her pacifism in the First World War, and her fear of the bombs in the Second, Stella enjoyed—if that's the word—her sojourn in the services. She liked living in barracks even when (as was usually the case) the conditions weren't comfortable. 'The WAAFs,' she told Tom when she was stationed in Wales, 'are very un-official & unassuming & it's almost like staying in a private house. At the officers' mess (where we eat) perfect strangers thrust drinks into your hands on all occasions & say "please have this with me." And all are interested in the idea of the picture.' It wasn't always the case that the people on the ground were interested in her painting, but even when they were not—usually because they were too busy and the war too close—she felt accepted in their midst *as an artist*. Whereas once she had suffered the ignominy of finding herself terrified, her knees collapsing under her at the sound of a bomb, when she was at work in her uniform, facing the young men and women who were doing the hard work of war, she found that she could once again hold herself steady. It was as if with this appointment, this initiation into the bodily reality of making war, the world became alive to her again.

The winter of 1944–45, like the winter twenty years before, was uncommonly bitter. Julie and Roland, who couldn't get coal, were carrying it scuttle by scuttle from Stella's house in Chelsea to the temporary rooms where they'd moved after the bomb hit Lower Sloane Street. Stella was in Yorkshire, not so far from where Ford had been stationed in 1917. It was so cold that the whole camp looked as if 'it had been iced for a birthday cake'. She had never been so cold, she told Kathleen. 'We are in Nissen huts with no central heating . . . Pipes and boilers are bursting everywhere.' And yet her letters are happier—fuller, more energetic—than they were when she was in civilian London.

It is one of the many ironies of Stella Bowen's life that this woman who learned her trade in the vulnerability of love found such full expression as an artist in war. One could say it was an accident of birth, an accident of history; but if we understand art to be about engagement with life, then we can say that her art wasn't separate from her life, an accident, but held in tension with it. We could say that the wounds of the self-portrait were transfigured into her understanding of the vulnerability of these young airmen. And her

struggle with the masculine modernism she'd encountered with Ford gave her a sense of structure and form which, in the culture of war, was strong enough to lead her further from the rubrics of modernist technique and yet give her a way of representing the modern nature of war.

Her war oils are full of echoes and tiny repetitions as she brought her powerful eye to the people she saw behind the lines where civilians couldn't go. In *'D' Day 0300 Interrogation Hut* (plate 13), we watch a briefing through a serving hatch. Rather like a small theatre, the men are illuminated through a series of apertures; and while they are given the map of their night mission, in the foreground a man and woman, both in uniform, look at each other across the counter that provided sustenance in the form of cigarettes, biscuits and tea as they prepare to fly out over the dark channel of water. Can they fall in love, these young people regarding each other across the gulf of danger? Dare they? The ordinary and the extraordinary abut each other, yet in the ordinariness of this scene is Stella Bowen saying that the most ordinary experiences, like a man talking to a woman, may always be extraordinary and dangerous, even without a war?

In *Remains of a Fly Bomb*, the twisted remains of the bomb lie like a torso, with divided buttocks, its legs of twisted metal. There is a surreal quality to this dispiriting image in which the implement of destruction—the feared bomb—evokes the flesh it destroys. Made by us, it kills us; again the double edge that Stella knew so well.

The War Memorial was pleased with the work that was shipped to them by the High Commission in London, and Stella's appointment was extended after the war had ended so that she could paint the return of the POWs. This time she was posted to Gowrie House in Eastbourne. In an oil of the reception desk, she captured the relief of the men and the tenderness of the women looking after them. She painted the hands of the POWs as they were processed through the medical debriefing; she painted their gaunt faces as they queued for blankets and kit; she painted them waiting for their papers; and she painted them, wounded and broken with limbs missing, in convalescence hospitals. At the same time as she was producing these images of the human cost of war, her son-in-law Roland was editing the footage that came out of the concentration camps, seeing before anyone else the terrible record that he was turning into films fit for the public.

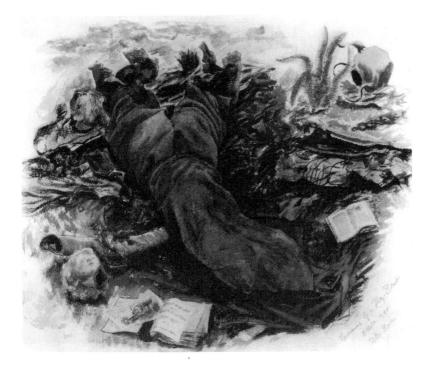

Stella Bowen,
REMAINS OF
A FLY BOMB,
1944.
'If I can somehow
come to terms with
it by painting it,'
she said of the war,
'I shall feel better.'

When her work arrived in Canberra, Colonel Treloar told the War Memorial that he found Stella Bowen's work 'interesting'. It was a feeble response that gave the appearance of a compliment while conveying a covert hesitation. There was clearly something in her work he didn't like, but he never made his objections clear, merely querying that there was not more of it.

Nora Heysen in New Guinea submitted much more than Stella—there are about 200 of her works in the War Memorial—but most of hers were quick sketches, with few as fully realised as Stella's. She got into a different kind of trouble with Treloar. He didn't have any problem understanding her work, and most of it passed his test of suitability. But he was furious that she had included two scenes of nurses relaxing, one at a dance, the other over a pot of tea on the verandah of their quarters. Treloar considered this choice of subject 'frivolous' and damaging to the way the war would be seen. That she had also made dozens of sketches as the nurses worked—in pathology, surgery, wards, kitchens, store rooms— seemed not to temper his anger.

I suspect Colonel Treloar did not know why, or how, to object to the paintings that came from Stella Bowen. They are not aesthetically radical, or at least their radicalism is not immediately recognisable as radical. There is nothing overtly anti-war about them. On the contrary, by celebrating the very real courage and hard work of the young people who were the tools of war, they appear celebratory. Even Admiral Colvin is painted with sympathetic respect for an uncomfortable role. And yet Stella's hatred of war is subtly present in every painting. Did her ability to capture vulnerability, her reminder that there were hearts beating under those uniforms, unsettle the colonel, or was it that the hands that operated the instruments of war were also hands that could be held in love? When his tone became querulous, the War Memorial reminded him that her canvases were more thoroughly worked than most they received from other war artists. 'No doubt the Commonwealth has received good value for the payments made,' he replied, as if to draw the matter to a conclusion.

12. STELLA'S CORRESPONDENCE WITH Colonel Treloar and the War Memorial didn't end with the consignment of her last canvas. She had assumed from the terms of her appointment—which included a medical for a repatriation pension—that she would be eligible for repatriation to Australia. Although she had passed the medical at the end of 1943, by 1945 she was ill with cancer of the colon. There is nothing in her rather depressed letters to Kathleen earlier in the war to suggest that her health was worrying her, and her war artist letters are full of vigour. But when she was given a final commission in 1946 to paint the King and Queen taking the salute on Victory Day, the painting was delayed in the studio by an operation that kept her in hospital for several weeks, and Julie had to help her finish it.

She was also not well enough to take up as fully as she would have liked an offer to write for the BBC's Pacific Service, although earlier in the year she had given several 'informal reports of life in England' that had been 'beamed at Australia'.[155] The Director of Talks who had made this offer was Theaden Hancock, who was married to the Australian historian Keith Hancock. 'Theaden and I got to know [Stella] in 1942,' Keith Hancock wrote in a letter to a friend to whom he gave one of her paintings. 'She lived in Danvers Street Chelsea in or near ground which had belonged four centuries before to Sir Thomas More. We lived a mile away in South Kensington, and hardly a week went by without a visit and a return visit. Both she and Theaden were wonder working cooks and in both houses there were usually young people to share the feast—airmen particularly.'[156]

Theaden shared with Stella that much-noted quality of practical good sense and you can see it in Stella's portrait of her. They also shared the experience of marriage to a man whose work kept them from their own; in Theaden's case it was accompanying Keith away from London that hindered her career, rather than unreasonable domestic demands. Stella painted *Theaden in Kensington* (plate 14) as

the war ended and she received the news of her own mortality. It is the largest portrait by her that I have seen, and one of the most intense. Standing almost life-size, its effect is powerful. Full of appreciation for all that she must leave behind, Stella painted her friend with admiration, sympathy and a kind of longing. Wearing a well-cut coat softened by the deep red of her cardigan, Theaden stands firm on the ground, and yet there is something melancholy, even transitory, in her stance. There is an open window behind her; she does not look out— but we do—onto a London garden that is at once formal and at ease. Beside the path there is an empty park bench of the sort you find in England, with a rolled back and elegant cast-iron arms. Never did a view from one of Stella's windows look more inviting.

Perhaps the bitterest twist in Stella's story comes here, right at the end, with her thwarted attempts to get back to Australia. Ill, knowing she probably did not have long to live, and with Julie married, there was nothing to prevent her return, at least for a visit. She wanted to see Tom, who had been imperilled by a stroke; she wanted to meet his children, who were growing up without her having seen them; she wanted to be near Kathleen; and she wanted to complete the circle, to stand again on the land where she had been born.

Her request for repatriation caused another flurry at the War Memorial. At first Treloar said she didn't have a case, but then weakened to the point of contemplating the possibility of finding her a berth on a troopship. After a lengthy exchange of anxious memos, he left the task of negotiating with her to Australia House in London. 'You will appreciate,' the High Commissioner wrote to her in November 1945, 'that you were not engaged in Australia and sent to this country but were appointed here.' He then reported to Treloar : 'It would appear that she has accepted my view . . . I have therefore not gone into the question of whether it would be practicable to arrange for her to travel to Australia on a troopship conveying returning RAAF personnel.'

Tom, still convalescent and without spare funds, drew a blank with the trustees, who said they would not be able to pay her fare. Kathleen offered to lend it, and Stella would have accepted had they been able to mount an exhibition from which she could have paid her back. It almost happened. Louis McCubbin offered his support for a touring exhibition under the auspices of the War Memorial,

and so did Will Ashton, an Adelaide painter who was by then director of the Art Gallery of New South Wales. But the idea was eventually scuttled by the savage government duties on works of art brought into, or sold in Australia by artists who had lived abroad for more than seven years: 11% customs duty, 25% sales tax, 70% tax on frames. As well as the 25% Stella would have lost on the exchange rate. McCubbin pointed out the duties problem in a letter to Treloar in October 1946, and to be fair to Treloar he was—quite genuinely I think—on side with the idea of an exhibition and prepared to lend works from the War Memorial. In July 1946 the prospects still looked promising enough for Stella to ask Kathleen about clothes. 'Shall I need anything good, or can I get away with one simple long black skirt and various tops?'

Her health when she wrote that letter was not immediately worrying. She hadn't been to a doctor for some time, and the cancer seemed to be in remission. But by the end of the year it was back. 'I have received my notice to Quit,' she wrote in January 1947 to Jenny Bradley, who, of all her friends, was the one she considered the best conversationalist. 'I am very sad Jenny, at the idea of not seeing you again . . . I grieve too at never seeing Paris again, nor the Midi.'[157] In the same month Phyllis wrote the first poem in a sequence of commemoration for her dying friend:

> You broke my heart when you spoke to me in gratitude,
> So gently, for the small things of no importance
> That I may do for you now—
> You, who for thirty years have cherished me
> With more than a sister's loving understanding . . .[158]

By the following summer, when Kathleen wrote again to Treloar about the exhibition that was still under consideration with the War Memorial, she told him that Stella was 'fatally ill, as I think you know'. There was no question of her returning at this stage, Kathleen said, but she would be comforted to know that her work would be shown in her own country. Could the exhibition start in Adelaide, Kathleen wanted to know, as Tom was still not well?

There is a photo of Stella sitting on her bench outside the cottage at Green End during that last summer of her life. She looks weary, as if the effort of holding herself up, even when sitting with a

wall to support her, was too great. Her hair is longer, greying and tied back, and there is a quality of luminosity around her that is sometimes to be seen in those who are approaching death. 'You were so beautiful, aureoled against the light/ In silver,' Phyllis wrote. She was an excellent friend though not a great poet. Her poems were published in a small edition after her own death in 1955 as another form of commemoration. Through them we glimpse Stella as she worked her way towards death, tended by Julie and Phyllis. Two days before she died, Phyllis gave her a voice in a poem in which she says she wants 'no sorrowing words, pale whispers' of 'friends assembling for a last goodbye'. Rather, and characteristically, 'a clarity/ Where friendly faces meet mine without fear.' But although the sentiments might be Stella's, the language is Phyllis's. Stella's own words were plain. 'Don't wait for the ashes or any nonsense of that sort!' she had written to Julie in a letter about funeral arrangements. 'Go and have a drink somewhere.'[159]

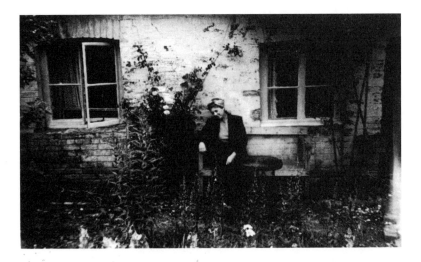

Stella at Green End, 1947.

Stella lived just long enough to see her grandson, Julian David. 'She felt him all over,' Julie said, 'saw that he was perfect, and ceremoniously put one drop of champagne on his lips for good luck.'[160] Stella had been looking forward to Julie's children, she'd told Kathleen in 1943, but not too soon. 'Otherwise I can foresee that I'd have to Mind the Baby, instead of enjoying my new-found freedom.' As it was, the pleasure of that conflict was denied her. She died on 30 October 1947, three weeks after Julian David was born. 'Peacefully,'

Julie wrote. 'Gentle', was Phyllis's word. 'It is not now, when the last rites are over,' she wrote in a 'Requiem' for her friend, 'that I am missing you most,' but in the future she'd face without those winter evenings 'when we sat and talked by the fire amongst your pictures.' It fell to Phyllis to register the death. 'Former wife of Ford Madox Ford,' she wrote. 'Now divorced.'

Stella Bowen was fifty-four when she died. She never returned to the world of art to reclaim that 'small stake' she'd made before the war stopped her, and she barely had a taste of her new-found freedom. Her last painting, a still life with grapes (plate 15), was left unfinished. Theaden and Keith Hancock had asked her to paint them a 'flower piece' during the last year of her life. The flowers are in a vase of Norwegian peasant pottery that belonged to the Hancocks; beside them a bunch of purple grapes is caught in a ghostly moment, promising much and yet showing the outline of canvas that lies beneath paint like bones beneath the flesh.

And if Stella had lived? What would she have gone on to paint? If she had returned to Adelaide, what would she have brought to Australian art? What would Australia have brought to her? 'Stella was the most courageous, vital and harmonious person I have ever known,' Keith Hancock wrote to Julie after she died. 'Her death is a waste, for she had so much to live for, and such a genius for living.'[161]

Julie and Roland visited Adelaide early in the 1950s, bringing with them a number of Stella's paintings, including the *Self-Portrait* and *Provençal Conversation*, two landscapes, *The House Opposite* and a still life of roses in a vase. *Villefranche*, *Avignon* and *Reclining Nude* had been brought back before the war by Kathleen and other returning cousins. Julie eventually took the rest that had been at Green End to California, where she, Roland and Julian settled. One of the Ford portraits found its way with the correspondence into the library of Cornell University; the rest that were Julie's are now with Julian's widow and their daughter Erica. The portraits of Margaret and George Cole are in the National Portrait Gallery in London. Many of her commissioned portraits have vanished, dispersed as people died and their families moved on. We don't even have a full record of where they started. And we don't know what paintings she gave to Phyllis, or to other friends. The photos she sent to Tom preserve some record of what should be there, but how many more are there of which we know nothing?

In Canberra the war paintings are at the War Memorial Museum, and there are a few drawings in the National Gallery. Otherwise, until recently, there has only been one major painting by Stella Bowen in an Australian public gallery: *Embankment Gardens* in the Art Gallery of South Australia. It is a large canvas, dated by the gallery c. 1943. I think it was probably painted earlier, before the blitz, before she was caught in the depressing round of teaching and travelling that ground her down in 1943, perhaps even before the war. The reason I think this is not only because there is no sign of war damage or uniforms. The painting is almost the same size as *Provençal Conversation* and, despite the obvious difference in climate and location, it has something of the same feel. It is winter, the trees are bare, it is bleak; and yet *Embankment Gardens* (plate 16) is calm and ordered. And expansive. It is painted from a vantage point of some elevation, perhaps a window. *Provençal Conversation* was painted from a slight elevation, perhaps by the doorway at the top of the white steps. But the significant change is that she no longer needed to show the window or the door as a point of mediation, or to protect herself, or to frame what she saw through anything other than her own eyes. In *Embankment Gardens* there is a lot of air.

I like this painting. Its mid-winter, mid-afternoon atmosphere. Its balance. Its symmetry. The misty city across the river. Because it came late and was painted (as far as we know) without the pressure of a commission, it is this painting more than any other which fills me with those sorrowful, impossible questions. Unlike *Provençal Conversation,* which draws a phase of her life to a conclusion, *Embankment Gardens* opens something up. And it is this, I think, that makes me wonder what would have come had she lived. At her best—in the *Self-Portrait*, in *Provençal Conversation*, in *Bomber Crew*—she is very good. What would she have done if she had had twenty more years untrammelled by Ford, or depression, or war, or cancer?

As it is, for the fifty years since her death, Stella Bowen has been little known in the country of her birth. There was finally an exhibition of her war paintings at the Art Gallery of South Australia in 1953, but it didn't tour; to date it is the only exhibition that has been given solely to her work anywhere on this continent. The family has always been generous, lending the paintings in their care to the few group exhibitions that have included her, and it has

recently given the *Self-Portrait* to the Art Gallery of South Australia.

I first saw Stella Bowen at an exhibition called *A Century of Women Artists: 1840s–1940s*, held at the Deutscher Fine Art Gallery in Melbourne.[162] It was 1993, a year which, as it happens, was the centenary of Stella Bowen's birth and also of Rose MacPherson's enrolment at Victoria's National Gallery School. The *Self-Portrait* shone from the wall, and I went back to see it again the next day. Also *Reclining Nude*, *The House Opposite* and *Provençal Conversation*, which made their own impact. When I returned to Sydney, I went straight to the library to find *Drawn from Life*.

Seeing Stella Bowen's brave and troubled face for the first time in an exhibition of Australian women's work confronted me with a paradox, for I saw at once how different she was—the sophistication of the expatriate, I suppose—and also how comfortably she sat among the women of her generation, none of whom, as I was to discover, she either knew or was known to. She shared the exhibition with one of Grace Cossington Smith's studies of a sister, her still life of teacups on a tray, and a sea-scape, awash with grief, that she had painted on the death of her mother. There were also a few good Dorrit Black linocuts and her splendid oil, *The Double Basses*; Olive Cotton's *Tea Cup Ballet*; Ethel Spowers' linocut *Wet Afternoon*; a small Sybil Craig watercolour; Clarice Beckett's *October Morning* and a sea-scape with a moored yacht; and Margaret Preston's *Tallong Road*, a dry landscape, brown and ochre, with ghostly silver-grey gums.

The exhibition also included one of Nora Heysen's self-portraits from the 1930s. There she was, holding a palette with her strong face fully revealed, though it is turned to look at us—or the mirror in which she regards herself—rather than at the paint she is holding. Another self-portrait from the same era, in which she holds a sketch-board, has a look almost of defiance; there is no doubt that this woman will make her mark. It is an arresting painting which captures a good deal of the determination that was required if a woman was to paint, if not the attendant ambivalences. The first of these paintings is privately owned, but the second is in a public collection in Hobart, and as a result Nora Heysen's image of herself is known in a way that Stella Bowen's is not. She is, for instance, the only Australian represented in a recent book on women's self-portraiture by an art historian from London University.[163] Indeed, she makes it to the cover with *A Portrait Study 1933*, and it is a painting

Nora Heysen,
A PORTRAIT
STUDY, *1933.*

worthy of the honour. But one of this century's great self-portraits by a woman is absent. I don't think that I'm being partial when I say that Stella Bowen's *Self-Portrait* belongs in the opening pages of a book which plots, with eight key paintings, the self-portraiture of women from Artemisia Gentileschi to Paula Rego.

Without her work in public galleries, Stella Bowen has been— literally—hard to see. Any artist is at a disadvantage if the work is not on public view. But this is not the only reason Stella Bowen has vanished through a lot of cracks. For a long time her resistance to the prevailing school put her outside accepted critical discourses; there is still no easy critical label for her. And the fact that she has been seen primarily as Ford's consort has cast a long shadow. *Drawn from Life,* which was reprinted in England in 1984 by the feminist press Virago, has always had a small following, and in so far as Stella Bowen has been known, it is for this. But even Germaine Greer, who drew on Stella's account of being held back from painting for *The Obstacle Race,* her large and celebrated book on women artists, did not reproduce or discuss a single painting.

But reputation is a precarious matter. Ford Madox Ford has never been well known in Australia, and this, perversely, has also

counted against Stella. For more than fifty years after its first London publication, *Drawn from Life* was not published in her own country. In the absence of any interest in Ford, for a long time the memoir was not considered appropriate for the Australian reading public. Despite champions of the calibre of Frank Dalby Davison and Geoffrey Dutton, who were advocates for her during the 1960s, Australian publishers remained (always with regret) not sufficiently interested in Stella Bowen to risk publishing her.

Now that there is a national portrait gallery in Canberra, maybe someone will be inspired to do the thorough search that is needed to place her among her peers as a painter of portraits. Maybe this chronicle of neglect is just another case of the world having to catch up with a woman whose art has for a long time been lost to us. The ways in which we can understand it now are very different from the views that prevailed during her lifetime. Where once it was the narratives of the great men which told the story, now it is as likely to be the voices of wives and mistresses that capture the imagination of readers. And at last, as the century closes, *Drawn from Life* is to be published in her own country.

But even during those long years when it seemed that Stella was doomed to obscurity, there were quiet victories. In the battle of the books, in which she had the great advantage of coming last, she got more than the last word. More than any of the others—including Ford—she has affected how the story is understood and told. 'Be truthful,' Virginia Woolf wrote in *A Room of One's Own*, 'and the result is bound to be amazingly interesting.' And of course it was, and is. In 1940 the sort of truth Stella Bowen had to tell was rarely heard: a woman who could speak of being wronged by a man and not be punitive; a woman who could say that in taking the freedoms of the century, she also took its risk. She is the one who is quoted in biographies, not only of Ford but of figures like Ezra Pound who surrounded them. She is quoted for her reliability, for her truth. 'You are one of the bravest and most reliable people I have ever met with,' Edith Sitwell wrote to her in 1929. 'Don't you know what you're like? Why, even talking to you for a few moments makes one feel braver, and more able to face things.'[164]

The story Stella told has served her well. By giving the generous version, she has come to be seen as generous. Which she was. By telling the story of her liaison with Ford as a great love story, it has

become a great love story, albeit in the modern idiom. Which it was. None of it is untrue. There were slippages and avoidances, even a few sleights of hand; and yet in being the version that gave voice to values she struggled to live by and wished to be remembered by, it has its own very real truth—not only because of the power with which she wanted it to be true, but because its lessons were drawn from, and returned to, her own life.

Rather like those faces on the streets of Paris, making and remaking themselves, Stella Bowen was the quintessential modern woman, using the material of her life to remake it in the image she wanted to live by. When she called her memoir *Drawn from Life* it was, like so much else in her story, a double move. She did draw on her life and on the lives of the people around her both in language and in paint—and she had a lot to say on the subject of art, love, and the factual inadequacies of a temperament like Ford's. Equally she knew that every image, every narrative, was complexly constructed, in no way as innocent as she sometimes let it appear. So to say that her writing and her art were drawn from life was at once true and ironic. For what mattered, as Rilke understood of Paula Modersohn-Becker, was the intensity and integrity she brought both to her life, and to her art.

> you pulled the lovely weft out of the loom
> and wove your threads into a different pattern.
> And still had courage enough for celebration.[165]

In the early 1950s, on a street in Sydney—a city Stella never visited—the painter James Gleeson met her old teacher Margaret Preston outside a framer's shop. Gleeson, then a young man, was going in as Margaret Preston, nearly eighty, was coming out. When he asked her if the wrapped and framed painting she was carrying was something of hers, she replied firmly that it was not. 'I'm not going through the pearly gates with paint on my wings,' she said.

I've heard this story told (not by Gleeson) as if to say that's the problem with women as artists. They baulk and back off before the end. The assumption is that a real artist would go bursting into heaven with paint splattering everywhere. I imagine St Peter curling his nose at the sight of Cézanne in his filthy smock. I imagine the flurry among the cherubim as Velasquez sweeps in amid his retinue

of kings and dwarfs; the silence of respect for the very splendid figure of Rembrandt, very old by then and rather blind, shuffling proudly in.

But the reality of leaving this life isn't like that. It is a painful surrender, and there's no divine right of control for any of us as we make that last labour. Ford died in a hospital in France with a tetchy doctor and a better woman than he deserved beside him. Stella died in her cottage with her daughter and sister-friend beside her. 'Aware of what the human heart empowers,' Phyllis wrote, 'Knowing that the last work is Love unfurled.'

Would Stella have wished the final word to be given to love? Of those great destinies, was Love the one, in the end, that she chose? The one that mattered? Would she have pointed out that the last word was given in poetry, and if we're to be churlish and say it isn't much of a poem, by whose standards do we judge? And by whose standards do we make the choice? Did she choose? Is choosing what she did? If her life teaches us anything, it is that more than one thing matters, and maybe in the end it is the conversations we have—both in love and in art—that will come trailing behind us through those pearly gates. I like to think so.

PLATE 1
Stella Bowen,
VILLEFRANCHE,
1923. Oil on wood panel,
33.8 × 23.2 cm (sight).
(Private collection)

PLATE 2
Stella Bowen, AVIGNON,
c. 1923. Oil on wood panel,
27.0 × 35.0 cm. (Private collection)

PLATE 3
Stella Bowen, UNTITLED
[French Seaside Village],
*c. 1923. Oil on wood panel, 34.8 ×
25.0 cm (sight). (Private collection)*

PLATE 4
Stella Bowen, FORD IN A
BOW-TIE, *c. 1924. Medium
and dimensions unknown.
(Private collection)*

PLATE 5
Stella Bowen, FORD IN AN
OPEN COLLAR, *c. 1924.
Medium and dimensions
unknown. (Private collection)*

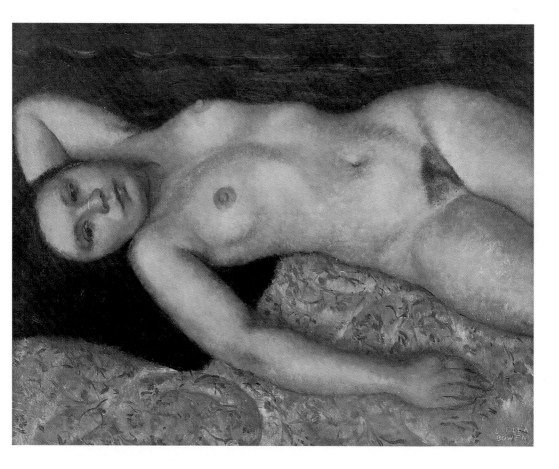

PLATE 6
Stella Bowen, RECLINING NUDE, *c. 1928.*
Oil on board, 31.5 × 40.5 cm. (Private collection)

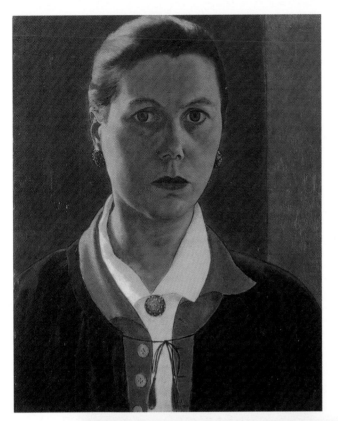

PLATE 7
Stella Bowen,
SELF-PORTRAIT, *c. 1928.*
Oil on plywood, 45.0 × 36.8 cm
(sight). (Art Gallery of South
Australia, Adelaide. Gift of
Suzanne Brookman)

PLATE 8
Stella Bowen, DAME
MARGARET ISABEL COLE,
c. 1944–45. Oil on board,
40.6 × 48.3 cm. (National
Portrait Gallery, London)

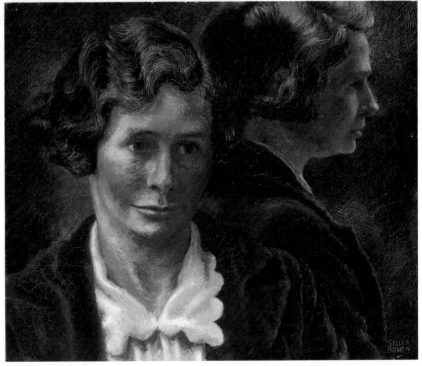

PLATE 9
Stella Bowen, PROVENÇAL
CONVERSATION, *c. 1938.*
Oil on canvas, 63.5 × 72.2 cm.
(Private collection)

PLATE 10
Stella Bowen, THE HOUSE
OPPOSITE, *c. 1941. Oil on
canvas, 63.5 × 39.5 cm.*
(Private collection)

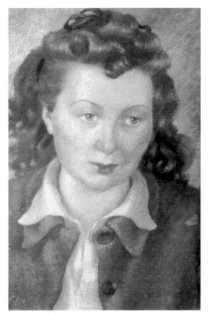

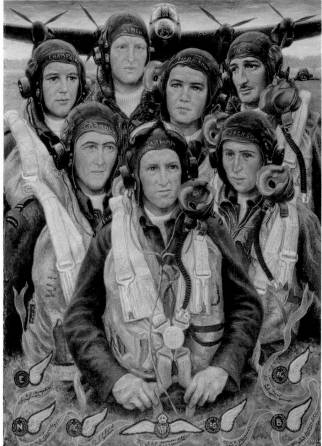

PLATE 11
Stella Bowen, JULIE, *1940.*
Medium and dimensions unknown.
(Private collection)

PLATE 12
Stella Bowen, BOMBER CREW, *1944.*
Oil on canvas, 86.1 × 63.3 cm.
(Australian War Memorial, Canberra)

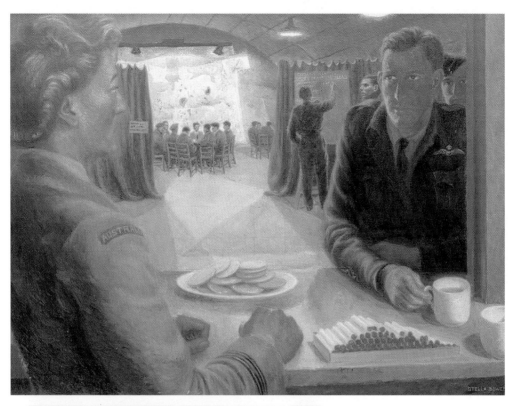

PLATE 13
Stella Bowen, 'D' DAY 0300
INTERROGATION HUT, *1944*.
Oil on canvas, 63.5 × 83.8 cm.
(Australian War Memorial,
Canberra)

PLATE 14
Stella Bowen, THEADEN
IN KENSINGTON, *1946*.
Oil on canvas, 91.8 × 76.8 cm.
(Private collection)

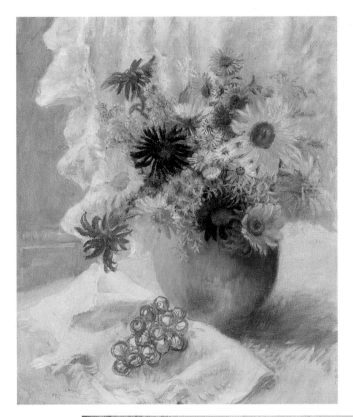

PLATE 15
Stella Bowen,
UNTITLED [Still
Life with Grapes],
1947. Oil on canvas,
44.2 × 37.0 cm (sight).
(Private collection)

PLATE 16
Stella Bowen,
EMBANKMENT GARDENS,
c. 1943. Oil on composition
board, 63.5 × 76.0 cm.
(Art Gallery of South
Australia, Adelaide;
Elder Bequest Fund, 1943)

III

No Man's Land

WHEN STELLA BOWEN was living in the rue Notre-Dame-des-Champs, three cousins on a Cook's tour of Paris visited her in her studio. Wanting to impress and to avoid being thought a 'queer bohemian', Stella invited Edith Sitwell to tea to meet them, but when her enormous friend arrived with her brother Sacheverell, who was 'also nine feet tall', Stella began to feel that 'impressiveness was perhaps over done'. As it turned out, she needn't have worried, for the cousins, though momentarily taken aback, were oblivious to the significance of the two giants before them and remained stolidly unimpressed. 'I had a cosy time with them,' Stella wrote, 'and got the impression that Australia was the one thing that remained the same in a changing world.'[1] Especially when it came to an understanding of art.

So she was in for a surprise ten years later when 'two young painters' turned up in London with an introduction from Adelaide. Remembering the rather desolate environment that she had left behind, this time she worried about how she would bridge the gap. 'I feared they would ask me to take them to the Academy and would want to know what I really thought about "all this modern stuff". Instead, it was they who put me through my paces concerning the entire course of European painting since the war. There was no name in modern art, however obscure, with which they were unfamiliar, and no reputation whose growth they had not followed with attention. And it had all been done by dint of enthusiastic reading and the study of reproductions. I . . . have thus become quite confused in my idea of Australia today.'[2]

Well might she have been confused. For while the Adelaide of 1914 had indeed been stuffy, the landscape of art in Australia had changed its shape and contour over the years that she was away. As it happens, the first signs of change came little over a year after her departure, but there was no way that she could have known about Grace Cossington Smith's *The Sock Knitter*; it was shown briefly at the Society of Artists' exhibition in Sydney in October 1915, received

no comment and was returned to her studio, where it remained for the better part of fifty years. When it was exhibited that first time, Stella was studying at the Westminster School in London and, had she known of it, she would—unlike the Australian newspaper critics and viewing public—have been in a position to understand what her distant compatriot was doing.

Grace Cossington Smith herself was studying in Sydney with Anthony Dattilo-Rubbo, the immigrant Italian who was the first artist to introduce reproductions of European post-impressionism into an Australian teaching studio. And by an odd coincidence one of Grace's fellow students, a young woman called Norah Simpson, had returned to Sydney from the Westminster School in 1913, bringing with her news of the English moderns with whom Stella was studying. So in this case of almost crossing paths, Grace Cossington Smith had some idea of what was happening in London and Europe, while Stella Bowen, in London and then Paris, had no idea what was happening in Sydney. One of the paradoxes of working as an artist (or writer) in Australia is that we have to know about elsewhere, while elsewhere rarely knows about us. The stories of these two women unfolded in ignorance of each other.

So it isn't odd that Stella Bowen knew nothing of Grace Cossington Smith; but it is odd—or perhaps sad would be a better word—that she knew nothing of another group of Australian artists—women almost exactly her age—who were studying in Paris during those years of the late 1920s while she was struggling with her self-portrait and giving tea to her oblivious cousins. Especially as one of those women had, like her, grown up in Adelaide.

Dorrit Black arrived in Paris at the end of 1927 to join her Sydney friends Grace Crowley and Anne Dangar, who were studying with the cubist André Lhote (one of the minor figures in Roger Fry's second post-impressionist exhibition). She caught a ferry across the Channel from London, where she had been working with Claude Flight at the Grosvenor School, and joined the classes that people were 'hanging by their bootstraps' to get in to.[3] The Académie Lhote was in Montparnasse; it was that close to Stella. Had she met Dorrit Black, or one of the others who were studying in Paris at the time—Mildred Lovett and Eveline Syme were also there—she might have been less taken by surprise when those two young unnamed painters turned up a decade later to visit her in London.

Despite their proximity, it was as if the interests of Stella and these visiting Australians were as partitioned as they had been by the hemispheres. The Australians were not part of Stella and Ford's expatriate group, and the high modernists of that milieu were not interested in a minor cubist whose classes were pitched at the English-speaking travelling young. Commerce and fashion: remember Pound's scorn when Stella wanted to study with Sonia Lewitska. And if the visitors had heard of Stella Bowen in Paris, it would not have been for her art—only her intimates had any idea what was going on in her studio—but for her liaison with Ford Madox Ford. They may have been in the same *arrondissement*, but that did not mean they had any way of realising how close her struggles were to theirs, for all that she was the married mistress and they—the generation of *The Sock Knitter*—were single women in search of an identity.

So when we consider Stella Bowen's failed attempt to return to Australia, there is the added, uncomfortable irony of knowing that she was part of a generation of Australian women she knew nothing about. I can't even say, as I can of Grace Cossington Smith, that she was on its fringes. She wasn't. For all she knew, it might never have existed. She knew Margaret Preston in her pre-war existence as Rose MacPherson, of course, but there's nothing to suggest that she met up with her former teacher in England, although she was there when Stella arrived in 1914 and stayed on for the war with Gladys Reynell, teaching pottery to shell-shocked soldiers in a hospital in Devon. Despite that moment of conjuncture in Adelaide and five years in the same theatre of war, they found their way to modern art by very different routes. And as far as I can tell, Stella did not know that Rose Margaret MacPherson married on her return to Australia in 1919, and, as Margaret Preston, became the most visible of Australia's first wave of modern artists. She knew nothing of the generation of women who were working in her homeland, and she knew little of the environment in which they worked, or of the antipodean experience of modernity.

By any reckoning it was an extraordinary generation.[4] Out of the ordinary in that there haven't been so many women, until very recently, working as artists and pushing at the boundaries of accepted practice. And there has never been a generation like it in that it was women who were, for that brief interlude between the wars, producing the most interesting and challenging of Australian art. Not that it would have seemed so at the time; their confidence in the direction they were taking was not matched by the praise of the world. Hans Heysen and George Lambert commanded the prices, not Grace Crowley and Dorrit Black. It's now, looking back from an age that is highly sensitive to the achievements of women, that we can say these things—which is why they get lumped together and called a generation; but when you consider the dates, you can see that it was a spread-out grouping, barely a generation at all. Margaret Preston, who took pride of place and was seen at the time to take it, was born in 1875 and her friend and rival Thea Proctor in 1879. Then there was a gap before the bunched-up rush of births: Anne Dangar, 1885; Clarice Beckett, 1887; Eveline Syme, 1888; Grace Crowley and Ethel Spowers, both 1890; Dorrit Black, 1891; Grace Cossington Smith, 1892; Stella Bowen, 1893; Daphne Mayo, 1895; Sybil Craig, 1901. And that's not all of them, anything like, and it doesn't include the writers such as Miles Franklin, Katharine Susannah Prichard and Christina Stead, who were also born in the rush of those years. You can see from the dry facts of the list that these women, born to greet the century as their own, came to young womanhood with the slaughter of the First World War, and found themselves thereby entering their maturity as artists at a time of extreme masculine crisis.

Did they succeed as artists, these women, even to the extent that they did, because a generation of men was either mangled and destroyed, or badly disoriented? Did they have to wait for a breach of the male order to get a toehold of their own? Does the success of women depend on the defeat of men?

In 1920 George Lambert, as official war artist, painted *A Sergeant of the Light Horse in Palestine*. He was over forty when, in the third year of the war, he took on the task of documenting the fate of men much younger than himself who were fighting on the front

lines. As Lambert was a horseman as well as an artist, his posting to Palestine to paint the Australian Light Horse Brigade was an appropriate though emotionally charged task. It would hardly be right to say that he enjoyed the assignment, but its impact stayed with him long past the armistice. This painting was done in London, in his Kensington studio, shortly before he returned to Australia; its power comes not from the proximity of action but from the reflection and knowledge of retrospect.

George Lambert, A SERGEANT OF THE LIGHT HORSE IN PALESTINE, *1920.*

Like Stella Bowen, Lambert had been smitten by an encounter with the early Italian painters; for him the clarified delicacy of Botticelli's figures was the inspiration, and like Stella Bowen he wanted to paint with a clear and even light. This painting is not simplified in the way of the moderns, nor is it entirely naturalistic; its mood is meditative, striving for essence rather than documentation. When I look at it, it is the contrast between the sinew of hand and forearm, and the battered tenderness of the face, that moves me. Lined beyond his years, this young man avoids our eyes as if he cannot bear to let us see what he has seen. He protects us in a way that he cannot protect himself. The expression on his face is an expression that no woman would wish to see on the face of a son, or a lover. When I look at it, I think again of Virginia Woolf and that passage in *To the Lighthouse* when she says that 'Not only was the furniture confounded; there was scarcely anything left of body or mind by which one could say "This is he" . . .

'Or "This is she."' It is a painting that makes an uncomfortable pairing with *The Sock Knitter*, for each captures something of the emotional and psychic legacy that was left to the young men and women who suffered that awful war. In its aftermath, it seems to have been easier—or perhaps I should say less difficult—for an Australian woman to find a modern idiom in which to say *This is she*, than for an Australian man to say *This is he*.

Which is why, for this generation of women, we might almost call those years between the wars a no man's land.[5] In the shake-up, the ways in which men and women saw themselves and each other inevitably changed, and in the flux of those years, possibilities opened out for thinking and creative women, even as in other ways they closed down. Perhaps their sense of self had been less brutally shaken by the war; perhaps the way they named themselves was already more fluid; perhaps without marriage and children, as so many of them were, they had to tap other sources of creativity and forge new ways of expressing themselves; perhaps it was merely a fluke. Wedged between a conservative old-guard who wanted gum trees to look like gum trees, and the young men who'd take over the running by the time the next war began, there was a moment in Australian art which favoured the feminine. It was the ground between the Heidelberg school of late-summer impressionism and the Australian, and very masculine, modernism that would display its hard edges to the world in a famous exhibition in London in 1961 at which not a single woman of this generation was represented.

Of course there were men painting in the aftermath of the war, and George Lambert was one of the more sympathetic of them. But the famous old men who had dominated Australian painting for the better part of thirty years were coming to the end of their run or had reached it. Conder had died before the war, McCubbin died during it, Tom Roberts in 1931. Arthur Streeton, who lasted until 1943, was churning out imitations of his earlier self. Elioth Grüner and Hans Heysen, painting in their shadow, were absorbed with the problem of earning a living and seemed closer to Heidelberg than to the women who were, in fact, nearer in age. Of the moderns, Roland Wakelin and Roy de Maistre began in the same studio as Grace Cossington Smith—the three are linked as the founding trio of Australian modernism—and by the 1930s, in Sydney (where the antipodean story of modern art began) men like Ralph Balson and Frank Hinder joined the women moderns in their commitment to the new ways of painting. But there was no equivalent to the world of masculine high modernism that Stella Bowen encountered in London and Paris. If a man wanted that, he had—like Roy de Maistre—to leave Australia to find it.

The disadvantage of this for those who worked here was that there was no powerful avant-garde voice to give modernism its

authority. When the anti-modernists huffed and puffed about the dangers of modern art—'at present turning Europe into a jungle'[6]—there was no strong masculine voice to counter them. When they bellowed that the feminine incursion into modern art would result in all manner of social ills—free verse, free love, 'companionate marriage' and 'welfarism' were listed, more or less in that order—it merely proved their point if a woman stood up to reply.

But the absence of an avant-garde also meant that by working here, the women were spared the modernist scorn for 'tea-table society'. They were free to explore the potential of the decorative and the domestic; there was no bar to their blurring of the boundaries between art and craft. Linocuts, woodblocks, pottery, fabrics, interior design, magazine covers, even furniture: these were as much the terrain of this generation as oils, watercolour or gouache. The women could celebrate the machine age with its freeing up of domestic labour; 'patent ice chests that need no ice', Margaret Preston wrote; 'irons heated by invisible heat; washing up machines; electric sweepers'.[7] They could paint, and pot, and design fabrics to decorate the new consciousness of the new woman in unashamedly domestic ways. There was no Wyndham Lewis sneering at the 'villa in the suburbs' and the 'manufacture [of] sentimental and lazy images . . . for wretched vegetable home existence'.[8]

If this generation existed in a no man's land, it wasn't only a matter of taking over the space left by the mangling of a generation of men. They inhabited a psychic space, carved out with difficulty, between intimate lives lived largely without the support of men, and public lives that claimed for them an identity as modern and independent. Their work burst the traditional definitions of art and flourished in craft and pottery and women's magazines. They existed in a strange zone, visible to those who read the women's magazines, though not to the arbiters of culture, visible for that moment and then forgotten. They inhabited a liminal space between forces in history and in culture, always on an edge, betwixt and between.

For these women the conflict between love and art was rarely, as it was for Stella Bowen, a matter of fighting for the time and the space to paint; and as so many of them lived and worked alone, it wasn't a matter of struggling up from under a loved but dominant man. For most it wasn't even a matter of stretching themselves thin to pay the bills. This was a generation of women, perhaps the last, for whom it was accepted that the families of the middle class would, if they could, support their unmarried daughters. Which gave them—or many of them—the freedom not only to travel abroad, and study, and live independently, but to dedicate themselves to a form of art that was not going to make them money. Women like Grace Crowley, Dorrit Black and Grace Cossington Smith did not, like Lloyd Rees and Roland Wakelin, have to work in Smith and Julius's advertising agency; they did not have the pressure of wives and children to support; they did not face the temptation of toning down their work in order to sell it.

But they did have the hard task of sustaining themselves as single women without the support and comfort that can come, along with the demands, from a settled married life. The paradox of their situation was that while there were very real freedoms opening to them, and while they had the support of each other, it was their art that had to carry them forward in a culture that was not kind to the spinster. Not unkind exactly; 'neglectful' might be a better word for the prevailing attitude towards 'spare' women.

Grace Crowley said that the three years she spent in Paris at the end of the 1920s were the happiest in her life. 'Why? Because they were productive . . . The "Woman's role" was reduced to a minimum. I could work every day at my painting and there was the joy of discovering Paris in our own way.' There was everything she needed: a good companion in Anne Dangar, bookshops which were 'paradise', shops that sold artist's materials, and cafés where they drank *café-crême* in the morning and ate every night.[9]

In Paris these two Australian women found themselves a teacher who gave direction to their art and meaning to the longings and ambitions that had been aimless, even frustrating, at the Julian Ashton School in Sydney, where they had studied and then taught before their departure. At the Académie Lhote in Montparnasse

there was a theory and a method, and in their excitement at finding it, Grace Crowley and Anne Dangar called on Dorrit Black to come across and join them. Ezra Pound might have sneered, but they were excited, even inspired, by a practice of art that was ruled by 'the beauty of geometrical rhythm instead of surface resemblance'.[10] No longer were they obliged to conform to the obviousness of appearance in their art, but could express the deep structure of planes and shapes, responding to the modern world with a formal dexterity that was fashionable in Europe but trounced by critics in Australia. 'The place was crowded,' Grace Crowley said, 'a feeling of expectancy permeated the place . . . Up on the wall were symbols of a curve, a double curve, and a circle.'[11] It was an extraordinary liberation, and for the moment it seemed as if they were freed into a life that was as new and refreshing as the ideas that were daily presented to them. 'It was,' Grace Crowley wrote back to Sydney, 'the confirmation of the WANT I had been feeling so long without knowing exactly what the WANT was . . .'[12]

But there was a shadow to this liberation, and it lay in their commitment to an aesthetic, a practice of art, that had come to them by invitation, almost as a doctrine—and an intensely masculine one at that. They took their role as pupils, and when they returned to Australia they brought with them the imprimatur of their master. When Anne Dangar set up a studio in Sydney, she advertised as a teacher from the Académie Lhote. Discouraged by the lack of enthusiasm for the art she'd embraced, she went back to France, this time never to return. But Dorrit Black opened a Modern Art Centre, and Grace Crowley (with Rah Fizelle) ran a small school of art, where she taught the modern method. In their studios at the end of George Street, almost in sight of the Harbour Bridge that was going up, they adapted what they had learned to their own Australian conditions, and

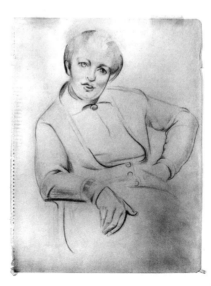

Grace Crowley, 'Portrait of Dorrit Black', 1932.

joined others to their cause. In the process they did indeed create an aesthetic that was to give substance and validity to the new identities they were establishing as women and as artists.

Their art became a kind of pledge, a way of being modern in the southern continent, even if it was an echo of somewhere else. Their images, their flattened planes, their pastel shades contributed to the way Australia began to find a style for its own modernity. And because they didn't sneer at magazine covers and were taken seriously by potters and fabric makers, the way they painted a modern Australia has been seen—and indeed was—a peculiarly feminine endeavour. Passion was injected into their work, and it came as a style of living as much as a form of art. With their city studios, their exhibitions and their notices in the magazines, these artist-women undercut the stigma of spinster, made good lives for themselves and produced pottery, prints and paintings that are valued today for their blending of the feminine and the modern.

From this end of the century we can say that if there was an uneasy fit between their embodied experience as women and an

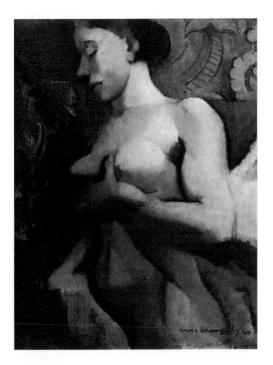

Grace Crowley,
TORSO, STUDY IN
VOLUME, *1929.*

aesthetic that disembodied the female form, it was to be expected. We have a critique of the nude as an arrangement of shapes and planes, but for them this tension showed itself only in the slightest clues. When Grace Crowley painted *Torso, Study in Volume* (1929), it was as an exercise in Lhote's studio. His teaching method was to break with the traditional background of a white sheet (which Julian Ashton had used in Sydney), posing his model in front of a patterned drape. The students were then instructed to follow the background in building up the nude, and to allow adjacent colours to form a *passage* from one element of the design to another. In this he was teaching a language of form and colour, and the energy of his method shines through Crowley's study. Yet her nude is not simply a torso, or a study in volume. The hand (which is poorly executed) might squeeze the breast into a cone, but there is nothing geometric about the roundness of the stomach or the fullness of the lips. Ten years later, back in Sydney, when she had pushed much further towards abstraction, there is still an edge of unease. Ralph Balson could paint the female figure as an abstract design of planes and

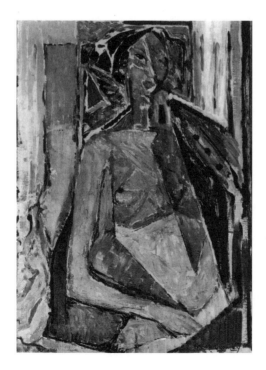

Grace Crowley,
WOMAN, *1939.*

edges, but in Grace Crowley's *Woman*, painted in 1939, there is a round nipple in a nude otherwise flattened into the geometric planes of a figure design. But while to us this nipple might suggest a sign of rebellion, it is harder to be sure that it was at the time.

If this was a generation to benefit from a breach in the masculine order, it was not a generation of women in opposition to men. They were emancipated in that they took their right to travel unchaperoned and to live alone, to command their own studios, and to dress themselves in turbans, or trousers, or artist's smocks. Those who were without men by circumstance rather than choice did not complain of the shortcomings in their personal lives. Instead they were practical, rather in the way that Stella Bowen was practical; they accepted their lot and made the best of it. Even when the behaviour of men damaged them, they forgave in ways that later generations of women would not. When they opposed the anti-modernist critics, it was not on the grounds that their position was masculine and self-interested, but because they were ignorant of modern art, behind the times, out of step with the machine age. Their years abroad gave them a foundation of confidence and a theory of art that had something of the standing of science. With this armour and ammunition, the criticism of the conservatives could be borne, in a way that the bad opinion of the men they felt aligned to could not. And far from being combative with the men who joined them in their task of adapting modern art to Australian conditions, they were protective (perhaps because there were so few of them) and accepted them as comrades. There were emotional cross-currents and fallings out, but these were as likely to occur between the women as between the men and the women. If there were griefs and sorrows—hopeless loves, secret loves, their own loneliness—they did not mythologise them, or see themselves as the victims of anything: of men, or even of circumstance.

By the way these women have been taken up as exemplars of an emancipated generation, one would think they had triumphed, and in a sense they had; years later Grace Crowley's studio at 227 George Street was still spoken of as a place that encompassed friendship and conversation, work and leisure. And yet, for all their achievement—which was considerable—a deeper expression of self, beyond the domestic manifestations of a feminine existence, seemed too often to elude them. Their view was blocked not by a Mr Tansley whispering that they couldn't do it, or by the grandiosities of a Ford

Madox Ford, but by their own submission to the formalism of a school they wanted to be accepted by and contribute to.

Was the price of this commitment that it had to hold them against all that was lost or not met in them? Can any art stand in the place of love, or children? Was there an inevitable streak of vulnerability?

❧

At first glance Margaret Preston's *Self-Portrait* gives nothing away. She was not a woman to rely on the imprimatur of a master, and when she spoke of modern art she commanded an authority that few of her generation could manage. She, alone of them, was celebrated during her lifetime. She, it often seems, was the one least vulnerable. Look at the certainty of that figure, the solidity of the wall behind her, the confidence of the face and gaze, the way she holds the palette. Painted in 1930, two years after Stella Bowen painted her self-portrait, there is none of that riven tension between grief and determination. The claim this self-portrait seems to be making is straightforward. As one of the few who married—and married successfully—one might think that for Margaret Preston the role of

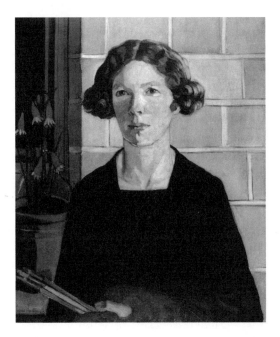

Margaret Preston,
Self-Portrait,
1930.

artist was without ambiguity. But look again at those eyes. This is a woman who knew things that are not so easily accommodated. She had after all worked with the shell-shocked and wounded, the human wreckage of war. Perhaps that is why something battened down in Rose MacPherson; or perhaps it was because she had spent too long eking out a living without support from her family. Whatever it was that fortified her, she achieved a strength that was widely remarked on—her voice, apparently, was a 'controlled bark' —and if there were vulnerabilities, she concealed them well. She managed to present herself as a serious artist and at the same time protect herself from anything that might destabilise her. She gave up portrait work because, she said, 'people used to grumble at the likenesses', and although her still lives have domestic intimacy and are finely decorative, there is something controlled, even cerebral, in her art—something insisted on even in this *Self-Portrait*, with her signature flowers over her shoulder. Art must 'delight the mind before the eye', she said.[13] And for the most part it did.

But there are odd moments when the eye—those intense, bright eyes—is subservient to the heart. Look again at the self-portrait and consider the fact that Margaret Preston was fifty-five when she painted it. Though it is not girlish, the face we see is not the face of a woman past her menopause. In 1919, at the age of forty-five, she had married a man six years her junior, and those who knew her suggested that the vanity she was prone to show, resisting photographs, fudging her age, was the one note of vulnerability to be found in her otherwise well-managed career. 'A sweet, feminine and touching conceit and the despair of cataloguers,' according to Hal Missingham, who was to become the director of the Art Gallery of New South Wales after the next war.[14]

Other than the one small fact of his age, William Preston was the perfect husband for Rose MacPherson, and she achieved what few women artists have managed: support without demand. She was in the rare position of being able to say that were her husband to ask it of her, she would give up her art—'my first priority is to him, always'[15]—because she knew that he would not ask. On the contrary, he was proud of her success and helped promote her. He was a businessman who could afford to support her so that she would never again have to teach for an income. And he took her travelling, not only to Japan and Europe, but also within Australia. Arthur

Murch, who didn't 'discover' modernism until he went to Europe in 1936, made two significant trips into the Centre, but Margaret Preston was the only inter-war modern to go into desert Australia and contemplate what she saw there; as early as the 1920s she was buying Aboriginal art (some of which found its way into the Art Gallery of New South Wales), and she began to incorporate her idea of the design and colour of Aboriginal Australia into her work. All this, William Preston supported and financed. He was even happy to live in hotels so that she would be relieved of housekeeping. But the question that comes to a woman who has even a modicum of success is what bargain can she make with her lover, her husband, her masculine protector. There was an edge of anxiety in the image of herself that even the formidable Margaret Preston presented to the world. Woman and artist, wife and painter; these were identities that did not sit together with quite the solidity of her brick wall.

'Yes, my self-portrait is completed,' she told the *Sun* in April 1930, 'but I am a flower painter and I am not a flower.'[16] She could be ironic, but under the irony was the tension of a woman well past the bloom of youth who did not want to be cast back onto the world alone. She knew the difficulty of that, even when young.

In 1926, the year Grace Crowley and Anne Dangar sailed for Europe, and four years before Margaret Preston painted her self-portrait, Grace Cossington Smith, at home in her studio, painted *Trees* (plate 25), one of the most glorious of her early paintings. At first sight one might think it had little to do with her life as a woman: it's not a self-portrait; it's not domestic; there's nothing particular to tell us it's the work of a woman. In the foreground is the marked edge of a tennis court, low down in the painting, and beyond, also low down, slipping away, are the gardens and paddocks of Turramurra where the suburbs of Sydney meet the bush. But the glory of the painting is in the trees, the great gums that soar above the slender cultivation, above the deciduous green and flowering pinks of the peach, filling the frame with a whirl of movement and colour: smoky greens and blues, dusky grey, ochre and olive.

As it was this painting which brought Grace Cossington Smith her first solo show, it would hardly be true to say that it went

unnoticed, even though it was returned to her studio and had to wait another fifty years before it could be seen for the achievement it was. And it wouldn't be entirely true to say that there was nothing like it in Australia in 1926. Roy de Maistre, who was instrumental in getting her that first show, had a not dissimilar palette and the same predilection for flattening the planes of his compositions. Roland Wakelin had already painted *Down the Hill to Berry's Bay* in colours as new. And, in a different register, Margaret Preston was perfecting her hand-coloured woodblocks of flowers and gums and harbour views. These, unabashed in their decorativeness, were already appearing on the covers of *Woman's World* and the *Home*, which in 1928 was promising to show 'where its readers can find the latest things'. And yet there was something abundantly new about *Trees*.

Margaret Preston's prints, with their bright colours and well-defined edges, still reproduce well in the pages of magazines; they please the eye and are quickly grasped. But even today you need to stand in front of *Trees* for some time for your eye to find its way into the painting's swirl of shapes, its strange perspective. Grace Cossington Smith said she wanted to paint all sides of a tree at once, and when she did, reducing it to its essential shapes, there were none of Margaret Preston's black lines keeping everything in place and telling us where to look. The effect can be as distancing as it is exhilarating.

Margaret Preston's strategy served her well; she was recognised then and she's recognised now. Grace Cossington Smith, who never had anything as programmed as a strategy, produced work of great subtlety and power, painted over six decades, but it was not until after the end of the last of those decades that she became known beyond a prescient few.

In writing of women and their art, this question of vision and visibility, of seeing and being seen, presents itself in many forms. There are the demands of the everyday world that make a woman all too visible, so that she must juggle husbands and lovers and children to get to her easel at all. And then there are her own vanities, her desire—her need—to be seen, and recognised, and taken account of. So that even as she retreats into the solitude of her studio, she may be painting to attract the attention of the world, or as compensation for all the dimensions of her life and being that are not recognised and cannot be recognised.

When Rilke wrote of the 'ancient enmity between our daily life and the great work',[17] he was gesturing, I think, to this harder truth that lies deeper down, below the difficulties—real though they are— of houses and money and other people. He was highly sensitive to the jugglings he saw as painfully detrimental to the working conditions of Paula Modersohn-Becker and yet essential to the work she did, needed somewhere inside even at her most ambivalent. But he also meant that there is countervailing pull, or resistance, to the plunge into art—at least his modernist conception of art—for it demands that we descend into that part of ourselves that is not encumbered by the regard of others; the part of the self that can live, and work, and paint, without the vanity of being seen.

While most of the moderns who were working in those parochial and conservative years between the wars spoke of the deeper structures of reality, and of seeing what lay beneath the surface of things, Grace Cossington Smith spoke of painting 'things unseen'. What interested her wasn't the surface, or even its hidden structures, so much as 'this other, silent quality which is unconscious, and belongs to all things created'.[18]

She, the least visible at the time, is—for me—the intriguing figure, for she is the one who had the ability to keep painting, to keep seeing, despite there being so few who could understand her vision and share her gaze. She kept painting through the critical barbs, careless slights and public disregard. One of the many paradoxes of her story is that of all of them she had the greatest range and span, and yet did nothing to create for herself the trappings of the life of the artist. She was content to live—and be seen to live—the unexceptional life of a single woman on the edge of the city. It was in the privacy of this life that she painted those 'things unseen' that were all around her, 'the golden thread running through time'.[19]

She did not join the women who escaped the cramped atmosphere of Sydney in the late 1920s and took off for the liberation of Paris. And when they returned, she did not visit them in their studios at the end of George Street. She was not that sort of painter, or that sort of person. She wasn't a joiner. She was never a political creature. She wasn't ideological, and she wasn't a fighter. Rather than a motivating force that she came to by invitation and invested with an identity, modern art was an attitude of eye, a way of seeing that came to her by instinct, or inclination. 'I hope the strawberries

are flourishing,' she wrote in a letter in 1917. 'Your description sounds very nice . . . Just right for a nice cubical drawing. Some things can only be seen when you shut your eyes, can't they?'[20] She, the most temperamentally suited to the forms of modernism, is the one of whom it is most difficult to use the word modern. There were none of the excitements of the modern woman for her, and little of the mobility. When I read the early reviews—*Trees* was damned as a 'freak' by the *Bulletin*—I understand why so many of the others escaped, or banded together and found ways to protect themselves. In comparison, Grace was unprotected, wide open.

It was her ability to sustain herself away from the regard of the world that allowed her perceptions to open, so that when she painted *Trees* she not only painted what she saw when she looked out into the bush beyond the tennis court, but something of her own heart. For this was a young woman who understood both the settled pleasures of a garden with its bloom of peach, and the hectic tangle of branch and leaf, the mysterious possibilities that lay beyond, in bush and gully.

Not that it was an easy upward curve. There were failures; there were stones in her path; there were times when she slipped back, when she lost that capacity to see, when the colour died on her palette. Then she had nothing to fall back on but herself. Just because hers isn't the usual story of the woman as artist, it doesn't mean that it was a charmed existence; I'm not putting her up as a model, as a counterpoint, as an exemplum. It was a hard way to do it, as spinster without cultural or social power. She was not without vulnerability as she faced the immense problem of sustaining herself as a woman and an artist, unseen and alone. But because she somehow managed to live with, and into, this difficult truth, she did not have the liability and limitation that came as a shadow to so many of her generation.

By 1939, the women born in the 1890s were approaching fifty, and for two decades they had done good work—some of it very good. But few of them went on. Margaret Preston, that extra bit older, had another decade's work in her before she began to think about the paint spots on her wings. Hers is a success story of a sort, but her major work came in those two decades between the wars. The rest

petered out. Grace Crowley produced some interesting abstracts, and then, when Ralph Balson's wife died, she took over the task of looking after the man she had loved so long in secret. Dorrit Black still had some good paintings in her, but died in 1951, at just sixty. Anne Dangar lived on in France, where her pots can still be seen in public galleries, including the Museum of Modern Art in Paris. She also died in 1951. Only Grace Cossington Smith produced a body of work that spanned six decades and made major advances in all of them. She painted *The Sock Knitter* in 1915, the Harbour Bridge in 1929 and 1930, and her magnificent stippled interiors in the mid-1950s and early 1960s; her last major painting was done in 1971. This spread, this achievement, rare in a woman artist, is one of the reasons why she is hard to keep within a narrative of this generation. She, the spinster, was the one who found a way to paint beyond the factor that scuttled the rest of them.

Their finest hour, you might think, was 1939. When an exhibition of *French and British Contemporary Art* opened in Melbourne, and then in Sydney, modernism could be said to have arrived in Australia. The exhibition was sponsored by Keith Murdoch, the owner of the Melbourne *Herald*, and curated by the art critic Basil Burdett. It was ravishing. Eight paintings each by Picasso, Matisse and Gauguin, seven by Cézanne, six by Bonnard, four by Braque. There were also works by de Chirico, Chagall, Dali, Derain, Dufy, Marie Laurencin, Léger, Modigliani, Redon, Toulouse-Lautrec, Augustus John, Paul Nash, Ben Nicholson and Walter Sickert. And this is nowhere near the full list. As the contemporary critic John McDonald says: 'Nowadays the insurance bill alone would make such an exhibition impossible.'[21]

Australia had seen nothing like it; crowds poured in to look, and not just for the shock value. We could say that the ground had been well prepared, and if these paintings could be seen for the glories they are, it was in no small measure due to the work of artists toiling away for twenty years to give modern art a toehold in this country. Could our women not congratulate themselves? If the way Australia saw itself was changing, surely some of the credit fell to them?

The old guard roared, aggravated rather than bowed by the chic visibility of this interloping art. Politicians like R.G. Menzies—who was then the Attorney-General—joined them. 'I represent a

class of people,' he optimistically said, 'who will, in the next one hundred years, determine the permanent place to be occupied in the world of art by those painting today.'[22] In other words, he represented the establishment which had the power of the purse.

Gallery trustees and directors refused to buy any of the paintings at the *Herald* exhibition. Canonical works, now in museums in Europe and America, could have been bought cheaply for our public galleries; it was one of the greatest missed opportunities in Australia's cultural history. The National Gallery of Victoria and the Art Gallery of New South Wales refused even to host the exhibition; it was shown at the Melbourne Town Hall and at David Jones in Sydney. When the Art Gallery of New South Wales reluctantly agreed to store the paintings during the war, which began in September that year, there was a wave of public protest that the paintings would not be on view while they were there. The names of local artists appeared in the press; they were angry and defiant—and most of them were young and male.

Let me give you another list of names and another bunched up rush of births. Russell Drysdale and Peter Purves-Smith were born in 1912, Albert Tucker in 1914, James Gleeson in 1915, Sidney Nolan in 1917, Arthur Boyd and Robert Klippel in 1920, Jeffrey Smart in 1921. When Grace Crowley and Dorrit Black returned to Sydney in the early 1930s to paint it modern, these boys were barely out of short trousers; Drysdale and Purves-Smith, the eldest of them, were yet to make their first appearance at the George Bell School in Melbourne. But by the time the *Herald* exhibition arrived, they knew it all and were shaping themselves into, and contending for, the avant-garde that seemed to have been missing for two decades.

In 1939 the eldest of them were almost out of their twenties; most had already been to Europe—were any of them Stella Bowen's knowledgeable young artists?—and having grown up with the fabrics and prints and pottery their mothers bought, they saw little to interest them in the modern art that was decorating Australia. When they went in to bat against the obstructionist Attorney-General and the old gallery directors, it was on their own account, not in praise, or defence, of the work of a generation of foremothers; far from seeing it as dangerous and corrupting, as their grandfathers, and even fathers, had done, it seemed just plain ordinary. Style without content is a verdict that has long hung over the artists of the

1930s. Not only that, but while the new young artists faced the next war at exactly the age they were most threatened by it, knowing they would be in a very literal line of fire, they were infused by a radicalism that went far beyond art; they projected themselves into the world not only as artists but as an intellectual force for political change. They were more likely to be attuned to the ugly and destructive face of the technologies of modernity; why should they bow to the wonders of patent ice chests, washing-machines and electric sweepers? They had content, and plenty of it.

In 1938 Frank Hinder drew a pastel portrait of Grace Crowley in which he portrayed his artist-friend with an appreciative eye. For many years he had painted with Crowley and Balson, and he shared their aesthetic. Dignified is the word for his Grace Crowley. There she is, seated against a background of her own design, well-dressed in the way of a woman of forty-eight, composed and comfortable in the colours and contours of a domestic space she had defined and created as her own. This portrait is a tribute to a woman who lived all her life 'in immaculate, sparsely decorated, light-filled spaces, with pots by Dangar and paintings by Balson'.[23]

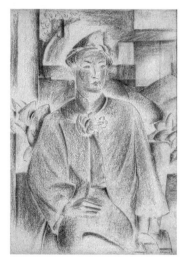

Frank Hinder, STUDIO CROWLEY, *1938.*

Compare it to Albert Tucker's self-portrait of 1939, or Sidney Nolan's of 1943. Here everything is different: colour, stance, line, sensibility. Young men making their mark in a confrontation with paint. There's nothing pastel about either self-portrait. The slanted background in Tucker's is tough, the lines are harsh, the figure clipped. His reds, blacks and ochres demand that we notice him, and attend. The eyes, almost grotesque in their largeness, are hungry and determined. Where Lambert's *A Sergeant of the Light Horse in Palestine* looked down and back, given over to memory, shaken by what he had seen, Tucker's young image of himself looks up and forward. The war he fears will give him the licence he needs to make his painter's assault, and his palette is primed for the task ahead.

Albert Tucker,
SELF-PORTRAIT,
c. 1939.

Sidney Nolan,
SELF-PORTRAIT,
1943.

Nolan was in the army when he painted this image of himself in primary colours as bold as war paint. His eyes, too, are exaggerated, and there is no ambiguity in the way he holds his brushes. In his case there is a strange blend of sophistication and innocence in the assault he makes on self-portraiture; he was not given to angst and despair as Tucker was, nor intellectually driven in the same way. But would either young man be able to distinguish Grace Crowley from the matrons taking tea in town at David Jones? Would Albert

Tucker even be seen at David Jones? This is not the face of an artist who is interested in fabrics, or interiors, or the dressing of the modern. Tucker wears his modernity as a given; his art will paint its grotesqueries, and expose its evils.

When this new generation of artists came into the strength of their early maturity, propelled by a youthful masculine energy that had been given an extra focus by the war, they were competing with each other and the young men of Britain and Europe; but they were not competing with the women of Stella Bowen and Grace Cossington Smith's generation. On the contrary, they leapfrogged over them, barely aware of what they had been doing, and with no sense at all of what they owed them. They might come to get it later—most of them would tell a different story as they grew older—but in 1939 they were young men, and young men don't, on the whole, understand the debt to the mother.

❧

In 1961 a large and prestigious exhibition of modern Australian art was shown at the Whitechapel Gallery in London. Fifty artists were exhibited, of whom three were women, but none of them from the generation which had peaked and laboured between the wars. Balson was there, and de Maistre, but not one of the women.[24] It was not callousness or intentional neglect that this was so. The moment that had opened like a gap in the tides had closed and was gone. In the catalogue, the history of Australian art was described without reference to the early modernist women; it was as if there had been a leap straight from Conder to Nolan, from Streeton to Boyd.

The same thing happened at a survey exhibition of Australian art at the Tate Gallery in 1962: *Colonial, Impressionist, Contemporary* it was called, and the same account of Australian art was given, and the same leap was made from Conder, Roberts and Streeton straight to Boyd, Drysdale and Nolan, as if there'd been nothing in between. Such was the reputation of the new generation that it is rather comic to find Menzies, now risen to Prime Minister, congratulating them in the foreword for their success in London, and aligning himself with 'the perceptive eye'.[25] Wakelin, de Maistre and Lloyd Rees were fitted in with these 'contemporaries'; but not one of the women was shown.[26] Invisible women; invisible decades.

I can't complain about the fact that Grace Cossington Smith's *Trees* wasn't in either of these London exhibitions. It was in her studio and had been since its brief public appearance in 1926. Nobody knew it was there. But they did know Margaret Preston was there. And Dorrit Black. If it was landscape that was to be offered to the English, was there not a place for one of Margaret Preston's ochre and brown visions of a land occupied by its indigenous population long before European art of any sort had arrived? Or what about Dorrit Black's 1946 *The Olive Plantation*, in which rows of olives march across the smooth rounds of her hills with the precision and ordered lines of tanks? It wasn't as if women only painted flowers and tea-cups. It wasn't as if they had no political instincts. There was a lot to see had anyone cared to look. But an era had passed, and paintings like these were, in a very literal sense, not able to be seen.

Which makes the story of Grace Cossington Smith all the more extraordinary. Perhaps it was because she had always been out on an edge, never part of the politics and groups and dramas of the art world down there in the George Street studios, that she was able to keep on working. Although she was knocked for a while, mistaken for a 'North Shore amateur', she was the one who pressed on long enough to reach through to the transfigured interiors of the 1950s and 1960s that take as their subject *daily life and the great work*.

Perhaps it is because a woman's relationship to art tends to the liminal that the most telling stories come from those who are most on the edge. First the mistress, and now the spinster.

IV

TO PAINT WHAT SHE SAW:
GRACE COSSINGTON SMITH

❧ 1. IN OLD AGE, at the end of a long and productive life, Grace Cossington Smith said it was just as well the critics hadn't liked her, for it gave her the freedom to paint as she wished. In any case, she said, all she ever wanted was to paint what she saw. 'I wanted to paint from the thing itself, really, from the subject itself.'[1]

When she spoke of the reviews she'd had half a century before, the one that had stuck in her mind was the *Bulletin*'s ill-mannered and ill-informed response to her first solo exhibition of 1928. Describing *Eastern Road, Turramurra*, a watercolour that is now considered one of Australia's finest, the unnamed reviewer's contribution to art criticism was to mistake, quite deliberately, a pony and cart in the foreground for 'a goat . . . drawing a rubbish cart up a hill'.[2]

It was not the worst she got, but something about it hurt her, and it's hard not to imagine the scene at 'Cossington', the family home at Turramurra on Sydney's northern outskirts, when her father turned his failing eyes to her at breakfast and said *Read me the review, Gracie dear*, and her mother and sisters turned their heads to hear.

The *Evening News* was much worse. MODERNIST AGAIN. DODGING TRUE ART the heading proclaimed over a column in which a certain George Galway (who did at least name himself) said that even 'with the most sympathetic intention'—a reviewer's phrase that usually means the opposite—he could find nothing in the exhibition that could be redeemed 'from a sane point of view'. He condemned another landscape as 'a lot of green frogs hanging out to dry' and one of her characteristic roads running straight up the modern centre of the picture plane as 'a wheat elevator in the wilderness'.[3]

Such words cannot be read without hurt, and I don't believe they were. Even so, and even accounting for the softening perspectives of age, there's a certain truth to what she says about benefiting from critical disregard; it is linked to that capacity of hers to remain untouched, even to the extent that she did, by the pressure of groups and movements and ideologies. One of the many paradoxes

of her story is that while she was one of the first of Australia's modernists, painting *The Sock Knitter* more than a decade before Grace Crowley and Anne Dangar sailed for France, she never used that name of herself. All she admitted to was painting as she saw. When she spoke of modern art, she always deferred to Roland Wakelin and Roy de Maistre as its antipodean founders. Even in old age when her work was acclaimed at last, and her own founding position yoked to theirs, she didn't accept that role for herself although, given the work she did, she well could have. She was more inclined towards a view of herself as a hidden talent developing in isolation on the outskirts of Sydney. The quiet revenge, one might say, of the spinster.

When Grace Cossington Smith died in 1984, her memorial service was dedicated to 'a sweet Christian lady and a great Australian artist'. As she was famously well-mannered and a regular church-goer, it was not inaccurate to describe her as a Christian, and, in the terminology of her day, she was certainly a lady. But one only has to look at her paintings, turn the pages of her sketchbooks, stumble on her letters, to know that sweet is too faint a term. Sweet is never the word for an artist; or if it is, you can be sure it's not a compliment. Formidable might be a better word when it comes to the signature on Grace Cossington Smith's canvases.

This *sweet Christian lady* painted the streets of Sydney, the landscape and gullies around Turramurra; she painted still lives of flowers, crockery from the kitchen, art deco cafés and, famously, the unmet arches of the Harbour Bridge. As she took it upon herself to paint whatever it was she saw around her, many of her images are of the trappings of a spinsterish existence. Single beds, doors opening onto verandahs, portraits of sisters and friends, views from the back of the garden, streets in her neighbourhood. And yet these images capture something essential of her time.

That the funeral epithet put her art second to her sweetness was not an afterthought exactly, and was proudly stated. But the fact that she was an artist of distinction was a belated discovery, even to those around her, and it sits uneasily beside the first, determining phrase. Much of her story has to do with the uncomfortable rub between these two identities, these two ways of *being seen*. Sweetness and lady-likeness veiled many eyes, though rarely hers.

There were two addresses at the memorial service. Owen Dykes,

the rector of St James's Church at Turramurra where she had prayed each week, spoke of the sweet Christian lady. Daniel Thomas spoke of Grace Cossington Smith as a great Australian artist.

Daniel Thomas was a fitting choice for this second task. Under the auspices of the Art Gallery of New South Wales he had hailed her as a discovery, bringing her to national attention with a retrospective exhibition that toured the country in 1973. It was then, when she was in her eighties, that the journalists rushed to interview the dignified old artist who was still living quietly at Turramurra, as she always had. That she had exhibited only the year before didn't make a discovery any less necessary. As Treania Smith of the Macquarie Galleries, which had been showing her since 1932, said: 'Daniel was the first official museum person to recognise her. It was wonderful for Gracie because although we all thought she was a wonderful painter, it wasn't enough. I think that he put her on the map.'[4]

Daniel Thomas—young, clever and enthusiastic—had arrived in Sydney in 1958 to take up a curatorial position at the Art Gallery of New South Wales just as Bernard Smith was finishing *Australian Painting*, his celebrated history of Australian art. It was through Bernard Smith that he saw *The Sock Knitter* for the first time, and he immediately understood its significance. The gallery, which under Hal Missingham was at last developing its collection, purchased it in 1960. It is now a jewel of the permanent collection, celebrated as Australia's first post-impressionist painting.

At the beginning of the 1960s the gallery also bought early works by de Maistre and Wakelin, by the Melbourne painters Arnold Shore and William Frater, and by Balson, Crowley and Fizelle. In 1967, spurred on by the fact that the gallery was curating a retrospective exhibition for Roland Wakelin, Daniel Thomas returned to the question of Grace Cossington Smith, indignant on her behalf for this was Wakelin's fourth while she had not yet had one. In that year, 1967, he wrote an article for *Art and Australia* which made the first mark on her map, bought a group of seven major paintings for the Gallery, and began the work of curating the exhibition that would at last show Australia this still barely known artist.

When he drove up to Cossington, where the artist had been living since 1914, before *The Sock Knitter* and the war for which the socks were being knitted, Grace Cossington Smith—now alone in

the house—invited him to tea and took him into her studio. There, piled against the walls, behind radiators, unframed and waiting, he found paintings that are now icons of Australian modernism. He found *Trees*, and *The Lacquer Room*, that famous art deco café, all greens and reds. He found *The Bridge In-Curve*, now reproduced as the most familiar image of the Bridge as it first rose across Sydney's skyline. He found *Interior with Wardrobe Mirror*, *Way to the Studio*, *The Prince*, *Crowd*, *Soldiers Marching*.

'How did you feel?' I asked him.

'Comprehensively excited,' he said. 'I saw at once that those canvases which had been leaning against the walls for decades would change the shape of Australian art history.'[5]

Daniel Thomas was exactly the right person to make this discovery. He knew what he was looking at, but he was not the man to plunder and disappear. It is due to him that these paintings are now in the permanent collections of our major museum galleries. Not only that, but in 1970 he began a year of Saturday afternoon visits. Twice a month he drove up to Turramurra, not just for the official business of preparing for the retrospective, but to get to know the woman who had painted with such grace and persistence while her work accumulated unseen in her studio. At the end of the afternoon, Miss Smith would offer him a glass of sherry, or a lime cordial if he preferred, before he drove back to town.

With the retrospective exhibition that toured Australia in 1973, the myth of Grace Cossington Smith was born. It's the sort of story the press loves—the artist who has existed in our midst, nobly carrying on without recognition, acknowledged at last, just as she's about to die. Of course Daniel Thomas didn't create this myth; he did the hard work of collecting and annotating the paintings, writing the first serious articles about her, curating the exhibition and buying her work for the gallery, making it possible for her to be seen as if for the first time. The media put their spin on it and told a story we were eager to hear.

But myth is not life. It might have been a story that accorded in some way with the one Grace herself told as the years passed without the national (let alone international) recognition that she saw other artists achieve—especially the young men who had swept to prominence after the Second World War. Even her old friends and once fellow-students Roland Wakelin and Roy de Maistre, suddenly

dull beside Sidney Nolan and Russell Drysdale, had had their share of attention. But not Miss Smith up at Turramurra. Nevertheless, while one of the puzzles presented by her life and work is to understand the extraordinary emergence of her distinctive and distinctively modernist take on an indeed limited environment, a closer look shows that for all the bad reviews, for all the carping against modernism, she was recognised in small ways right from the start and the support she got, without fanfare or trumpets, was necessary, and enough. Rather like America, she had been there all along, and there were people who knew it.

But isolation did exact its price. For many years she was, almost literally, not seen by those who dealt in cultural power. That kind of invisibility can be hard to bear. It can make one doubt the sanity of any artistic enterprise, and there were times when she nearly gave way under it. But there was one hidden advantage—and that's what she was referring to—because out of sight, so to speak, away from the trends and fashions and expectations, she was able to see without being seen. Invisibility can occasionally produce a powerful, rather unnerving vantage point.

It wasn't strange for a conservative family on the outskirts of a conservative city to produce an arty daughter; family attics and even the basements of our galleries and museums contain remnants of their efforts. Many a neglected daughter has dreamed of redemption as fine as Grace Cossington Smith's. What is extraordinary, and very wonderful, is that one such daughter, living an almost Edwardian existence, overcame the invisibility, the loneliness, the slights and the fantasies to produce images by which we have come to know ourselves as creatures of the twentieth century.

Who was the young woman who, as G.C. Smith, exhibited *The Sock Knitter* in Sydney in 1915, as the AIF dug in on the Gallipoli Peninsula? Who was she, this young woman who painted *Trees* with an eye that wouldn't be matched for twenty years? Who was this Miss Smith who could see human dilemma in a half-built bridge and show it to us as intensely as it has ever been seen? How did she come to make the moves, and view the world in such a way that these were the canvases she painted? What were her allegiances? How did she take her lunch?

It would be a great deal easier if she were a character of fiction, if I could show her to you as a young woman playing tennis in the

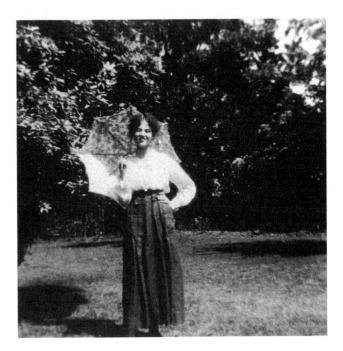

*Grace Cossington
Smith in the garden
at Cossington,
c. 1915.*

first summer of the Great War, the ping of the ball as she lobbed it
back across the net, or running with one of her sisters towards their
mother watching from a chair on the verandah. Or if I could take
you into her studio on the other side of the tennis court where the
garden dipped into the gully. If the hand of imagination could turn
the handle, open the door and turn up the lamps so that you could
see her at her easel, her springy hair tied back in a loose knot.

Let's move along a bit, and say it's 1926 and she's working
on *Trees*, giving form to movement, and also stillness, with those
splashes of colour which bring the gum tree into the modern world.
If she were a character of fiction, this young woman working out her
oddly private aesthetic at the bottom of the garden, I could slip
straight into an interior monologue, and tell her story from inside
out. The first person could slide from me to her. *There is a path,* I'd
say in her voice. *Look, you can see it. There, beneath the trees, beyond
the tennis court. Step on that path and my heart lifts in wonder.
Everything lifts. Tiredness lifts and is blown away with the wind. Listen,
can you hear the birds? In that gum. There. Open the door, and you'll see.
There. And the parrots in the firewheel tree, look—its scarlet flowers
grow straight from the branch. One day I'll paint them. Just at this*

moment I'm busy with this tree. I have a strange sensation, as if I am the
tree, as if I am the colour I squeeze from the tube.

I am here, come in, let me open the door.

But she isn't a character. Thanks to Daniel Thomas, *Trees* hangs
in the Newcastle Gallery; you can go and see it for yourself. And
perhaps you will see her there, and the difficulty of finding her, the
presence behind the canvas, will be mine alone. The temptation of
fiction rests, as it always does, on sleight of hand; two pieces of
coloured scarf go into the conjuror's sleeve, and out comes a rabbit or
a dove. The danger of turning real people into fiction is that fiction
takes life from wherever it can find it, so the fictional being swells
with well-nourished certainty while the original person, the person
we want to understand with all the hesitations and awkwardnesses of
real life, can be replaced in our imaginations as if she were indeed
real; the necessary mystery is lost and, knowing too much, we forget
how little we know.

There is another conundrum at the heart of Grace Cossington
Smith's story. Her paintings swell with the superabundance of life,
they are the wonder of her, they are absolutely her, or at any rate *hers*;
but the actuality of her daily life, her daily being, slips away behind
them. Grace Cossington Smith, once a sister, a daughter, *a sweet
Christian lady*, and now a cultural icon, exists in an extreme state of
contingency. I can't tell you how she walked, or laughed, or sneezed.
I can't tell you what was in her head when she painted *Trees*. I can
tell you that in the small snippet of tape that exists of her voice, she
sounds terribly English, somewhere between the Queen and an
elderly aunt; she has a light, fluttery, slightly trilling voice. When she
says that people watching her as she sketched put her off, the word
off is pronounced *orf*. It is a way of speaking, precise and elongated,
that is as distant as the sound track of a crackly film.

Other than that, she has left very little trace of herself. Her
private, personal self. There are few interviews, few letters, few
photos, no diaries. The work, the shining work, hides as much as it
reveals. As I endeavour to find a coherent story, a pattern, a shape for
the work, and for the woman who gave us these astonishing
paintings, I am working all the time with bright patches of light in
deep shade. As if, in a splash of sunlight, she is suddenly there,
visible, at hand, understandable; but such appearances are brief,
fluttering. Stella Bowen told her own story from inside out, and she

alerted us to its essential drama. Grace painted the life around her and breathed herself into her work with such transforming and elusive power that she vanishes in the very act of giving us herself.

The sensation I get, trying to write about her, is rather like looking at her late interiors, those wonderful paintings, dense with yellow, in which a cupboard door swings open, and you have the feeling that if you just leaned a little more this way or that, or poked your neck through the picture plane, you'd be able to glimpse her. But she placed that mirror, she tilted it, and she cannot be seen. She is not there. The painting is redolent of her, every brush stroke was made by her, and yet where is she, this Grace Cossington Smith? Who was the inhabitant of this bedroom with its neat, narrow bed and its door open onto the verandah and the garden beyond?

I can tell Stella Bowen's story; it's a story I know, a story I understand. I am of a generation which has lived its own version of that story: sex and love and betrayal, babies and work (babies *or* work), Paris, cafés, a precarious independence. I am of a disposition that understands all too well the struggle between the desire to give in to the narrative of love and the almost automatic habit of keeping on, of somehow managing. I know the insistence of work and the support that comes from one's bruised and brilliant women friends. I even know Grace Crowley's rather more genteel version of it. I know the desire to make something of an ambivalent femininity by creating an enigmatic link between the man one keeps secret in the background of life, and the work that takes us forward with something to argue for. All this I understand.

But Grace? No husbands. No babies. No affairs. No scandals. No cafés in Paris. By the time she was my age, the most exciting thing that happened in a year was when her sister Diddy bought a car and they could venture further afield. Diddy would put a deck chair in the boot so that she could read or snooze while Grace sketched. In the prejudices of our time, Grace's story, viewed externally, would never make a book. In the prejudices of her time, she was, simply, a spinster.

This time the hand of imagination lifts the curtain to a tennis court no longer used unless the nieces, her brother Gordon's girls, come over on holiday weekends. A week interrupted by nothing more strenuous than a tea party for neighbouring ladies. Cakes, chairs of slatted cane, tea pots, comfortable cardigans. There are still

odd train trips into town, over the bridge we know how to see because she painted it for us; best dresses for a concert or ballet; shopping at Farmers' or at David Jones, and a cup of tea in the lacquer room. Church every Sunday. The last two sisters alone in the house where once there'd been five—four girls and one brother. Running onto the lawn, it had been their racquets that had met the dull thwack of the ball and sent it back across the net. It had been Grace who had run ahead to their mother, to kiss her temple, her two young sisters dressed as Quaker girls grinning for her camera.

Who was she, this girl who comes to us in these slender glimpses? Who was this young woman who saw a kind of fundamental knowledge in a tangle of branches? Who opened the door to her studio and bowed before the colour—'it has to shine; light must be in it'[6]—which she saw in the world around her, and squeezed from her tubes of paint? What did she know of the stiffening body which thirty years later would lift the deck chair and easel from the boot of the car? Did she already have a premonition, did she already know the shape of the woman who would open the cool, quiet house while her sister parked the car in the garage? When she pushed open the door of her studio to put down the easel, had her hope for the journey been replaced with resignation for the road?

It's all nonsense of course.

It's imagining that comes from the word spinster and not from the strange paradoxes of Grace herself. I can't even answer the most basic of questions: did she choose this way of living, or was it thrust upon her? Did she develop the life of the spinster into an art-form, virtue stitched from necessity, or did she use it as a ruse for a very different life? Was she released into her art by her distance from men? Was it easier for her, or harder? Was art given a free run, untrammelled by the vagaries and exigencies of love? How did she remain alive to the world around her without the charge and satisfactions that come to us when we plunge into love? How did she hold desire at bay? What went on under the spinsterly camouflage, if camouflage it was? What held her to her work? What did she mean when she said she painted what she saw? What, in any case, did she see?

Who was she, this sweet Christian lady? This great Australian artist?

How shall I tell her story?

2. GRACE COSSINGTON SMITH was born in Sydney on 20 April 1892. She was the second child of Grace and Ernest Smith, who were both recent English immigrants. Ernest, a widower, had fallen in love with Grace Fisher at a garden party in Hobart, where he was holidaying in 1890. When he arrived at the party, Grace was singing, accompanying herself at the piano. Hearing her, Ernest determined to marry her even before he had been introduced. His determination was rewarded; within weeks he married the singing Miss Fisher at All Saints' Anglican Church in Hobart. Although they both had large families in England—but no parents—there was no member of either family present. He was thirty-nine, she thirty-one.

That same year, 1890, Ernest Smith had been appointed Crown Solicitor to the Colony of New South Wales, and when he returned to Sydney his new wife accompanied him. The following year he bought a house in Wycombe Road, Neutral Bay, which the pair called 'Cossington' in memory of the Leicestershire parish where Grace Fisher's father had been Rector. It was the first of two 'Cossingtons', and there they set up in style, and there the children were born.

Perhaps because Grace and Ernest were both immigrants and had been orphaned as teenagers, and because they had married late (he for the second time), they were particularly devoted to their family. There were four daughters and one son: Mabel, born in 1891, Grace in 1892, Margaret, known as Madge, in 1896, and the twins Gordon and Charlotte, or Diddy, in 1897. By then Ernest had resigned his Crown job and established his own firm of solicitors. Photographs from the 1890s show a prosperous family taking tea in their garden, with a nanny and two men servants.

And then, early in the new century, their fortunes were swiftly reversed; Ernest's partner absconded with the funds, leaving the firm in considerable debt. Ernest Smith was an honourable man, and he worked for more than a decade to pay back every pound of it,

even though it meant selling their lovely Cossington and packing up his young family for a rented house at Thornleigh on the northern fringes of the city. It is a story that Grace's niece has told me more than once; the family is proud of Ernest, and still lives by a sense of honour passed down.

In 1913, with the debts paid, Ernest moved his family to a house that would become the next Cossington, this time at 43 Ku-ring-gai Chase Avenue, Turramurra,[7] although Mabel and Grace did not see it for another year as they were visiting relatives in England. On their return they found a large house with a tennis court, a garden that dropped into a gully, and plenty of room for a studio for Grace. It was a solid house set at a discreet distance from the road in a street of other solid houses set back in their gardens. Even today the sounds of passing cars seem hushed.

Grace lived there from 1914, the year before she painted *The Sock Knitter*, until she was moved to a nursing home in 1979. Her niece lives there now with her husband; rooms that once were Diddy's and Madge's are filled with the memories of another generation of grown children. In the living room is Florence Rodway's pastel *Portrait of Ernest Augustus Smith*, which was commissioned in 1914 by the New South Wales Society of Notaries as a mark of respect for this much-admired man. It shows an eccentric, slightly aloof paterfamilias smoking a cigar. Painted by a woman on commission, it is unexpectedly relaxed, capturing not only Ernest's fine, strong face, but something of the informality as well as the authority of a man who was admired by the notaries, and father to four girls and one son.

The girls were educated at Abbotsleigh, the boy at Tudor House and then at The Armidale School. Grace, their mother, was serious about the education of her daughters, but even the best of schools for girls didn't match the seriousness of the education for boys and young men. Gordon was destined for Oxford and his father's firm. But for Grace, Abbotsleigh was a good choice. Albert Collins and Alfred Coffey, both professional artists, taught at the school, and Grace also gave credit for the start she was given to her headmistress, the famous Miss Clarke. 'She called me into her study one day,' she told an interviewer, 'and said "Grace, I want you to make a copy of this photograph" and it was a very lovely photograph of a Roman statue—just the head. So I made a copy of it, a

watercolour copy of it, and took it to Miss Clarke in fear and trembling and she put her hand on my shoulder and said "Well done, you." Well that encouraged me.'[8]

Grace Smith left school with an art prize of four volumes of *Burlington Art Miniatures* of the Italian old masters. 'I think it was the beginning,'[9] she said, taking for granted the role of her mother, who made room for the books on her shelves. The Smiths were a literary family. On Ernest's side there was a nephew, A. Talbot Smith, who was an illustrator for *Punch*, and there were volumes of *Punch* in the house. More significantly, Mrs Smith had a fondness for German poetry; as well as nineteenth-century English novels, there were studies of music on her shelves, and—not so usual in a conservative colonial family—translations of Tolstoy's *Anna Karenina* and Ibsen's *Hedda Gabler*. The very least that can be said of her is that she recognised talent in her namesake daughter and did what she could to let it bloom. She encouraged her to learn, and gave her the confidence to try. Believing in the creativity of children, she gave her daughters books to read and made sure that Grace, within the confines of Sydney, was well taught. She sent her youngest daughter, Diddy, to Eirene Mort for lessons in woodcarving, which

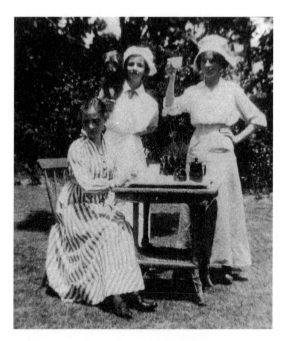

Mrs Smith, Diddy and Madge posing for Grace's camera at a tea party in the garden at Cossington, c. 1915.

she kept up as a hobby—her 'outlet', Grace said—even after she had taken up nursing. For all her children she provided an atmosphere of love and security. Years later, talking to Daniel Thomas in old age, Grace Cossington Smith remembered the feeling of going home at the end of the day and her father saying 'the smile of home'.[10] In 1925 she drew a sketch of a sister standing in a lighted doorway, which captured this mood of welcome return.

Four sisters came out of that family; four different stories, four different fates.

Mabel, the eldest, was the only one who married. She met her future husband—who went by the splendid name of Ridley Pakenham-Walsh—on board ship when she was returning to Australia with Grace at the beginning of 1914. The two sisters, the eldest in the family, had been on a two-year visit to England and the Continent. Ridley, a young British officer, was on his way to Duntroon, where he was to take up a secondment on the training staff. The Smith girls, even when swept up in the drama of romance, may have known that Ridley's presence was one small indicator of the proximity of war. But when Mabel heard of the destination of her beau, she probably thought less of the military implications than the prospect of a continuing romance made all the easier by a propitious connection. The Smith girls had been at school with the Cunningham girls, and the Cunningham family lived at 'Lanyon', the grand manorial homestead that was only a few miles from Duntroon on the outskirts of what is now Canberra. I expect Mabel thought it was meant.

House parties at Lanyon, to which the elder Smith girls were frequent guests, were straight from a Victorian novel. Dresses, long polished tables for dinner, candles, several beds to a room, girls laughing and sighing into the night. Horses, long rides, tennis, tea on the lawn, croquet. Books beside cane chairs on the verandah. Maids in bonnets. The newspapers on the table in the hall. Fancy dress parties, fêtes to be opened, farm workers to be visited. It was a life that had been understood for many years, transferred from one side of the world to the other, a way of life echoed in the books they read, the paintings they saw, the expectations they had. Duntroon, with its handsome supply of young officers, served to heighten the allure and solidity of a way of living, exactly as those same young officers heralded its passing. No one who took those newspapers from the

hall table, or who listened to the men when the girls were not around, could pretend that the life they'd grown up to expect would last for ever. Or even for long. Emotion ran high. Grace was not unaffected.

But the story I tell here is the more expected version of romance: Mabel and Ridley. They travel to Australia, entirely by chance, on the same ship in April 1914. While Mabel and Grace are reunited with their family and see the house in Ku-ring-gai Chase Avenue for the first time, Ridley takes the train to Goulburn and makes his way to Duntroon where the talk is already of war. Within weeks Mabel and Grace are guests at Lanyon. Mabel and Ridley walk in the garden in the early afternoon. By five it's cold; the wind from the Monaro whistles across the tablelands and in autumn it gets chilly fast. On winter evenings with the house lit with lamps, they dance together. Mrs Cunningham seats them together. At Lanyon their romance ripens.

And then the war began, and it was not over by Christmas and clearly not going to be for some time. While Stella Bowen battled the queues in that wet and wretched English winter, Ridley was enjoying his secondment, walking in the gardens with Mabel once the heat had gone out of the sun.

Madge, the third sister, old enough at last to attend the parties, watches from the shade of the verandah.

Grace is inside sitting with Mrs Cunningham in the cool, still drawing room. *Draw me another, Gracie dear*, Mrs Cunningham says, and Grace draws a cartoon full of sparkle floating up to the corners of the page.

In May 1915 Ridley was posted back to England. He was on his way to the front. It was a shock for Mabel, though she must have known it would come—a change that not only meant separation but danger, and possibly death. When Ridley got the news, Mabel was in Sydney. War work kept the girls busy, and weekends at Lanyon had to be squeezed around other obligations; war was no respecter of love. Ridley rang Mabel. Great excitement at Cossington. A modern proposal. No bended knee. No evening shadows. A high-tech telephone proposal. Mabel said yes. Of course she said yes.

Mabel and Ridley were married in May 1915 at St James's Anglican Church, Turramurra, where Grace's memorial service was to be held nearly seventy years later. They sailed for England the

next day. Mabel was taken to Ridley's family home in Ireland, where she was left in the charge of the Irish granny, quite a matriarch according to her grand-daughter. Mabel's first son, who was given the name of Ernest Ridley, was born in 1916 on the day before the Easter Rebellion. 'Nothing worse happened,' Grace told Mrs Cunningham, 'than the pram getting burnt, which was fortunate, but Mabel said the noise of the firing etc carried a long way and was "quite disturbing".'[11]

That was the fate in store for the eldest Smith girl as Ernest walked her up the aisle. The wedding was, as you can imagine, an occasion of mixed emotion. Her family knew it would be a long time before they saw Mabel again.

The three Smith sisters, Grace, Madge and Diddy, were brides-maids, and none of them would go on to be brides. This is a serious issue, for once again we are brought up against the reality faced by young women of this generation when the hopes and expectations they'd grown up with were cut across by a savage war. For Madge, as we will see, the consequences were about as bad as they could be. But for Grace there was an element of release. Perhaps it could be said that while the war wrecked the expectations of girls like Madge, it freed girls like Grace. Exactly as Mabel married and Madge grieved, Grace painted *The Sock Knitter* (plate 17).

For her there had been no shipboard romance. What she brought back to Australia was subtler, and harder to know than the heart of a handsome officer. The art historians would like to know what reproductions were in her trunk as she sailed back into Sydney Harbour. Which books? Which monographs on which artists? Which magazines? They would like to know, and so would I, which exhibitions she had seen, which painters she had discovered, which she admired. Later, in the nursing home interviews, she said she didn't see any modern art while she was in Europe, and she had said the same to Daniel Thomas. Can it possibly be so? In old age Grace saw herself, and was happy to be seen, as an artist working in isolation on the fringe of her society; it was substantially the case, and from the perspective of old age undoubtedly true. But what were the stories she told herself in youth? No one sets out to be an artist in isolation. No one sets out wanting to be peripheral. No one wants to wait until eighty to be appreciated. Have you ever heard of that as the ambition of a twenty-year-old?

*Grace
Cossington
Smith,
'Backdoor
onto Passage,
Thornleigh',
1911.*

Everything we know —and it's not much—shows us that her early moves into art were deliberate, considered and serious. She'd won those prizes in art at school, and she had the advantage of a mother who took her seriously; it was like ballast in her pocket. There was no doubt that after school she would continue her studies. The obvious choice would have been Julian Ashton's Sydney Art School, but with her mother's support she chose instead to attend Dattilo-Rubbo's Atelier in Rowe Street. Julian Ashton's School was better known and better connected: it was the destination of most young ladies. Grace Crowley and Dorrit Black went there before they'd heard the name Cézanne. Anne Dangar taught there until she and Crowley left for Paris in 1926. Rubbo was a quirky choice. As he offered drawing classes for young ladies, it could be interpreted as cautious. But caution is not a convincing note when it comes to Grace Cossington Smith. I prefer to see the positive meanings of a choice that was off the standard, as so much about Grace was. If it was an oblique choice, it was also a knowing one.

Anthony Dattilo-Rubbo, who had trained at the Royal Academy of Fine Arts in Naples, had emigrated to Australia in 1897; he taught in schools for several years, arguing for professional standards, and by the turn of the century his studio classes in Rowe Street had become the main competition to Julian Ashton. He was a strange figure— small with curly black hair, at once a bohemian and a council member of the conservative Art Society of New South Wales. As a painter he was an impressionist who made no great leaps of his own, but as a teacher he was eclectic and exploratory. In 1906 he went back to Italy for seven months and returned with the first reproductions of European post-impressionism: Cézanne, Gauguin, Van Gogh, Seurat. The following year he was giving lectures on colour, and writing

about Van Gogh and Gauguin.[12] In pre-war Sydney, his was the only studio with reproductions of their work on the walls. Not that there is much evidence of post-impressionism in Grace's sketchbooks before she boarded the ship with Mabel and her father in March 1912. The classes she took with Rubbo were in drawing; her early sketches show traditional student subjects—gardening tools, old boots, a dish—competently done with a lot of shading, the first marks of a young woman who had talent but as yet no idiom.

Grace (left) and Mabel on the deck of the Orvieto, *March 1912, with Ernest behind and an unidentified chaperone between them.*

With both the Smith and Fisher families in England, the voyage there was in part a visit of respect and in part the 'finishing' tour that young women of the Australian middle-classes were customarily given to complete their education. But while many such girls made the trip, few were sent with a kookaburra as a gift to be delivered to their art teacher's relatives when the boat stopped in Naples. The kookaburra flew away—'I lost him somehow,' Grace said, remembering it late in her life. 'I was very upset over that.'[13] But Rubbo's commission raises the question of what else he might have sent with her. Or sent her to do. A list of galleries? Artists to look out for?

When they first arrived in England, Ernest and the two girls travelled around visiting family. Later in the year, when Ernest returned to Sydney, Mabel and Grace stayed on with an aunt in Winchester. In that damp town around its grand cathedral, Grace enrolled at the art school. There she continued with her drawing and

won several prizes. Not adventurous, you'd have to say, but consistent, or at least persistent.

There are photographs from this trip of Grace in a long pale coat—beige, maybe, or grey—which would be fashionable today if the collar wasn't so large and if it wasn't done up. Her face is strong under a huge hat. In a group photo, like the one of them on the deck of the *Orvieto*, it's almost as if there's an extra light on Grace's face. *She shines.* She also looks sexy; alive in that way. She could unbutton that coat and step out of the picture and, with a swing to her hips, look over her shoulder and be gone.

Winchester was only a short train ride away from London, but we don't know when, or how often, the sisters made that journey. If they made it in the autumn of 1912, did they go to see Roger Fry's Second Post-Impressionist exhibition at the Grafton Galleries? Or perhaps they saw the Camden Town Group exhibition at the Carfax Gallery in December? Winchester Art School may have been provincial, but every art school took the art magazines, and Roger Fry's exhibition had caused a sufficient stir for it to become a subject for the daily papers. The English weren't taking any more kindly to modern art than were their colonial cousins in Australia.

We know from Stella Bowen's stint in Pimlico that London could be as stuffy as the worst of provincial Australia—if anything more restrictive—and Winchester, by virtue of its proximity to London, would have had the additional drawback of not being able to recognise its own limitations. Even so, I look at the vitality of the photos of Grace Smith as she was then, and find it hard to believe that curiosity didn't take a girl with a face like that to galleries and bookshops. In the eye of imagination, I can see her on the train, rattling through the soggy fields of Hampshire's countryside; and I can see the swing of that coat at Waterloo as she got off the train and made her way through the crowds, swerving slightly with the roar of steam; there she goes through the ticket barrier. And I can see her in the bookshops of Charing Cross Road, browsing, lifting the heavy monographs that cost so much more in Australia, leafing through the postcards and reproductions, noticing the names that Rubbo called in his Atelier on the other side of the world. But imagination is not fact. There are no facts to tie Grace to London at any particular moment of that trip, there are no facts to put her in a bookshop, a gallery, or even a train. *Nothing modern*, she said.

But the question is, how much weight do we put on her old-age memories? Everyone shapes their own version of their life story, and the versions change as we get older; memory, always selective, moulds the process of forgetting. The way an artist sees herself inevitably changes as influences are incorporated or outgrown. The fact that Grace Cossington Smith says she saw nothing modern doesn't necessarily mean that she saw nothing modern. In any case what did she mean by 'modern' when she made this much seized-upon remark? And what would she have meant in 1912? With sixty years of painting life before her, would curiosity not have carried her? You only have to look at that face in the early photos to think that it would.

The Second Post-Impressionist Exhibition opened in October 1912 to such outraged interest that it was extended into the first months of 1913. By then Ernest Smith had returned to Sydney and Grace and Mabel were settled in Winchester. Not only this, but in 1913 Norah Simpson, whom Grace knew from Rubbo's classes, was studying in London at the Westminster School. Would Grace not have met up with her? Could these young women have gone to this exhibition together? Vanessa Bell painted a view into the Grafton Galleries while it was on; the canvases she places on the wall—one of them clearly a Matisse—may have been startling, but the gallery itself was respectably appointed with leather seats and wide doorways; it wasn't such a scandalous outing that I propose. And if they did go, could Grace have focused her attention on Cézanne and Van Gogh who were already familiar to her from reproductions she had seen in Sydney? Because she never thought of herself as modern, perhaps she didn't use the term for these models she was so soon to take into her work. Or could she have concentrated on the Camden Town Group of English painters that Norah Simpson was an enthusiast of and studying with? If she read Roger Fry's catalogue essay, perhaps she responded less to the notion of the new than to his comments about art giving form to 'spiritual experiences' (rather than trying to 'imitate' life), and accepted Cézanne not as shockingly modern but as 'the great originator of the whole idea'.[14] Could she have gone to the exhibition and missed, or mis-remembered, seeing Picasso and Matisse? Looking back, we can say that these were the giants of the exhibition, but to young women from the provinces they would have blurred into the names of the many other artists whose work had been brought from France.

Admittedly there's nothing in her sketchbooks to show the impact of Cézanne, let alone Matisse. Her drawings of Winchester Cathedral are traditional student works. But could she not have been learning the grammar of this draftsmanship while still looking at very different art? As a visitor in her aunt's house she was not equipped with a studio, and the classes she took at the art school were in drawing (and sculpture) but not, it seems, in painting. It was not until her return that she took the plunge into oil, and when she did the influence—immediately—was from Cézanne and Van Gogh.

The one thing she did tell Daniel Thomas was that in Germany she saw some early eighteenth-century paintings by Watteau, and that these had made a mark. As he says, it's a sophisticated and rather surprising response from a young woman who was only twenty that year.[15]

Mabel and Grace visited Germany briefly in 1913, to stay with a friend of their mother in a country house near Stettin. It was there that Grace first used tempera—though as far as I know, none of this work survives—at the suggestion of a young woman who was engaged to teach her. She describes returning from a morning's painting with this teacher in time for lunch. 'It was a big house and there were lots of people talking German and it suddenly struck me that they were talking about my painting which they had seen in the hall where I had left it to dry, and they all liked it so much. They were very enthusiastic about art.'[16] What would these people, *enthusiastic about art,* have given this talented young Australian to read, to look at? Which galleries, which books, which magazines, would they have recommended?

Stettin, now in Poland, lies north-east of Berlin, and the two Smith girls would have gone through the capital to get there. Perhaps they saw Watteau's famous *Embarkation to the Island of Cythera.* There's a version of it at the Charlottenburg in Berlin; there are also drawings in lovely rusty crayon and a number of other oils. Even if we don't know exactly what Grace saw, the question that arises is what it was that drew her young attention to this great painter of love. What was it about his decorous sensuality, his restrained eroticism, that she responded to? Or was it his delight in the material of paint and crayon, his pleasure in the texture and feel of the medium itself? Or did she respond to the yearning which is like an emotional template in everything he drew? Did she recognise

the fleeting moment as his figures lean in towards each other even as they lean away? Did her eye accord with his?

Grace didn't use Watteau as a model in any direct way—as she would Van Gogh and Cézanne on her return to Australia—but the fact that he was the painter she remembered, rather than anything she might (or might not) have seen at Roger Fry's exhibition, is less a clue to what happened than to the rhythm of her inner eye. Maybe in the end it is this rhythm that matters rather than influences more directly incorporated. Nevertheless, as a young artist she needed an idiom appropriate to her time, and I suspect that she found it in England, but not a way to use it until her return to Rubbo's Atelier.

Sometimes returning can have a greater resonance than the fact of being away, as if one returns to find that a life once taken more or less for granted is deepened by re-meeting it from another perspective. Perhaps all that happened was that by finding there was as much constraint in provincial England as at home, she thought that if she was going to do anything, she might as well do it where she was. Perhaps Watteau told her that if art can move us across the centuries, why not across the hemispheres? Perhaps she looked out on the world around her and saw Cézanne in the shape of the trees.

When Grace returned with Mabel to Sydney and the house in Ku-ring-gai Chase Avenue, where Ernest had moved the family during their absence, she was welcomed back with a studio of her own. Ernest had had it built for her in the garden. It was a generous gesture, a manifestation of her family's faith in her and the seriousness they saw in her. In April 1914, five months before the war began, Grace stepped into that studio with the confidence of an artist in the making. It was small, and made of weatherboard, not much more than a shed really, with high windows, a door that opened to the famous eucalypt she would paint in 1926, and a funny, slightly lopsided roof. She painted a sunflower on the door. Yellow, 'the colour of the sun', she said. 'The colour that advances.'[17]

Because we know what was to happen, it could be said that Grace stepped off that ship with Mabel in April 1914 with a relationship as significant as the one that was occupying her sister's imagination; but hers was a romance not with an officer but with art, and her dreams were not of marriage, but of herself and the painting she would do.

3. AT COSSINGTON, GRACE was not required to keep house. That role fell to Madge. Diddy, who was seventeen when her sisters returned, was training to be a nurse and so she was away from home on long stints of live-in duty. Grace's work was treated as seriously. It was only when Madge was away—which from Madge's point of view was far too seldom—that Grace had to grapple with kitchen equipment. She made a joke of it, but it was no joke. 'Anticipate breaking some inoffensive eggs tomorrow,' she wrote to Mrs Cunningham in 1917, 'in wild attempts to make a cake! Awful efforts at domesticity now my two young *soeurs* are away.'[18] If Diddy could fill in, she would, but when all else failed, the kitchen—which she managed never to master—fell to Grace. Her lack of domestic proficiency, maintained over a lifetime, was quite an achievement.

When Grace wasn't at work in her studio, she was in town at the Atelier, where Rubbo was at her shoulder as she made the big move into oils. 'Take out the dashed brown,' she has him saying in one of her cartoons,[19] though he hardly needed to encourage. At lunchtime he sometimes read to the students, and early in 1915 when he was reading Van Gogh's description of the painting of his bedroom at Arles, Grace made quick notes of the colours. When she went home to her studio she painted *Van Gogh's Room*.

'The sky is greenish blue, the water royal blue, the ground mauve.' That's Van Gogh in Arles. It could as well be Grace Smith crossing to the North Shore, riding the ferry over royal blue water, for that is the flamboyance of colour, the idea of colour that she fell in love with. 'The town is blue and violet, the gas is yellow and the reflections are russet gold down to greenish-bronze.'[20] What colour did she see as the train clattered through the suburbs taking her home to Turramurra and the studio where she could take the sketchbook from her bag and, unobserved, squeeze the paint from the tubes?

'This time the colour shall do everything. By means of its simplicity it shall lend things a grand style, and shall suggest absolute

peace and slumber to the spectator . . . The walls are pale violet, the floor is covered with red tiles, the wood of the bed and of the chairs is warm yellow . . .'[21] Those are Van Gogh's words; *Van Gogh's Room* (plate 18), which she painted in 1916, is Grace Cossington Smith's. It is his idea of colour transformed into her colour and her room. It glows violet, red and orange. 'Bed cover,' she wrote, 'yellow green. Furniture orange.' And there it is in the National Gallery in Canberra for us all to see. Apprentice piece and homage.

'My chief interest, I think,' she said many years later, 'has always been colour, but not flat crude colour, it must be colour within colour, it has to shine; light must be in it, it is no good having heavy, dead colour.'[22]

There's a cartoon sketch, also in the National Gallery, that Grace called 'The Awful Result of Sketching on a Roof'. There is no date, but it fits with the comic drawings that she made for the family during those early years at Cossington: Christmas cards, birthday greetings, sketches of funny events. This one is a small comic strip joke at her own expense which, in the way of jokes, tells us something that isn't. On the left a woman is sitting sketching on the roof of a tall, thin house; and then on the right we see her hanging from the gutter with her chair, sketchbook and pencils clattering to the ground beneath her. Her skirt is long and her feet are swinging out. It captures the exuberance and sense of freedom, the fun Grace

Grace Cossington Smith, 'The Awful Result of Sketching on a Roof', *c. 1914.*

227

found in painting; and also its recklessness and risk. It captures something of the double-edged nature of her experience, leaning in even as she leans out. Everything about Grace Cossington Smith's story tends to this stance. It is not so much that she was taken in different directions at once, or that there were clashes between one aspect of her life and another; rather that she seemed able, as if by instinct, to hold to more than one position, or idea, or possibility.

Mrs Van Gogh, Rubbo called her. A playful, teasing name, and also respectful. A tribute to her flair with colour, her energy, her open stance. A name to mark her out; also a name that recognised there was competition in the studio. Norah Simpson had returned from the Westminster School a year before Grace, arriving back at Rubbo's studio an enthusiast for the English moderns. The reproductions she had brought with her were pinned to the walls and for a while hers was the dominant note at the Atelier; this was the introduction to modern art that Wakelin remembered.[23] But I do not believe Grace walked back into that studio to discover the post-impressionism of the Westminster School as if it were a revelation.

Grace described Norah Simpson as 'very determined . . . outspoken and forthright'. And Grace, it seems, was content to let her have the credit. 'I got on well with her,' Grace said. 'She was a slightly difficult person because she was firm, wanted her own way and that sort of thing. She was an outstanding person.'[24] But it strikes me as interesting that although Norah Simpson aligned herself with English modernism and Grace insisted that she had seen nothing modern, of two paintings from 1915 by these two young Australians —*The Sock Knitter* and *Studio Portrait, Chelsea*—Grace's, for all the talk of isolation, is the more telling. The influence in her painting is not Sickert or Gilman, but Cézanne—and Grace painted it within a year of her return. Is that the behaviour of naive genius? Or is it ambition?

Studio Portrait, Chelsea, which Norah Simpson painted in England (where she went again in 1915) is straight from the English modernism she'd learned from Harold Gilman. The young woman who sits near the corner of the room is slumped in a stance of ennui; she looks straight ahead, but without certainty. It is an equivocal statement by a young woman in a studio in Chelsea with the guns pounding across the Channel. That she is in a studio and in the grip of a knowing weariness marks her as modern, as does the tall totemic

figure which looms behind her as a mysterious shadow of other possibilities. The paint is thick, applied in stippled, broken strokes. Yet compared to the clear lines of *The Sock Knitter*, the composition is cluttered.

It may not be a fair comparison, for *Studio Portrait, Chelsea* is all we have to know Norah Simpson by. It seems that on this second arrival in London she took up once again with the English moderns and painted, travelling a little, until she married in 1920. But when she gave birth to her son the following year she stopped painting and destroyed everything she had done. This is the brick wall one comes up against with Norah Simpson. One day someone may find a way to flesh out the details and discover what happened, and why. If it is the case that she destroyed everything, never to paint again, does it mean that rather than succumbing to a process of attrition, this *outstanding person* made a deliberate choice for babies over art? As far as we know, Grace lost touch with Norah Simpson.

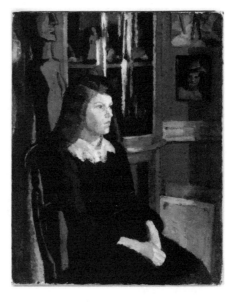

Norah Simpson, STUDIO PORTRAIT, CHELSEA, *1915.*

When Norah left for England in 1915, Grace was working two days a week with the War Chest flower shop. Decked out in 'very large and voluminous holland and blue overalls', she sold flowers picked from suburban gardens to raise funds for the men at the front. It wasn't onerous work and the shop was handily placed in Pitt Street, round the corner from Rubbo's Rowe Street studio. And there, in that first year of the war, Grace discovered what she could do with Cézanne. 'Because of his forms and planes,' she said in one of those late interviews, 'and because his paint is miraculous.'[25]

Cézanne's influence on Grace Cossington Smith is usually dated to her later landscapes, but *The Sock Knitter* has such strong references to him that it's hard not to see it as a student piece as

deliberate in its borrowings as *Van Gogh's Room*. The references are more veiled, that's all. Later she said Cézanne had been the one, always Cézanne. 'Form expressed in colour, vibrating with light.'[26] The flat knobbly planes of the sock knitter's hands are Cézanne hands. Consider, if you have the chance, *An Old Woman With A Rosary* (c. 1896) and, even more so, *Madame Cézanne Consant* (1877) in which Madame Cézanne crochets. But the really striking parallel comes from the subsidiary figure in *Young Girl at the Piano— Overture to Tannhäuser* (c. 1869–70). While one sister plays the piano, the other sits on a long bench against the wall, her head down as she concentrates on her needlework. Was she the model for *The Sock Knitter*?

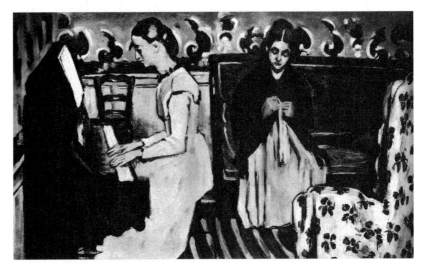

Paul Cézanne,
YOUNG GIRL AT
THE PIANO—
OVERTURE TO
TANNHÄUSER,
c. 1869–70.

Young Girl at the Piano had been reproduced by *Apollon* in 1912. Was it in Grace's suitcase? The first illustrated monograph on Cézanne was published in Germany in 1910. Did she see it there, in that household of people enthusiastic about art? In the foreground is a corner of the chair in which, on other occasions, Cézanne frequently painted his father. Its cover has a floral pattern in green and pinks against a cream background which is echoed in the cover of the seat, or bench, on which the sock knitter knits her socks.

The Sock Knitter was exhibited at the Royal Society of Artists' Sydney exhibition in October 1915. For it to get in, and be hung at all,

Roland Wakelin,
THE FRUITSELLER
OF FARM COVE,
1915.

Rubbo had to argue for it, and also for Roland Wakelin's *The Fruitseller of Farm Cove*. After this initial behind-the-scenes scuffle, very little attention was paid to either painting. Neither sold; *The Sock Knitter* was left on the wall at fifteen guineas, *The Fruitseller of Farm Cove* at seventy-five. *The Sock Knitter* suffered the additional slight of getting no critical mention at all. Not a word. Wakelin's painting at least achieved a mention in the press, albeit patronising: 'With a more complete understanding of the science of colour,' the reviewer wrote, 'this artist will paint light well.'[27]

Of the two works, hers is the more innovative. His, influenced by the Australian impressionist E. Phillips Fox whom he admired at the time, uses a close-toned palette and tiny flecks of colour in an almost pointillist manner. Perspective is still recognisably traditional. A group of people—a man, a woman, a sailor, a child—cluster beside the fruitseller's stall. Behind them, facing into the light, are the gardens and buildings on the other side of Farm Cove. There is nothing to indicate war or crisis, either in art or in the world the painting depicts.

The Sock Knitter, by contrast, is an image of utmost simplicity. It is 1915, and a young woman is knitting socks. All over Australia, all over the British Empire, in enemy countries too no doubt, young

women were knitting socks. And yet in this simplicity, Grace Cossington Smith shows us the feminine underside of war.

The Sock Knitter makes two moves that bring this portrait—and Australian art—slap into the modern world. The figure is pressed forward onto the picture plane, and the background is stripped of anecdotal detail. Large blocks of colour—viridian blue, ochre, and cream—illuminate a background with virtually nothing to place the woman who knits other than the green knitting bag with its startling inner skin of orange. The broad brush strokes leave a stronger trace on the canvas than her social standing does. *The Sock Knitter* makes its claim—or rather we make our claim of it—as post-impressionist because, by stripping the portrait of name and place, by removing the familiar props of social context, it confronts the viewer with itself as art; the planes and shapes of form, the possibilities of colour take precedence over character and position. It is less important who the woman is than what she feels. And what she feels is given to us in the shape she makes, and in the streaky colour of her skirt, the clotted impasto, the heavy brush strokes. *The Sock Knitter* makes no attempt to convince us that it is anything but a painting. And yet, paradoxically, by its very bareness, this painting tells us all we need to know about the fate and feeling of a young woman knitting socks in 1915.

In biographical fact, *The Sock Knitter* is Grace's sister, Madge. She is one of the thousands of middle-class women who with utmost propriety took up this war task. Madge does not affect the ennui of Norah Simpson's portrait with its stance of a modern sensibility. She is not bored or rebellious. She is oddly impassive. But we know, and she knows, and Grace Smith, her sister, certainly knows, that Madge is knitting socks for the men whose names would be posted in great lists in the papers each week as news of the casualties came in, among them the names of men they might have expected to marry, the men they would otherwise have married. Madge is not stitching the trousseau she longed to stitch. She is not knitting in soft colours for the baby she would never have. The balls of wool are stiff and heavy. Her task is a sorrowful duty. The portrait of Madge, set against a featureless background, offers no comforting sign of her future, or even of her desire; there is no promise of remedy for all that will remain unmet in her. Madge does not display any of this; but she felt it. And we, standing in front of the painting all these years later, can

feel it. It is absolutely appropriate that the portrait is stripped of the sort of detail that might have placed her—a letter on a table, perhaps—for the truth that Madge faced as she knitted her socks, and that Grace faced as she painted her, was that the certainties they might have expected as good middle-class daughters were vanishing with every sock they knitted, every death that was listed. What they faced, what the future held for them, they did not know.

In that family Madge drew the short straw. Coming in the middle, between two older sisters and younger twins, it was almost as if she were positioned to suffer. She was only sixteen in 1912 and too young to accompany Mabel and Grace on their finishing tour of England, but by the time she was old enough to travel on her own account, the war had started. So her trip was postponed until 1924, by which time she was twenty-eight, an age when, in the pre-war world, a woman would have considered herself 'on the shelf'. At twenty-eight, the ever-dimming prospect of marriage was exercising Madge. For a young woman of her sensibility, it was a great deal to forgo—or be denied. The trip to England offered new horizons, new possibilities, new hope. And she loved it there. The life of the villages and small towns was utterly congenial to her. She found a cousin on her mother's side whom she liked, and a world she could have slipped into as comfortably as a pair of gumboots and a cardigan.

Her cousin, Frances Crawshaw, was a painter of an accomplished English variety, good enough to hold exhibitions but not good enough to leave a lasting mark on the culture. She was a generation older than Madge, a bustling, confident sort of woman who whisked Madge along with her. Madge, being Madge, made herself useful and, in the congenial environment of this English family, she felt herself not to be a drudge. And by great good chance—I present this from Madge's point of view—Frances Crawshaw had a son by her first marriage with whom Madge felt both sympathy and affinity. Robert Kettlewell was a curate, and on Madge's side at least it was an attachment redolent of possibility.

Just as the romance might have bloomed in England, across the world in Australia Ernest fell ill with appendicitis, and Madge was called home. She cut short her short year and returned to Cossington, where she took up her duties and put it to her father that when he was quite well again, she should return to England. She

could live with cousin Frances. She could be of help. She would be near Robert.

Ernest said no. Ernest, the loving father, forbade his middle daughter to return to England. It was in part a protective move. Madge, with no training and no proposal from her curate cousin, would have been going to an uncertain future. But there was a darker side to his decision. In a family of girls, one sister had to be sacrificed to the household. Mabel had married and left for England. Grace had her art. Diddy was nursing. Grace, their mother, was often unwell and needed additional help.

Such was the family and such the times that Madge accepted, and obeyed.

Ernest flanked by Grace (left) and Madge (right) at Cossington, c. 1919.

Grace, with her aversion to kitchens, must have been glad to have Madge back. But how did it feel to her when Ernest denied Madge's request and set her sister on a course quite contrary to her wishes? There is a photo of Grace and Madge with their father, one on either side of him, and looking at it makes me think again of that riddle of the Sphinx: *Who are the two sisters who give birth to each other?* with its answer: *Day and night.* There is Grace with her strong, intelligent face lifted to the sun. Madge's lowered head is shrouded in misery so intense it seems to burn the paper their images are printed on. Ernest, with his hands in his pockets, stands tall and unperturbed

between them. You can tell at a glance that there'd be no question of Grace taking over the kitchen.

In 1915, all this was in the future and unknown to Grace when she painted Madge as *The Sock Knitter* exactly as the family was rejoicing at Mabel's marriage and grieving at her departure. But what she did know—or see—was that under the rejoicing a more sombre note was struck, not only as Mabel was consigned to Ireland and her husband to the trenches, but in the lives of her younger sisters left behind in the safety of Turramurra. So when Grace says she was painting what she saw, we don't need to evoke Virginia Woolf and the complications of journeying *To the Lighthouse*. There is a profound and literal truth to what she says. And to what she saw. She saw the sorrow of her younger sister. She saw her dutiful acceptance. She saw the wound, and she saw the strength that would be required.

Early in 1916, six months after Mabel had left with Ridley, Diddy's twin Gordon also sailed for England. He was on his way to Oxford, but within a matter of months of enrolling at the university, he had enlisted in the army. Like Tom Bowen, he was a junior officer in the trenches of France. 'I don't think there can ever have been a time,' Grace wrote to Mary Cunningham whose son Andy was also at the front, 'when there is so much to think about.'[28] The war, at first seen only through the posies of flowers she sold, had begun to bite and the harsh fact of it was touching everyone she knew.

The Cunninghams and the Smiths supported the conservative National Party. Despite her exposure to Rubbo's very different politics, Grace joined them in this, drawing patriotic cartoons and programs for fund-raising concerts and fêtes. She went to the studio each day and heard the talk there, but still she shared her family's deep opposition to Australia's vote against conscription and their unquestioning loyalty to the distant country of England. 'I listen to the recruiting speeches in Martin Place sometimes. How they can listen & lounge with pipes in their mouths,' she wrote in a letter worried about her brother and Andy Cunningham. 'The sickening part is to see the triumph of the cowards.'[29]

I don't think Grace's worry involved much sense of what Gordon and Andy faced: the possibility of death, yes; but the daily horror of the trenches, no. Unlike Margaret Preston and Gladys

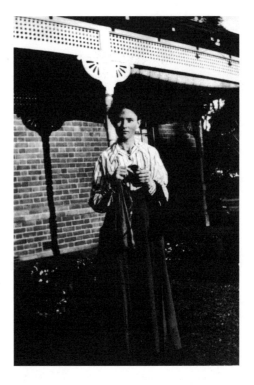

*Grace knitting socks
in the garden at
Cossington, 1915.*

Reynell, who had worked in the Devon rehabilitation hospital, or
Stella Bowen in London, from the letters it would seem that even with
a brother at the front, Grace Cossington Smith had little imaginative
grasp of what it might have been like for the men who were fighting.
She could hold to an unexamined jingoism as a kind of clothing
because she had not seen anything to strip it from her. She had not
seen the wounded or the shell-shocked; she had not seen the condition
of the trenches, or the wrecked evidence of slaughter. With her, as we
know, seeing was what mattered. But she did see the distress of her
sister knitting socks; the distress of women all around her as they
waved their men off to fight. She may not have been able to articulate
what she saw in words, but her intuitive eye turned what she saw into
images for us to see, and therefore to feel. As to the experience of the
men themselves, once they'd boarded ship and sailed out of sight, for
Gallipoli or France, well, she didn't come close to understanding it.
Heroes and cowards: those were the terms she used. So it is ironic that,
when the bad reviews started, she was mistaken for a left-winger, or
worse, a traitor to the cause of war.

In 1917, at the depth of the war when thousands of young Australians were being killed and wounded in Flanders, she painted a tiny oil which she exhibited in 1918 as *Reinforcements*, and sold to the Art Gallery of New South Wales in 1967 as *Soldiers Marching* (plate 19). It is one of the paintings Daniel Thomas found. In it you can see that she is still high on the possibilities of colour: a bright separated palette, bold brush strokes leaving traces of colour on clear colour. Ochre and burnt sienna buildings in the distance, a lollipop-striped dress in the line of women whose backs we see in the foreground, and between them the ranks of faceless soldiers marching to their fate. It is another celebrated work, now iconic of the war, but then dismissed for its flattened perspective, a composition too parallel for comfort.

This is another painting Rubbo had to fight for. Every year it became harder; in 1917 he had had to challenge the president of the Royal Art Society to a duel to get Grace and Wakelin into the exhibition. That was the year the first anti-modernist wave broke; the critics behaved as if youthful daubs from Rubbo's studio were opening the floodgates to social chaos. When *Soldiers Marching* was exhibited in 1918, along with Grace's *Candlelight* and Wakelin's *Boatsheds*, Howard Ashton dubbed them 'deliberate frightfulness'. This play on the term used for German atrocities in Europe implied that these paintings were as radical in politics as they were in technique. But *Soldiers Marching* was not consciously an anti-war picture. She painted, as she always did, as she saw. She saw the troops marching off to war and she applauded. She also saw the sorrow of the women who bade them farewell. One could say she painted a great deal more than she saw.

The key to the painting, which accounts—I think—for the fury it provoked in the belligerent Mr Ashton and the emotion it evokes in us, standing in front of it the better part of a century later, is the perfectly placed child who screams in the forefront of the painting, neglected on the footpath behind the backs of the women. This is the figure that gives the painting its bite; for the child screams, it seems to me, with the distress of all the babies who would never be born; a silent cry of loss for the women who line the streets, apparently oblivious to it, waving off the troops. How conscious of this Grace was, it is impossible to say. In terms of composition she would almost certainly have realised the power of what she was

doing. But my meaning would not have been hers. The paradox of Grace Cossington Smith is that she did not realise the paradox. It is another example of the simplicity of her statement that all she wanted was to paint what she saw. It is a case of her seeing more than she knew she saw. Or a case of the seeing of the unconscious, rather than of the conscious mind; the power of an inner eye that saw loss and longing in the tilt of a body. In both *The Sock Knitter* and *Soldiers Marching* she tackled without sentimentality the solid fact of war and the women who suffered it. A tear might arise in our eye; but there wasn't even the glaze of mist to block her view.

At least not when she was painting. But what about when she saw her family read Howard Ashton's review? She, of all people, would have known what it was that she saw: disappointment, embarrassment, maybe, a surge of loving pity. Was there a glaze to her eye that day when she crossed the tennis court and opened the door to her studio? Did she take her hat from the peg and walk down into the gully she hadn't yet painted, look up through the canopy of gums and weep alone?

Not if we are to believe her letter to Mrs Cunningham, written the next day: 'What do you think!' she wrote as if it were all a great joke. 'One of the Deliberate Frightfulnesses is *sold!* On arriving at the studio this morning the room buzzed with "Congratulations"— I said "don't be funny, I'm deliberately frightful" thinking it was that—but a volley of screams rent the air, "one of your pictures are sold".' She signed the letter 'deliberately adoring'.[30]

I believe the drama in the studio, and the additional drama of having given *Candlelight* to her mother and then having to 'ungive' it. But I don't believe the letter's jaunty tone. Even taking into account the countervailing excitement of selling her first canvas, no one who has read a bad review in the company of people they wish to think well of them will entirely believe this letter. In fact no one who's had a bad review, especially right at the beginning, will (if they're honest) believe this letter. They'll recognise it, but they'll know there is another, more private truth. This, Grace expressed to Mrs Cunningham in a letter written a year later, after she'd seen an exhibition of Hilda Rix Nicholas's work which moved and impressed her. It, too, had 'horrid' reviews. 'It is astonishing,' she wrote, 'how clumsy people can be with other people's feelings.'[31] When it came to someone else's bad reviews she had a knowing sympathy. But none of it

kept her from her work. She stretched another canvas. She squeezed from their tubes paints with double names: cobalt blue, cadmium yellow, viridian green, raw sienna.

What was going on in the heart of this young woman, this Miss Smith, at work in the studio in Cossington's well-appointed garden? She, too, was facing life without the support of marriage, and in her early twenties had already felt the full weight and scorn of the men who took it upon themselves to police the aesthetic borders and who held the cultural power to criticise and trample. What was going on in her heart as she closed the door to the studio her father had built for her, and took out her paints while her sister lifted the trays and rattled the pots in the kitchen? What shadows fell across her canvas? What were her hopes? Her romances?

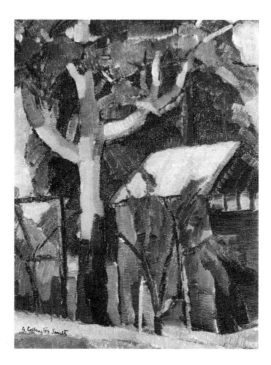

Grace Cossington Smith, THE ARTIST'S STUDIO, COSSINGTON, *1926.*

4. YOU MAY HAVE noticed that the letters I quote from are all written to Mrs Cunningham. Mrs Cunningham of Lanyon, the mother of Grace's school friend, Peggy. They are the only private letters of Grace Cossington Smith available in a public collection, and they are quite extraordinary. There's a cache of them in the Cunningham papers in the National Library in Canberra: thirty-five letters and eight fragments, written by Grace to Mary Cunningham between 1916 and 1922.[32] All but two of the letters appear to have been written between July 1916 and June 1920. The immediately curious feature is that the envelopes are addressed in Grace's hand to Mrs James Cunningham, but, when you open them, the letters themselves, all but the last two, are addressed to 'Very Dear Madame Medusa', or to 'Darling Madame'.

The first letter was written in mid-1916 to welcome Mary, Madame Medusa, back from Europe to 'this country, the antipodes'. Perseus, as Grace called herself in all but those last two letters, wanted to know whether on her way through Egypt, Madame 'had discovered any relics of him—or any locks of Madame's hair!'. The entire antipodes, he (she) tells her, 'are rejoiced at Madame Medusa's return . . . the poor things have been sitting in sack cloth and ashes . . . and they have got almost "stuck with stiffness" with sitting in the same position, but now the sack cloth, dingy old stuff, has been thrown off'.

As Grace, or Perseus—what should we call her?—had clearly been waiting for this moment, the relationship, whatever it was, must already have been established before Mary went to Europe. That much I could deduce from the first letter. Even in the reading room of the National Library, gingerly handling these letters worn thin by time, her words still have a kick to them eighty years later. I knew about the letters. In thinking about Grace Cossington Smith, I am following in the footsteps not only of Daniel Thomas but of Bruce James, who has written the only monograph on the span of her work. He mentions these letters glancingly, and as soon as I

opened them I could see why he was cautious in his approach. They show Grace at her most slithery, shifting between first person and third, masculine and feminine, singular and plural, and yet somehow shiningly present. Bruce James put the correspondence down to a girlish crush. Was it? Or was it, could it have been, closer to a love affair?

In that first letter, the private names of the letters are fleshed out as Perseus tells Madame Medusa the story of his encounter with the Sphinx. 'I have discovered,' he wrote, 'the story of the Sphinx: a lion in the desert, with a black moustache and a (ahem!) satanic countenance growled very saucily, in the desert one day, long long ago; Madame Medusa, who was flying through the air with her black locks streaming out, & looking very nice, said, "Ha, I will meet, & I will crush, & I will <u>freeze</u>" so she turned herself about and faced the lion with the satanic countenance, & lo & behold he was crushed and frozen into stone; with his two front paws straight out in front, and his two ears stuck out, listening—& his two eyes fixed & gazing—for he could not escape from Madame Medusa's eyes—& so he remains to this day—(unless you <u>un</u>fixed him when you went back the other day!)'

Perseus, it seems, was just as transfixed, and although there are no letters from Mary to Grace in the collection, it is clear that something of this intensity was reciprocated. A month later Grace, Perseus, proclaims himself 'struck all of a heap by your Valentine yesterday morning . . . delivered by that nice person Dan Cupid Esq . . . Perseus was not expecting such a message straight from Godland it seemed . . . I'm afraid Perseus's reply is not worthy of "Love's Latitude" but then I don't think Gods ever quite come up to Goddesses'.

In another he (she) is 'in "star land" after a week at Lanyon'. And a year later she tells 'Very Dear Madame' that she owes 'Perseus all sorts of things—first the sun, & the moon, & the stars . . .'.

In one of the undated fragments, Grace writes that he, Perseus, is 'pining for a letter—couldn't he have one—even a little one'. There are sudden confidences, loaned books—'Don't like the Keats too much because I want you to like Brooke'—and bad poems about snared hearts: all the tell-tale signs of love. When Mrs Cunningham, Madame Medusa, was on holiday by the sea and Grace was languishing in the heat at Turramurra, she wrote, 'I think I'm jealous of the waves!' Exclamation marks—of which there were plenty—were

renamed admiration marks. Parting was always hard: 'After leaving Madame today, Perseus felt so bereft he nearly had to come back.' And she admits to thinking about Madame all the time, and laughs at that gulp of self-conscious surprise when someone mentioned her name and she had to feign indifference, a casual disregard.

All the signs are there. But do we read them right?

Research into the letters nineteenth-century women wrote to each other shows that a romantic rhetoric was part of the convention of letter writing between women friends. Passionate friendships were not uncommon among women of the middle and upper classes whose lives were structured both before and after marriage into highly integrated female networks of kin and community. These passionate friendships, it has been suggested, were emotionally ambivalent, hovering somewhere between the platonic and the sensual.[33]

Had the correspondence been between Grace and Peggy, the Cunningham daughter closest to her, the intensity could perhaps be explained in this way. But how common were such rhetorical flourishes, even at the height of the Victorian era, which was well past by the time these letters were written? How common were they, even then, between women across generations? In 1916 Grace Smith was twenty-four and Mary Cunningham forty-seven.

The letters do indeed oscillate letter by letter, line by line, between the rhetoric of romance and the more expected formalities of a young woman to the mother of a friend. Consider this one: 'It was very nice seeing you on Tuesday,' Grace wrote. 'Perseus thought Madame very specially BONZE—madness, mud, meringues? and pros and cons. What matter? Madame's there? and she is BONZE . . . Mummy is very sorry to have missed you again—she is better now but her head still feels giddy at times.' I read this letter with its schoolgirl slang—*bonze* for the exuberance of *bonzer*—and think I'm being overdramatic. Yet what explanation other than an illicit love can there be when Grace wrote on the train back to Sydney from Lanyon that 'Perseus was very miserable not being able to say goodbye to you last night. I saw you from the back of the hall and looked a goodbye to you, so perhaps you understood.' Why, as a house guest, could she not have said goodbye, unless there was a form of goodbye that was disallowed her? What hall were they in anyway? It doesn't make sense that she couldn't say goodbye in Lanyon's hall; for a start it wasn't that big.

If this were a novel, which it's not, the scene would write itself. Let us imagine that the party from Lanyon had spent the afternoon at a concert in a hall in nearby Queanbeyan; it had been organised to raise money for the war and Mrs Cunningham was on the committee. There she is near the stage with the other ladies, bustling about thanking the singers who have come all the way from Sydney. At her elbow is her husband James, wiping his nose with a large handkerchief and talking to the young officers in their braid and uniform who are there to accompany the singers and play in the brass band. Milling around underfoot are children dancing beneath the Union Jack, trying to catch the attention of their teacher, but she is shooing them away, anxious for a word with Mrs Cunningham.

So when the sulky comes to take Grace and Madge from the hall to the train that evening, there isn't a chance for the goodbye Grace wants to make. She hovers and Mary turns to her, but the teacher is telling Mary about her nephew in Flanders, and just as Mary is about to cross the hall to say goodbye, Peggy comes up. So Grace watches from the door and waves, that's all, as Madge hurries her along. Outside, if this were a novel, she'd climb into the seat, silent beside her sister. She'd smell sheep, and the distant rumbling of a storm.

Grace Cossington Smith was in the first years of her twenties during this correspondence, a prime age for marrying, and even in wartime there were still dances. Opportunities for courtship continued, heightened if anything by the pressure of war. She enjoyed balls at Government House which she described to Mary with characteristic enthusiasm; and in June 1920 she wrote that she was 'absolutely thrilled to the core over the arrival of a most lovely invitation card'. She was at Jervis Bay, 'bivouacking' with her friend Nell Campbell, when the *Renown* sailed in with the Prince of Wales on board. The invitation was to dine in the presence of the Prince. 'There were only three ladies from the Naval College and us two, and we had a great time.'

But the accounts she gives of these glittering occasions are not those of a girl looking for a husband, or even a beau. What she loved was the colour—always a theme with Grace—the braid and the gold, the flowers and the music, the ceremony and the officers. Of a Government House ball she reported: 'I danced with two very exciting creations all over gold and medals and the floor was perfect,

only too crowded—it took very expert steering.' On the *Renown* she sat next to a 'very large, lovely, jolly gold person, Capt Hardy. My only tragedy was an unseen hand whisked off my champagne before I had nearly finished it. After dinner the Prince signed our music cards and we had two dances, only two unluckily.'

All this is embedded in an absorbing correspondence with Madame Medusa that was filled with surprises, tantalising promises of meetings and letters and gifts exchanged. From Mary there were poems; from Grace drawings. And for Grace a green bouquet and a cape with a flame-red lining. 'What a perfectly lovely and stupendous surprise—only one word can express it—and the one the gods use when they speak of anything <u>very</u> special, just as in a whisper among themselves—heavenlyoso—deliciousoso. I picked it up in my last flight, one of them whispered it a trifle too loud, so I just caught it. From what I saw in passing one of them was wearing something just like IT—dark blue outside and all red flame colour inside—which made Perseus break the ten command—as it is quite his favourite colour.'

And then, some time in the middle of 1920, the letters in this form end. Mary, her husband James, and Peggy left for Colombo on their way to Europe. I don't know why, or for how long. From mid-1920 there is a gap in the correspondence of about a year, then two final letters, both signed 'from Gracie'; neither mentions Perseus. In the first, in response to a letter from Mary, who was back and in Sydney, she writes that no, 'unluckily I am not the sender of the lovely pink carnations—though I should like to be—and shall pretend I am'. The last letter, addressed to 'Dear Mrs Cunningham' regrets that she will be unable to visit either on Thursday or Friday as she is preparing for a tennis party at the weekend in honour of her birthday. Lob that ball, Gracie. Over the net.

There are no further letters. None to mark Peggy's marriage in 1920 or James's death in 1921. There's no letter to Peggy on Mary's death in 1930. Clearly the moment of intensity had passed. Almost as if she could see it coming, Grace had written to Mary in 1917: 'There is somewhere a huge invisible policeman that stands with a stern collosal finger pointing on, & saying "move on" "move on"—it must be—or the traffic would be congested.'

In one of the late interviews, Grace Cossington Smith was asked if it had been a deliberate decision not to marry. 'If I had

married,' she replied, 'I don't think I would have been able to paint so much. There was one friend I went to see, but it didn't come to anything because I didn't want to marry. I think it was because I was wholly interested in painting.'[34] It's another of those maddening statements she made in old age, at once dense with meaning and politely evasive. The friend, I suppose, could have been Andy Cunningham; she wrote friendly, conversational letters to him at the front, sent him snapshots from Lanyon, worried about his safety, and marvelled at his and 'their' bravery. But on the evidence of her letters to his mother, the 'friend' is more likely an acceptable shield to a more difficult truth. Certainly her closest friendships were always to be with women, and these letters would suggest a stronger pull. When she sent Rupert Brooke's poetry to Mary hoping that she would share her enthusiasm for him, she chose as a teaser, or taster: *And there's an end I think of kissing/When our mouths are one with mouth*, she quoted. 'Don't you think it's rather nice?'

I don't know what term to use of this relationship; it is the prurience of our age—not theirs—that wants everything labelled and accounted for. There were women—Frances Burke, a fabric maker in Melbourne during the 1930s was one—who presented themselves with Sapphic panache, but it took a certain assurance, a kind of mannish confidence, and an environment sufficiently bohemian to hold what was still considered a deviation and enjoy its freedoms. Living in the most settled and conservative of families, neither Mary nor Grace were in a position to present themselves as this sort of woman, and it probably never occurred to either that anyone would. Whatever it was they were experiencing, equivocal and shifting, Grace, at least, seems to have been blithely unselfconscious and not troubled by it at all. Her letters are almost naively cheerful.

Mary Cunningham, on the other hand, was often unwell, laid up in bed with various minor ailments and bouts of 'racked nerves', for which Grace sent witty diagrams of machines for un-racking nerves. With sons at the war, a husband with a perpetual cold and Grace the age of a daughter, this is perhaps not surprising. It could be counted as a classic case of hysteria, when the body manifests unspoken conflicts in physical symptoms. A very feminine malaise. It's not the best way to conduct a love affair—if that's what it was—and I assume that in the end reason, convention, the dictates of family, tradition and good sense—to say nothing of guilt—meant

that the older and socially more knowing Mary laid Grace gently to one side when she and James, recovered from his cold at last, left for Colombo.

Some time between 1916 and 1918 Grace painted her first oil self-portrait, which she called *Study of a Head: Self-Portrait* (plate 20) as if she, too, could come under her own scrutiny. She was in her mid-twenties. Look at her. I'd say that that is the face of a young woman who has known sexual passion—or at any rate passion—and is giving nothing away. Whatever else, it is not the face of a young woman inviting the desires of men. It is not a face waiting to be seen. It is a face that sees. It is boldly executed, with sharp lines and planes built up in uncompromising colour, reds and greens emphasising the structure of bone, the set of the jaw. There are secrets behind those eyes.

Or, to put it another way, what man would be up to a girl with a look like that? What man in Sydney in 1918? Not the man she painted soon after this in a work she entitled simply *Portrait of a Man*. She rarely painted men, which is partly why this one draws my attention. There are several sketches and drawings of her father and her brother, but few oils of masculine faces. There are some group studies of men—soldiers, workmen, schoolboys, a church congregation—but this portrait is unusual for its intimate focus on an individual man. Which makes it all the odder that we don't know who the man is. He isn't Gordon, or Ernest, or Ridley. He isn't Roland Wakelin. He doesn't match any of the faces from known family or holiday photographs. Perhaps he was the 'friend', though I doubt it. Bruce James thinks he was probably a Turramurra neighbour.

In a sense it doesn't matter who he was; Grace deliberately didn't tell us. She called the painting *Portrait of a Man* not to confuse us, but to draw attention to his formal properties. As with *The Sock Knitter*, she was aiming for the shape, the density, the planes, the weight of (in this case) a man. And by doing so she presents us with something of the felt reality of a man at the end of the war. But unlike *The Sock Knitter* and most of her portraits and sketches of girls and women, *Portrait of a Man* does not evoke an uneasy interiority. Her reading sisters tend to bring their books close in towards themselves as if they must hold the anxieties of the world at bay before they can let themselves become absorbed in their reading. The man holds his book at a confident, slightly long-sighted distance

Grace Cossington Smith, PORTRAIT OF A MAN, *c. 1918.*

and spreads himself into the available space; there is not the same sense of conflict between the world he withdraws into and the world that presses upon him. We surmise from his stance that the man does not doubt his right to be in that chair. Yet this confidence is not without anxiety; consider the furrow to the brow and the way the light falls across his face, leaving half in shadow, and the slight discomfort of the arm that leans out of the chair as if it were not quite sufficient to hold him. Behind him is a ledge—perhaps a window, perhaps a hatch, with a jar and a bowl of fruit on it—and from this uncertain aperture there is light, a yellow-cream light. It is this that illuminates the man, and the portrait. Is it light from a window? From the world outside? Or is it light from another part of the house, where meals are prepared and women talk as they cook and work? It is in the relationship of this man to the world beyond his chair that we find a clue to the portrait's meaning.

From her earliest drawings, Grace Cossington Smith had a fascination with the world beyond. Her student sketchbooks, which date from 1911, contain many drawings of hallways and doors, windows and verandahs, one space opening onto another, light entering from unseen sources. In the early oils there is often an unease about these hidden sources of light; it unsettles *Portrait of a Man* in

interesting ways. There is an anxiety inherent in the composition that contradicts the confidence of the pipe, the attention of the man on the deeply coloured book. We share his focus in that our eye is drawn to the line between eye, pipe and book, and yet even as it is drawn into that moment of concentration, it is pulled away by the ledge. Other possibilities vie for our attention. Like a woman knitting socks, a man reading a book took on different meanings with the carnage of a war that killed thousands upon thousands of young men.

So who was the man in *Portrait of a Man?* To be literal about it, he was probably that Turramurra neighbour. But his real life, his historical identity, is not what is important about him. In a sense it doesn't matter. One could say instead that he was the husband the Smith girls would never have, the husband Madge could not have and Grace would not have. Or that he represents the condition of a man who was still alive when that war that killed nearly 60,000 Australians ended. He takes his place, opens his book with a certain masculine confidence, and yet the sorrow in his bearing falls across his face, a trace of shadow which no amount of light, be it from the kitchen or from the world beyond, can alleviate or lift.

This is what Grace Cossington Smith saw of the condition of a man at the end of the war; this the shared secret of his being. There is no hero here, no striding power, no certainty of control. His future may be different, but it is no more certain than the future is for Madge as she knits her socks. Though he could have a wife where so many women could not have husbands, his relationship with the women who hover just out of range has for ever changed. And perhaps the greatest change, accelerated by the war, comes with the observing gaze of the painter. For that detached and steady eye is feminine. It is no longer the man who paints—who sees—the woman, marking her as he wished her to be; it is the woman who paints the man.

Grace Cossington Smith was well aware of the power as well as the challenge of *what she saw*. At one level it is absolutely clear what she meant when she said she preferred to paint than to marry. When you put *Portrait of a Man* alongside the 1918 *Study of a Head*, there can be no doubt about what it was that she was not marrying.

Looking at these two paintings together, I begin to understand why it is that when I look at that self-portrait, I think I am looking at a boy. I don't mean that I consider her masculine, or mannish. I mean I see her capacity to act in the world; I see a force in her, a

tender force, one that she doesn't quite yet understand. I look at Madge as *The Sock Knitter* and I see compliance, the desire to be acted upon. In Grace I see the stretch into ambition and drive, and it is this which makes me think of a youth when I look at her, although I know full well that I am looking at a young woman. It's as if that aspect of her, still young and with the blush of a boy, is present in the portrait. And perhaps it is. I think of the letters and the ease with which Perseus and Grace can slide between each other—*she* slips into *he*, masculine and feminine no longer fixed but mobile and fluid, capable of becoming each other. And I think of the story of Perseus with his gifts of winged boots, a magic pouch and a helmet of invisibility, bestowed by the gods as he set out to slay the terrifying Medusa, the Gorgon with a stony glance and wild snakes in her hair. What a strange story to choose for a romance. But then, was it a romance? Perhaps it is a story about the different parts of her own psyche: the fleet, and the endangered?

It is one thing to say a young woman like Grace might prefer to side-step marriage when by marriage we mean the white picket fence and the Monday wash. It is another thing altogether to look at that face, read those letters and then say she was laying aside a life of passion as if there were some unambiguous replacement pleasure awaiting her in the studio. However we read the letters to Mary Cunningham, we'd have to say they were written by a young woman of highly calibrated feeling. Feeling was an attribute Grace admired and associated with the feminine. When she wrote to Mary about Hilda Rix Nicholas's exhibition, she said: 'The strange part is all this is painted by "only a woman"!! Screaming, isn't it. Of course <u>really</u> only a woman <u>could</u> paint like that; a mere man not being capable of feeling things in the least like that—he may <u>paint</u> better, but not <u>feel</u> better!' Painting and feeling pitted against each other. Masculine and Feminine. Inner and Outer. Could she make her claim to both? The war might have saved her from the fate Madge longed for, a life with a husband and children, a *kitchen*, but it released her into the fullness of her own inner life, a complex relationship both to feeling and painting, to herself and the world beyond.

5. FOR ALL GRACE'S play with oblique light sources, for all her exuberance and ambition, the world beyond was not a safe place. Not in 1918. Not even for a young woman safely living in Turramurra. Certainly not for a young woman setting out as an artist in a parochial and masculine culture.

With the war's end all should have been well. Gordon had returned with a Military Cross, awarded for 'conspicuous gallantry and devotion to duty', and an injury to his ears that was to upset his balance in later life. Ridley was reunited with Mabel in Ireland. The Smith family had fared better than most. In 1920 Ernest bought the house in Ku-ring-gai Chase Avenue where they had been living for seven years and its name became 'Cossington'. And in the same year Mrs Smith suggested that Grace incorporate Cossington into her professional signature. It was a confident move. But beyond the house there was discord. Strikes and industrial upheavals were reported in the papers; the unease could be felt on the streets. Rubbo, sympathetic to labour, was painting workers and scenes from strikes. Grace, taking her lead from him, also painted what she saw on the streets. But her canvases were less sympathetic.

After a day at the races in 1922—Wednesday, Ladies' Day— she painted *Crowd*, a powerful image of a mass of men moving as a group, taking all the room. It was a disapproving painting. 'They swagger about with their hats on one side, chewing & laughing & lolling,' she'd written to Mary Cunningham during the war of the men gathering against conscription. 'I hate them all . . . & their minds only take in the next public holiday & tonight's picture palace.' As for these men at the races, what were they doing there on a Wednesday afternoon anyway? Why weren't they at work? 'A humorous attempt at modernism,' yet another hostile reviewer wrote, missing the point, 'by someone who has discovered the astonishing fact that hats are smaller the further they are away.'[35]

What would it have meant to Grace, coming under assault from this kind of criticism, when she already felt herself under assault

from the men who moved in crowds on the streets? There was the obvious and immediate cut of reading scornful reviews of her work in the company of her family. But beyond that what did it mean? Is it making too much of it to suggest that this brick wall of masculine critical hostility would have felt to her a bit like those lolling, jeering crowds? They are not in the same register, but in each case she was confronted with what must have seemed an intransigent masculine edifice: hostile, ungiving, impenetrable. And capable of doing her harm—personal harm and professional harm. The question that faced her, as it did all women, was how to make her way in the world, both literally as she walked through the city, and figuratively as she tried to find a way of living as a woman of the twentieth century. And there was the more particular struggle of how to make her way as an artist and maintain belief in herself against that wall of incomprehension and derision.

She was not the only painter to face critical hostility; the men got it too. When, in 1919, Roy de Maistre and Roland Wakelin exhibited their 'colour music' paintings which tried to equate colour to the musical scale, Howard Ashton was savage. 'Elaborate and pretentious bosh,' was his verdict on their exuberant colour key-board as he set about ridiculing paintings with titles like *Synchromy in Red Major* or *Caprice in Blue Minor*.

One way of thinking about Howard Ashton is as a paid-up member of the power elite Naomi Mitchison called *the buggers' union*. After a savaging from reviewers in the 1920s, she is said to have said that she never expected a fair deal from the buggers' union. In England, of course, it had the double meaning of the hidden sexualities of public schools. But even without that cultural lading, we know exactly what she is referring to. The buggers' union has had a long history and although it has taken a few body blows in the past two decades, it is still in business; ask any woman who paints or writes. At least now we can name it.

For Grace there was no such concept. Of course she was wounded by the critics. How could she not be? More robust egos like Roland Wakelin and Roy de Maistre, with the slim protection of identifying with an intellectual movement, were affected. After the mangling of their colour keyboard, they drew back from their experiments in abstraction as well as colour and it took some years before they regained their dash. In 1922 Roland Wakelin and his wife sailed

for London and didn't return until the end of 1924. In 1923 Roy de Maistre was awarded the Society of Artists travelling exhibition, which he won over Grace Crowley. He wasn't back until 1926, and then only briefly before he left for ever. Grace Cossington Smith stayed at Turramurra, and although she didn't depend on de Maistre or Wakelin in any social way, she was very much alone. You only have to look at the drawings Grace Crowley put in for the travelling scholarship that de Maistre got and she didn't, to see that Julian Ashton's Sydney School of Art had not yet encountered the modern.

So although long afterwards Grace said it was just as well the critics hadn't liked her, for it meant she could go for broke and paint as she wanted, it wasn't that easy at the time. Again and again she had to struggle to get her footing, to regain it, to find it afresh, to keep it. The greatest mischief done by a man like Howard Ashton lies in his insistence that far from speaking on behalf of a power elite, maintaining the terms of culture, he is representing some kind of universal standard, and unassailable truth. Two years after the triumph of *The Sock Knitter* and one year after the 'deliberately frightful' *Soldiers Marching*, she wrote to her darling Madame Medusa: 'I am floundering in the mud of paint and failures.' I wouldn't use the word 'failure', and I wouldn't use the word 'mud', but in the early 1920s something did go out of her work for a while; that burst of colour ushered in by her homage to Van Gogh and Cézanne was toned down as if she too had lost some of her dash. The simplicity of form, once so easily hers, had to be striven for.

In 1920, when Wakelin and de Maistre were still smarting from Howard Ashton's attack, Max Meldrum made a brief visit from Melbourne. They were caught into the whirlwind of his arrival and although their flirtation with his theories of tone was brief, it made its way onto their canvases. For Meldrum—a charismatic and insistent teacher—tone, the gradual shading of light and dark, was the only method by which reality could be expressed in paint, and it was his influence as much as the bad reviews that has been held responsible for Wakelin's and de Maistre's loss of confidence in their modernist colour.

The impact of Meldrum on Grace Cossington Smith is less clear and although it almost certainly had a part to play in the dulling of her palette for those few years at the beginning of the 1920s when she went uncharacteristically tonal, she was protected from the worst

excesses of his malign presence. She didn't go to the 'scout camps and tobacco taverns' where the men hung out with him.[36] In her narrative, Meldrum's visit is barely worth a mention. But he was Clarice Beckett's teacher, and although the two women never met—one living in Sydney and the other in Melbourne—it is at this point that Grace's story glances at hers.

Clarice Beckett and Grace Cossington Smith were both single daughters living in the family home and both came to their best work in conditions of considerable isolation. Clarice Beckett was no more bohemian or 'modern' than Grace, and insofar as she was part of the Meldrumite group, socially she was very much on its fringes. Compared with Grace she had three crucial disadvantages. Her father was an unpleasant man who seems not to have done well in his career—which may have been why he resented his daughter and refused her a studio: that was the second disadvantage. The third was that for Clarice there was no Madge. Worse, she had to be Madge as well as herself, which meant that for the most part she could only paint early in the mornings and again in the evenings; she left the house and painted outside, pulling her little cart of paints along behind her. But like Grace, she painted what she saw in her immediate environment; she transformed the suburban streets and bay-side views of Beaumaris into images of a modern Australia, just as Grace transformed the gullies and gardens of Turramurra.

What Clarice Beckett had that Grace Cossington Smith did not was a defining relationship with a teacher. She took Meldrum's method and made it her own. Despite his opposition to any form of emotional subjectivity in art, she made the misty tones of morning or evening hers; they are utterly expressive in their watchful detachment. Because Meldrum's teaching suited her sufficiently, she never had the turmoil that Grace was experiencing at this moment in the early 1920s of casting around for a method, pulled and drawn in various directions as she tried to find her own idiom. Rubbo was a very different kind of teacher, who encouraged his students' exploratory diversions and didn't have a single theory that he insisted on. But he did have his limits and when Grace came up against them and made her break with him, even a teacher of his temperament was hard to leave.

As there are no manifestos, no explanations, no further letters, it is the paintings themselves that must offer some sense of what was

happening to Grace during those low years after the war when she
was struggling to regain her confidence with colour. She painted a
lot and her sketchbooks are full, and the only way I can make sense
of what she was doing is to say that there are two loose groups of
paintings and drawings, each working and reworking different ver-
sions of similar problems while tackling very different subjects.

There are familiar images that modestly and insistently slow
the eye to an encounter with private and domestic experience. In her
sketchbooks, an uncensored record of studies that were not striving
for permanence, there are those many drawings of girls and women
—usually her sisters—reading in deck chairs, in armchairs, in the
garden, on the verandah, in bed. Transitory moments. In each, as
with *The Sock Knitter*, the eyes are lowered, allowing us to view the
woman undisturbed, while she is absorbed in her work. In most of
these drawings it is a book that claims the woman's attention in

*Grace
Cossington
Smith,
'My Dear
Sister
Diddy'.*

*Grace
Cossington
Smith,
'Mrs Smith
Reading'.*

ways, it seems to me, that evoke both the world of intellectuality that Virginia Woolf laments is denied to women and the private world of the intellect that women make their own; a feminine space that is at once hemmed and filled with possibility.

In *Open Window* (plate 21), which she painted in 1919, Madge is sewing at an open window. This time the material in her hand is soft and feminine. She looks down at her task and although the window is open she does not turn her face to it; the room inside has more power than the garden outside. The window is not a barrier framing the world, as it was for Stella Bowen, it is not a protection; it is an extension of the enclosed feminine world that Madge inhabits. The world beyond is concealed by the hazy light of the garden.

Then there's a second quite different group of paintings: large urban oils that pre-date her Harbour Bridge paintings—images of strikers, crowds and commuters; the modern urban world of mass movement which, on the evidence of the letters, repulsed and frightened her. In another letter to Mary Cunningham, she described going home on a packed train with the crowd 'scrambling & pushing & squeezing'—an image that she painted in *Rushing*, 1922. In *Crowd* (plate 22), the racecourse punters are undifferentiated, without feature or personality; only one face looks out. But in both these paintings, as well as threat there is a tremendous sense of movement. In *Crowd*, the throng, though contained on all sides by the racecourse buildings, achieves a pressured energy as it converges on the tree that bursts from its centre, an image of life and growth that softens the harshness of the scene, just as the warm ochre of the buildings is picked up in the faces of the crowd.

Rushing (plate 23) is a more frightening image as the commuters running for their train are forced along by movement outside their control. The women's feet are twisted and their step perilous. But even here the energy of the crowd is compelling as well as daunting. Was Grace Cossington Smith giving shape in these paintings to the complex problem facing women of the early twentieth century as they tried to place themselves in a public world? By this reckoning the public spaces of modern urban life that women could not inhabit safely were nevertheless exciting: the double inheritance of promise and threat that comes with modernity.

Or was this the conservative impulse of femininity, rejecting the mass of men moving in crowds which left no place for women,

tripping them up as they rushed for their train? Or was a claim being made: move over, it is our world too? For the alternative, of women reading or sewing in safe rooms, was not so cosy. Although Grace Cossington Smith lived so thoroughly within the family, her vision of it is stark, her women very much alone in a feminine space that is deeply ambivalent. Are they shut in? Or shut out? Her view of her readers is uncompromising. Here is a life that must nurture itself: elusive, subtle, silent and filled with unresolved longings. Yet these are the women who must find a way into the rushing world.

Rather than an impediment to understanding Grace, this ambivalence, this potent uncertainty, is a key to her work, and to the drive by which she became an artist who produced iconical works of early Australian modernism. Even if the colour doesn't have the shine of *The Sock Knitter*, who else was painting the tension on the streets? Compared to hers, Rubbo's more heroic images of workers and strikers have dated as the expected images of his time. We can be surprised that it was a young woman from the safe reaches of Sydney's North Shore who painted the turbulence of the city's post-war streets. Or we can say, of course it was her, for who better to understand that painful double dance of inheritance and exclusion. Grace Cossington Smith had a sense of profound association with a culture from which she was, in crucial ways, held at a distance; the ambivalence that Virginia Woolf describes so well as a condition of exile, at home and not at home. There she was, barracking for conscription, drinking to the King, absolutely the Anglo-Australian; and there she was, the boyish girl who was filled with feminine intensity, aberrant passions and a vision that could give a gum tree its primeval colours.

In her next self-portrait, drawn in the garden at Cossington, the boyish energy of 1918 has gone. It is 1923, and her hair has been cut short, as if it is no longer important. Gone, too, is that charge of unused energy. Her shoulders are slumped. A sunhat shades her face. If it weren't for the eyes, I'd say this woman was in retreat. Certainly sad. But those eyes, wide open and certain, give a blast of life to her drawn-back stillness.

In 1923 Grace Cossington Smith had plenty to draw back from. The end of the affair, whatever it was, with Mary Cunningham cast a long shadow, as any loss of love does—all the more so when it cannot be acknowledged. Then, in 1924, there was the year without

*Grace
Cossington
Smith,
'Self-Portrait
Outdoors',
1923.*

Madge. While her sister was discovering the enticements of an English village and making the acquaintance of Robert Kettlewell, Grace was in the kitchen at Cossington. Diddy was still training; as a 'baby nurse' she didn't get much leave and wasn't enthusiastic about housekeeping when she did. On top of that, Ernest's bad eyes were getting worse and he needed to be read to and guided about. Her mother, never well, was showing signs of the cancer that would kill her in 1931. She needed her meals on a tray. That year, 1924, Grace did not exhibit with the Society of Artists.

In retrospect I can see that she was on a springboard. The moment before one leaps is often depressive. Or rather it can seem depressive if all that can be seen from outside is the shut-down that occurs—a necessary conserving of energy and retreat from an unsympathetic gaze. When the spring came, it came from her, but the person who was to give strength to that spring was still a good year away. Like a good fairy, the writer and art critic Ethel Anderson was about to make her entry. She was a woman who, like Naomi Mitchison, could take on the art world's powerful men. Grace was in need of an ally.

At the end of 1924 Ethel Anderson returned to Sydney from London with her English husband and their daughter. They took a house in Karuah Road, Turramurra, literally round the corner from Cossington. Mrs Smith made a call early in 1925 to welcome her new neighbour and took Grace with her. We know this because Ethel Anderson's daughter Bethia, who was coming up for twenty at the time, was with her mother when Mrs Smith and Grace arrived at the door; years later she wrote of it, giving us a glimpse of Grace at this auspicious meeting. Grace, Bethia reports, 'behaved in a dutiful manner, sitting silent, her eyes devoid of emotion, while Mrs Smith discoursed smoothly on the weather, the district, their English home on the Isle of Wight, where her father-in-law had once been chaplain to Queen Victoria'.[37]

There were, I suppose, many occasions when Grace would have accompanied her mother on social calls, many occasions on which she sat with *eyes devoid of emotion*, good manners laid like a protective shield over her painter's heart. What would Grace have been thinking under that polite exterior as the intricacies of the social map were set out between the ladies around her? Perhaps she wasn't thinking exactly, but allowing herself to feel the shape of work she was facing as she regained her colour with little to support her; it must have been a bit like swinging from a high gutter.

Rubbo, once the adored master, the joyful encourager, had stepped back in disapproval. The break with him had begun. Not an ugly incident, or even unpleasant, but certain, unmistakable and disturbing. 'I had been very depressed,' she told Daniel Thomas, 'when Signor Rubbo didn't understand the way I wanted to go and thought I was wrong.'[38] Colour was at issue, and so was perspective; Rubbo felt she was taking both too far. He disapproved of a painting of a garden that was 'all on the same plane' and told her that she had to 'get some distance'. 'Well,' she said to Daniel Thomas, 'I didn't want to.'[39] Not only this, but in making her way back to *colour vibrant with light*, she was moving too far from the standard of complementary colour. As she broke loose, he resisted. He wanted her to retain at least a residual gesture to traditional perspective; she wanted to imagine her paintings from all sides at once, superimposing one flat plane on another. 'I just see a plane, and another beside it,' she told Daniel Thomas. 'I don't want the distance.'[40]

Daniel Thomas calls *Centre of a City* (plate 24) her farewell to

Rubbo.[41] She painted it in 1925, and in her sketchbooks one can see the work and preparation that went into it with ten preliminary studies and a lot of notes. 'Warm light, cold shadow,' she wrote. 'Note position of pillar box on pavement.'[42] Colour and perspective concede to Rubbo; her view of the city street is calm again after the turbulence of the crowd paintings. Bruce James points out that this was her first *blue sky*.[43] Was she saying goodbye to her master, bowing to his teaching as she left it behind? Was she finding that she could walk more safely through the streets of the city? If she was no longer being jostled in this painting, she was very much alone. 'I suddenly liked the subject,' she told Daniel Thomas. 'I liked the going downhill of Moore Street [now Martin Place], the feeling that the Post Office at the bottom was the centre of the city, the people hurrying about . . . I like a street going down . . . The downward road has interesting different directions.'[44]

When you look at its palette and then at *Trees* (plate 25), which she painted a year later, you can see the leap that put her beyond Rubbo's reach. And compare these works of hers with Rubbo's own self-portrait of 1924, the year of their parting. His colours are complementary, his perspective is in place. He shows himself with brushes and canvas, well dressed beneath his overalls, in command of his profession, coiffed and posed as if this was how he wanted the world to see him; it's the painting of a teacher demonstrating his repertoire. 'A cautious exercise in a more modern form of expression,' the art historian Helen Topliss calls it.[45] There's nothing cautious about *Trees*, and it's not an exercise in anything. It is fully realised from an imagination that can indeed see a tree from all sides at once. Her planes are flattened, her colour is heightened; that tree is a eucalypt unlike any that had yet been painted, an utterly Australian, utterly modern tree.

Anthony Dattilo-Rubbo, SELF-PORTRAIT, *1924.*

Early in 1926, the year we are creeping towards, the year she painted *Trees*, Grace went back to Rubbo's Atelier to hear George Lambert speak. She put an oil called *Still Life with Vegetables* into a competition—with prize money of five guineas—that he was to judge. According to the Sydney Art School magazine, Lambert deliberated between Grace's still life and a study of fruit and flowers by a Miss Walton Smith. 'I was tempted by the apples,' he is reported as saying and Miss Walton Smith won the prize. Grace said he told her that hers interested him 'most'—'He said it was after the style of a German painter I'd never heard of'⁴⁶—but the student magazine reported that 'Miss Cossington Smith's rigorous design fell short, in his estimation, by reason of two edges of a wall running diagonally across the picture in opposition to the lines of its frame. He thought it a "Bolshevik" upsetting of the first principle of decoration.'⁴⁷

Grace Cossington Smith, 'Study for STILL LIFE WITH VEGETABLES', *c. 1926.*

Look at that knife in *Still Life with Vegetables*, its blade straight into the heart of the composition, its handle poised for us—for her?—to pick up. It took three goes to get the angle of that knife right; there are two preliminary sketches, and then suddenly it is there: strong and clear. What she needed was someone who would understand not only her colour but that dagger in the kitchen;

someone who would respond to her not as a student but as an artist. 'Ethel Anderson came in like a sunbeam,' Grace said.[48]

It was early 1925, while it was still summer, that Mrs Smith and Grace first called on Mrs Anderson.[49] A few days later Ethel Anderson and Bethia walked round to Cossington to return the visit. Mrs Anderson must already have made her interest in art known, for on their arrival Mrs Smith suggested that Grace take their guest down to her studio. Grace, according to Bethia, was not keen. 'With the owner's reluctance, the door of the little folly was opened; Mother and Grace went in, the door was shut, and we who were left departed for the shade of the verandah, where tea had now appeared. "I hope dear Gracie does not keep Mrs Anderson too long," one of the girls said.

'"Oh I'm sure she won't. I do hope your mother won't be bored," Mrs Smith pouring out tea from a silver pot as big as Cinderella's coach, unconsciously showed how little they understood or appreciated the artist in their midst. It said a great deal for Mr and Mrs Smith, whose minds were controlled and civilised, but quite unacquainted with art, that they had paid for Grace's trip to Europe; accepted her unremitting studies, her struggles and rebuffs, to the extent that they had given her so well equipped a studio. It was really wonderful of them, for none of them, then, had any idea of how good she was, or how well known she was, so rightly, to become.'

Crystal among glass, Nabokov calls this condition. *A sphere among circles.*[50]

'As the door of the studio remained shut, I thought about Grace,' Bethia continues. 'Not as tall as her mother, she was slender, her frizzy brown hair cut short like a boy . . . She was not a smart dresser, as I was to learn, but she was always neat in low-heeled shoes, preferring brown for winter, or cream and red for her dresses in the summer. No prattler, her voice was sometimes hesitant, not from any impediment, but because she searched her mind carefully for the right word to describe exactly what she meant. Her eyes, I was just thinking, gave nothing away, devoid of expression. But at this moment the studio door opened and I could scarcely believe my eyes. Mrs Smith was surprised too, holding that vast tea pot temporarily suspended, as she gazed at her transformed daughter.

'My mother's eyes were sparkling with excitement. Gracie's too were alight. I do not think either of them saw us, they were so intent,

talking as fast as a horse races in a steeplechase, jumping from one idea to another, from the Pre-Raphaelite Brotherhood to the way Burne-Jones had benefited from Botticelli, and the religious influence of the Italian school; to the French Impressionists; to the Pointillists, and the exciting new concept of space composition . . . "And who knows?" Mother encouraged Grace. "With your unique brush stroke, with your grasp of colour, you may be about to give an expression to a quality in life, more moving than beauty alone, more intimate than infinity. *You* may find a fourth dimensional element as yet unfound, un-named."

'No one had ever spoken to Grace like that before. The Smith family sat goggle-eyed; and Grace was overcome. To have her work taken so seriously, to have it praised, was like a burgeoning flower in the arid desert of her life.'[51]

6. 1926 WAS A happy year. Indeed, the next few years were among the happiest in Grace's long life. Not necessarily the most contented—that, I think, came later—or peaceful, but *happy*. It is a word to use of youth, when life is full and begins to find its shape. It is a word that belongs to Grace in her thirties.

Consider the paintings that came, all of a rush, in 1926. There was *Trees*, that blast of colour into the Australian bush. It is the painting that brings the gum tree into the modern world: there's nothing else like it between Tom Roberts and Fred Williams. Great splashes of pink and ochre, greeny blues, a whirl of colour, a receding landscape at once deeply familiar and strangely unexpected. The edge of the tennis court is in the foreground; the domestic gardens—the tame, the safe, the cultivated—slip under a brilliant rise of colour; above the tangle of branch and tree, plane and shape. The eye is swept up into the trees, into the hectic intricacy of branch and leaf, and then set down in the settled garden beneath. There is movement, and also stillness.

And there was *Eastern Road, Turramurra* (plate 26). Incandescent with not so much as a puddle to mar its glory, its greens and yellows and splinters of cadmium red, its earthy ochres and viridian shine render it a watercolour that we stand before in the National Gallery of Australia as one of this country's finest. It captures the equivocal state of Turramurra, on the edge of the city with suburbs encroaching—the telegraph wires only reach halfway down the road—in a landscape that is neither settled, nor not settled. Now it is a suburb, no longer on the edge of the city, and at the bottom of the hill there's a shopping centre. But then, in 1926, it was an in-between place, a zone that Grace knew well.

And there were more paintings of roads going down and the first of the flower still lives with their 'soft brilliant colour, like our atmosphere'.[52] And the delicious *Pumpkin Leaves Drooping* (plate 27), which captures at ground level the breathless heat of summer as if she had entered the experience and colour of the leaves themselves.

'I have always wanted, and my aim has always been to express form in colour,' she said. 'Colour within colour, vibrant with light.'[53] After the dip of *mud and failures* in those last years at Rubbo's Atelier, she achieved it—utterly on her own terms and in her own right—with these paintings that began in 1926. And also that other aim, just to capture the planes, without the distance. Gone were the student works that were tied, like *Van Gogh's Room* and *The Sock Knitter*, to the model of a master; she had moved out, beyond the Atelier, into her own idiom. She was painting what she saw, and no one else was seeing anything quite like it.

The rush of painting goes on through the rest of the 1920s and into the 1930s. *Things on an Iron Tray on the Floor*, which from our point of view, though not from hers, makes an interesting counterpoint to Margaret Preston's *Implement Blue*. Preston's is cerebral, the manifestation of an idea; Grace's is clever but emotionally realised. It's hard to imagine Margaret Preston's cups actually being held to anything as messy as lips—the smear of lipstick or saliva is unthinkable—but Grace's tray has come straight from the kitchen. One can almost feel Madge's irritation as she lifted those jugs and mugs, that saucepan, from the draining board.

Grace Cossington Smith,
Things on an
Iron Tray on
the Floor,
c. 1928.

264

Krinkly Konks, the Cossington bulldog curled into its hock, was a more obliging subject. Then there's *The Gully*, which slaps us up even closer to Fred Williams, some lovely clear oils from a holiday at Wamberal Lake, a lily growing alone in a field by the sea—one feels a great empathy for it, as if she has given it her own aloneness—and *Waratahs*, the grandest of the Australian flowers. And the large four-panelled screen that is now in the National Gallery of Australia. And, as a kind of climax, the brilliant paintings of the Bridge.

In 1926, that happy year at the beginning of this exuberant run of work, one could almost say that she had found the perfect requirements for a woman to paint. She had an excellent companion and guide in Ethel Anderson. She was in good health. She did not have to keep house. She had no obligations to keep her from her studio. She taught for a few hours each week at Turramurra College, a boys' school round another corner from Cossington, or the boys came to her for tuition, and from this she netted a few extra shillings and a store of sketches and one rather nice oil of *Boys Drawing* (1926). She had no money worries. Ernest provided for his unmarried daughters and the support, modest but enough, lasted after his death until theirs. Money is not at issue in Grace Cossington Smith's story.

Margaret Preston,
IMPLEMENT BLUE,
1927.

265

When she took a class, she did so because she wanted to. And when she asked Roland Wakelin to teach her commercial art, she—unlike him, supporting a family on the most precarious of incomes—could give it up almost immediately. It's clear from a hilariously hopeless attempt at an advertisement for Kodak that this was not for her. WHEN YOU SEE THIS YOU WILL WANT A KODAK. 'Note construction of letters,' she wrote. KODAK CAMERA SHOULD BE QUITE RELIABLE.[54] There's a sketch of a camera in the corner but not one that was sufficient, even then, to persuade anyone to *buy*.

But this is by the by. Commercial art does not figure in this story. We are in 1926. A year of travel. That was the year Grace Crowley and Anne Dangar sailed for Europe. And that year, Mr and Mrs Smith took Diddy to England where Gordon, her twin, was at Oxford picking up the education that had been interrupted by the war. It was Diddy's turn to travel and she took leave from her post at the hospital. Madge did not go with them. Did Ernest wish to avoid a further outbreak of inappropriate desires? Had Robert Kettlewell married already? Surely she wasn't left at Cossington in order to look after Grace. But as Madge was there, no doubt she kept house, and no doubt Grace benefited from it. With a sister in the kitchen and answering the door, she could remain undisturbed in her studio.

If we'd burst in on her, she might have pointed to the pulpboard she was priming. It was a time in her life when the interest of the moment was more potent than the long stretch of the journey. That, perhaps, is a definition of happiness. When life absorbs us and we are relieved of the burden of reaching back and leaning forward. She would be more likely to say *Look what can be done with plywood and pulpboard.* It was part of that leap into colour; the relief of being away from canvas onto a surface that came forward to meet her. Prime the pulpboard white, thin the oils, add tempera or gouache, and it goes on wet, shiny, and thin. It gleams. *It shines.* And if we were bursting in on her, our faces startling her through the window and the door, wanting to catch her in the act, she would be as likely to say, *Sorry*, putting on her hat, *I'm going round to Ball Green. I'm expected.*

'Ball Green' was the name the Andersons gave their house in Karuah Road, and there Ethel Anderson kept a lively house. By the time Grace knew her, she was a stout woman of substantial proportions, short with a splendid bosom. At forty-two, she wore her

hair, still with colour in it, tied back in a loose knot; her face was strong and already lined; her nose was large and fleshy, bulbous one would almost say. The fact that she was deaf didn't slow her down; she used a silver ear-trumpet decorated with flowers and ribbons or a scarf to match her dress. She had arrived in Sydney like a small tornado.

For the first two years in Turramurra the Andersons suffered a genteel form of poverty. Her husband, Brigadier-General Austin Anderson, had left his post with the British Army in India and his pension had gone astray, and it wasn't until 1927 that he was offered a position as private secretary to the Governors of New South Wales. Undaunted, Ethel took up her pen and wrote while he planted vegetables and made jam. Ethel had already been writing short stories but they didn't bring in much money. So she switched to articles for magazines like the *Home* and the *Bulletin*, and the daily papers. Her preferred topic was art, particularly modern art, and she had astonishing success in getting editors to agree to her proposals. She wrote well and knew her audience. She took on the conservatives of the art world with a gusto that's enjoyable all these years later; in a gentler vein she took it upon herself to explain the changing face of art to the reading public of Australia. She wasn't a teacher to the artists whom she took up; she was a teacher to their audience. It was a role greatly needed in Sydney in 1926.

If she had any doubt about the battles waiting to be fought here, she would have known what she was up against when, almost as soon as she arrived, she read Howard Ashton's venomous review of Roland Wakelin's 1925 exhibition; work he had done during his three years in Europe was on show at the newly founded and, in the terminology of the day, 'forward looking' Macquarie Galleries. 'Roland Wakelin,' Ashton wrote, 'has come back from Europe with an immense admiration for one of the worst landscape draftsmen who ever got by momentary aberration into the Louvre—Paul Cézanne.'[55] In Howard Ashton's view, Cézanne would have made a better butcher. Now it just looks silly. But in Sydney in the 1920s Howard Ashton not only wrote highly visible reviews, but he had the ear of the buying public and the men who made the decisions at the public galleries. For an artist like Wakelin with a family to support, it mattered a great deal what Howard Ashton said. Ethel Anderson read the review and rolled up her sleeves.

Margaret Preston had been Wakelin's champion at that 1925 exhibition, and her foreword explained that modern art was not the depiction of surface realities. 'These are the works of his inner consciousness, not of mere optical vision,' she wrote.[56] Ethel Anderson made the same point, explaining the ways in which 'he makes us aware of reality'.[57] In her art criticism, she let her enthusiasm show as if the virtues of the paintings she was describing were self-evident. As the artists she admired were the difficult ones, like Cézanne, Gauguin, Seurat and Van Gogh, she knew that nothing of the sort could be assumed. In a series of clever moves she wrote many column inches explaining that true art isn't imitation, and isn't decoration; it is emotion, and the experience of feeling, and seeing, and being; it is aesthetics, and the exploration of form and colour. She translated into language suitable for Sydney's newspapers the message that Roger Fry had put before the English reading public in 1912 to such explosive effect. The new art, she said, with its bold colour and emphasis on line and rhythm, was not striving for a description of life but for an *equivalence* of life. By reaching the emotional and spiritual truths that lie beneath the surface, modern art offered not illusion but a deeper reality. The role of the artist, she wrote in terms at once reassuring and challenging, is to disturb, to awaken, to get us thinking.

Ethel Anderson, in her splendid dresses and sporting her ear-trumpet, was well placed to make this plea. She wasn't confronting anyone with the neurasthenic figure of the artist; she didn't have any nasty habits; she believed in King and country and her husband was to be found at Government House. It was hard to link her to Bolshevism or degeneracy. An invitation to Ball Green was sought after.

'Ethel's next plan,' Bethia tells us, taking the story on a bit, 'was to boost Mr Wakelin's sagging morale by having a retrospective exhibition of seventy-two pictures by him at our house in Turra-murra. Father and I accepted this upheaval with resignation which was just as well, for it proved to be such a success that at various times she held several more. In order to provide enough space to show his lovely pictures, the furniture from our drawing room and dining room, from my bedroom, a spare room and the hall, had to be stacked on the verandahs, where my bed was wedged between a bookcase and the sofa. No one thought of thieves in those days. The

*Ethel Anderson
(right) and Bethia.*

house was kept open for a fortnight; Gwen and Jean [Ramsay] and I, with Gracie and Enid Cambridge, had charge of one room each, where we lectured at set times, on modern art—the knowledge, for us three younger ones, being hastily drummed into us by Mother —while my parents took it in turns to welcome everyone by our front door.'

It was September 1930, and Roland Wakelin's first retrospective. Nearly a thousand people came.

'We served no food; but sight-seers from over the harbour were wise enough to bring their own sandwiches. The garden was filled with picknickers, while the police (alerted for that purpose) turned the chaos of cars into neat lines, parked on the verges of three different streets. And every day, when the gates closed, Father and Mother and I collapsed on the back verandah with a loaf of bread, butter in the slab, and a tin of sardines each, to have our supper—all washed down with black, sweet tea.'

The Brigadier-General accepted it all, according to his daughter, even making a joke of their unorthodox eating habits. His suggestion was that 'a photograph of us, shoes off, dunking bread with our fingers into the bottom of that lovely oil in the bottom of our sardine tins, perhaps called "Dinner at Ball Green" would look well in the social columns when reporting the exhibition the next

day'.[58] It is worth pointing out that Ethel Anderson's own creative work—her fiction—wasn't published until after the next war, and most of it not until after her husband's death in 1949. If I were telling her story, I might place a different accent on this whirlwind generosity of hers, but as it's Grace's story, I am grateful for it. Not because Ethel Anderson made Grace the artist she was—Grace had that already in her—but because she eased the way for the potential that was there to come forth. She allowed Grace to show herself the way.

Roy de Maistre, also back from Europe, was another artist Ethel Anderson supported. She found work for him and for Roland Wakelin when they were broke; she found them buyers and benefactors; she worried about de Maistre's poverty, and about Wakelin's family living on the commercial art that kept him from the painting she was educating the Australian public to understand. In fostering them, she was aided by their view of themselves as artists and by their own ambitions. With Grace it was different. Her ambition didn't run along predictable, or clear lines. She wasn't one to push herself forward—even the glimpse of her lecturing at Wakelin's exhibition gives a sudden start, so out of character does it seem. But then we are hindered by the assumption of a character she endorsed in old age.

Grace might have been shy but as a young woman she had as much ambition as the men, and as good an opinion of herself, but her ambition was oriented less to the prizes of money and fame than to the work and its process. Not entirely; but the balance was different. Grace Cossington Smith might secretly want to change the world— or at least the way it was seen—but she had no desire to conquer it. Ethel Anderson understood this, and rather than making Grace her protégée, uniting with her in an assault on the world, she befriended her.

She made a bridge, perhaps that's the way to see it, at this crucial moment, between Grace's courage and ambition, and the discomfort that came to her when she found herself the centre of even small attention. A counter to the buggers' union. Ethel held her steady during the years in which she did her first batch of really good work; and she held her steady as she began to get the first inkling of a public, small though it was, that might reflect her back to herself not just as young and talented but as *an artist*. Ethel Anderson was the

first, it seems to me, to value her at her true worth—her complex worth—without a trace of envy, or anxiety, or competition. And without needing to teach or instruct. Because she shared her conservative politics and inhabited the same social world, she could enter the life of Cossington as Rubbo had never been able to do, or even her *dear Mr Wakelin*. She didn't challenge that foundation of Grace's life and because she accepted her radical aesthetic and understood the imperatives of modern art, she could see what was happening in the studio as no one in her immediate environment could. And perhaps because she shared this mix of radicalism and conservatism, she understood something of Grace's experience, at once deeply at home in her society, yet always on an edge, seeing what everyone else missed—or seeing what they saw through a lens that rendered it strange and uncomfortable to those around her.

The gift that Ethel Anderson brought to Grace Cossington Smith's life was to understand the sensibility of this young woman who could see drama in the trees beyond the tennis court, and who could paint the edges of a city where it met the bush. She understood what it meant to dwell in a zone that was not quite one or the other, betwixt and between; she knew its solitariness, its desires, and its edgy pleasures. She saw what Grace saw, she rejoiced in it, and interpreted it to her kind, bewildered family. And she offered this understanding at exactly the moment Grace most needed it. Ethel Anderson could be said to have played something of the role that Ford Madox Ford played for Stella Bowen when she spoke of her 'remarkable education'. She didn't educate Grace in quite that way, and she didn't have a self-conscious notion of a 'circle', but she drew people around her, giving shape to Sydney's scattered and embattled artists. And she had intellectual confidence and a breadth of experience that ranged beyond art into literature.

Bethia describes Grace on a stool at Ball Green with art books open on her knee, and Ethel at the bookcase with books and magazines and reproductions on the floor all around them. Ethel Anderson was the first to use the word 'intellectual' of Grace, and also 'spiritual'. 'All form,' Grace said many years later, 'landscape, interiors, still life, flowers, animals, people—has an inarticulate grace and beauty: painting to me is expressing this form in colour, colour vibrant with light—but containing this other, silent quality which is unconscious, and belongs to all things created.'[59]

Grace flourished in this environment. I imagine her lying awake at night, her arms behind her head *giving thanks* before she fell into a satisfied sleep. With Ethel Anderson's arrival, her quiet suburb no longer seemed quite so quiet, tame, to one side. The streets, the trees, the gullies were alive with possibility: look at the paintings, almost all of them of places less than a mile from Cossington. At this point in her story we can see again the sense of fun that had danced through the letters to Mary Cunningham and for a brief moment there she was, taking part in the community that Ethel Anderson drew around her.

She joined the Turramurra Wall Painters group—her first and only group—which Ethel Anderson started, having studied tempera and fresco at the Slade when she was in London. It was a loose group of artists, professional and amateur, good and not so good, who joined together to paint murals. They began with the stables at Ball Green; a better way for the young to use their time, Ethel said, once she'd sized up the narrow range of Turramurra's social activities; they need to *think*, she said. By 1927 the wall painters had graduated to the Children's Chapel at St James's Church in Sydney. That got Grace onto the ferry and into the city. There was even a photo of her in the *Home,* squeezed watchfully on the edge of the frame while the boys from Turramurra College painted a mural of the Harbour Bridge under construction with the great span of its arm disappearing into the sky above the roofs of Sydney. They were working from photographs from the *Sydney Morning Herald*—an early sign of Grace's fascination with this feat of engineering and architecture, a glimpsed preview of the paintings that would come to underpin her reputation.

So successful was Ethel Anderson in getting Grace out of her reclusive habits that she was frequently to be seen at Ball Green's social gatherings. Thea Proctor was there, flamboyant in her gaudy dresses, with George Lambert in slightly nervous tow. He treated Grace with a new edge of respect. She wrote to congratulate him on winning the Archibald Prize: 'It was so delightful to meet you,' she wrote, 'and the realisation exceeded the expectation.'[60] He and Thea Proctor established the Contemporary Group in 1926 and Grace showed with them in 1927, the year Virginia Woolf published *To the Lighthouse* on the other side of the world, though I don't know if it was realised by any of them. Perhaps by Ethel Anderson, whose

private love was fiction, but there's nothing to suggest that she spoke of it to Grace.

Wakelin was also at Ball Green; *Dear Mr Wakelin*, Grace called him. She liked him better than de Maistre. 'I liked him,' she said of de Maistre in that polite but deadly way of hers, 'but I wasn't very *fond* of him. He was clever, but I think cleverness is not enough in itself: you have to have something good in your character.'[61]

Then there were the Ramsay girls, Jean and Gwen, much younger than Grace, not her match as artists, but fun, and good for tennis and walks. And the already famous anthropologist Professor Radcliffe Brown, who was too daunting to be fun. And Ethel Turner and her stuffy old husband Judge Curlewis. And Treania Smith, who was painting then but would soon take over the Macquarie Galleries, which would show Grace from the 1930s. And, most significant of all, Enid Cambridge, who was to become a dearly loved friend and a companion for the later years of her life.

Grace, in her mid-thirties, walked freely along the shaded streets between Ball Green and Cossington, between the charged peace of her studio and the energy of a house that made her think, that gave shape to her thoughts. Turramurra, it seemed, offered all that the world held and it was as if this richness spilled over into paint and colour celebrating this quiet edge of a still distant city with its going-down roads.

1926 was, you can see, a good year. And so were the next that followed: those late years of the 1920s while Grace Crowley, Anne Dangar and Dorrit Black were discovering modern art, but not Stella Bowen, in a studio in Montparnasse. Knowing nothing of each other, Stella Bowen was painting her way towards her self-portrait, while Grace was painting the glorious colours of the land where they were both born.

The only niggle in the back of my mind as I write, is the thought of Madge in the kitchen at Cossington. Did she go round to Ball Green as well? Would it have made it any easier if she had? In 1926 it was only a little over a year since she had been with her cousin Frances and Robert Kettlewell. Madge, a silent shadow to this happy story, did charity work for the Red Cross during the day, and wrote letters to England by a dim light in her room at night.

✳ 7. PEOPLE WHO KNEW her have sometimes described Grace Cossington Smith as having a child-like quality. I've never quite known what they meant, although it's invariably said in a spirit of respect. What they seem to be referring to is a quality of straight-forwardness or simplicity. She wasn't hedged about with sophist-ications; she wasn't projecting herself as an image of anything. She had, as they say, no side.

Treania Smith, a partner in the Macquarie Galleries and also a friend, said that Grace 'was like a child in the sense that she loved everything she did'.[62] This capacity in her, held in tension with that other description of her sitting quietly beside her mother, *devoid of emotion*, is a tantalising glimpse; another of the strange bifurcations in her experience and character.

Mungo MacCallum, the radio and television journalist, took a few disastrous classes with her in the late 1920s while he was still at school and prey to artistic ambitions. In his autobiography he describes her as so perfectly mannered that she omitted to notice even when he vomited on the ground in front of the gum tree she was encouraging him to imagine from all sides. Barley water and a retreat to the house were suggested. *Politesse* was the word he used for her. He'd just discovered it, and revisiting this incident a lifetime later, he pressed it back into service. There's nothing child-like about Edwardian manners, or politesse. On the contrary. Nevertheless, he prefaced his account of these lessons with the comment that 'all children are artists because they see the it-ness, the essence of things'. Politesse aside, this is the capacity that Grace managed to keep into her adult and artistic life, and that Mungo MacCallum, like most of us, felt he lost with the storms of 'self-consciousness, knowledge and hormones' that come with adolescence.

This is what is gestured to in those descriptions of Grace as *like a child*. Simplicity as part of the ability to see the essence of things when the surface is stripped back, when noise quietens and prejudice and illusion are cast off. This is what Rilke was gesturing

to in *Requiem for a Friend*—a capacity usually associated with a great male artist like Cézanne; what was remarkable about Rilke was that he saw a feminine form of it; women and children *molded/ from inside, into the shapes of their existence.*

Grace Cossington Smith suggested that the schoolboy Mungo should draw her an egg. '"Eggs where?"' he asked. '"Any old where. In a bowl, on a table, you choose." "In a hen?" She laughed, politesse itself.'

Have you ever tried? An egg? Or an apple? *Fruit in white bowls?* A jug? It's not easy.

'During the week eggishness eluded me,' Mungo MacCallum writes of his chagrined younger self, 'but I produced four ovoids of suet on a plate of mud and carried the vision to Turramurra. She looked. "Yes. Well. It might be nice to go into the garden."' Which is when the unfortunate episode of the vomit occurred.[63]

This glimpse of Grace in the late 1920s presents us with another paradox. There she is, formidably polite, and yet everything she says is relaxed and funny—at least until the suet egg. It's a glimpse that helps us to understand the nature of this woman who could be at once socially witty, yet out on a limb, alive to the world around her and oddly unworldly.

This strange simplicity made her the artist she was and despite the *politesse*, it also left her unprotected. With Ethel Anderson seeing her as she had not been seen before, and drawing her out to be seen, Grace Cossington Smith faced again—if anything, even more acutely—the uncomfortable rub between seeing and being seen. The candour and rhythm of her inner eye, the quality that marked her art and drew supporters to her, was also the quality that brought out the detractors.

It was in response to this impassioned and daring run of work from 1926 that she got the reviews she still remembered at the end of her life. 'The art critic of the *Bulletin*,' she said in one of the late interviews, 'was very rude to me, condemning my work out of hand.'[64] Grace Crowley and Dorrit Black, returning from Paris to this critical climate, had a rhetorical as well as an aesthetic platform from which to defend themselves and launch a counter-offensive. Despite Grace's sophistication, her work did not come with the stamp of a system, or a school, or a master. And because she had so little grasp of the politics of criticism and no strategy of reply,

another bifurcation opens up—this time between her porousness, her capacity to remain open to the world that she painted as she saw, and a tough enough skin to withstand the onslaught of the critics.

In 1927 Grace Cossington Smith exhibited *Trees* at the September exhibition of The Society of Artists. Thea Proctor and George Lambert had supported her entry. She also exhibited *White Dahlia* and *Trees in Wind and Rain*. But *Trees* was the one. Adrien Feint, who was then running the Grosvenor Galleries, the other 'forward looking' gallery in Sydney, saw the painting and recognised it for what it was. He motored up to Turramurra with Roy de Maistre. When Grace took them into her studio, Adrien Feint offered her an exhibition on the spot. Her first solo show.

Grace Cossington Smith, WAMBERAL LAKE NO. I, *1927–8.*

'She braced herself to stand the awful trial of someone looking at her picture,' Virginia Woolf wrote of Lily Briscoe. 'At the same time it was immensely exciting.'[65]

The exhibition was held in Sydney in July of 1928, in the middle of a blustery winter. Thirty-eight oils and nine watercolours were shown, almost all of them painted since her break with Rubbo in 1925. It was a powerful exhibition—not the early apprentice-pieces in homage to Van Gogh and Cézanne, not the more tonal crowd scenes from her years with Rubbo when she felt stampeded on the streets, but the ravishing paintings that had begun with *Trees*. *Eastern Road, Turramurra*, *Pumpkin Leaves Drooping*, *The Gully* were all there, the first of her tough flowers, *Things on an Iron Tray on the Floor*, the family dog and two landscapes in a wash of pink and blue from a family holiday at Wamberal Lake.

It's here that there's a splattering of Gauguin pink; it's here, in the exuberance of the late 1920s, that there's a hint of his Tahitian paintings with their pure flat colour and their grand simplifications of form. By the 1920s, these paintings of Gauguin's had become canonical and after Van Gogh and Cézanne—whose prints she had

on her walls at Cossington—he was the next of her post-impressionist loves. I don't think it was the exoticism of his Tahitian experiments that attracted her, although they did offer a way of seeing the Pacific in colours that were not tied to Europe; more that they gave expression to the hidden shapes of thought and the mysteries of feeling. 'Roger Fry's maturer dictum allows "psychological interest" to plastic art,' Ethel Anderson wrote of these paintings. For her their 'fabulous pinks and blues' were 'Tiepolo's colours'. 'The spirit of delight is in them,' she wrote.[66]

The Smith family, home from England, was in attendance when the exhibition opened. As the address was given by Professor Radcliffe Brown and she was introduced by the Brigadier-General, it doesn't take much to detect the hand of Ethel Anderson in the arrangement of the event.

'In Miss Smith,' the *Sydney Morning Herald* reported Professor Radcliffe Brown as saying, 'Sydney has an artist not only of exceptional promise but of achievement.' It was a short, packed, notice. 'There is an attractiveness in Miss Smith's work,' Professor Radcliffe Brown went on to say, 'which appeals to me very strongly. Her work shows a dominating personality and originality, and there are prospects of still greater achievement.'

A dominating personality. You can see the signs of it in the work, he said. There are many ways of dominating, and Grace was not one to dominate a room in a striding, social way. Dominating is not the same as domineering. Nevertheless it is an interesting observation, which captures the element of *force* in her.

In August, Ethel Anderson's review of the show appeared in the *Sydney Morning Herald*. 'Miss Grace Cossington Smith's paintings have the cool elegance of hail,' she wrote, 'or cherry blossom in a spring shower . . . And they are all happy pictures.'[67] It was a review to read to Ernest over breakfast. Another good one came with the *Sydney Mail*. Beatrice Tildesley also responded to Grace's 'joy in the life about her'; she understood her quirky view of pumpkin leaves, enjoyed her contrast between the cliff and the lake in *Wamberal Lake I* and *II*, and described *The Gully*, priced at thirty guineas, as 'a strong and beautiful design full of the feeling of the bush down in the hollows'. She made the pointed comment that 'it should certainly be bought by the N.S.W. Gallery'.[68] But the trustees weren't reading the *Sydney Mail* that day. Others were, and a few private buyers

appeared. Gladys MacDermot, the wife of an Irish solicitor, swept in, bought a still life and commissioned the screen with four panels that is now in the National Gallery of Australia. Each panel is over three feet tall, giving an extraordinary sensation of being at once down below, looking up, and also up, looking down. But many years were to pass before Grace Cossington Smith's work could be seen by visitors to the Art Gallery of New South Wales.

In 1940 Ethel Anderson organised for the donation of *Wildflowers in a Jug* (1936), the first of her paintings to go into the collection, and the gallery did buy a couple of lesser works at the end of that decade, but it wasn't until Daniel Thomas bought the major paintings he found in her studio in 1967 that she was well represented in the public gallery of the city where she had lived and painted for fifty years. 'It is not easy for a woman to make a name,' Ethel wrote in *Art in Australia* in the year of the donation. 'In the history of Italian art a footnote of ten lines dismisses the women painters of four centuries.' The work of a woman like Grace Cossington Smith, she wrote with uncharacteristic understatement, 'should be more valued.'[69]

'People thought that a woman painter couldn't be good,' Grace herself said when she was very old. 'They just took it for granted.'[70]

At that first exhibition, in 1928 when so much seemed at stake, Grace had three good women on her side. But the anti-modernist men, sensing the changing wind, were mustering, incensed by precisely the vision Beatrice Tildesley and Gladys MacDermot valued. Ethel Anderson's fierce support couldn't save Grace from their attack. *Trees* had already been ridiculed the year before when the *Bulletin* said that 'the most curious of the freaks' in the Society of Artists' show, was 'H. Cossington Smith whose picture of trees is evidently intended to suggest how trees might have looked if a demented creator had wrought them'.[71] They couldn't even get her name right. The *Bulletin* looked at her pumpkin leaves and made a joke about snails. That was in the review that panned *Eastern Road, Turramurra*—of all the paintings exhibited, surely one of the best—in words that still stung her in the nursing home when she was nearly ninety.

Read me the review, Gracie dear, I can hear Ernest say, and her voice soft in her throat as she reads: 'A goat is drawing a rubbish cart up a hill—or would be drawing it if his legs were not falling from under him.'[72]

And when George Galway headed his review in the *Evening News* MODERNIST AGAIN, DODGING TRUE ART, it was the glorious landscapes of these years—many now in public collections—that he described as *a lot of green frogs hanging out to dry in the sun*.

When one reads these reviews it is easy to understand not only the plight of women as artists in this country, but the stampede of the young and talented out of the country. A woman of Grace Cossington Smith's calibre would not have been so crudely ridiculed in England simply for her modernism, and even if her audience had been small and the critical environment dominated by the large egos of the masculine avant-garde, she may have been spared ignorant brutality of this sort. I can see why Anne Dangar didn't want to come back, and why Grace Crowley, called home before she was ready, wondered what would have happened if she'd been able to stay away. And I can see why Roy de Maistre left again in March 1930 in search of an environment in which he wouldn't be considered a freak. Christina Stead, pining for destiny, for love, for greatness, had boarded the *Oronsay* as a steerage passenger in March 1928. A few years later Patrick White arrived in London—a place 'you could burrow into and just lead your own life'.[73]

Such grand escapes were not possible for Grace. Not because of Ernest. She was a daughter of different substance, and I doubt that he would have forbidden her, had she wished to go; when it came to wills, hers was probably the stronger. She didn't escape because it wasn't in her nature to do so. For her there was no question of going off to find a life to suit her art; her art grew out of the life, for better or for worse, that she actually lived.

Does that mean that in settling for Australia, Grace settled for second-best? Many would think so. Then and now. I remember, as an aside, a man asking me at one of the first writers' festivals I was invited to when I was still quite young, whether I lived here so I could be a big fish in a small pond instead (the implication was) of a small fish in a big pond. With a banging heart, I replied rather gracelessly that I didn't accept the terms. Which was more or less, if not entirely, true. In Grace's case it was, I think, absolutely true. While she could tell at a glance a good painting from a bad and knew that at her best she was good, she didn't rank places—or possible lives—in that way. And, more to the point, she could see what could be done here, what was to be *seen* here. Just by looking, she could

strip back the surface and see the mythic past and deep potential of the place she called home. *This place, the antipodes*, she had said to Mary Cunningham. She took up the challenge of painting what it was that she saw here, where she lived.

In an early sketchbook, she copied out a long quote from Hans Heysen which includes this comment: 'When artists return [from Europe], <u>one and all proclaim the wonderful material there is in Australia;</u> its light and its vastness. If they see these great beauties, why don't they stop and paint what they profess to love? Is it that they are afraid of the isolation?'[74] The underlinings are hers, not mine.

Bruce James says that in the 1920s Grace read and was impressed by the colour theory of a 'poet-performer ... who travelled the world giving Colour Poem Recitals'. Beatrice Irwin saw Australia as an untouched continent waiting to be made into art. 'Like an astonished child, it is slowly rubbing its eyes open, and I doubt it knows yet whether the wattle is green or gold.'[75] At the end of the century we can't read any of this without thinking of the Aborigines and the dispossession of their art. But that was so far from obvious then, that to mention it is to ram our world into theirs. Which makes Margaret Preston interesting, for she—the only one who travelled into the outback and collected Aboriginal art— understood that the question wasn't exactly one of making an art anew. Someone like her, with her black and ochre landscapes of the 1940s, or Katharine Susannah Prichard with her novel *Coonardoo*, which caused a ripple of outrage in 1929 with its story of the tragic— and destroying—love of a white man for a black woman and its evocation of a land raped and taken, are now in danger of being accused of co-opting a culture that wasn't theirs. But from the perspective of the 1920s when such things were barely spoken of, it was not only subversive but brave.

Grace Cossington Smith didn't have a trace of that kind of radicalism, though Bruce James is kind enough to say that if you look at *Landscape at Pentecost* (plate 28), which she painted in 1929 or 1930, the red-brown clay of the cut-away road might almost be peeling back 'the suburban crust' to discover 'the original, even aboriginal continent'.[76] If this is so, it is almost certainly another case of Grace seeing more than she thought she saw; the power of her unconscious eye. She would not have made this claim for herself. On the contrary. 'I'm particularly fond of the Australian bush with its

marvellous soft colour,' she said in 1965. 'The Australian bush, I feel, has never really been painted and I think it is still waiting for somebody to paint [it] as it is.'[77]

After the lightness and grace of *Trees, The Gully* takes us into a darker possibility: her vision of the gullies that were in walking distance of Cossington is alien to the paddocks of *Eastern Road, Turramurra* that they border. If she is hinting at something—a hidden, half-concealed consciousness of an ancient Australia—I doubt that she could have articulated it in any way other than through deftly applied ochre and olive. An undercurrent, not a formulated thought. Her political thinking rarely ventured from the conservative opinions that she heard from the people, including Ethel Anderson, who lived around her. Her aesthetic was deeply European. So when it came to painting what she saw of Australia, she used the inheritance that came through post-impressionism to open up a landscape redolent of mystery and majesty, strange colours and hinted-at secrets, with very little political articulation of what she was doing.

When it came to shifting the way Australia saw itself, it was less her bush than her great urban landscapes of the Harbour Bridge that have gone to the heart of the national psyche. When, in 1982, a journalist from the *Sydney Morning Herald* rang her nursing home to tell her that *The Bridge In-Curve* had been chosen for an exhibition to commemorate fifty years of the Bridge, the ninety-year-old Grace said, 'I don't remember that particular bridge painting but I often sketched it. I loved it, you see.' And time dissolves back, and there she is with the large black Winsor & Newton sketching umbrella that Ernest had given her, set up at Milsons Point. That's when it put her *orf*, being watched while she worked. Fifty years later when the journalist showed her a reproduction of *The Bridge In-Curve*, she said: 'It's a very good painting,' and reminisced about the ferry, crossing the harbour with the arches balanced above her, which wasn't the view she painted. 'It was early morning, and it was so lovely—the harbour, the water, and my dear old Bridge. Fancy it being fifty! It doesn't seem that many years ago.'[78]

Like everyone else in Sydney, Grace Cossington Smith watched the great arms span out over the harbour. Margaret Preston hated the Bridge, thinking it heavy and old-fashioned. But most of the city's other artists had a go at it. Harold Cazneaux photographed

it. Dorrit Black made a geometric design of it. Jessie Traill delved into the intricacies of its iron-work. Roland Wakelin painted one of the arms lurching up over the quiet suburbs like the neck of a mechanical beast, beautiful but menacing. Grace had many goes at it. There are sketches, studies, oils and pastels. As she said, she loved it. The rhythm of its great girders, the pattern of straight lines bending to a curve, the pathos of those arms reaching for each other across a body of water. Approach without touching. Promise and yearning. She knew them both. Her arms were stretching up into that same, hopeful sky.

The two greatest of her Bridge paintings—of *the* Bridge paintings—are *The Curve of the Bridge*, which is now in the Art Gallery of New South Wales, and *The Bridge In-Curve* (plate 29) in the National Gallery of Victoria. For as long as I've looked at them, I have asked myself the same question: what is the sensibility of the artist who painted them? What is the soul of the woman who stood

at Milsons Point with her sketching umbrella and looked up from below? What was in the mind of the still-young woman who laid out the lines of these extraordinary paintings in her studio at Cossington on the northern outskirts of the city? A sensibility, I answer myself, that acknowledges the overwhelming nature of the building of the Bridge, and at the same time knows that it must be grounded. A sensibility that grounds it. The graceful arms soar up, the buttress pylons hold the structure down. It is a sensibility that responds to the grandeur of its architecture and at the same time demurs from it; that loves its monumental aspect but doesn't buy into it; that lets the Bridge gesture to transcendence without letting it become grandiose. It is an intensely personal view; it absolutely understands the building of the Bridge as a public moment, but refuses a public view of it. People walk underneath going about their business; the harbour still has to work, ships sail under it with an eye not to the majesty above but to the tides below. It is an intensely feminine sensibility, and yet a vision that knows something of the monumental fantasies of the masculine. Her Bridge doesn't triumph over the city, it celebrates it.

A dominating personality, Professor Radcliffe Brown said. A dominating personality that is evident in her work. Perhaps he meant her impassioned understanding, her capacity to hold to her own view. And yet fifty years later she is flummoxed by the wake that comes behind her. Her experience of herself was always modest. At the moment of painting all she was doing was painting. If it is exhilarating, that moment of creation, it is precisely because it doesn't hold the future—fame, reputation, reward—in it. It is full in itself, right then, and enough. 'The Bridge was much more exciting before it was built,' she told Daniel Thomas. 'Afterwards I felt flat.'[79]

At the time, when she first brought these two paintings out of her studio for an airing, the story was rather different. She put *The Curve of the Bridge* into a high-profile and very visible competition sponsored by the State Theatre—then under construction—which was looking for paintings to buy and hang in its lavishly designed interior. The judges accepted it for exhibition but did not buy it, which put it firmly in the category of also-ran. Among the paintings they bought was one of Howard Ashton's feeble landscapes.

The Bridge In-Curve fared even worse. It was refused entry by the Society of Artists' exhibition in 1930. Grace suspected the veto of

Sydney Ure Smith, who was president of the Society and had a large watercolour of almost exactly the same view in that year's show. 'He wasn't very nice to me,' Grace confided to Daniel Thomas. 'I tried to avoid him. I think he thought I wasn't earning my living—that I was sort of amateur.'[80] So *The Bridge In-Curve*, up against the buggers' union and without a gallery to sponsor it, made, in Bruce James's words, 'its unglamorous debut' at an exhibition at Ball Green.[81]

It was hard, as Ethel Anderson said, for a woman to make her name as an artist. It was to become very much harder.

§ 8. MRS SMITH, GRACE senior, the Miss Fisher who had turned Ernest's head with her singing long ago in the mists of a previous century, died in Sydney in April 1931. Her husband—almost completely blind now—and her four Australian children buried her in the churchyard of St James's Turramurra. It was an expected death—Grace had been gaunt for years, you can see it in photos from the mid-1920s—but even an awaited death can come as a shock. To lose a mother is always hard. For a single woman to lose a mother has added pathos, for without the clamour of her own husband and children, it is her mother, often, who knows her the most intimately, who accepts her most fully, who is there as a constant to return to. And to lose a parent at a point when one's own life is opening wide is an additional twist of pain, for it can seem as if the life that is left, inhabited without the mother, is in some awful way built upon her death. This was the territory Grace inhabited as she stood by the graveside, and as she walked the beaches at Thirroul where Ernest took her, Madge and Diddy for a mourning sojourn.

Ethel Anderson's daughter Bethia portrays Mrs Smith as a chattering, social creature with little understanding of her daughter's talent, let alone her art. This is not entirely true. She didn't have much of an understanding of post-impressionism, or of modern art; why would she, she was a Turramurra wife, indeed social and a bit chattery. But she did recognise her daughter's talent, and made sure she had the training she needed—within the confines of Sydney—and most important of all she *backed* her. It had been Mrs Smith who had suggested that her daughter Grace use Cossington, a name she was given at birth as well as the name of their house, to denote herself as an artist. If you look carefully at the paintings, you will see that after 1920 she signed herself 'Grace Cossington Smith'. Until then she signed herself 'Grace Smith', 'G.C. Smith', or 'Grace C. Smith', as if she wasn't yet sure of her identity.

To have had a mother who named her an artist, even if her understanding when it came to the art itself was rudimentary, has to

be considered a blessing. To have Ethel Anderson as a champion was a boon, a benefit, possibly even essential if she was to be reflected back in the eyes of someone who knew what her work meant. But all this, everything, was underpinned by the mother who had given her her first sketchbooks and pencils—and the protected space in which to discover her own capacities; the mother who held her to the exploration of her own creativity, and who *believed* in her. It is the sort of blessing that is easily forgotten or taken for granted, setting up a slightly exasperated irritation, so that it can sometimes feel too great an interest and therefore a constraint. There is, it might almost be said, an inevitable betrayal by the daughter-artist if she is to live and to paint without the shadow of her mother falling across the canvas.

While Mrs Smith was dying, Grace—as we have seen—was on a run, one good painting after another tumbling out of her studio. What conflict was set up in her between the pressure to give expression to this burst of energy and the countervailing desire—and need—to tend her mother? Dying, as anyone who has tended a cancer death will know, is a time-consuming and difficult business. Death takes no notice of the desires and schedules of those who live around it. It cares nothing for painting or for exhibitions. And while the dying parent might care, and almost certainly does, the narrative of life's ending takes precedence. Even for the most self-sacrificing of mothers. I think it can be safely said that Grace would not have been painting the Bridge had there not been Madge. Even so, the conflict remained and Madge, easing it in one way, would have compounded it in another. Grace Cossington Smith hasn't spoken or written of this, at least not in any form that remains for her intrusive biographers. I say it from what I know. And I know, as so many of us will, if we haven't yet, how easily regret can become entwined into grief, for the frustrations and difficulties of tending a long illness are as nothing compared to the thud of earth on the closed coffin. And I know the fall, the drop, that comes after. The work doesn't necessarily stop, but it changes key.

At Thirroul Grace painted sea-scapes that took up the pinks and blues she'd experimented with at Wamberal Lake, but they are filled with such luminosity that they are quite unlike anything that came before or after. The sea rolls in, fold after fold, wave after wave, the colours of a bruise, giving rhythm and shape to her grief. These pink-blue waves remind me, in a way that nothing else of hers

does, of Georgia O'Keeffe.⁸² I'm sure Grace Cossington Smith would not have had the inner folds of femininity in mind as she painted, but she captures nevertheless something of the internal, hidden, watery nature of the feminine. It is a sensibility quite different from that of the Bridge paintings. There the feminine eye understood something of the monumental fantasies of the masculine. Here is a femininity that has retreated onto its own terrain, defined by fluidity and rhythm rather than by structure. In *Bulli Pier, South Coast* (plate 30), the pier—small, rickety and precarious—makes a valiant attempt to control the waves but the roll of the ocean remains oblivious; it makes little impact on a sea given over to its own musings. Because the painting depends so much on the mark of the brush strokes which curve with the sky and roll with the sea, no reproduction can capture the *aliveness* of the painting or the pureness of its colour. I have only seen the original twice—once in an exhibition and once privately—and on each occasion I felt the presence of Grace so powerfully that it was as if the speculations and frustrations involved in trying to give shape to her story had never existed. In the presence of that painting, eye to eye with her, everything made sense and I could join her in saying—or seeing—simply that *This is*. But when I left the room, whatever it was that I had grasped faded again.

The grief of that year also produced a run of flower paintings: foxgloves, hippeastrums, poinsettias. Soft colours again—smoky reds and pinks, creamy yellows, a blush of mauve, another hint of Gauguin—and a close lens onto fleshy bloom that is all the sweeter for the knowing how soon it will fall. It is knowlege that often comes with the death of those near to us, and with the prefiguring of our own mortality. Her waves are full of intensity as they break and are gone; her flowers are caught at the fullest moment of their bloom. In *Hippeastrums Growing* (plate 31), there is no question of a still life. These flowers haven't been arranged for us to enjoy; she has taken us to them as they grow and has filled the frame with them so that we look into petal and stamen as if we could reach inside and touch the essence of flower-ness.

And then there are the more woody flowers that have grown from hard Australian soil. 'I used to love wildflowers,' she said many years later. 'The Australian wildflowers are quite on their own. They are the most lovely things that we have and their colour is not what you'd call brilliant colour, but it is a soft brilliant colour like our

atmosphere.'[83] Soft brilliant was the palette of these years. A *knowing* soft brilliance.

Despite the death of her mother, a glance at her list of exhibitions during the 1930s shows that she didn't slow down. Her first solo at the Macquarie Galleries was held in March 1932, just short of a year after her mother's death. And another in 1937. Every year between, she showed in at least one group show: the Contemporary Group, the Watercolour Institute, the Society of Artists, and Dorrit Black's Modern Art Centre.

And her first—and only—exhibition in London. She was invited to join her cousin Frances Crawshaw, Madge's friend, whose work Bruce James describes as 'well mannered impressionism',[84] at the Walker Gallery in Bond Street. The exhibition, which also included Frances's husband Lionel, opened in April 1932 with an accompanying essay on Grace by Ethel Anderson, who reused her phrase about *the cool elegance of hail*. Both the Bridge paintings were there, and the pick of the late-1920s' crop: *Lily Growing in a Field by the Sea*, *Waratahs*, and *White Dahlia*. Also *Foxgloves Growing*, the Wamberal Lake paintings and *Bulli Pier, South Coast* fresh from her mother's death. Australian gullies and cliffs and lakes and wildflowers to trump Frances Crawshaw's English poppies.

The British reviews were good. At worst, bland and merely descriptive; at best almost insightful. *Clear* and *vivid* were words that were used—and also, interestingly, *virile*. The critics responded to the 'fantastic colour and forms' of Australia, but it was her Bridge paintings that met with particular approval; 'the leap of its great curves and the vivid blue sky into which it seems to be flinging itself'.[85] There were reviews in major newspapers, but not in the *News Chronicle*; it was three years before Stella Bowen was to begin her column. But imagine the excitement at Cossington when it was reported that the Queen had visited the exhibition and not been displeased. And imagine the sorrow that Mrs Smith was not there to know her daughter's triumph.

Despite this success, nothing much sold and a good few of the paintings exhibited there remained in England with Mabel. Gladys MacDermot, who had returned to Ireland with her solicitor husband, took *The Curve of the Bridge* with her. It now hangs in the Art Gallery of New South Wales, but it did not come back until after Grace's death.

In Australia the reviews also improved. Colin Simpson wrote of her as 'the most interesting female artist in Australia, and likely to be the most misunderstood'.[86] There wasn't a great deal of understanding but at least the personal vindictiveness of the early reviews stopped. In part this was because she had had the imprimatur of an English show; success there has always had the power to affect the way an artist is seen here. As well as this, the art world was at last beginning to get her measure, and as the 1930s progressed, the battle lines began to shift and she was becoming less contentious. In 1932 Ethel Anderson introduced her to a British audience as 'one of the very few Australian artists (there are, perhaps, five in the whole continent) who have abandoned purely representational art'.[87]

By the end of the decade this was very far from the case. In not much more than ten years she went from outraging the conservative critics to finding herself consigned to a backwater. It was not an experience that was easy to accommodate. But it was, paradoxically, not the sort of experience that is noticed much at the time. The accommodation comes after and is understood in retrospect, when the effects of it having happened are suddenly and powerfully present.

At the time there was plenty to occupy her. There were changes at Cossington. Gordon had married Mary Yarwood in 1929 and moved to Woollahra. With his departure, and Mrs Smith's death, rooms at Cossington were reorganised, and small visitors in the shape of nieces and nephews appeared. Ball Green continued to hold exhibitions and gatherings. Ethel Anderson welcomed the returning travellers from Europe and took an interest in Grace Crowley and Dorrit Black. Was Grace Cossington Smith with her when she opened the first exhibition at Dorrit Black's Modern Art Centre in 1932? At the end of her life Grace Crowley said that she had never met Grace Cossington Smith.[88] It seems extraordinary that these two artists were never at the same exhibition at the same time. If they were to have met, this would have been the time. Grace Cossington Smith exhibited with the Modern Art Centre in 1932 and 1933, and with the Contemporary Group almost every year between 1932 and the war, bringing her as close as she was to get to the modernism of Grace Crowley and Dorrit Black. You can see their kind of boldness of design in her work in the early 1930s. There's the quasi-geometric *Govett's Leap* (plate 32), painted over Christmas in the

Blue Mountains in 1933, in which the brush marks are scoured into the paint like crevices in the cliff-face. And a great splash of pink in *Landscape with Flowering Peach*, some stylish Canberra trees (painted in 1932 while giving some lessons to Lady Isaacs, the wife of the Governor-General), several landscapes, a boxy, squared-off composition of a *House with Tree*, and an adorable brood of chicks. And there is the startling colour, with its bow this time to Thea Proctor, of *The Lacquer Room*.

In 1935 Mabel returned from England with her daughter Marigold. Ernest was frail and, at eighty, clearly not destined to be among them for long. It was a sorrowful visit that Mabel made, but not gloomy, as Ernest's state, though low, was stable. With the four sisters reunited, there was a flurry of activity with outings to theatres and ballets—a great love of Grace's which she tried to capture in oil more than once—and trips into town. It was during Mabel's visit that she painted *The Lacquer Room* (plate 33) with its red and green furniture and art deco fittings. There has been confusion over whether this café was in David Jones' Elizabeth Street store, or at Farmers'; both had Lacquer Rooms. But in fact it was neither. Photos of the Soda Fountain, a second café at David Jones, show that this was the location of Grace's painting, not the Lacquer Room down the road at Farmers', which had been designed by Thea Proctor.

In the reds and greens of this painting, Grace captured a modern moment of sharp surfaces and bewildered faces. There is a mis-match between the colour and style of the decor, and the ordinariness of the people who are there for a cup of tea—except for the one rather smart lady sitting by herself, at home in an environment that the artist regards with a quizzical eye. She, Grace, is not dismissive; not at all. 'The people struck me as particularly interesting,' she said in a film that captured her fluting voice, 'because they were all different kinds of people all in different stages of life and'—here she laughs, a kind of giggle—'all the faces of the people looking towards me because they knew they were being drawn.' It is one of the few snippets of her voice that we have: deliberate, slowed down, and amused. In the film she described the painting as Thea Proctor's café. 'One of her wonderful thoughts expressed in form.'[89] It is Grace's tribute to the feminine moment of Sydney's modernism. It was a gesture made exactly as its influence

peaked, and waned. 'Scarlet, green and white held me spellbound,' she said.

In 1936, when she finished *The Lacquer Room*, there was no reason for Grace to believe that anything was passing her by. She had a group around her and there was no need to look beyond it. As well as Ethel Anderson, there was Enid Cambridge, a shadowy figure in this story, for little remains to tell us of their friendship. There are no letters, few photographs and only the sketchiest of accounts from others. Born in 1903, Enid was eleven years younger than Grace. She had studied with Grace Crowley and Anne Dangar at the Julian Ashton School before they left for France in 1926. She then took classes with Roland Wakelin in Chatswood (which was where she lived), and it was through the connection with Wakelin and Ethel Anderson that she met Grace some time during those years at Ball Green. They had certainly met by the time of Wakelin's exhibition in September 1930, for Bethia's report of it has a room assigned to 'Enid and Gracie', where they 'lectured at set times'. As an artist Enid Cambridge was not in the same rank as Grace. She worked best in watercolour and her small, impressionistic scenes—flowers, glimpses of the harbour, trees, and corners of houses—are sometimes reminiscent of Grace; if there was an influence, it flowed that way. Nevertheless, she understood what Grace was doing and shared with her an interest in the numinous, and *things unseen*.

Photographs of Enid Cambridge taken between the wars show a tall, rather elegant woman with high cheekbones, a straight nose and flattering hats. There is a delicacy to her that suggests that, despite the hats and well-cut jackets, she was not one to press herself forward. She was not like Ethel Anderson. She didn't have her drive or her worldly understanding. She didn't teach Grace. She comforted her, understood her struggles and maybe loved her. Grace, I think, loved her. Twenty years later, in 1957, Grace painted a rather grand oil of Enid bedecked in red, lounging on a sofa. She is formally dressed and slightly alien in her formality—but then it was a valedictory painting as Enid was about to sail for Europe and Grace knew she would have to do without her for several years. Perhaps she needed to dress her in distant splendour to let her go. It is a grand composition and Enid is presented in a queenly pose, but there is an odd clash between the formality of the dress and the intimacy with which the figure of Enid is known, as if Grace hasn't quite captured either.

The relationship with Mary Cunningham—and the extra-ordinary cache of letters from Perseus—allowed us to see a defining aspect of Grace's character: her polymorphous capacity and an early ability to step into myth. The friendship with Enid, ultimately much more significant, was the sort of friendship that comes with age when the desire is less to explore one's many parts than to bring them into some sort of harmony—if not hammered into a solid shape, then at least brought together into a bunch as robust and satisfying as the flowers she painted. But because there are no letters, there is not much more I can say; it is another case of the ease with which friendships between women can disappear from the record. Their quiet constancy lasted until Enid's death in 1975.

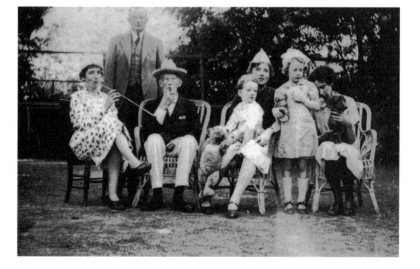

The Smith family at Cossington, 1937. Left to right: Diddy with the cigarette holder, Gordon standing behind, Ernest, Grace with Robert on her knee, Ann and Madge with the dog.

Another friend during the 1930s was the New Zealand artist Helen Stewart, a jazzy modern who lived in Sydney for a few years on her way back from London's Grosvenor School. She had a car and drove Grace and Enid sketching. She took them to exhibitions, and visited for tennis at Cossington. There were other tennis friends—the court was still in good use—and although the household dwindled again when Mabel went back to England and to Ridley, there was still tea on the verandah and a glass of sherry or lime juice before people went home. The studio door was open to the garden and although Grace knew of the distress that had been caused by the Depression—there were men knocking on the door

for food or work—and although she read of the worrying events in Europe in the daily papers, there is no more sense of them pressing on her than there is of the changes which, unbeknownst to her, were taking place in the small world of Australian art politics. None of it touched her as she had been touched by the loss of her mother.

Although I sometimes wonder if the bleakness of the political world is a factor in *Bonfire in the Bush* (plate 34), a sombre painting from 1937. The small figures of Ernest, Madge and Diddy stand beside a smoking fire surrounded by the gloom of the bush that towers above them. Patrick White, who owned the painting for many years, is said to have liked the intensity of the family drama.[90] Grace herself said it was a painting about the four of them being alone now that their mother was gone, but there is something ominous about the painting as if this small group is not only alone but threatened. Would they survive, this tiny rump of a once large family? Did the world press on her in menacing ways as she watched her family beside the weak heat of a bonfire? Is it a note of warning?

But it is the only image of such darkness. Her flowers, in contrast, took on bolder colours. By 1937 they had moved back a bit so that she was no longer inviting us to look into the intensity of their hearts; they become separate and distinct, no longer soft and blushing; their beauty is more collected. Painting into this small focus, safe from the pressures of the world, there is assurance, and confidence. In 1932 she painted herself carrying a vase of flowers so large that they almost obscure her; seeing her through the flowers, it is as if she is one of them. The flowers themselves are distinct, as is she, but the awareness that is brought to each is the same. This close attention to flowers, almost to the point of identification, reached its strongest expression in 1937 when she painted *Firewheel in a Glass Bowl* (plate 35).

This, to my mind, is as close as Grace gets to a self-portrait during that decade. It isn't, of course, a self-portrait at all, but it is how I have come to see her at this point in her life. The fiery energy of the firewheel is fed by the water we can see in the glass bowl; fire and water are thus contained—not restrained—but given a shape that is at once sufficient unto itself, absolutely satisfying, and reaching out towards the frame like the long knobbly leaves that could, but don't, topple the composition. In the Bridge paintings the dominant note had been one of yearning as the two arms reached towards each other, for ever held apart. *Firewheel in a Glass Bowl*

isn't a comparable painting in type or genre—art historians would disapprove of the link I am making—but here, a decade later, it seems to me, is an ease as if yearning has, at least for that moment, been laid aside and something—precarious, subtly stated—has been reached, or achieved. Although that something, like a bowl of flowers, and unlike a bridge, is at a certain remove from the noise of a public world. 'The firewheel is a lovely scarlet wheel,' she told an interviewer in 1965, 'and it grows right on to the branches.'[91]

During the 1930s Grace was in her forties. The forties are powerful years in a woman's life, but such sweetness as there is, is mixed with the tart taste of time passing. In 1936 she painted Diddy, the youngest of her sisters, whose fortieth birthday fell that year. It is a heroic painting of a plain woman reaching middle age. The figure of Diddy sits forward, pressed onto the picture plane, and her shoulders reach to the edge of the frame; there's no missing this woman. Behind her is a modern landscape of uncertain nature. Diddy pays it scant attention. She does not smile. She is looking resolutely ahead, composed, serious, author of her own destiny. It is interesting that the portrait is titled *The Artist's Sister* (plate 36) as if in being the sister of the artist, she shared something of the artist. Is that modest assurance how Grace understood her own life, as well as her sister's, as she was advancing through her forties? The quiet heroism of the spinster who finds her way and lives it regardless of the judgment of a world that would call her plain, to one side, of little consequence.

For an artist, the forties have additional resonance. It is a time when many women writers and artists come into their mature work. It is also a kind of pivot. A firewheel. At thirty-five, if not thirty-nine, an artist is still young; potential can still be spoken of, art school is not yet a distant memory. But at fifty, one is not by any accounting still young. If a woman artist hasn't found sure footing by then, it is hard to do so after. Some do, and a writer like Elizabeth Jolley springs immediately to mind, writing for many years and not published until she was fifty-three. In her case it was a matter of the world catching up with her.

For Grace it was more a case of the world rushing past. She had established herself sufficiently to feel there was solid ground under her, and she had tasted the first moment of recognition; and yet while she was enjoying Ball Green and taking trips with Enid Cambridge

and Helen Stewart, painting the landscape around her, the new wave of young men-artists twenty years her junior was emerging from the art schools of Melbourne, and also Sydney, painting in ways that had never been seen in this country; they were about to leap past her. *Govett's Leap* might have looked up to the modern moment in 1933, but how staid *Mossvale Landscape* (1938–9) can seem when you hold it against Drysdale's

Grace Cossington Smith, Mossvale Landscape, *1938–9.*

early landscapes, *Man Feeding His Dogs*, say, which came only two years later. Or Nolan's hot and dazzlingly empty Wimmera landscapes which he painted while serving with the Australian army during the next war that was about to break over them.

Russell Drysdale, Man Feeding His Dogs, *1941.*

9. IN 1938 I doubt that Grace Cossington Smith knew of the existence of the young Russell Drysdale. The ground that was giving under her was of another order.

In September of that year, Ernest died. Another awaited death, painful in a different way. If her mother had held Grace to the world of interiority and emotion, then Ernest in his quiet way offered a passage, or a link, out into the world of reputation and events. 'My dear father, you know,' Grace told a journalist in 1974, 'was terribly good to me. He encouraged me in every way. He built me a studio in the back of the house. Everybody loved him. I remember one day my sisters and I were in church and my father had been delayed somewhere. He arrived late and I remember him as he stood in the doorway of the church, framed in the light, looking at us. Just at that moment someone in the pew in front said: "That's Ernest Smith . . . a marvellous man." I have always treasured that moment!'[92] Here again I can't help a passing thought for Madge, who bore the brunt of so much, but for Grace there was a great sense of solidity associated with her father. In another interview, recorded in the nursing home not long before she died, by which time she had become very wandery, she insisted that Ernest had built Cossington himself 'out of rock', and for her in a manner of speaking he had.[93]

When her mother died, Grace had painted water and the insides of flowers. When Ernest died, as if in unconscious tribute to him, she moved away from images that softened into a private world and turned to public events far beyond the confines of Cossington. Perhaps also she could hear the footsteps over her shoulder as the young men marched into view. It wasn't a new move; in one way or another, she had always painted the exterior world of city streets, the world inhabited by men. There had been those soldiers marching in the last war, and the muddy, threatening crowds of the early 1920s. *Centre of a City* had its own public monumentalism. She knew the desire to portray the grandeur of modernity and claim its geometry as her own. Which is why her Bridge paintings are so good; because

she knew that fantasy, and knew that it was a fantasy. The paintings that came after Ernest's death were different. More determined or contrived, perhaps, almost as if she were trying to appease the male world. Theatre scenes. Orchestras. Crowds in orderly congregation, as if she had joined them in some civic enterprise. When the next war came, she gave painted shape to her imaginings of dawn landings and treaty signings.

In 1938, the year of Ernest's death, Grace Cossington Smith accepted an invitation to become a member of the Australian Academy of Art. The Academy was an ill-fated and short-lived initiative on the part of Menzies and his friend J.S. MacDonald who had been the director of the National Gallery of Victoria since 1936 and still spoke of modernist 'filth'. Menzies presented the Academy as a move towards a National Gallery and government support for the arts, but it was clear to the new generation of modernists, if not to Grace, that it was also an ill-concealed move against their angry colours; the dying world of Heidelberg was to be promoted as an ideal of Australian art. From that perspective an invitation to join this august body was a faint compliment indeed. Her work hung in the Academy's inaugural exhibition in April 1938.

There had always been a note of innocence in Grace's understanding of the political world, but while this was an act of naivety it was also an act of confidence. The invitation came at a time when she was painting with assurance and in terms very much her own. After the struggle of the 1920s and the humiliations she suffered from the pen of Howard Ashton, why should she not take this small accolade while her father was still alive to see it? After all, Roland Wakelin and Margaret Preston made the same move. But when I look at *Bonfire in the Bush* with its ominous sense of threat, I wonder whether her acceptance of the offer from the Attorney-General was in some measure a gesture of compliance with an order that might protect her.

Exactly a year after Ernest died, the Second World War began. At Cossington it was felt in domestic ways. Madge didn't make her escape fast enough and was stranded at Cossington for another six years. Diddy volunteered for overseas nursing service and embarked for Burma. She was away for seven years. The house was reorganised again, this time to accommodate lodgers as well as the two resident sisters. When Ernest died, Grace had taken over his bedroom, the

master bedroom, a large and beautiful room with a fireplace between two french doors opening onto the verandah. It was the room she would paint in her glorious interiors, but not for some years yet. In 1938 she had claimed it as her own and with this move she closed down her garden studio and had another built inside the house, along a little corridor from the room that was now hers. Madge extended her room and designed herself a built-in cupboard, one of the first in Turramurra, her niece told me, and a desk under the window. They are still there. To the contemporary eye Madge's room, even in its extended form, seems dark and modest.

Round at Ball Green there were also changes. The Brigadier-General had a crippling stroke in 1943 while on parade at Dubbo. Ethel Anderson had to change direction, give up her art salon— which had in any case been interrupted by the war—and swing into action as nurse and breadwinner, for once again they found themselves in financial difficulties. Austin's pension seems to have had an extraordinary capacity for going astray. This time Ethel responded by writing fiction: *Indian Tales*, based on her years on the sub-continent with her husband, were published in 1946.

Enid was still in Chatswood, on the railway line into the city, and came up to visit. She and Grace spoke on the phone every day. There was still an occasional game of tennis. There were exhibitions; even in war-time the Macquarie Galleries showed Grace every few years. The changes to her art that had begun with her father's death continued. She still painted flowers, but a certain formality replaced the intimacy of the early 1930s. Where once she had painted flowers and furniture as and where they were, without interference, now she took them to pose for her in the studio: set pieces like chairs with material draped across them and flowers arranged in jugs.

In 1944 she began a large painting about the war, which she called *Dawn Landing* and worked up through a number of studies. Young men are tipped out of the dark belly of a landing craft in a painting heavy with khaki, browns and dull greens. If the military apparatus does not ring entirely true, the face of the boy-soldier leading the way to the dangers that await them on the shore is powerfully done. Is this the child who had screamed behind the backs of women sending reinforcements off to the first war? Has he grown up to fight in another? Or did Grace have Mabel's second son, William, in mind, her nephew in the Normandy invasion?

When she painted concerts and churches, she achieved a greater sense of authenticity as they were places that she knew. But it is the authenticity of observation, showing us what many another would have seen. These civic paintings are not work that came from the powerful knowing of the inner eye that had guided her into her best work. With the death of Ernest, that vision seemed for the moment eclipsed, or closed, or turned elsewhere.

The other change that came after Ernest's death is to be seen in the way she painted landscapes. After the *Exhibition of French and British Contemporary Art*, which had caused such controversy in 1939, Grace moved from the geometric construction of paintings like *Wamberal Lake I*, *Govett's Leap* and *Mossvale Landscape*, and began to paint in small blocks of colour applied with a broad brush. It was in part a response to seeing Cézanne at the exhibition and in part an attempt, I think, to find a way to press beyond the work she had already done. For more than ten years she experimented with this technique, no longer taking drawings back to her studio, but painting the Australian landscape while she was in it. She would sit and look for a long time and then paint straight onto the board with a broad chisel-shaped brush, completing the painting there and then in a matter of hours.

There are people who admire the many landscapes from these years and among them are some small museum pieces that catch the flicker of light through the bush. But many are dull and repetitive. They do not reproduce well, and on the page tend to lose the light that gives them such power as they have. They are more convincing when one stands before them, but even then there is often something depressing about their drab persistence. The technique that she used, capturing light in individual brush strokes, was the one that she would use to wonderful effect in her interiors of the 1950s and 1960s, but in these bush paintings it was as if she had the right method but the wrong subject matter. When she painted an interior in 1940, it was plainly descriptive without a hint of what was to come once she turned this brushwork onto her own room.

If Grace Cossington Smith had died then, during the war or soon after, she'd be remembered as one of the better of the Sydney moderns. Her Bridge would still hang in our galleries, and so would *The Sock Knitter*. *Trees* would still be used to demonstrate a moment in Australian art when colour made the imaginative leap to greet a

*Grace
Cossington
Smith,*
'Studies for
DAWN
LANDING',
c. 1944.

new age. She'd still hang alongside Wakelin and de Maistre. It
would be an honourable enough place in Australian cultural history
and we'd lament that like Clarice Beckett she'd died so soon. Or if
she had lived into old age but had given up painting, as Grace
Crowley did, or if she had painted only those dreary landscapes and
monumental mishaps, she would have remained corralled in the
pre-war history of Australian modernism, which is where the
women have been given their place. There'd be a good deal less to
disturb us as we rushed on to the next phase: the gritty boy-moderns
who were springing into view.

Our attention would turn neatly to the generation of young men,
who knew from the mid-1930s in ways that Grace did not, that in
Europe artists and writers of their age were fighting and dying in
Spain. Theirs was a generation that knew, as she—and hers—did not,
that they would be the ones called on to fight this next war. Their art
was stained with politics, as were their lives. When Russell Drysdale
painted *The Medical Examination* in 1941, he knew the vulnerability of
white flesh exposed first for the stethoscope and then for the bullet.
This was something Stella Bowen understood when she painted
Bomber Crew, but from the vantage point of Turramurra, Grace
Cossington Smith's knowledge of the war came from newspapers and

Russell Drysdale,
THE MEDICAL
EXAMINATION,
1941.

newsreels. Her attempts to paint it may not have been successful, but the face of the boy-soldier landing on the Normandy coast shows her struggle to understand. Gone is the surface patriotism of *Soldiers Marching*; this time her concern is less with the women left at home than with the fate of soldiers young enough to be her children. Compassion was mixed with the experience of displacement. As to the young men, they simply did not see the middle-aged Grace Cossington Smith and they knew little or nothing of her work. They wouldn't have seen *Trees* and they wouldn't have seen *The Sock Knitter*; each had been exhibited in Sydney, briefly, and once only, many years before. Her paintings were not in the public galleries. There was nothing in the way art history was taught or written about for them to take seriously the work of an artist like Grace Cossington Smith as progenitor or older contemporary. From their perspective why would they be interested in a woman approaching fifty who had blundered into the Academy of Art and faced nothing more daunting than a train ride over the new Bridge into town?

Actually, when war came Grace volunteered as an air-raid warden and patrolled the night streets in uniform. But there's not a lot to make of that. Turramurra was hardly a major point in Sydney's defences, and while bombs were possible, they were not likely. She

and Madge did not retreat to the mountains, as many people did when Japanese submarines made it up the harbour to the Bridge, but I am straining to find heroism here. Grace's struggle, if that's the word for it, her *courage*, lay in an altogether different realm.

It was a hard time. As she felt herself slide, no *glide* into obscurity, she lost the colour that had once come to her so easily. When she painted the landscapes that seem so depressive, were they coloured as much by her emotion, her inner states of being, as by the paint that squeezed from the tubes? *Yellow, the colour of the sun*; her favourite colour, and for the better part of a decade she missed it, she lost it, it is not in her palette. Or rather it is there, but muted with greens and browns, dusky reds that draw the gold from it. Colour had lost its shine. Not entirely. But compared with what went before and what was to come, the landscapes of those years are lacklustre. Her attempts to paint the world of external political events suggest only the object and not her relation to it; the paintings flatten out in the loss of that exchange.

Yet she had the strength, and depth in herself, simply to keep painting. The colour might not be there, but her task was to paint anyway. Because she had always lived quietly with her sisters and her friends, at one level she continued much as she always had—and the benefits of this life were real. She still went into the bush with Enid and still found solace there, even if she couldn't quite capture its colour in the new brush strokes she'd learned from the Cézannes she saw in 1939. She knew the struggle and achievement of *clear unworried paint*, all the more so because she knew what it was to have the light go out of it and to be left painting with paint that was neither clear nor without worry.

One of the ways in which women have been kept in their place as artists is by the ever-present reminder of the dreary safety of their lives. As if life is lived most fully in the fighting of wars of one sort or another. In *Three Guineas*, which was published just before the war, Virginia Woolf had pointed out the the dangers of a way of thinking that split the feminine from the masculine, feeling from thinking, contemplation from action. But she might as well have been meeting the tide with a broom, and she did not live to see the war's end.

In March 1941, after another bitter English winter, she walked into the river near her house in Sussex and drowned. *River Ouse*

dragged for missing authoress, the local paper announced. When her body was retrieved nearly three weeks later, the stone that had weighed her down was found in her pocket. Her death makes it seem all the more as if it was the end of an era, although its significance is to us, looking back. What would Grace have taken from the news when she read it in the papers, or heard of it from Ethel Anderson? Would she have felt that there were stones in her pocket at this time when it was so hard for a woman to stay true to her own feminine impulses? And at an age when the gaze of the world tends to turn away from her.

I think of the early Australian moderns, the women who waded into the river of our small culture, and how few of them made it to the other bank. Has the creativity of women leaked out in grief at being invisible, ignored and trivialised? In disappointment, frustration and containment? Did Grace Crowley's paintings draw to a halt because she waited out Ralph Balson's marriage and gave herself over to looking after him? Or because she felt there was no longer an audience as the environment she had so carefully nourished was swept away? What would Dorrit Black have painted had she not suffered a mysterious 'great sorrow' and driven her Fiat into a bollard in Adelaide's North Terrace? Not that I'm suggesting she did it deliberately, she swerved to avoid a taxi; only that such repose as came to her, as an artist and as a woman, came hard and late, through 'the bitterness of frustrated tears'.[94] In Clarice Beckett's case even the doctor said she lost the will to live. She caught a chill one night in 1935 from painting during a storm, and when it turned into pneumonia she made no effort to struggle against it. She was not yet fifty when she let death come. Would her story have been different had she not been cloistered all those years with less than sympathetic parents? Had she been able to bring friends to anything other than a meal presided over by a disapproving father? Had she been able to take a lover without shame or subterfuge? How is a woman to paint under these conditions, even without the world turning its eyes from her?

Another way of thinking about Grace Cossington Smith at this difficult time is to see her not so much as a woman attempting to appease a masculine world, as a woman who went, as it were, into hibernation during the war years, to bloom again with another vision. Part of her wisdom was to know that everything has its rise and its fall. (Which is why the flower paintings work and *Dawn*

Landing doesn't.) And it was in that knowledge that her resilience lay. Yet another paradox is that there was vigour in her even at this time when she seems least vigorous. She was quietly honing her technique, learning all the time, and although it was a period of drought, her soul was never dry. This is what needs to be recognised, not the attempt to join the masculine world when her morale was low and she was mourning her father.

Some time in the mid-1940s, a street photographer caught Grace unawares as she was striding through the city. Her expression is startled, even cross, and yet she went back to collect a photo which captures something of this force in her as well as the stress. She was fifty in 1943 and in mid-war her coat is tight as if she has a layer too many clothes or has suddenly grown beyond the shape she is used to. But her shoes are shiny and elegant. Although here in this photo more than anywhere else we can see that modernity has claimed her, she wears its clothes with a certain disregard. There is determination in the eyes and a trenchant bend to the arm that carries the bag. You might walk past this woman in the street, the photograph seems to say, but you disregard her at your peril.

In the sketchbook for 1947 there is a self-portrait in coloured pencil. Here, too, the woman who stares out is stern. It is a face that refuses to arrange itself for the comfort of its regarding audience. Her bespectacled gaze meets ours and dares us to hold it and meet the emotion of a woman, still full of life, still full of strength, who has been rendered irrelevant. Spinster. Amateur. Sweet Christian lady. It is not a sweet face. Formidable and knowing, but not sweet. It is the face of a woman whose attitude and intelligence have gone past the expected feminine look, beyond stereotype and sexual usefulness. It is a face that says it is here for itself, not for anyone else. It is the face of a menopausal woman who finds herself invisible and does not like it, not out of vanity, but out of work that is still to be done. *Look*, she is saying. *Look at me. Do you consign one such as me to the scrap heap? Watch, for there is something you have missed. In me. And in the life we all share.*

In these images there is nothing of the grief-filled, teary Grace of 1931. For all her hesitation, she is unnervingly present for one who showed herself so rarely.

This time there was no angel waiting in the wings. No Ethel Anderson coming round for tea and swooping her up. This time

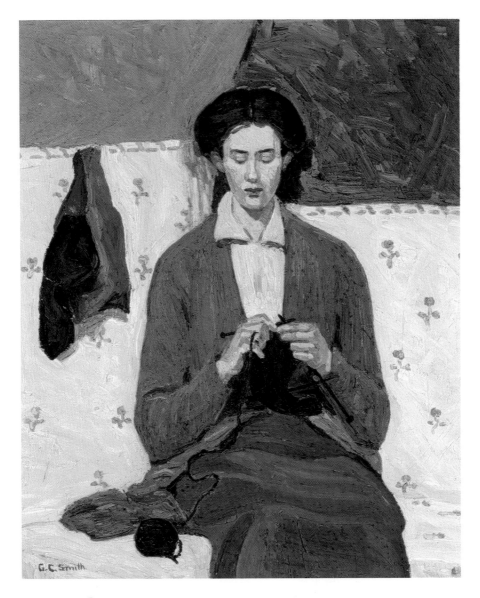

PLATE 17
Grace Cossington Smith, THE SOCK KNITTER, *1915. Oil on
canvas, 61.6 × 50.7 cm. (Art Gallery of New South Wales, Sydney)*

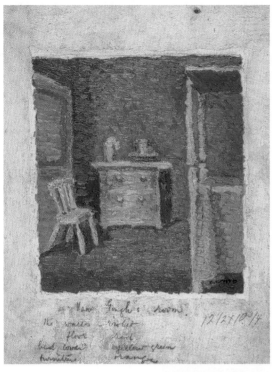

PLATE 18
Grace Cossington Smith,
VAN GOGH'S ROOM, *c. 1918.*
Oil on paper on composition
board, 19.4 × 17.5 cm.
(National Gallery of Australia,
Canberra)

PLATE 19
Grace Cossington Smith,
SOLDIERS MARCHING,
c. 1917. Oil on paper on
hardboard, 23.7 × 21.5 cm.
(Art Gallery of New South
Wales, Sydney)

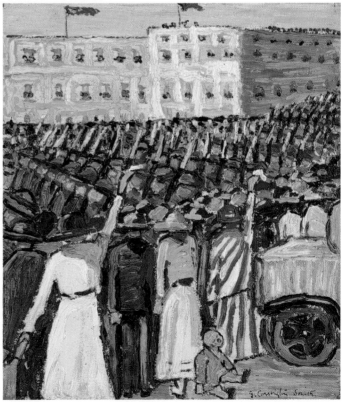

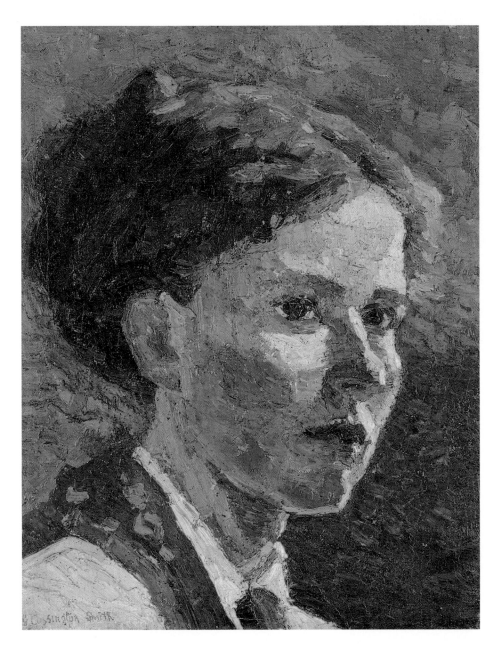

PLATE 20
Grace Cossington Smith, STUDY OF A HEAD: SELF-PORTRAIT, *c. 1918.*
Oil on canvas on board, 26.0 × 21.0 cm. (The Holmes à Court Collection, Heytesbury)

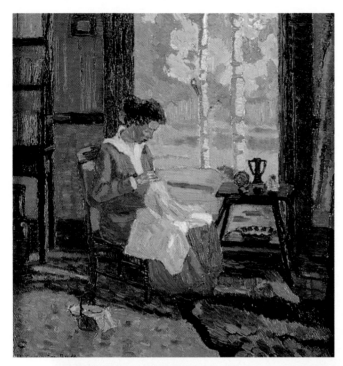

PLATE 21
Grace Cossington
Smith, OPEN WINDOW,
1919. Oil on cardboard,
22.3 × 21.3 cm. (Newcastle
Region Art Gallery,
Newcastle)

PLATE 22
Grace Cossington Smith,
CROWD, *c. 1922. Oil on*
cardboard, 66.7 × 87.5 cm.
(National Gallery of Victoria,
Melbourne; gift of the National
Gallery Society of Victoria, 1967)

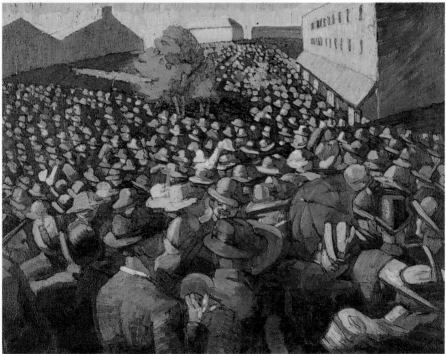

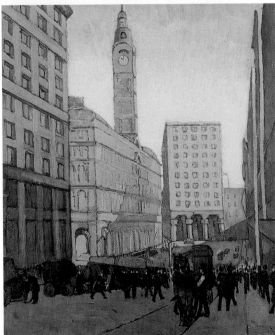

PLATE 23
Grace Cossington Smith, RUSHING,
c. 1922. Oil on canvas on paperboard,
65.6 × 91.3 cm. (Art Gallery of New
South Wales, Sydney)

PLATE 24
Grace Cossington Smith,
CENTRE OF A CITY, 1925. Oil on
canvas on board, 83.2 × 71.1 cm.
(John Fairfax Group)

PLATE 25
Grace Cossington Smith, TREES, 1926. Oil on plywood, 91.5 × 74.3 cm.
(Newcastle Region Art Gallery, Newcastle)

PLATE 26

Grace Cossington Smith, EASTERN ROAD, TURRAMURRA, *c. 1926.*
Watercolour and pencil, 40.6 × 33.0 cm. (National Gallery of Australia,
Canberra; bequest of Mervyn Horton, 1984)

PLATE 27
Grace Cossington Smith,
PUMPKIN LEAVES DROOPING,
*c. 1926. Oil on five layer
plywood, 61.2 × 44.2 cm.
(National Gallery of Australia,
Canberra)*

PLATE 28
Grace Cossington Smith,
LANDSCAPE AT PENTECOST,
*1929–30. Oil on paperboard,
83.7 × 111.8 cm. (Art Gallery
of South Australia, Adelaide;
South Australian Government
Grant, 1981)*

PLATE 29

Grace Cossington Smith, THE BRIDGE IN-CURVE, *c. 1930.*
Tempera on cardboard, 83.6 × 111.8 cm. (National Gallery of Victoria,
Melbourne; gift of the National Gallery Society of Victoria, 1967)

PLATE 30
Grace Cossington Smith,
BULLI PIER, SOUTH COAST,
*1931. Oil on pulpboard,
41.5 × 40.5 cm. (Private
collection; photograph by courtesy
of Deutscher-Menzies Fine Art)*

PLATE 31
Grace Cossington Smith,
HIPPEASTRUMS GROWING,
*1931. Oil on pulpboard,
47.5 × 37.5 cm. (Private
collection; photograph by courtesy
of Bruce James)*

PLATE 32
Grace
Cossington
Smith, GOVETT'S
LEAP, *c. 1933.*
Oil on pulpboard,
41.3 × 49.5 cm.
(Private collection;
photograph by
courtesy of
Deutscher-Menzies
Fine Art)

PLATE 33
Grace
Cossington
Smith,
THE LACQUER
ROOM, *c. 1935.*
Oil on paperboard
on plywood,
74.0 × 90.8 cm.
(Art Gallery of
New South Wales,
Sydney)

PLATE 34
Grace Cossington Smith,
BONFIRE IN THE BUSH,
c. 1937. Oil on paperboard,
61.0 × 45.7 cm. (Art Gallery
of New South Wales, Sydney)

PLATE 35
Grace Cossington Smith,
FIREWHEEL IN A GLASS
BOWL, 1937. Oil on
pulpboard, 40.5 × 36.5 cm.
(Private collection; photograph
by courtesy of Bruce James)

PLATE 36
Grace Cossington Smith, THE
ARTIST'S SISTER, *1936. Oil on
paperboard, 49.5 × 41.5 cm. (Art
Gallery of South Australia, Adelaide;
South Australian Government Grant and
d'Auvergne Boxall Bequest Fund, 1989)*

PLATE 37
Grace Cossington Smith, DOOR INTO
THE GARDEN, *1947. Oil on pulpboard,
62.5 × 47.0 cm. (Private collection;
photograph by courtesy of Bruce James)*

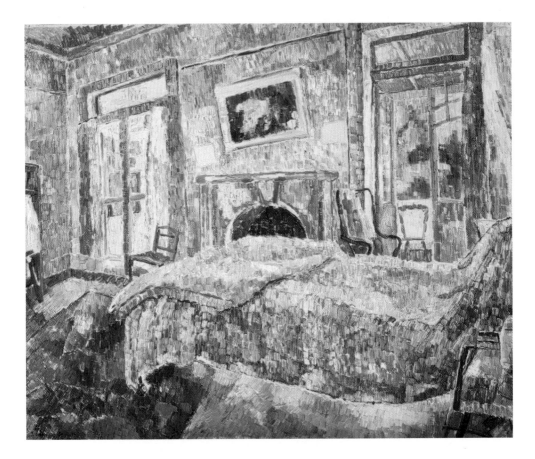

PLATE 38
Grace Cossington Smith, INTERIOR WITH VERANDAH DOORS, 1954.
*Oil on composition board, 76.2 × 91.0 cm. (National Gallery of Australia,
Canberra; bequest of Lucy Swanton, 1982)*

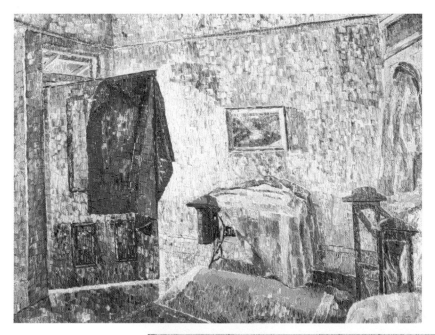

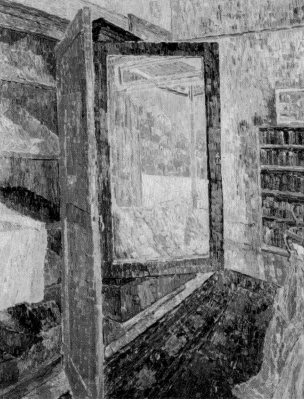

PLATE 39
Grace Cossington Smith,
INTERIOR WITH BLUE PAINTING,
1956. Oil on composition board,
89.6 × 121.2 cm. (National Gallery
of Victoria, Melbourne)

PLATE 40
Grace Cossington Smith,
INTERIOR WITH WARDROBE MIRROR,
1955. Oil on canvas on paperboard,
91.4 × 73.7 cm. (Art Gallery of New
South Wales, Sydney)

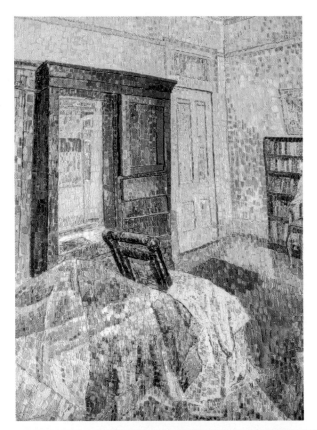

PLATE 41
Grace Cossington Smith,
INTERIOR IN YELLOW, *1964.*
Oil on composition board,
121.7 × 90.2 cm. (National
Gallery of Australia,
Canberra)

PLATE 42
Grace Cossington Smith,
STILL LIFE WITH WHITE CUP
AND SAUCER, *1971. Oil on*
pulpboard, 59.1 × 86.4 cm.
(Private collection)

*Grace
Cossington
Smith,
mid-1940s.*

*Grace
Cossington
Smith,
'Self-Portrait',
1947.*

whatever was to come next had to come from Grace herself. And this time the depressiveness we can see in the work—if depressiveness is the word—was years long. Not depression exactly, I wouldn't hazard a diagnosis, but a long low period, a long dip, a long time in the wilderness. Wilderness is an over-dramatic term for the paddocks of Bowral, or the liminal world of Turramurra with its gullies and creeping suburbs; perhaps also for the internal landscape of those years. A time of drawing in, a long drawing in, when life was no less beautiful, but hard somehow; a desert or a salt lake are the images that come to mind. A time of doubt when faith is necessary. *Return oh God of Hosts, Behold thy servant in distress.* I listen to Kathleen Ferrier's deep contralto; it is the voice Grace would have had, had she been a singer during those years of obscurity.

Her friends Helen and Enid felt it; they felt her feel it. There were still winter fires at Cossington, but the circle of warmth was small. They wrote her a birthday ode, with watercolour birds and celebratory flowers, that included the verses:

> Wishing dearest Gracie
> On this her natal day
> All the world can offer
> Both in work and play.
>
> Squeeze, O squeeze the paint out
> Slap it on the board
> Cadmium chrome and lemon
> Such a golden hoard.
>
> Madly with abandon
> Let the critics roar
> Take their silly notices
> Cast them on the floor.

Perhaps it helped. I'm sure it did. The tendency to over-dramatise is mine. Hers, always, was to take pleasure in the moment. Can't you hear the crack of her laughter as we close the door on them?

But they knew, and we know, that though the moment may pass happily enough, there were narratives in train that cared little

for them, and a buggers' union that was blind to them. There is a post-script to the birthday ode. 'Original manuscript,' they wrote, 'not in the British Museum!'[95]

10. AM I GIVING a coherent view of Grace Cossington Smith's life? Let me cloud the picture a little by going back to the beginning to tell you that Ernest Smith had a sister called Charlotte after whom Diddy was named. Aunt Charlotte was an Anglican nun and when Mabel and Grace were in England with their father in 1912, they went to visit her in Sussex, at her mother house, St Margaret's Convent in East Grinstead. There the young Grace saw in this elderly nun a woman who had given her life not to the love of a man and family, but to God and vocation. And she saw that her aunt was content. More than once over the years Grace made sketches of nuns, drawing them with attention. Although I have not mentioned Aunt Charlotte, her presence has hovered at the back of my mind, a little bell or warning, calling me back from the temptations of certainty and the assurance of narrative.

If we are to judge by the best of Grace Cossington Smith's work, we'd say her instinct was less for narrative than for image and reverie and colour. There is no story in *The Sock Knitter*, or in *Trees*, and little in *Eastern Road, Turramurra*, or in *The Bridge In-Curve*. 'Reverie' is the word for these paintings, for they are radiant with inner knowledge, evoking in us a state of contemplation, opening us to another kind of thinking and being in the world.

In an interview Grace gave in 1965, she said that art was for her 'a continual try'. By this she didn't mean that she was at it all the time. On the contrary, she said, also in that interview, that 'I don't make a continuous job of it and sometimes I go quite a long time without painting at all. When I do paint, it is something I want to do.' As this interview was given while she was still painting, it has a high significance for Cossington Smith researchers. In it she talks about colour, her intentions, and the patterns of her work. It is more detailed and less wandery than those last interviews in the nursing home. At the end of it, though, she drifts off as if her attention has left the microphone and she is back in a more accustomed and congenial realm—her *dear Cossington*. It's almost as if she is transported as she

listens to the garden and dreams her thoughts aloud. For years I read over this bit, disappointed that the approach of old age seemed, momentarily, to have captured her. This is what she said, switching quite suddenly and without preamble or apology from talking about Roland Wakelin and Roy de Maistre:

'The spring is coming in the garden and the bulbs are out, and the camellias are beginning to come out, and the birds very often sing. There is a bird now. There it is again. There they are again. I think there must be several of them away down among the trees. It is such a happy, clear note. There is an enormous gum tree at the bottom of my garden and the birds go for that. Years ago we used to have wagtails and blue wrens, but unfortunately so many people and the Council use these poisonous sprays, and so we haven't had any wagtails for a long long time. I'm afraid it has affected them.

'It's lovely to hear the birds, there they are again, quite a chorus. We have a firewheel tree in the garden and sometimes the parrots come to the scarlet flowers, and it is a perfect picture to see them with their bright colours flying in and out of the boughs . . .'.[96]

I now see this odd diversion as the most telling moment of the interview. When you listen to it on tape, her voice softens and drops as if her attention has shifted into a different register, and I think that register has something to do with the state I am calling *reverie*. Until she gets to the bit about the Council and its sprays, when she sort of wakes up—you can hear it on the tape—and shifts into explanation, the edge of a narrative. And then there's another, deeper, painterly, drop to the firewheel that she had painted with the intensity of attention she brought to her self-portraits. 'The firewheel is a lovely scarlet wheel and it grows right on to the branches.'

Reverie is an interesting word. It captures something of a dream state, and yet it is not sleep. It is a state of absorption, or play, and it is also serious; it conjures a state of not quite being in the world, a little apart, and yet it is in reverie that life is often at its most vivid and alive. It is, if you like, an *in-between* state. A state that resists narrative, or at least disturbs and unsettles it. And that dissolves the distinction between thinking and feeling, between watching and experiencing.

It is a state that psychoanalysts and mystics speak of. Winnicott calls it transitional space, which originates in the child's capacity to

play creatively in the private world that is allowed to her, or to him, by the holding presence of the mother. In other words the child is freed creatively and imaginatively by the knowledge of the protective presence of the mother nearby. Bachelard, recognising that the creative mind does not function well in the full blaze of attention, talks of 'sheltered space' in which we are at once open and attentive, sheltered from the blasts of worldly demands and distractions. It is not quite a meditative state, but akin to a meditative state. The Buddhists talk of 'bare attention' as the capacity to be at ease with oneself, to burst through the endless cycle of desires and obsessions and attend to the world simply as it is—the ordinary world most of us overlook, or look at without seeing, regarding and disregarding it in the same glance. It is the capacity to be held in a space in which you are alive to the world, and the world is alive to you. A state Grace recognised, I suspect, in her Aunt Charlotte. Or glimpsed. She was after all very young then, and the narratives of romance and ambition make a powerful claim.

So you can see why I left Aunt Charlotte until now. This is where she belongs. Not as part of the story so much as a beacon for a different way of living. Vocation is another interesting word. In Aunt Charlotte's case it meant a calling to the service of God. In Grace's case it was more a sense of having been called to a station or a destiny that had some kind of divine sanction. A shape to her life that was ordained by something greater than her own fluctuating wishes. Her path as an artist was, I think, held with something of this resonance. Not as a right, or as an excuse, as it was in the case of Ford Madox Ford. She never spoke of vocation. Her holding to her art had a more modest and less strident quality; it is visible in her life not because she made portentous statements about it, but because she stayed with it in faith even during those long years when the earth was bare around her.

Ethel Anderson might have used the word *intellectual* to denote the clarity of structure in her work, and her profound understanding of the history of art, but she also used the word *spiritual*. Grace's painting is not best understood (as the work of artists like Grace Crowley and Dorrit Black may be) as a matter of intellectualising, making a modern art in an antipodean country. Nor was she creating an identity for herself, although she was giving expression to something about herself, to the becoming of her self.

A continual try, she'd said. At her best it was never a matter of rep-
resenting something *out there*. Even with the building of the Bridge
which, as much as anything else she painted, was out there in the
world, a shared, iconic event, she was not giving us a structure in a
public space. The brilliance of those paintings is that she was able to
pull a public icon into private reflection, or rather that she could
approach it through the intensity of her attention and recreate it in
both registers, so that it is at once public, *ours*, and also *hers*. It shines
in that *in-between* space.

So when she says she paints as she sees, she doesn't mean that
she sees as a camera might see. She sees the essence of things, the life
that is alive around her, and she gives it her deepest attention; she is
inspired by it and when she is at her best there is nothing blocking
the view. No hopeless desire, no grievous disappointment, no
struggle against failure and rejection. Being human, of course, even
in her spinsterly narrative, there was desire, there was disap-
pointment, and there was rejection. There were long loops of time
when the view was blocked and the paint lay flat and dull on the
board. Those repetitious landscapes; those dry statements of
appearance. Those botched attempts at taking on the imperatives of
the external world. It was as if she fell out of love with her own
powerful—and also tentative—capacities, and tumbled back under
the thrall of the masculine rubrics of cultural significance.

It was then that the dogged persistence of vocation, or of a
calling outside the vagaries of daily desires, came into its own. If we
say that creative life exists in that potent, transforming, in-between
space where thinking and doing merge, we also face the fact that
opening oneself to it can be dangerous. We are not children with
protective mothers within reach, and that space is not always so
sheltered, or so safe. Or rather, in so far as it is, it must be made safe,
sheltered by our own strengths, by the gods that live inside us, by our
own transforming capacities.

'Certainly,' Marion Milner says in her celebrated meditation on
the subject, 'it seemed that as long as one is content to live amongst
the accepted realities and the common sense world, the fear of losing
one's hold on the solid earth may remain unrecognised; but that as
soon as one tries to use one's imagination, to see with the inner as
well as with the outer eye, then it may have to be faced.'[97] She is not
alone in speaking of the abyss that can also be entered through that

in-between space, when its sheltering capacities dissolve and leave a person up against the stern fact of her own unprotected self, her fears and demons. 'It was an odd road to be walking, this of painting,' Virginia Woolf writes in *To the Lighthouse*. 'Out and out one went, further and further, until at last one seemed to be on a narrow plank, perfectly alone, over the sea.'[98]

If we say, following this argument, that in Grace Cossington Smith's grand successes, in a painting like *Trees* say, or *Eastern Road, Turramurra*, or *The Bridge In-Curve*, or *Firewheel in a Glass Bowl*, she had drawn the outer into the realm of the inner, and infused what she saw there with the radiance of her own soul, then the question to ask is what was she doing with the drab landscapes and monumental failures that dogged her middle years? 'Not only one's gods take up their abode in shrines in the external world,' Marion Milner also says, 'but also one's devils.'[99] Was the devil that was nipping at Grace's heels the desire, unconscious and unacknowledged, to be seen by the men who had ridiculed or ignored her, the men whose public events she failed to capture? Was she resisting being reduced to the judgment of *amateur* that comes to a woman who paints flowers and interiors and sisters reading? Or was it that, without children to grow into that feminine world and fill it with a new life, those interior scenes—which had always had an element of constraint about them—seemed suddenly as dry as the landscapes she was painting?

Enough of this speculation.

After the war, Grace put away her air warden's uniform, and when Diddy's troopship sailed into the harbour, she and Madge were on the wharf to welcome her home. After seven years as an army nurse in Burma, Diddy was not in good health when she returned to Parramatta Hospital as deputy matron. Her niece says she could have gone back as matron, but administration was not what she wanted. The wards had been her life, and there she took charge and worked with the last threads of her energy. On her days off she returned to the quiet of Cossington. After seven years of disruption, the three sisters were united again. A table set for three. The curtains were opened to let in the sky, now that there was no need to watch for enemy planes. The lines were painted on the tennis court. Gordon and Mary came over from their house in Woollahra, and their children pinged the ball over the net. Madge kept up her tasks

in the kitchen while Grace walked down the corridor beyond her bedroom to the new studio inside.

Grace Cossington Smith, Signing, *c. 1945.*

In 1945, the year the war ended, she painted two more of her monumental disasters. In *Signing*, a row of men in uniform are lined up along a bench that looks like a bar; the man signing on the other side looks for all the world as if he is taking their order for drinks. Really! When it comes to imagining the world of men, she hadn't a clue. Bruce James says *Signing* came from press photos of Yalta, so it has a certain verisimilitude and it's possible to work out which figure is which world leader. But it is without truth. Not that she was dishonest—there was never anything dishonest about Grace Cossington Smith's work—just that *Signing* misses whatever it was that gave the occasion significance beyond the historical fact. With this as her subject, it was as if she couldn't leap the barrier of appearances. *Thanksgiving Service*, which came at the end of the war, is more convincing. This time we are in a church she knew well; a congregation, viewed from behind, is giving thanks. The colour is celebratory, glowing red.

Much more significant than either of these are two paintings which brought her back to her own register and terrain. In 1947, the year Stella Bowen died, Grace painted an interior, one of her first in that stippled mode of small blocks of paint that she had been using in her landscapes. It was called *Door into the Garden* (plate 37). It is the door that opened from her bedroom—the room that would be the subject of the late interiors—looking back across the garden to the studio where she had begun her life's work and the eucalypt that would never have a more brilliant life than in *Trees*. Bruce James sees *Door into the Garden* as a homage and farewell to her youth. There is something sweetly nostalgic about it, but I see it more as a drawing-in of her attention—her bare attention—back to the life she actually lived, to a room and a space that held her; a small gesture that allowed her to test her impulses again—her unmonumental, feminine, reflective impulses.

The other painting that interests me came the following year, in 1948, and is a self-portrait painted in the green and russet colours of her landscapes, as if she was bringing the technique she'd practised in the bush to bear on the contemplation of herself. Once again the face of a woman in her mid-fifties, stark and unadorned, confronts us without even a hint of a smile. For the first and—as far as I know—only time, she painted herself before a canvas. We can see the corner

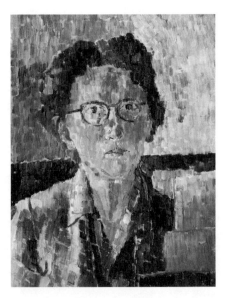

Grace Cossington Smith, SELF-PORTRAIT, *1948.*

of her easel in the bottom right, but her eyes are not on it, and her arms are not lifted to it. She paints herself painting at the moment she is not painting. Instead she sits still with her gaze grazing ours as it passes over and beyond the easel. To what? To herself reflected back in a mirror we cannot see? Or to the world beyond that was foxing her? It is a face that is serious about itself but not, I think, entirely comfortable with itself. It is a face that not only makes no concessions to the buggers' union but has knowledge it will never have. It is the face of a woman waiting for the day to come when she'll pick up her brush and give form and colour and light to what it is that, in this painful and invisible state, she sees.

There was a while to wait yet.

At the end of that year, in December 1948, the three sisters, Grace, Madge and Diddy, boarded the liner *Arawa* for Cape Town and England. In Grace's sketchbooks there are coloured pencil drawings from the voyage: port holes, horizons, sea-birds, land receding and reappearing. There are sketches of rigging and gang-ways and ship's equipment. Diddy's feet rest on the ship's rail. (I assume they are Diddy's. Madge, I think, wouldn't be so informal.) Grace enjoyed the voyage and was a dab hand at deck quoits and cricket. 'Yes, I often won,' she told Daniel Thomas, although she also complained that 'a wretched man always stepped out of the crease before I bowled'.[100]

Grace
Cossington
Smith,
'Ship Rails
and Feet, the
Arawa, Shaw
Saville Line',
1949.

In England the three sisters separated. Diddy went to a nursing friend in Cheltenham; she returned to Sydney and Parramatta Hospital in 1949. Madge went straight to Devon where she moved into the rectory at Trusham with Frances and Lionel Crawshaw. Grace went to Nell Campbell, the friend she had 'bivouacked' with at Jervis Bay in 1920. In 1949 Nell was living at Ingram's Green in Sussex. Together they toured the south of England; there are sketches to record their progress. They also took a train to Italy, where they stayed with friends of Nell at Poggio San Felice, 'up high on a hill over-looking Florence'.[101] From there they visited Assisi and explored the museums of Florence. At the age of fifty-seven, Grace Cossington Smith encountered the early Italian painters who had challenged the young Stella Bowen in 1923. But where Stella had taken Giotto's assembled angels as her inspiration, Grace—who had known the quattrocento only in reproduction—took Fra Angelico's devotional paintings as a guide out of the impasse she had reached.

In her library when she died there was a monograph on the work of Piero della Francesca, which Diddy gave her for Christmas in 1955. And another, which she bought for herself, of Fra Angelico's frescoes from the San Marco museum in Florence. Painted on the walls of the monks' cells, the San Marco frescoes were dedicated to lives of devotion and contemplation. They are pure in the simplicity of their composition and the clarity of their colour; there is serenity in them and a tough austerity. In *The Annunciation* the Virgin leans in towards the angel as she accepts the task and vocation of her life. In another cell Christ, arisen from the grave, reaches towards Mary Magdalen but forbids her to touch. The chaste, restrained lines of their bodies are marked not by yearning, or a discreet sensuality, but by devotion and a life given over to God.

Inside the book that Grace bought at the San Marco museum is the inscription: *Florence, June/July 1949*. This time we know exactly what was in her bags on that long voyage back to Australia.

There were also twenty-six sketchbooks, which are now in the National Gallery of Australia. Looking at them is rather like looking at a photo album, although unlike the photographs she had taken on her first visit to England in 1912 there were few people in these sketches. Here Grace Cossington Smith was, in the most literal sense, drawing what she saw. She drew the places she passed

through—houses, churches, bridges, hillsides, rivers—because they were there to be sketched. The towns and villages of southern England; the squares and hills of Tuscany; some views of Florence. The drawings are calm, informative, detailed. They are also oddly impassive. For me, the inscription on the inside of the book of frescoes has more resonance. The sketchbooks show Grace at her most external. Whatever it was that was going on inside, deep in the painter part of herself, was not finding its way onto the pages of the sketchbooks.

When Grace returned to Sydney early in 1951, she travelled alone. Diddy had been back a year, and Madge stayed on at Trusham. Lionel Crawshaw, Frances's husband, died soon after her arrival in 1949, and Madge stepped into the breach. I think she had intended it all along and Lionel's death was a timely convenience. In one of the boxes of sketches in the National Gallery there is a list, in Grace's hand, of her and Madge's luggage which was to be insured for the journey out. While Grace had one cabin trunk and one suitcase, along with a hat box and rug carrier, Madge left with two trunks, two suitcases, a hat box, rug carrier and coats valued at £12. A lot for a visit, but not so much if you're making your escape.

In the intervening years since Madge's first visit, Robert Kettlewell had married, but by the time she moved in with his mother, he had separated from his wife. It was an unusual situation for a country clergyman, but one which held, no doubt, a certain piquancy for Madge—who had had to endure news of the marriage relayed to her on the other side of the world. By 1949 Robert was the Rector at Trusham, which is why Frances had bought a house in the village. Madge ran the house, and also the parish, most efficiently. She lived in Devon for the rest of her life although both Frances and Robert died within ten years of her coming to live with them. She nursed them to the end, first Robert, then Frances. But she still didn't return to Cossington. In 1959, when Gordon's eldest girl Ann married, she came back to Sydney for the wedding. Although it was a happy time for Grace and Diddy, reunited with their sister, Madge didn't like the heat and she didn't like the journey, which she never made again. When Frances died, she settled in a neighbouring village where she continued for another twenty years until she broke a hip in 1982 and had to be moved to a nursing home. She died in 1986, the last of the sisters to go.

I could tell her story as the doomed fate of a woman crushed by that first, husband-killing war. And there is something doomed about Madge. Grace described Frances Crawshaw as 'very unusual as some English are—reserved, dignified, affectionate, fond of animals, flowers, trees, all those nice things; she'd feed birds in winter at her window sills'.[102] From a present-day perspective it could seem as if Madge chose a life as cramped and narrow as anything she'd endured at Cossington, but in Turramurra at least she looked out onto an Australian sky. But who am I to judge? I could convert Madge's story into a middle-class gothic tale. Or turn the lens a little and find in it a quiet story of success.

There are several sketches of Cousin Frances's well-appointed house in Grace's album sketchbooks, and according to her nieces Madge was happy there. She took pride in the parish and was well liked. *Happy* is not a word I would have used of Madge. Not in *The Sock Knitter*, or in any of the early sketches. At Trusham she might have been happy, or she might not. Happiness is not the point. The point is that she was at last doing what she wanted to do. She had reached the place she wanted to reach. She remade herself into the person she should always have been, a gentle-woman in an English rectory. Maybe all that is required of any of us is to know our destiny and reach it, to feel its shape, and beyond that it is incidental if happiness follows. Contentment resides elsewhere, I think.

11. WHEN GRACE ARRIVED back in Sydney, Diddy had bought the car, that highlight in Cossington's post-war life. She drove her sister home from the wharf in style. *Oh my, Diddy*, Grace said. *This is splendid. Look at the trees. Everything is blue. And silver. And yes, yellow. It's yellow. Australia is yellow. They don't know that in England.*

It was the end of summer. February 1951. The table at Cossington was set for two. And when Diddy was on duty at Parramatta Hospital the table was set for one. A woman came in to cook, and another to clean. Gordon brought the children to visit. The net was rolled up and the thud of balls was not to be heard on the court behind the house. The old studio became a garden shed.

On days off, Diddy took Grace painting. They drove to Bowral and Moss Vale. Sometimes Enid went with them. Sometimes Jean Appleton went. Occasionally Treania Smith from the Macquarie Galleries. Grace packed her huge black sketching umbrella and a picnic basket, which went into the boot with her paints, Diddy's deck chair and book, and a special padded box she'd made to protect her feet from insects as she painted.[103] 'She would sit for a long time in front of a subject,' Treania said, 'and then she would start up in one corner of the board and just go straight through.'[104] Oil on pulpboard, with no intermediary drawing; this had become her procedure with the landscapes of the late 1930s and the war; the return to a sketchbook in Europe had been an aberration born of necessity.

Back at Cossington, Diddy put the car in the garage while Grace carried the deck chair and insect-foiling box inside. In the film of imagination Grace walks down the corridor and pushes open the door of her studio. She puts the paints down on the table and stands the painting she's just done against the wall. It is not good. The colour is flat. She opens the windows, pulls back the blinds; the studio is flooded with light. *Yellow. The colour that advances.* 'Descend with the painter into the dim tangled roots of things,'

Cézanne said, 'and rise again from them in colours, be steeped in the light of them.' Grace had spent long enough in the tangled roots. The way out was through colour. 'Shut your eyes, wait, think of nothing. Now, open them . . . One sees nothing but a great coloured undulation. What then? An irradiation and glory of colour.'[105] Did Grace know these words of Cézanne? With half a dozen books on him in her library she might have, but even if she hadn't read them, she knew them.

Shall we have tea on the verandah? Diddy's voice calls through the still house.

The first studio paintings Grace did on her return from England and Italy, composed entirely in the studio, were the last and most interesting of her monumental failures. The knot was about to give. The Blake prize for religious art had held its first exhibition in 1951. Grace didn't enter anything as she'd just arrived back, but she had a small exhibition of her European sketches at the Macquarie that year; nothing sold.

In her studio she took two religious texts and prepared to enter the next year's competition. *Then One of Them, Which was a Lawyer, Asked Him a Question* is in the National Gallery of Australia. The more interesting of the two, once owned by Daniel Thomas, is entitled *'I Looked, and Behold, a Door Was Opened in Heaven'*. It is dated 1952–3, and the text comes from the Revelation of St John The Divine. On a first glance at this painting, it is hard not to laugh. A circle of sitting saints, with their large bottoms overflowing small stools, surrounds the figure of God who—seated on a golden throne in a yellow aureole—seems to float on a rather billowy magic carpet. A friar-like figure looks up through the door in astonishment and bliss.

It would be very easy to make fun of this painting, especially as the model she used for the saints' bottoms was her own, studied in the mirror. Also the soles of her feet. But it is a serious painting, essential to her story. It was her first attempt to find her own way to a modern rendition of the devotional art she saw at San Marco. In *The Last Judgement* a heavenly assembly of saints is seated in the sky above the mortals who have just risen from their tombs; in the centre, high above the earthly repenters, a circle of saints and angels surrounds a seated God with his hands held out in blessing. *'I Looked, and Behold, a Door was Opened in Heaven'* is a borrowing far too literal for the twentieth century.

*Grace
Cossington
Smith,*
'I Looked,
and Behold,
a Door Was
Opened in
Heaven',
1952–3.

But there are three things about this painting, utterly her own, that presage the interiors which were, at last, about to come. Those brush strokes, released from the landscapes, that had already begun to say *Look, I am here*; the yellow that had been trying to get out and advance; and the door through which the friar looks, which must surely be a door at Cossington. We are only a year away from the first of the great interiors, and when I look at them and then at this clunky monster on which the influence of Fra Angelico rests heavily, I can see the smallness of the step that had to be taken. Small, but crucial.

Another way of looking at this painting would be to dwell for a moment on the quotation. *'I Looked, and Behold, a Door Was Opened in Heaven'*. Grace had been sitting for so long with only the fine thread of faith to hold her to her empty easel while the door that had once opened to her was no longer open. There had been moments and glimpses, but no sense of a door flung wide. When it had opened before, it had been with the abandon of youth. That's not

quite the way to put it, but there was a sense in which it had happened anyway, not without struggle but without despair. This time, after many years in which despair was a real possibility as she sat with her own marginality, invisibility, and ageing, dampened spirit, that door was to be opened by the strength of her vocation. Or would faith be a better word? For it was not just that she had been invisible to the new generation of artist-men who were striding to success with their noisy—and often brilliant—re-interpretations of the continent and the history they shared, but that she had not been in sight of that throne, those juicy, saintly bottoms, that yellow. She had been out of touch with the glow that had once been so much a part of her life, her vision. In this painting, the bearded friar opens the door of Cossington and there is a heavenly spectre, but it is still *out there*, beyond the door.

And then, quite suddenly it would seem, we are with the interiors. Calm, beatific, assured, so naturally a part of her, it's as if they had always been there. There is no sign of struggle. It's as if she had pushed open that door, stepped through, and found that the vision of heaven was where she was all the time—in her own bedroom. But the sense of suddenness is as illusory as the rest of it. *A continual try*, she said. It's true of painting, it's true of writing, and it's true of life. The process of staying with that continual try can produce long low loops and sudden illuminations which we see in retrospect as springing open and banging closed. But in the tug and pull of time it is another day lived, another piece of board on the easel, another squeeze from the tube. Cadmium yellow, spectrum yellow, aureolin, Indian yellow, lemon. *The sun is God*, Turner said at the end of his life. If anyone knew about yellow, he did. Grace had him on her bookshelves as well.

The first of the interiors was *Interior with Verandah Doors* (plate 38), which she painted in 1954. The doors open east onto the verandah from her bedroom; the painting above the fireplace is a reproduction of a flowering chestnut by Van Gogh. *Interior with Wardrobe Mirror* came the following year, and then they tumbled out: *Interior with Blue Painting* (1956), *Studio Doorway* (1956), *The Way to the Studio* (1957), *The Sideboard* (1959), *Open Door* (1960), *Wardrobe Mirror* (1961). And the culminating, and rather different, *Interior in Yellow*, which she began in 1962 and finished in 1964.

In all of them except *Interior in Yellow* there is a sense of doors

opening, of light sources from half-concealed angles, hallways, passages. In all of them, there is a sense of being contained and held in the calm space of the room and at the same time open to the world beyond. They are contemplative, but not cut off from all that lies outside. This is the room of a twentieth-century woman, not the cell of a monk. In many of the interiors we look across the garden to the sky beyond. The doors are open: air, light, sun can enter. Outside merges with inside.

In others there are half-open drawers and cupboards as if the psyche can reach into its own depths with the same ease with which a person might step through a verandah door and into the garden. In a sense it is all the same. From an open position at the heart of one's own life, in that in-between space of reverie and contentment, there is not a huge distinction between verandah doors and cupboard doors. All possibilities are there.

Of all of these interiors there are two to which I am particularly attached. One is *Interior with Blue Painting* (plate 39), which is in the National Gallery of Victoria. It is a sewing room this time, with a door ajar and some material draped over it. There is more material on the sewing table. It is a large painting, grand in scale but modest in subject matter. Someone—probably Grace herself—has just left the room, covering the sewing machine while she is away. We can almost see her silhouette in the bright light behind the door which is angled against us. It is a presence that we feel, not a person that we see. The elusive presence of the artist. Once again she slips from sight even at the moment she is showing herself more intensely than she ever had before. The paradox of the full and empty room. The painting that hangs on the wall above the machine is one of her own, *Deep Water, Bobbin Head*, which she painted in 1942, and its blue— the blue of deep water—suffuses the room which is otherwise painted, of course, in yellow; yellow edging into the reds and ochres of the hill above the bend in the river at Bobbin Head. She painted that landscape in 1942, a flat year, and it is one of the ones that 'worked'. In the reflection of that deep water, there is movement as the river glides out of sight round that graceful bend.

Deep Water, Bobbin Head once hung beside my desk for a few months nearly ten years ago; it was loaned to me by the friend who'd told the story of Stravinsky's lunch at dinner that night. He was doing a little trade in paintings and he lent it to me between sales and

I have always been grateful that he trusted it to my ramshackle house. Living with it, it became a focus for my own reverie. I was drawn to its sense of deep water, of stillness combined with movement, as if in that bend of river one could feel both the tug of tide and eddy, and the calm buoyancy of the water. I didn't know then that this landscape was a jewel in a long barren period in the work of the woman whose paintings I took as not only iconic but exemplary. A kind of guide. I felt as if I could safely float there, cradled between those hills. I had no idea then of the risk that a plunge into that water could bring, for she had filled the abyss, so to speak, with that deep blue and the view of it was resolutely from above.

The other interior I am particularly fond of—for reasons equally solipsistic—is *Interior with Wardrobe Mirror* (plate 40). It may simply be that because it is in the Art Gallery of New South Wales, and usually on public display, it is easily accessible and therefore familiar. If I added it all up, I would probably have spent more hours than there are in a day, or even a week, in front of that painting. Its where I fell in love with her, and where I railed against her refusal to step forward and meet my query. Look at that mirror swinging out towards us. We ought to be able to see her reflection there because before we stood in front of the painting, she, the artist, stood in front of the mirror. But she has erased her reflection, giving us instead the end of her neatly made bed, the verandah door, the garden and the high Australian sky like a heavenly dome above and beyond.

This is the painting I wanted to poke my head through, as if by getting behind that mirror I'd find her. It's just as well there are guards in galleries, not so much because of thieves but because of those moments when the dreamworld of the artist and the dreamworld of the viewer meet and mix, a potentially potent collision. But it went on safely inside my head, or my heart, somewhere other than on the gallery floor; the guards paid me no attention and the passers-by seemed not to notice a thing.

It took me a long time to accept that Grace tilted the mirror just so, that she packed up her paints without leaving a trace, that she was not going to give me, give us, another, final, triumphant, self-portrait. It took me even longer to see that there was no need for her to, because every brush mark—each of those little blocks of colour—says: *This is*. 'Lo, behold a door was opened in heaven.' In *The Sideboard*, which she painted in 1959 after Diddy became ill, there's

a glimpse—a grazing glimpse—of her, reflected in a self-portrait caught in the mirror. But for the rest she didn't need to put herself into these paintings because in a sense she *is* the painting. Which is why the interiors are so powerful. And why, for all their absence of figures, they seem *embodied*. For while the rooms are given to us without the body of their inhabitant, they show the physicality of the one who has just walked through the door. She sits in that room. She undresses and sleeps in that room. She is that room. That room is her. And not. In reality she probably put away her paints, closed the door, walked down the corridor, put on the kettle and took in a pot of tea to Diddy, convalescing in bed.

In 1953 Diddy had a stroke. So great was the rupture and the blood flooding her brain, that it took two years for her to get well enough to come home. For those two years she was a patient first in one of the wards she'd presided over at Parramatta Hospital and then at a rehabilitation home. Grace, who never learned to drive, made the long trek across Sydney by train and bus to visit her. She sat by the bed of her adored sister and stroked her paralysed hand. She sat beside her as she learned with awkward steps to regain the smallest shadow of the confidence with which she'd once moved through those wards.

When Diddy came home in 1955, a hospital bed was set up for her at the dining end of Cossington's large double room that had been used as a Quaker meeting room before the Smiths' time; the heavy doors with stained-glass panels could be drawn to protect her from view of the sitting room. There was help in the house—as there had been since Madge's desertion—and some casual nursing, but the care of Diddy fell mainly to Grace. She moved up and down the corridor between her studio and Diddy's bed, or the chair on the verandah where her crippled sister sat on good days; she rationed her sister's cigarettes and looked across to the spreading arms of the great eucalypt that she'd painted forty years before when Diddy had still been a 'baby nurse' bouncing through the door on leave. *Diddy dear*, she said.

Interior with Wardrobe Mirror was painted in 1955, when Diddy came home; *Interior with Blue Painting* the next year. It was a sorrowful context for those great paintings. Diddy's illness, a shock reminder of her own mortality as well as her sister's, grounded Grace once more in the daily and modest reality of Cossington. In

her devotion to her crippled sister, she gave up trying to make the world notice her.

The paradox of the interiors is that they were born not only of the fullness of Grace's vision, but the bleak reality of Diddy's slow decline. That was the next hard truth. She had faced the abyss of an offended ego and turned from it to see what had been there all the time, awaiting her in her own room. Now she had to face the fact that exactly as she came to know that fullness—and feel it and become it—she also came to know that in attaining it, she must let it go. The knowledge, or wisdom, that's in those paintings cannot be had as a possession is had, certainly not as a trophy, or even as a companion. It comes and it must go. That too is why Grace is not there. She has filled that room—that kingly domain that was once her father's—and she has left it. She does not need to sit there like an angel guarding the portals. In *Interior in Yellow*, which she began in 1962, she shuts the cupboard, pushes in the drawers, and closes the door.

Everything is paradoxical. Here, in these paintings, we have the fullness of the spinster's life, the majesty of the room occupied by one, the intimacy of solitude, the contentment of faith, the revelation that there is no revelation, the experience of heaven and the know-ledge that there is no door that opens into heaven. If there is such a realm we are already in it. 'I sit here a lot,' she told Daniel Thomas. 'You get to know it.'[106]

When she had copied out those notes from Heysen at the back of her young woman's sketchbook, she had underlined this sentence: 'Personally I believe isolation is a good thing for an artist: he has the chance of finding himself and is not always too anxious to paint for exhibitions.' And underneath she wrote, quoting Heysen again: 'After all the main thing is to be honest to oneself and paint what one sees.' And then her own thought: '(i.e. what seeing things makes one feel.)'[107]

It had been a long journey. From the young woman who fell in love with Watteau, to the old woman who bowed before Fra Angelico. *Sometimes it tires me out*, she says as I stand behind her in the studio. *But now, well now I'd say not that it was worth it, but that it was. That's all. Listen, do you hear the birds, it's a thrush, not an English thrush, an Australian thrush, it has the most beautiful note of all, a singing note. It's a happy, clear note. And the parrots. Do you see them*

in the firewheel tree? It's a perfect picture with their bright colours flying in and out of the boughs. They're after the honey of course, the honey in the firewheel flowers. I'm just like them, but I'm after the colour. Come, we'll go outside. Diddy has tea on the verandah.

There is contentment in these late interiors and there was contentment in Grace. In some ways there always had been. And just as her long low loop did not prevent her from having fun, the epiphany of her late painting, maintained for a decade or more, did not keep her from the sorrows and difficulties of life. These, in the nature of things, continued.

12. ANYONE WHO LIVES to be old will tell you that age brings with it the momentous sorrow of losing people you have lived alongside, and one way of accounting for this last period in Grace's long life would be a list of deaths. Ethel Anderson died in 1958, Diddy in 1962, Gordon, also of a stroke, in 1968, her dear Mr Wakelin in 1971, her sustaining Enid in 1976, and Mabel, her eldest sister, in 1982.

In 1962, the year of Diddy's death, Grace began *Interior in Yellow* (plate 41) which is now in the National Gallery of Australia. Unlike all the others, it is of a room that has been closed; the cupboard is shut and so is the door onto the corridor. One drawer is left open a crack and the upper wardrobe door could also be shut tighter, but there is no sign of clothes extruding. The bed is neatly made, the blanket is folded on the chair, the books are straight on their shelves. It is a homage to Diddy and yet the room Grace paints is her own. It is an oblique memorial and a reminder that this room, so richly inhabited, would one day be closed and packed with the passing of its resident.

It was a lesson all the sterner when later that year Grace fell and broke her hip. She was alone when it happened and had to haul herself in a dragging crawl from one end of that long house to reach the phone at the other. And she had to endure her own immobilisation in hospital without a sister to sit by her bed. She came home quite quickly, but it was not until 1964 that she finished *Interior in Yellow*. She knew how easily that room could be closed behind her.

But there were still a few years of work left to her. She painted *Studio Door* in 1966, glorious in yellow. In it we look through the door out onto the garden again; there's a lightness to the trees and sky that are created from the same colour, the same brush strokes as the room in which she paints. In 1969 there was *Studio Doorway*, another view through the same door: greens and blues this time, a blush of mauve, and yellow. And then, in 1971, when her eyes were already beginning to dim, came her last painting, *Still Life with White Cup and Saucer* (plate 42). A cup and saucer, two vases and

three jugs are arranged on a table beneath the window in the studio, drawing our attention inwards, although above the table we are shown a narrow band of window, a last glimpse out into the garden. The white cup and saucer are made of a fine china. The jugs are large and heavy, their weight bears down on the table. The one in the middle has a fancy handle, but the others are modest, everyday kitchen jugs, the sort that might be used for vases. The cup and saucer are very white, a translucent white, waiting to be filled.

It was during these last of her painting years that Daniel Thomas made his visits to Cossington, interviewing Grace, taking his glass of sherry, or lime juice if he preferred, before driving back to town. When he had lunch with her, which he did only once, the meal was cooked by the woman who came in to help. All Grace had to do was to carry in the tray.

'The meal was very white,' Daniel said.

'White sauce?' I asked

'Yes,' he said. 'I was interested in the whiteness and plainness and blandness of the meal.'

'And it was a proper cooked meal?'

'It was fish and some white sauce and mashed potato. I got the feeling that Grace was scarcely aware of what it was—or cared. It was simply left to this slightly boring cook.'[108]

Lunch, clearly, wasn't Grace's thing. Her attention was elsewhere.

Another of the many ironies of Grace Cossington Smith's life is that exactly as her work reached the fullness of its final phase, the world which had been so doggedly oblivious to her suddenly opened its eyes. 'She has had so much appreciation at last,' Enid wrote to their friend Jean Appleton after she'd taken Grace to the eye specialist one afternoon in October 1973. 'As she says it doesn't mean as much to her now as it would have done twenty years ago.'[109]

If we gasp at the thought of those long years of obscurity when a little would have meant so much, it is we who draw in our breath, not Grace. She had reached a point of balance in her work and no longer needed the world of critics and opinion-makers to tell her she was an artist. She was pleased to be given her due, but she was old enough to know the benefit of recognition that comes after the battles of the ego are done, after the chasm has been faced, after the work has found its authentic mark. That, I think, is what she meant

when, viewing it from the end, she said it had been as well the critics hadn't liked her.

In November 1960 the Macquarie Galleries had shown *Pioneer Contemporaries*, an exhibition that presented Grace Cossington Smith along with Roy de Maistre and Roland Wakelin as a pioneer of Australian modernism. Sydney's art establishment took notice. In that same year the Art Gallery of New South Wales, with its new assistant curator Daniel Thomas, bought *The Sock Knitter*. Bernard Smith's prestigious *Australian Painting* was published two years later with the painting reproduced in colour, confirming her position in that founding trio. These two events—exhibition and book—began the process of repositioning Grace Cossington Smith from North Shore amateur to Artist.

The Macquarie Galleries held solo shows of the interiors in 1964, 1967 and 1968. The first, in 1964, was slow. For ten years Grace had been producing interiors and for ten years they hadn't sold. Lucy Swanton, another partner of the gallery, kept *Interior with Verandah Doors*, which Grace had brought proudly to the gallery in 1954. 'I've done it, Lucy,' Grace had said, unwrapping a painting which was not only incandescent with colour, but conceived on a scale that she had until then reserved for her paintings of public events. It was Lucy who had suggested the larger size. 'I looked at that beautiful painting hanging there, still unsold,' she said of the painting she subsequently gave to the National Gallery in Canberra. 'It just shone from the wall. I thought, "That's for me," and I bought it myself.'[110] The rest of the interiors went back to Cossington where, propped against the studio wall, they awaited the arrival of Daniel Thomas.

In 1967 he bought the run of paintings that he found in her studio and distributed them to the galleries, and in the same year he published an article on her in *Art in Australia*. 'He was young and very enthusiastic,' Treania Smith said. 'Her work really meant something to him and he shouted it everywhere.'[111] He had just come back from half a year in the United States and Europe. It was his first exposure to American early twentieth-century art, and it was there that he realised how good Grace was; 'Better than most comparable, much admired American painting,' he said. 'There's nothing like going away and coming back to help see Australia clearly.'[112] In *Art in Australia* he catalogued her neglect, listed her achievements and marvelled at her 'juicy brushwork'; he pointed out that while the

work of de Maistre and Roland Wakelin had been well served by books and articles and exhibitions—Wakelin had had his fourth retrospective at the Art Gallery of New South Wales in 1967—less than a dozen of her paintings had ever been reproduced. It was clear that he put Grace Cossington Smith in the first rank of Australian artists. The whiff of money began to attach to her signature. The 1968 exhibition at the Macquarie Galleries sold out. 'Thirty-five red spots,' Grace told Helen Stewart.[113] And again in 1970 she sold. More red dots.

But the real fillip came with Daniel Thomas's retrospective which travelled the country during 1973 and 1974 under the im-primatur of the Art Gallery of New South Wales. Grace wasn't well enough to be present when it opened. 'Enid and I saw the paintings at the gallery twice before the opening,' she told Jean Appleton, who was away at the time. 'Daniel arranged them all (not hanging) for us to see—I had forgotten some of them, & it was wonderful to see them, like <u>new</u> paintings.'[114] 'It really is the most beautiful Retrospective we have ever had,' Enid wrote to Jean on the same day. 'It is <u>very important</u> for as many painters as possible to see it.'[115]

The exhibition was shown in seven cities. It began with *The Sock Knitter* and ended with *Still Life with White Cup and Saucer*. Eighty paintings spanning six decades told the story of the woman who began with those early oils of sisters reading, who experimented with Van Gogh and Cézanne, and painted crowd scenes and city streets as the Edwardian world gave way to the rush of modernity. It told the story of a painter who could endure obscurity and hold to the integrity of both her art and her daily life, painting through the turbulence of the century and of her own heart to bring us at last images of great tranquillity.

The exhibition secured Grace Cossington Smith a place in the history of Australian art and won her an audience. Her representation of a formative moment in Australia's modernity dating from the First World War has become part of the way we see ourselves, and the very thing that once held her back from being seen—those glancing elisions between public and private, that unsentimental eye—now render her the most visible of the founding trio. Contrary to her own inclination, which was always to bow to the role of Wakelin and de Maistre, Grace Cossington Smith has come to take precedence, and it is now Wakelin, not her, who is undervalued.

Where her being a woman, and the sort of woman she was, counted against her in the early years of the century, at its close it is exactly the slant of that view that has come to be valued. For at her best Grace Cossington Smith has given us—in a way that no other Australian artist of her time quite managed—a view of what she saw through an intensely feminine sensibility. She saw the cost of war, she saw the monumental fantasies of men, she saw the colour of the bush and those roads going down; she saw the pain and the sweetness of life in small moments and ordinary objects; she saw pumpkin leaves drooping from the heat, things jostling on an iron tray, a girl reading in a deck chair, a lily in the middle of a field. This was the vision that was on show at the retrospective, and it could be said that with feminism kicking in, it was perfectly timed to catch a female audience. We were ready for the story—the myth—of a woman working in isolation, ignored by a patriarchal culture. There are some who have been cynical about this and I still sometimes hear rumblings that she's really only a North Shore painter, that she lacks masculine qualities of resistance, but in the climate of our day such rumblings remain *sotto voce*.

In 1987, three years after her death, Robert Rooney reviewed a posthumous exhibition of her work at the Niagara Galleries in Melbourne and spent almost as much time on the audience reaction as on the paintings themselves. 'Not since the video of *Elvis on Tour*,' he wrote, 'had I witnessed such spontaneous, uncontrolled expressions of passionate enthusiasm among the over forties.' Women over forty, he meant. 'They quickly dashed upstairs.'[116] He was making a dig, but if we turn it around, what he says becomes a tribute. Grace Cossington Smith's painting expresses something absolutely true about a modern, twentieth-century sensibility. What she saw, and how she saw it, has gone into the making of her century as surely as the noisier, more heroic claims that have been made on our modern attention. Of course we respond to her with a jolt of recognition.

In 1928, the year of Grace's first solo exhibition, none of this could be seen by the men with the power to review; in 1987, a man could be caustic, but he didn't dismiss her. Let us not forget that with this myth there was money to be made. Within three years of her death a single painting would sell for more than the entire value of her estate. The *Financial Review* reported in 1987 the sale at auction

of *Studio Door* for $140,000 and another unnamed interior for $160,000. Her estate had been proved at $129,850 two years before.[117] And prices have gone up since. Up and up, and not to her advantage. Daniel Thomas couldn't stop any of this from happening, and we have him to thank for the fact that the major works have landed in our public galleries and are not circulating between the hands of the rich.

This is the story of the paintings that go with the signature *Grace Cossington Smith*. It is not the story of the woman who was growing old in the house at Turramurra. While Grace's work started its dramatic rise to visibility and high prices, she was withdrawing into herself in preparation for death.

At Cossington, Grace lived alone, and in the last years her eyes —like her father's before her—began to fade. The doors to Madge's and Diddy's rooms were kept closed. There was a table in the corner of the sitting room where a small splash of sun came in. But by 1973, even in the light of her studio, she couldn't see well enough to paint. 'It was very sad,' she told a journalist, 'that I couldn't see the paint as it squeezed out of the tubes.'[118] She had painted her way through love and loss, and she'd painted her way through the deaths of sisters and friends. When Wakelin died in 1971 she wrote to her friend Jean Appleton saying that with his death they had lost something 'serene and true in the turbulent sea of froth and insincerity'.[119]

Of all the deaths, Enid's was the most difficult to bear. It came in 1976, when Grace was already frail. Grace had spoken to her friend on the phone every day for the many years they'd both inhabited the same city and felt her death with the full impact of her body. 'A physical shock,' Bruce James said.[120] It was news that came as a herald to her own departure from Cossington. She lived on there for another couple of years, taking her leave, with cats for company and the women who came to clean and cook for her. Friends and nieces and younger artists came to visit. She banged a notice on the gate saying *Save Our Kangaroos*.

As she turned inwards, the outside world that passed beyond her vision, and perhaps also beyond her interest, made one last jibe as if to shake her into recognising its power. In 1977 the Macquarie Galleries planned an exhibition of her small works; they were left-over pieces, for there had been nothing new since 1971. The show was hung when, the night before it would have opened, the door was

forced and all the paintings stolen. The papers were full of it the next morning. Grace, usually sanguine, reacted badly. The police were involved and so were lawyers; the gallery's insurance turned out to be inadequate. It was a strange episode which has never been explained, nor the paintings recovered; a sad end to her long association with the Macquarie Galleries. The legal wrangle ground on, drawing into its intrigue a painter who had lived outside the glare of publicity and scandal. It did her no good. Already drained by grief and failing health, she felt her hold on the practicalities of life begin to slip. In 1979 she was moved into a nursing home in Roseville.

In a small but pleasant room, an old woman sits in a chair; her niece describes the scene many years later. Photos show Grace with her neck in a brace, her leg in a calliper, and eyes that no longer focus. Grace Cossington Smith sits in a dream, in reverie, thinking—she tells the journalists who intrude from time to time—of all the people she's known and the paintings she's done. There is a serenity to her that is remarked on by her visitors. The sun outside is hot, the yellow gold of her finest work, the colour that advances; inside, the pattern of its light flickers on the floor beside her chair.

Grace Cossington Smith died at Roseville, on Sydney's lower North Shore, on 10 December 1984. She was ninety-two years old. Her ashes are scattered at the Northern Suburbs Crematorium.

A month later, on 11 January 1985, a memorial service was held at St James's Church, Turramurra, to consign to the heavens the memory of a sweet Christian lady and a great Australian artist. One story had ended, and another begun. Or rather, two stories were offered up: the private Grace, sweet and Christian, and the public Cossington Smith. The family, the nieces who knew and loved her, would like, I think, to keep the private private. Those who trade in her paintings and watch the prices go up don't mind who she was as long as she sells. Curators and historians speculate. Her niece, Gordon's eldest daughter, lives at Cossington now with her husband. They receive people like me kindly and show me where the tree once was until it fell over in a storm in 1991. They show me the *en suite* that has been put beside the room that once was Grace's, and the built-ins that have replaced the old wardrobe with its mirror, the windows that have taken the place of those verandah doors. Carpet muffles the sound of our feet in the corridor.

EPILOGUE

'EMOTION WITHOUT KNOWLEDGE is the mother of all sentimentality,' Grace Cossington Smith wrote in her notes on Hans Heysen. 'Knowledge without emotion is cold and sterile.' It is a way of speaking against the split, the many splits, that Stella Bowen also spoke against: thinking and feeling, inner and outer, public and private. 'The word truth in art opens out a vast and limitless argument,' Grace says, reminding me—as she always does—of the impossibility of solutions, the danger of answers. 'Your book seemed like part of an eternal argument,' Naomi Mitchison wrote to Virginia Woolf on reading *Three Guineas*, 'that is bound to go on in one's mind, on and off, the whole time.' When it comes to a subject like love and art, or daily life and the great work, there are no answers, no conclusions, only conversations, meditations—and the shining work.

When I first saw Stella Bowen's *Self-Portrait*, it was at a time in my life when I understood all too well the dilemma in which she found herself; although my circumstances were entirely different, like her I did not know how to turn my face to the public world while privately bowed by what felt at the time to be an intolerable burden of grief. What I responded to in that image of herself was the directness of the look. It was this that drew me into the thinking, the work and the meditation that has resulted in this book. I enjoyed the paradox—which became more and more evident to me as I looked at the self-portraits of women—that invisibility, the experience of not being seen even as one sees so much, can produce moments of extraordinary candour and clarity.

As soon as I arrived home from Melbourne after my first encounter with Stella Bowen, I went to the library for *Drawn from Life*. Reading it was like joining a conversation that has continued in my mind *on and off* ever since. There I heard the voices of Naomi Mitchison, Margaret Postgate, Edith Sitwell and, most particularly, Virginia Woolf gathered into the memoir of a woman who, after all she had endured, had the generosity and honesty to say that love also matters. She didn't blame, she didn't intellectualise, she didn't

persuade. She stood firm against the 'Prevailing School' of Ezra Pound and the British Left, but she didn't try to convert, or convince anyone of anything. She simply said *This is* and allowed the image to do the rest. She painted the rooms where she lived and the views from her windows; she painted her friends and the places where they ate. When war came she painted its impact on ordinary life, she painted the daily experience of the young men who flew the bombers, and she painted her daughter on the eve of her call-up.

If anyone understood the dilemma of Stravinsky's lunch and its implications in a world in which the sacrifice of a wife could slip into the sacrifice of a generation, it was Stella Bowen. But her attitude to it wasn't adversarial. If the truth of her life was the clash of those great ideals of love and art, then that is what she painted. By dwelling in the immediacy, in the *thusness* of life, in the discomforts of the present, she painted the dilemma. The claim she makes, if claim it is, is not the transcendence of life through art, nor the triumph of certainty, an end to ambivalence—there was no surmounting—only the capacity to witness what is. As I went in to bat for her, by turns outraged and saddened that fifty years after her death she was still unknown in her own country, I came at last to understand that the point was not to approach the dilemma as a warrior, but to come into relationship with it and feel its shape. This was the gift of the *Self-Portrait*.

As to Grace Cossington Smith's story, I have pursued it because I wanted to know who she was, this elusive figure who evokes so much in us and yet keeps herself well hidden, and because I knew there was something else. For her story never quite fits the dilemma of Stravinsky's lunch. There have been times when I thought it was perverse of me to persist with her when there were so many others who illustrated my point better; but it is precisely because of this perversity—hers, and mine—that the dilemma begins to resolve. Now, at the end of the book, I can *feel* my way into the koan with which I began. I knew that I was getting somewhere when my attitude to the story of Stravinsky's lunch began to change. When I first heard it, I felt challenged and defensive, and as a result got cross with the man who told the story; then I found I was cross not with him but with the story itself; and after that it no longer seemed so potent. But it took a long time, almost the entire writing of this book, to realise the insidious nature of the dichotomy on which the story of

Stravinsky's lunch is based. For it not only buys into a way of thinking that would separate art from life, with art striding above and beyond, transcending the ordinary and humble, but it sets life against art, or art against life. For those of us who are not the sort of people who stride and command—and don't want to—it inevitably makes us pit one part of ourselves against another, as so much in the culture helps us do, so that we experience these hard emotions as oppositional, one against the other.

What makes Grace Cossington Smith so interesting is that she is that rarity, a woman who simply didn't accept the terms. Or rather, didn't *get* the terms. It wasn't that she didn't suffer from them. Simply that she lived—genuinely and absolutely—by some other rubric. Perhaps it was because she was sufficiently isolated not to know the bohemian struggles of a woman like Stella Bowen. Perhaps it was because her psyche was peopled with sufficient figures from myth, and was touched with enough of the masculine to carry ambition without shame or self-consciousness. Perhaps it was because she didn't need the admiration of men to make her feel she was a woman. Perhaps it was because Madge relieved her of so much. Or perhaps it was because she was a dweller in that in-between zone, and understood the meaning of vocation. She didn't escape the grab and tension that inevitably occurs if one is an artist in a culture that allows the way we value and understand art to remain in the keeping of men. When she found a way through, it was not by moving between one and the other, art and life, but by encompassing both in the same fluid gesture.

The reason her work moves me isn't, as I initially thought, that she articulated some inverted version of the rub between life and art, though she certainly gestures to it. And it isn't that she settles the tension, or resolves it, although in a sense that is exactly what the late interiors do. What she does is illuminate both so that each is held in the other. Are the interiors about art? Or about life? Ridiculous questions. How can they be disentangled? What manner of thinking requires that they could, or should? Maybe the women at the Niagara Galleries in 1987 *dashed upstairs* to see more of her work because she lets us see, she lets us think, she lets us *feel*, that we can get to a position where we do not have to struggle, we do not have to choose, and that there are ways of being in the world that allow us, in the same breath, to live in our domestic ordinariness and still

create. She allows us a glimpse of—and from—that in-between zone where experiencing and watching, thinking and feeling, painting and living, are taken into the heart and into the body and held there in the flux of the spirit. She shows us that if we can hold our gaze steady, breathing in and breathing out, the heart opens as the mind ceases to struggle. We don't need to scale the heights or fight wars to become artists. We don't need to give up love, or subdue life. We merely need to open the door to something, or some capacity in ourselves, that is already there—or potentially there—if we can free ourselves from the dualisms that tell us it's impossible. That's what Rilke glimpsed in Paula Modersohn-Becker; that's what Stella Bowen understood as she painted her way into her *impossible independence*.

In Grace Cossington Smith's last painting there are three jugs, two vases and one white china cup and saucer, arranged on a table in her studio. A simple image composed of things she had only to walk into the kitchen to find. It was the perfect note to end on. For if we take the cup to be the life we are given to fill, then the painting tells us that it must be filled from several jugs. And if we take this translucent cup to be the art we struggle to produce, then it too must be filled from the same jugs that wait, heavy on the table. Are the jugs filled with the stuff of life, or the stuff of art? We can't see what is in them, but we know they must fill the cup—and the vases that are there beside them. What she saw was a cup and saucer, two vases and three jugs; and that is what she painted. And in painting that cup and those jugs she painted all we need to know about art and life. Whichever way we like to look at it, there is knowledge in those jugs, knowledge, and also nourishment; if there is to be nourishment in art as well as in life, and in life as well as in art, we must keep the image of the jug before us. For the jug pours the stuff of both, and the cup it fills is filled with both. There is no separation. There is no dilemma. That is what Grace came to see, and that is what she painted.

'The intensity with which a subject is grasped
is what makes for beauty in art. Isn't it also
true for love?'
Paula Modersohn-Becker

'You see I tried to convey the idea of each part of a
composition being as important as the whole.'
Gertrude Stein

'They don't see that I'm after something interesting.'
Virginia Woolf

ACKNOWLEDGMENTS

———

For kind permission to reproduce the paintings, drawings, photos and other illustrations, and to consult and refer to manuscript and archival materials, my grateful acknowlegments are due to the following galleries, libraries and private collections: the ACT Parks, Museums unit; the Agapitos/ Wilson collection; the Art Gallery of New South Wales; the Art Gallery of South Australia; the Australian War Memorial; Carl A. Kroch Library, Cornell University; the Courtauld Institute, London; the Sir James and Lady Cruthers collection; Deutscher-Menzies Fine Art, Melbourne; the Hermitage Museum, Leningrad; the Janet Holmes à Court Collection; the John Fairfax Group; Martin Browne Fine Art Gallery, Sydney; Mitchell Library, Sydney; National Gallery of Australia; National Gallery of Victoria; National Library of Australia; National Gallery, London; National Portrait Gallery, London; Niagara Galleries, Melbourne; Newcastle Region Art Gallery; Paula Modersohn-Becker Museum, Bremen; Queensland Art Gallery; Tasmanian Museum and Art Gallery, Hobart.

For further copyright permissions, thanks and acknowledgment go to the following people: Brian Brocklebank, for permission to quote from the letters of Keith Hancock; David Higham Associates Ltd, for permission to quote from *Selected Letters of Edith Sitwell*; Dickon G. Snell, for quoted material from *The Selected Poetry of Rainer Maria Rilke*; Faber & Faber Ltd, for permission to quote from *Hugh Selwyn Mauberley* by Ezra Pound (from *Selected Poems 1908–1969*); Northwestern University Press, Illinois, for permission to quote from *Paula Modersohn-Becker: The Letters and Journals*; Rainforest Publishing, for permission to quote from *Ethel and the Governors General* by Bethia Foott; Random House Australia, for permission to quote from *Plankton's Luck: A Life in Retrospect* by Mungo MacCallum; Random House UK Ltd, for excerpts from *The Diary of Virginia Woolf* (vols 1 and 2); Robert Craft, for permission to quote from *Chronicle of a Friendship, 1948–1971*; and Tom Thompson, for permission to quote from *For Love Alone* by Christina Stead.

I also wish to thank Donald H. Brown, for permission to reproduce *Studio Portrait, Chelsea* by Norah Simpson; Eena Job, for permission to reproduce paintings by Grace Crowley; Enid Hawkins, for permission to reproduce *Studio Crowley* by Frank Hinder; Henry Hopton, for permission

to reproduce *Studies of Jugs* by Gladys Reynell; Judith Murray, for permission to reproduce *The Fruitseller of Farm Cove* by Roland Wakelin; Lauraine Diggins Fine Art, Melbourne, and Albert Tucker, for permission to reproduce *Self-Portrait, 1939*; Mark Rubbo, for permission to reproduce *Self-Portrait* by Anthony Dattilo-Rubbo; Nora Heysen, for permission to reproduce *A Portrait Study*; Permanent Trustee Company, for permission to reproduce paintings by Margaret Preston; the estate of the late Sidney Nolan, for permission to reproduce *Self-Portrait, 1943*; and Henrietta Garnett for the Estate of Vanessa Bell for permission to reproduce *A Conversation 1913–16.*

This book has been made possible by an Australian Research Council fellowship held in the Department of English at the University of Sydney from 1993–97. Without this fellowship I could not have undertaken the research and given myself the time to learn about this generation of women and their art. In the English Department I would like to thank particularly Professor Elizabeth Webby and Professor Margaret Harris for their support and encouragement. I would also like to thank the department's hard-working support staff. In 1991 I was also awarded a grant from the Literature Unit of the Australia Council to begin this book, but the task proved too difficult and I wrote *The Orchard* instead. Nevertheless I am grateful also for this support.

In writing about Grace Cossington Smith, I am indebted first to her niece, Ann Mills. She and her husband John have been generous with their time and their welcome on several visits to Cossington. I am grateful to them for their kind permission to reproduce paintings, sketches and photos, and to quote from letters. I am also grateful to Robert and Winsome Smith and Marigold Pakenham-Walsh for further information about their aunt.

Anyone coming to Grace Cossington Smith owes a major debt to Daniel Thomas and to Bruce James. Inevitably the work of both stands behind my understanding of her. Daniel Thomas patiently answered my questions about his visits to Cossington in the late 1960s, about the 1973 retrospective and its reception, and about the subsequent career of some paintings. His comments on an early draft of this book were invaluable. In the absence of a catalogue raisonné, Bruce James's monograph on Grace Cossington Smith, published by Craftsman House in 1990, remains the standard documentation of her work and the chronology of her life. It is

thorough and reliable and should be consulted by anyone who wishes to extend their study of the artist. I have drawn extensively on his research and acknowledge it with gratitude. I am also grateful for his help in tracking down paintings from private collections and for reading the manuscript. However, when it comes to interpretation, I have felt from the start that I needed to find my own ground with this most elusive of artists, and must emphasise that no one else can be held responsible for the interpretations I make.

In researching Stella Bowen, there is no comparable figure of authority. However, there are fellow researchers to whom I owe a great deal. Joseph Wiesenfarth of the University of Wisconsin-Madison and Ros Pesman from the University of Sydney have both been very generous in sharing their research findings and allowing me to read their work before publication. I am grateful to them both. I am also grateful to Lola Wilkins at the Australian War Memorial and Jane Hylton at the Art Gallery of South Australia for sharing their knowledge of the paintings.

In the case of Ford Madox Ford, there are, of course, many authoritative scholars. I am particularly indebted to his most recent biographer, Max Saunders, and have relied on his *Ford Madox Ford: A Dual Life*, published in two volumes by Oxford University Press in 1996, as a guide to the chronology of Ford's life. I am grateful to Indiana University Press for permission to quote from his and Stella Bowen's letters. Similarly I have relied on Hermione Lee's biography of Virginia Woolf for chronological and factual information.

For permission to reproduce paintings and to quote from Stella Bowen's letters, I am grateful to Margaret Johnston. I am also grateful to Mary Alice Pelham Thorman, one of Stella Bowen's nieces, for reading drafts and for permission to reproduce the paintings in her keeping. My greatest debt is to Stella Bowen's other niece, Suzanne Brookman, who has been a staunch companion in the long endeavour of piecing together Stella's life, dating the paintings and making sense of the fragments. It is due to her care of the family archive that it has been possible to fill out the life to the extent that I have. It has been a continuing pleasure to work with her, and I thank her for her generosity, patience and sense of fun.

Other personal thanks and acknowledgments are due to Mary Eagle, who encouraged me from the start and who stood with me in front of paintings as I learned to see what I was looking at; to Maisie Drysdale, who helped bring the world of the early moderns alive for me and has given permission to reproduce paintings by Russell Drysdale; to Katherine

KEY TO NOTES

ABBREVIATIONS

ADB *Australian Dictionary of Biography*

AGNSW Art Gallery of New South Wales,
 Sydney

AWM Australian War Memorial, Canberra

GCS Grace Cossington Smith

DFL *Drawn from Life*

FMF Ford Madox Ford

ML Mitchell Library, State Library of
 New South Wales, Sydney

NGA National Gallery of Australia,
 Canberra

NLA National Library of Australia,
 Canberra

PMB Paula Modersohn-Becker

SB Stella Bowen

SMH *Sydney Morning Herald*

VW Virginia Woolf

SHORTENED REFERENCES TO BOOKS, EXHIBITION CATALOGUES, ARTICLES, TAPE RECORDINGS AND UNPUBLISHED MANUSCRIPTS

Anderson 1928 Ethel Anderson, 'Thought of
 Art: Mr Roland Wakelin's pictures',
 Undergrowth, September/October 1928

Anderson 1932 'Happy Pictures by a Young
 Australian', Catalogue essay for the Walker
 exhibition, London 1932
 Cutting in GCS Sketchbook, 1932, NGA

Anderson 1940 'A Bouquet of Women Artists',
 in *Art in Australia*, no. 78, 23 February 1940,
 pp. 56–58

Angier Carole Angier, *Jean Rhys: Life and Work*,
 Boston, Little, Brown & Co, 1990

Australian Eye 'The Australian Modernists
 1916–42', *The Australian Eye*, Film Australia,
 1984

AWM 1 1. AWM file 205/2002/031

AWM 2 2. 'Lancaster Crew', in *As You Were! A
 Cavalcade of Events With the Australian Services
 from 1788 to 1946*, AWM, 1946

Borzello Frances Borzello, *Seeing Ourselves:*
 Women's Self-Portraiture, London, Thames
 and Hudson, 1998

Bowen Stella Bowen, *Drawn from Life*, first
 published in London by Collins, 1941.
 Reprinted, with an introduction by Julia
 Loewe, by Virago, 1984. Edition used,
 London, Virago

Burke Janine Burke, *Australian Women Artists
 1840–1940*, Melbourne, Greenhouse
 Publications, 1980

Butel Elizabeth Butel, 'The Enchanted World
 of Grace Cossington Smith', *The National
 Times*, February 8–14, 1985, p. 27

Butts Mary Butts, 'The Master's Last Dancing',
 reprinted in *New Yorker*, 30 March 1998,
 pp. 80–83

Cole Margaret Cole, *Growing up into Revolution*,
 London, Green & Co, 1949

Correspondence Sondra J. Stang & Karen
 Cochran, *The Correspondence of Ford Madox
 Ford and Stella Bowen*, Bloomington &
 Indianapolis, Indiana University Press, 1993

Craft Robert Craft, *Chronicle of a Friendship,
 1948–1971*, New York, Knopf, 1972

Crowley Grace Crowley, 'Grace Crowley's
 Student Years', in Janine Burke, *Australian
 Women Artists 1840–1940*, Melbourne,
 Greenhouse Publications, 1980, pp. 77–86

de Berg Grace Cossington Smith in an
 interview with Hazel de Berg, 16 August
 1965, NLA

DeKoven Marianne DeKoven, *A Different
 Language: Gertrude Stein's Experimental
 Writing*, Madison, University of Wisconsin
 Press, 1983

Duigan Virginia Duigan, 'A Portrait of the Artist
 at 90', *The National Times*, 7–13 March 1982

Eagle Mary Eagle, *Australian Modern Painting
 Between the Wars 1914–1939*, Sydney, Bay
 Books, 1990

Elliott & Wallace Bridget Elliott and Jo-Ann
 Wallace, *Women Artists and Writers*, London,
 Routledge, 1994

FMF Ford Madox Ford, *The Good Soldier*, first
 published 1915
 A House, London, The Poetry Workshop, 1921

It Was the Nightingale, London, Heinemann, 1934. Edition used, New York, Ecco Press, 1984

The Marsden Case, Duckworth, 1923

Thus to Revisit: Some Reminiscences, London, Chapman & Hall, 1921. Edition used, New York, Octagon Books, 1966

Some Do Not (1924), *No More Parades* (1925), *A Man Could Stand Up* (1926), *The Last Post* (1928). Published together as *Parade's End* in 1979. Edition used, London, Penguin, 1982

Mightier Than The Sword, George Allen & Unwin, 1938

The Letters of Ford Madox Ford, edited by Richard M. Ludwig, Princeton, NJ, Princeton University Press, 1965

Foott Bethia Foott, *Ethel and the Governors General*, Sydney, Rainforest Publishing, 1992 p. 128

Frascina & Harrison Francis Frascina and Charles Harrison, *Modern Art and Modernism: A Critical Anthology*, London, Harper & Row, 1982

Fussell Paul Fussell, *The Great War and Modern Memory*, Oxford University Press, 1975

Gilbert & Gubar Sandra M. Gilbert and Susan Gubar, *No Man's Land: The Place of the Woman Writer in the Twentieth Century*, Yale University Press, 1988

Goldring 1943 Douglas Goldring, *South Lodge: Reminiscences of Violet Hunt, Ford Madox Ford and the English Review Circle*, London, Constable, 1943

Goldring 1948 Douglas Goldring, *The Last Pre-Raphaelite: A Record of the Life and Writings of Ford Madox Ford*, London, Macdonald, 1948

Hammond Victoria Hammond, *A Century of Australian Women Artists 1840s–1940s*, Deutscher Fine Art Catalogue, Melbourne, 1993

Hemingway Ernest Hemingway, *A Moveable Feast*, New York, 1964

The Sun Also Rises, first published in 1927. Edition used published as *Fiesta*, Arrow Books, 1993

Hillman James Hillman, *A Blue Fire: The Essential James Hillman*, London, Routledge, 1989

Hobsbawm Eric Hobsbawm, *The Age of Extremes: A History of the World, 1914–1991*, New York, Random House, 1994

Horton Grace Cossington Smith, artist's statement in Mervyn Horton, *Present Day Art in Australia*, Sydney, Ure Smith, 1969

Hughes Robert Hughes, *The Art of Australia*, first published 1966. Edition used, Penguin, 1970

Hylton Jane Hylton, *South Australian Women Artists; paintings from the 1890s to the 1940s*, Adelaide, Art Gallery of South Australia, 1994

James Bruce James, *Grace Cossington Smith*, Sydney, Craftsman House, 1990

Jenkins David Fraser Jenkins, 'Gwen John; An appreciation', Cecily Langdale and David Fraser Jenkins, *Gwen John: An Interior Life*, Phaidon Press and Barbican Art Gallery, 1985

Jones Margaret Jones, Interview with Grace Cossington Smith, *SMH*, 13 January 1973

Kerr Joan Kerr (ed.) *Heritage: The National Women's Art Book*, Sydney, Craftsman House, 1995

King James King, *Virginia Woolf*, London, Hamish Hamilton, 1994

Lambert Papers Lambert papers, ML MSS 97

Lee Hermione Lee, *Virginia Woolf*, London, Chatto & Windus, 1996

Lindberg-Seyersted Brita Lindberg-Seyersted, *Pound/Ford: the Story of a Literary Friendship*, London, Faber & Faber, 1983

Lindsay Norman Lindsay, 'A Homage to Julian Ashton', in Julian Ashton, *Now Came Still Evening On*, Sydney, Angus & Robertson, 1941

Loewe Julia Loewe, introduction to Stella Bowen, *Drawn from Life*, Virago edition, 1984

MacCallum Mungo MacCallum, *Plankton's Luck: A Life in Retrospect*, Melbourne, Hutchinson, 1986

Marr David Marr, *Patrick White: A Life*, Sydney, Random House, 1991

Marsden Robyn Marsden, archival interview with Grace Cossington Smith, 18 December 1982. Australia Council archival films.

McQueen Humphrey McQueen, *The Black Swan of Trespass*, Sydney, Alternative Publishing Cooperative, 1979

Milner Marion Milner, *On Not Being Able To Paint*, first published in 1950. Edition used, Heinemann, 1971

Missingham Hal Missingham, 'Margaret Preston', *Art and Australia*, vol. 1, no. 2, August 1963

News Chronicle 'Round the Galleries' by 'Palette' (Stella Bowen), *News Chronicle*, London, 1934–5

Nabokov Vladimir Nabokov, *The Real Life of Sebastian Knight*, first published 1941. Edition used, Penguin, 1964

Nindethana papers Papers of the Cunningham family, NLA MSS 6749/10

North Ian North, *The Art of Dorrit Black*, Sydney, Macmillan & The Art Gallery of South Australia, 1979

PMB Gunther Busch & Liselotte von Reinken (eds), *Paula Modersohn-Becker, The Letters and Journals*, translated by Arthur S. Wensinger and Carole Clew Hoey, Evanston, Illinois, Northwestern University Press, 1990

Pesman 1 Ros Pesman, 'Autobiography, Biography and Ford Madox Ford's Women', *Women's History Review*, 1999. Kindly shown to me in manuscript

Pesman 2 Ros Pesman, '"Drawn from Life": Stella Bowen and Ford Madox Ford', to be published in Robert Hampson and Max Saunders, *Ford Madox Ford's Modernity*, London, Macmillan, 2000. Kindly shown to me in manuscript

Pound Ezra Pound, 'Hugh Selwyn Mauberley', in Ezra Pound, *Selected Poems, 1908–1969*, London, Faber & Faber, 1975. (First published as *Hugh Selwyn Mauberley*, 1919.)

Preston 1927 Margaret Preston, 'From Eggs To Electrolux', *Art In Australia*, no. 22, December 1927, no pagination

Preston 1933 'An Exhibition', *Manuscripts*, no. 4, February 1933

Read Herbert Read, *The Contrary Experience: Autobiographies*, London, Secker & Warburg, 1963

Reed Christopher Reed (ed.), *Not At Home: The Suppression of Domesticity in Modern Art and Architecture*, London, Thames and Hudson, 1996

Rhys Jean Rhys, *Quartet*, first published London, Chatto & Windus, 1928. Edition used, Penguin, 1977

Rilke Rainer Maria Rilke, *The Selected Poetry of Rainer Maria Rilke*, edited and translated by Stephen Mitchell, Picador Classics, 1980

Rosenberg Carroll Smith Rosenberg, 'The female world of love and ritual', in *Disorderly Conduct: Vision of Gender in Victorian America*, New York, OUP, 1985, pp. 53–76.

Saunders Max Saunders, *Ford Madox Ford: A Dual Life*, 2 vols, Oxford, OUP, 1996

Sitwell Richard Greene (ed.), *Selected Letters of Edith Sitwell*, London, Virago, 1997

Spalding Frances Spalding, *Vanessa Bell*, first published Weidenfeld and Nicolson, 1983. Edition used, Phoenix, 1994

Speer Anne Speer, 'Ethel Anderson, Pioneer Supporter of Sydney's Post-Impressionism', MA thesis, English Department, University of Sydney, 1994

Stead Christina Stead, *For Love Alone*, first published in England in 1945. First published in Australia by Angus and Robertson in 1966. Edition used, Angus & Robertson, 1990

Stang Sondra J. Stang, *The Presence of Ford Madox Ford: A Memorial Volume of Essays, Poems and Memoirs*, Philadelphia, University of Pennsylvania Press, 1981

Stravinsky & Craft Vera Stravinsky & Robert Craft, *Stravinsky in Pictures and Documents*, London, Hutchinson, 1979

Sund Judy Sund, *True to Temperament: Van Gogh and French Naturalist Literature*, Cambridge University Press, 1992

Tate exhibition *Australian Painting: Colonial, Impressionist, Contemporary*, Tate Gallery, London, 1962

Thomas 1973a Daniel Thomas, *Grace Cossington Smith*, Catalogue to the Retrospective Exhibition, Trustees, Art Gallery of New South Wales, 1973

Thomas 1973b Daniel Thomas, 'Grace Cossington Smith', *Art and Australia*, vol. 4, no. 4, March 1973

Thomas 1981 Daniel Thomas, 'Grace Crowley', *Australian Dictionary of Biography*, vol. 8, 1891–1939, Melbourne University Press, 1981

Thomas 1988 Daniel Thomas (ed.), *Creating Australia, 200 Years of Art, 1788–1988*, Art Gallery of South Australia, 1988

Thomas 1993 Daniel Thomas, *Grace Cossington Smith: A Life from Drawings in the Collection of the National Gallery of Australia*, National Gallery of Australia, 1993

Thomas 1995 Daniel Thomas, interview with Drusilla Modjeska, Adelaide, February 1995

Helen Thomas Helen Thomas, *As It Was … World Without End*, London, Heinemann, 1935

Topliss Helen Topliss, *Modernism and Feminism, Australian Women Artists 1900–1940*, Sydney, Craftsman House, 1996

Undergrowth *Undergrowth*, the student magazine of the Sydney Art School, 1925–9, no pagination

Vallance Phyllis Vallance, *The Legacy*, London, Villers Publications, 1956

VW *The Diary of Virginia Woolf*, vols. 1 & 2, edited by Anne Olivier Bell & Andrew McNeillie, London, Hogarth Press, 1977–78

Virginia Woolf, *To the Lighthouse*, London, Hogarth Press, 1927. Edition used, Penguin, 1992

Wakelin Roland Wakelin, 'The Modern Art Movement in Australia', *Art in Australia*, December 1928

Walton Leslie Walton, *The Art of Roland Wakelin*, Sydney, Craftsman House, 1987

Whitechapel exhibition *Recent Australian Painting*, Whitechapel Gallery, London, June–July, 1961

Wiesenfarth 1 Joseph Wiesenfarth, 'Drawn from Life: Stella Bowen and Ford Madox Ford', presented at the first meeting of the FMF Society, London, 10 January 1998. Kindly shown to me in manuscript.

Wiesenfarth 2 Joseph Wiesenfarth, 'The battle of the books: Violet Hunt, Jean Rhys, Stella Bowen, and Ford Madox Ford', presented at the University of Wollongong, 2 May 1995. Kindly shown to me in manuscript.

OTHER WORKS CONSULTED INCLUDE

Christopher Allen, *Art in Autralia: From Colonization to Postmodernism*, London, Thames and Hudson, 1997

Carol Ambrus, *Australian Women Artists: First Fleet to 1945: History, Hearsay and Her Say*, Canberra, Irrepressible Press, 1992

Shari Benstock, *Women of the Left Bank, Paris, 1900–1940*, London, Virago, 1987

Elizabeth Butel, *Margaret Preston*, first published by Penguin Books for the exhibition *Margaret Preston* at the Art Gallery of New South Wales, 1985. Reprinted as an Imprint Book, Editions Tom Thompson, 1995

Christopher Butler, *Early Modernism: Literature, Music and Painting in Europe 1900–1916*, Oxford, Clarendon Press, 1994

Humphrey Carpenter, *A Serious Character: The Life of Ezra Pound*, London, Faber & Faber, 1988

Frank Dalby Davison, 'Stella Bowen's Odyssey', *The Age Literary Review*, 7 January 1967

Patricia Fullerton, *Hugh Ramsay, His Life and Work*, Melbourne, Hudson, 1988

Germaine Greer, *The Obstacle Race: the Fortunes of Women Painters and Their Work*, London, Secker & Warburg, 1979

Richard Haese, *Rebels and Precursors: The Revolutionary Years of Australian Art*, Melbourne, Allen Lane, 1981

Charles Harrison, *English Art and Modernism, 1900–1939*, Yale University Press, 1981

Violet Hunt, *I Have This to Say*, New York, Boni & Liveright, 1926. Also published as *The Flurried Years*, London, Hurst & Blackett Ltd, 1926

Heather Johnson, *Roy de Maistre: The Australian Years 1894–1930*, Sydney, Craftsman House, 1988

Jeffrey Meyers, *Hemingway: A Biography*, London, Macmillan, 1986

Linda Nochlin, *Women, Art and Power, and Other Essays*, London, Thames & Hudson, 1991

Gillian Perry, *Paula Modersohn-Becker, Her Life and Work*, London, The Women's Press, 1979

Ros Pesman, *Duty Free: Australian Women Abroad*, Melbourne, Oxford University Press, 1996

Ros Pesman, 'The Letters of Stella Bowen and Ford Madox Ford', *Overland*, no. 139, Winter 1995

Bernard Smith, *Australian Painting 1788–1970*, first published 1962. Second edition: Melbourne, Oxford University Press, 1971

Joseph Wiesenfarth, 'The Ford–Bowen Correspondence', *Review*, no. 17, 1995, pp. 85–94

Lola Wilkins, 'Stella Bowen. Australian War Artist', *Art and Australia*, vol. 28, no. 4, 1991, pp. 493–497

Virginia Woolf, *A Room of One's Own*, London, Hogarth Press, 1929
Three Guineas, London, Hogarth Press, 1938 Published with *A Room of One's Own*, Penguin, 1993

Francis Wyndham and Diana Melly, *Jean Rhys Letters, 1931–1966*, London, André Deutsch, 1984

NOTES

I
STRAVINSKY'S LUNCH

1 Review of the Victorian Artists' Society
 Annual Exhibition, *Age*, 8 July 1904
2 *Weser-Zeitung* (Bremen), 20 December 1899,
 PMB, pp. 141–2
3 PMB to Milly Becker, 30 November 1903,
 PMB, p. 325
4 PMB to Mathilde Becker, 10 May 1906,
 PMB, p. 397
5 PMB to Milly Rohland-Becker, May 1906,
 PMB, p. 395
6 Quoted by the editors, PMB, p. 346
7 Rilke, p. xxviii
8 Rilke, *Requiem for a Friend*, p. 79
9 Rilke, *Requiem for a Friend*, pp. 75–77
10 Rilke, *Requiem for a Friend*, p. 75
11 Bowen, p. 83
12 Craft, p. 375
13 Stravinsky & Craft, p. 31
14 Bowen, p. 153
15 King, p. xviii
16 Bowen, p. 141

II
CONVERSATION PIECE:
STELLA BOWEN

1 Bowen, p. 11. All unattributed quotations
 from Stella Bowen are from this source.
2 Stead, p. 1
3 Preston, 'From Eggs To Electrolux'
4 Yehudi Menuhin quoted in Hobsbawm, p. 2
5 VW, *The Diary*, 13 February 1915,
 vol. 1, p. 33
6 Vanessa Bell to VW, quoted in Lee, p. 346
7 VW, *To the Lighthouse*, p. 94; for Mrs
 Ramsay's dinner see pp. 90–121
8 VW, *To the Lighthouse*, p. 137
9 Cole, p. 74
10 See Lee, Chapter 19
11 FMF, *The Marsden Case*, 1923, p. 144
12 FMF, *Mightier Than The Sword*, 1938,
 pp. 264–5
13 Violet Hunt's diary, quoted in Saunders,
 vol. 2, p. 39

14 Read, p. 134
15 FMF to SB, 26 October 1917, *Correspondence*,
 p. 3
16 FMF to SB, 28 August 1918, *Correspondence*,
 p. 10
17 SB to FMF, 23 April 1919, *Correspondence*,
 p. 97
18 FMF to SB, 1 August 1918, *Correspondence*,
 p. 4
19 FMF to SB, 13 December 1918,
 Correspondence, p. 50
20 Fussell, p. 236
21 FMF to SB, 2 May 1919, *Correspondence*,
 p. 114
22 Violet Hunt's diary, quoted in Saunders, p. 74
23 Goldring 1948, pp. 208–9
24 SB to FMF, 5 April 1919, *Correspondence*, p. 66
25 FMF to SB, early September 1918,
 Correspondence, p. 11
26 FMF to SB, 4 January 1919, *Correspondence*,
 p. 51
27 FMF to SB, 4 January 1919, *Correspondence*,
 p. 52
28 FMF to SB, 16 April 1919, *Correspondence*,
 p. 95
29 FMF to SB, 18 September 1919,
 Correspondence, p. 17
30 SB to FMF, 4 April 1919, *Correspondence*,
 p. 63
31 FMF to SB, 23 April 1919, *Correspondence*,
 p. 95
32 SB to FMF, 26 April 1919, *Correspondence*,
 pp. 104–5
33 FMF to SB, 21 May 1919, *Correspondence*,
 p. 137
34 SB to FMF, 24 May 1919, *Correspondence*,
 p. 144
35 SB to FMF, 23 April 1919, *Correspondence*,
 p. 97
36 FMF to SB, 25 April 1919, *Correspondence*,
 p. 101
37 FMF, *Nightingale*, pp. 63–4
38 FMF, *Nightingale*, p. 156
39 Pound, p. 104
40 FMF to Ezra Pound, 27 July 1920, Lindberg-
 Seyersted, p. 33
41 Hemingway, *A Moveable Feast*, p. 70

42 Helen Thomas, p. 153

43 FMF to SB, 3 February 1922, *Correspondence*, p. 167

44 Cole, p. 83

45 FMF to Edgar Jepson, 9 July 1921, FMF, *Letters*, p. 134

46 *Parade's End* became the title for the tetralogy in 1950 when the four novels were first published in one volume. I use it for the sequence for convenience.

47 FMF to H.G. Wells, 14 October 1923, FMF, *Letters*, p. 154

48 FMF to SB, 10 March 1923, *Correspondence*, p. 178

49 SB to FMF, 10 March 1923, *Correspondence*, p. 180

50 FMF to SB, 7 March 1923, *Correspondence*, p. 175

51 FMF to SB, 14 March 1923, *Correspondence*, p. 186

52 VW, *To the Lighthouse*, p. 115

53 FMF to SB, 8 May 1923, *Correspondence*, pp. 196–7

54 FMF, *Thus to Revisit*, p. 9. Also quoted in Joseph Wiesenfarth 1995

55 SB to FMF, 12 March 1923, *Correspondence*, p. 184–5

56 VW, *To the Lighthouse*, p. 94

57 FMF to SB, 11 May 1923, *Correspondence*, p. 199

58 FMF to SB, early September 1918, *Correspondence*, p. 11

59 She earned £545 from her books in 1927; her total income for the year was £748. See Lee, Chapter 31.

60 Goldring 1943, p. 148

61 Butts, p. 110

62 Cole, p. 128

63 Herbert Gorman quoted in Saunders, vol. 2, p. 293

64 Loewe, p. ix

65 SB to FMF, 11–13 December 1926, *Correspondence*, p. 260

66 Paul Nash quoted in Saunders, vol. 2, p. 282

67 Rhys, p. 92

68 Rhys, p. 119

69 Rhys, p. 57

70 SB to FMF, 8 February 1927, *Correspondence*, p. 316

71 Joseph Wiesenfarth made this suggestion in Wiesenfarth 1998

72 Cathy Hueffer to Frank Soskice, 4 February 1924. Quoted in Saunders, vol. 2, p. 147

73 Ford's biographer documents this conclusively. See Saunders, vol. 2, chapter 15.

74 FMF, *Nightingale*, p. 320

75 SB to FMF, 11 January 1927, *Correspondence*, p. 294

76 Pesman 1999 makes this point

77 SB to FMF, 22 November 1926, *Correspondence*, p. 234

78 SB to FMF, 27 December 1926, *correspondence*, p. 277

79 SB to FMF, 3 December 1926, *Correspondence*, p. 247

80 SB to FMF, 9 November 1926, *Correspondence*, p. 218–9. You will be pleased to know that Hadley subsequently remarried.

81 SB to FMF, 22 November 1926, *Correspondence*, p. 234

82 SB to FMF, 2 January 1927, *Correspondence*, p. 284

83 FMF to SB, 3 January 1927, *Correspondence*, p. 285

84 FMF to SB, 20 November 1926, *Correspondence*, p. 230

85 This letter of dedication to Stella Bowen is reprinted in the Penguin edition of *The Good Soldier.*

86 SB to FMF, 18 April 1928, *Correspondence*, p. 380

87 SB to FMF, 11–13 December 1926, *Correspondence*, p. 260

88 SB to FMF, 11 January 1927, *Correspondence*, p. 293

89 SB to FMF, 3 January 1928, *Correspondence*, p. 373

90 SB to FMF, 22 November 1926, *Correspondence*, p. 233

91 FMF to SB, 18 February 1927, *Correspondence*, p. 320

92 SB to FMF, 25 November 1926, *Correspondence*, p. 235

93 Marie Laurencin quoted in Elliott & Wallace, p. 90

94 SB to FMF, 14 October 1927, *Correspondence*, p. 332

95 SB to FMF, 1 November 1927, *Correspondence*, p. 343

96 SB to FMF, 14 October 1927, *Correspondence*, p. 332

97 SB to FMF, 18 April 1928, *Correspondence*, p. 379

98 This is the title of the American edition published in New York by Boni and Liveright, 1926. The British edition was entitled *The Flurried Years* and was published by Hurst & Blackett Ltd, also in 1926.

99 FMF to SB, 2 December 1926, *Correspondence*, p. 245

100 SB to FMF, 13 December 1926, *Correspondence*, p. 259

101 Wiesenfarth 1995 uses this title. See also Ros Pesman 1999. I am grateful to them both.

102 FMF, *Some Do Not*, p. 128

103 FMF, *Thus to Revisit*, p. 22

104 FMF, *Thus to Revisit*, p. 19

105 FMF, *Nightingale*, pp. 192ff, 126

106 FMF, *Thus to Revisit*, p. 6. Also quoted in Wiesenfarth 1995.

107 VW quoted in Lee, p. 525

108 SB to FMF, 18 April 1928, *Correspondence*, p. 380

109 Edith Sitwell to SB, 5 December 1928, *Sitwell*, p. 95. Previous quotation (p. 107) also taken from this letter.

110 Rilke, 'Duino Elegies', p. 201

111 Marie Laurencin quoted in Elliott & Wallace, p. 113

112 Gertrude Stein quoted in Dekoven, p. 136

113 Marie Laurencin quoted in Elliott & Wallace, p. 107

114 *News Chronicle*, 10 December 1934, p. 6

115 Gwen John quoted in Jenkins, p. 40

116 VW, *The Diary*, 8 April 1921, vol. 2, 1920–1924, p. 107

117 SB to Jenny Bradley, December 1928. Quoted in Ros Pesman, in press.

118 Edith Sitwell to SB, 25 April 1930, *Sitwell*, p. 113

119 Hillman, p. 271

120 SB to Tom Bowen, 19 November 1930. Private collection.

121 SB to Kathleen Kyffin Thomas, 15 July 1932. Private collection.

122 SB to Tom Bowen, 19 November 1930. Private collection.

123 Goldring 1943, p. 192

124 Edith Sitwell to SB, 25 April 1930, *Sitwell*, p. 112

125 SB to FMF, 6 March 1933, *Correspondence*, p. 404

126 SB to Kathleen Kyffin Thomas, 26 January 1931. Private collection. All correspondence with Kathleen Kyffin Thomas during the 1930s is in this collection. Dates of letters quoted from: 13 January 1930, 15 July 1932.

127 SB to Tom Bowen, 6 December 1935. Private collection. All other quotations from SB to Tom Bowen before the war are from this letter.

128 *News Chronicle*, 18 November 1935, p. 8

129 *News Chronicle*, 20 May 1935, p. 14 & 25 March 1935, p. 4

130 FMF to SB, 19–23 January 1934, *Correspondence*, p. 431

131 SB to FMF, 1 February 1934, *Correspondence*, pp. 433–435

132 Julie Ford to FMF, May 1937, *Correspondence*, p. 452

133 SB to FMF, 20 March 1934, *Correspondence*, p. 436

134 *News Chronicle*, 4 March 1935, p. 4

135 *News Chronicle*, 2 December 1934, p 13

136 Spalding, p. 212

137 *News Chronicle*, 13 May 1935, p. 14

138 ibid.

139 Cole, p. 166

140 Saunders, p. 548

141 Quoted in Saunders, vol. 2, p. 548

142 Quoted in Pesman 1999

143 Janice Biala in Stang, p. 198

144 SB to FMF, 4 October 1938, *Correspondence*, p. 459

145 Julie Ford to FMF, 9 October 1938, *Correspondence*, p. 460

146 Julie Ford to FMF, Summer 1938, *Correspondence*, p. 456

147 See Pesman 1999

148 SB to Kathleen Kyffin Thomas, 21 October 1941. Private collection. All further correspondence with Kathleen Kyffin Thomas is in this collection. Dates of letters quoted from: 3 September 1940, Good Friday (1941), 25 November 1941, 5 February 1942, 9 August 1943, 27 January 1945.

149 Rilke, *Requiem for a Friend*, p. 85

150 Vallance. p. 71

151 A.W. Bazley–Col. J.L. Treloar, 9 July 1943, AWM. All quoted correspondence with Treloar is to be found in this file.

152 SB to Tom Bowen, 27 September 1944. Private collection. All further quotations from SB to Tom Bowen are from this letter.

153 AWM 1946, p. 84

154 ibid.

155 Loewe, p. xi

156 Keith Hancock to Joan Butlin, 6 July 1971. Private collection.

157 Quoted in Pesman 1999, ms. p. 16

158 Vallance, p. 87. All quotations from Phyllis's poetry are from this volume.

159 Pesman 1999, ms. p. 16

160 Loewe, p. xiv

161 Keith Hancock to Julie Loewe, quoted in Loewe, p. xv

162 The other group exhibition in which Stella Bowen appeared was an exhibition of South Australian women artists at the Art Gallery of South Australia in 1994.
163 Borzello
164 Edith Sitwell to SB, 12 April 1929, *Sitwell*, p. 102
165 Rilke, *Requiem for a Friend*, p. 81

26 This time Jean Bellette (b. 1919) and Dawn Sime (b. 1932) were exhibited, as well as Margot Lewers (b. 1908) and Frances Smith (b. 1938) who were also in the Whitechapel exhibition. This was out of a total of 48 exhibited as contemporary. There were no women in the other categories.

III
NO MAN'S LAND

1 Bowen, p. 176
2 ibid.
3 Grace Crowley, undated letter, *Undergrowth*, 1927
4 This generation has been written about extensively. This chapter is not a survey: for that and for the individual stories of the many women who were working in Australia during the inter-war years, see Burke, 1980; Eagle, 1989; Topliss, 1996; Kerr 1995.
5 As Sandra M. Gilbert and Susan Gubar do in a broader context: *No Man's Land: The Place of the Woman Writer in the Twentieth Century*, Yale University Press, 1988
6 Lindsay, p. xii
7 Preston 1927.
8 Wyndham Lewis quoted in Reed, p. 11
9 Crowley, p. 83
10 A lecture by André Lhote, *Undergrowth*, March/April 1928
11 Crowley, p. 82
12 Crowley, letter to *Undergrowth*, October–November 1927
13 Preston, 1933, p. 48
14 Missingham, p. 96
15 Margaret Preston quoted in McQueen, p. 142
16 *Sun* (Sydney), 6 April 1930
17 Rilke, *Requiem for a Friend*, p. 87
18 CGS quoted in Horton
19 GCS quoted in Thomas, 1993, p. 6
20 GCS to Mary Cunningham, October 1917. Nindethana Papers.
21 John McDonald, *SMH*, Saturday 29 March 1997, *Spectrum*, p. 1
22 R.G. Menzies quoted in Hughes, p. 132
23 Thomas 1981, p. 540
24 Elizabeth Durack (b. 1915), Margot Lewers (b. 1908) and Frances Smith (b. 1938) were the only women exhibited of 111 pieces by more than 50 artists.
25 R.G. Menzies, foreword to catalogue, Tate Gallery exhibition, 1962

IV
TO PAINT WHAT SHE SAW: GRACE COSSINGTON SMITH

1 de Berg
2 'Art and Some Pot Boilers', *Bulletin*, 1 August 1928, p. 37
3 *Evening News*, 24 July 1928
4 Treania Smith quoted in Butel
5 Thomas 1995
6 de Berg
7 He did not buy the house until 1920, when it was given the name Cossington. The street was called Ku-ring-gai Chase Avenue until the 1930s and is now called Ku-ring-gai Avenue.
8 GCS quoted in James, p. 13.
9 GCS quoted in Thomas, 1993, p. 9
10 Thomas 1993, p. 11
11 GCS to Mary Cunningham, 2 July 1916. Nindethana Papers.
12 Eagle, p. 31
13 Marsden, p. 4
14 Roger Fry, 'The French Post-Impressionists', in Frascina & Harrison, pp. 89–90
15 Thomas 1995
16 GCS quoted in James, p. 25
17 GCS quoted in Duigan
18 GCS to Mary Cunningham, n.d., Nindethana papers
19 James, p. 29
20 Van Gogh quoted in Sund, p. 202
21 Van Gogh quoted in Eagle, p. 37
22 de Berg
23 Wakelin, 1928
24 GCS quoted in James, p. 29
25 GCS quoted in Jones
26 GCS quoted in Thomas 1973a, p. 6
27 *Salon*, October 1915, p. 52
28 GCS to Mary Cunningham, c. July 1917. Nindethana papers.
29 GCS to Mary Cunningham, 32 December 1917. Nindethana papers.
30 GCS to Mary Cunninham, n.d., Nindethana papers.

31 GCS to Mary Cunningham, 10 August 1918. Nindethana papers.

32 Nindethana papers. All letters quoted in this section, many of them undated, are in this collection.

33 Rosenberg

34 GCS quoted in Duigan

35 *New Outlook*, August 1922, p. 222. cf. *Daily Telegraph*, 4 August 1922

36 James, p. 54

37 Foott, p. 128

38 GCS quoted in Thomas 1993, p. 24

39 GCS quoted in Thomas 1993, p. 22

40 GCS quoted in Thomas 1973a, p. 8

41 Thomas 1993, p. 24

42 Sketchbook no. 10. NGA.

43 James, p. 60

44 GCS quoted in Thomas 1993, p. 23

45 Topliss, p. 62

46 GCS quoted in Thomas 1993, p. 24

47 *Undergrowth*, March 1926

48 GCS quoted in Thomas 1993, p. 24

49 Bruce James dates this auspicious meeting to the following summer 1926–7, but in a thesis on Ethel Anderson, Anne Speer argues persuasively that it was in fact the earlier summer. I have followed her lead in this. See Speer.

50 Vladimir Nabokov, *The Real Life of Sebastian Knight*, first published 1941

51 Foott, pp. 128–130

52 de Berg

53 GCS quoted in Thomas 1973a, p. 6

54 Sketchbook no. 15. NGA.

55 *Sun*, Sydney, 19 April 1925, p. 16

56 Margaret Preston quoted in Walton, p. 21

57 Anderson 1928

58 This and the previous quotation both from Foott, p. 150

59 GCS quoted in Horton

60 GCS to G.W. Lambert, 2 February 1928. Lambert papers.

61 GCS quoted in Duigan

62 Treania Smith quoted in Butel

63 This was Mungo MacCallum 3. See MacCallum, pp. 71–3.

64 GCS quoted in Duigan

65 VW, *To the Lighthouse*, p. 58

66 Anderson 1932

67 *SMH*, 11 August 1928, p. 11

68 *Sydney Mail*, 1 August 1928, p. 33

69 Anderson 1940, pp. 56–58

70 GCS in Marsden, p. 11

71 *Bulletin*, 15 September 1927, p. 5

72 *Bulletin*, 1 August 1928, p. 37

73 Marr, p. 137

74 Sketchbook no. 3. NGA.

75 Beatrice Irwin quoted in James, pp. 67–8

76 James, p. 85

77 de Berg

78 *SMH*, 20 February 1982

79 GCS quoted in Thomas 1993, p. 28

80 GCS quoted in Thomas 1993, p 29

81 James, p. 93

82 James also makes this connection

83 de Berg

84 James, p. 95

85 *Birmingham Post*, n.d., cutting in Sketchbook, 1932, NGA.

86 *Daily Telegraph*, 2 March 1932

87 Anderson 1932

88 James, p. 69

89 *The Australian Eye*

90 Thomas 1995

91 de Berg

92 *SMH*, 1 November 1974

93 GCS in Marsden, p. 2

94 Dorrit Black, 'Three Poems' in North, p. 145

95 NGA 1976, 705–51–5

96 de Berg

97 Milner, p. 25

98 VW, *To the Lighthouse*, p. 187

99 Milner, p. 31

100 GCS quoted in Thomas 1993, p. 50

101 GCS quoted in Thomas 1993, p. 55

102 GCS quoted in Thomas 1993, p. 53

103 James, p. 135

104 Treania Smith quoted in Butel

105 Cézanne quoted in Milner, pp. 24–25

106 GCS quoted in Thomas, 1973a, p. 8

107 Sketchbook no. 3. NGA.

108 Thomas 1995

109 Enid Cambridge to Jean Appleton, 24 October 1973. Private collection.

110 Lucy Swanton quoted in *SMH*, 21 November 1979

111 Treania Smith quoted in Butel, p. 26

112 Daniel Thomas in a letter to Drusilla Modjeska, 27 July 1998

113 GCS to Helen Stewart, 17 June 1968. Private collection.

114 GCS to Jean Appleton, 16 June 1973. Private collection.

115 Enid Cambridge to Jean Appleton, 16 June 1973. Private collection.

116 Robert Rooney, 'Luminosity of an unsung modernist', *The Weekend Australian*, 24–25 October 1987

117 *Australian Financial Review*, 10 September
 1987
118 GCS quoted in Duigan
119 GCS to Jean Appleton, 13 June 1971. Private
 collection.
120 James, p. 157

INDEX